THE LONE TWIN BOAT PR

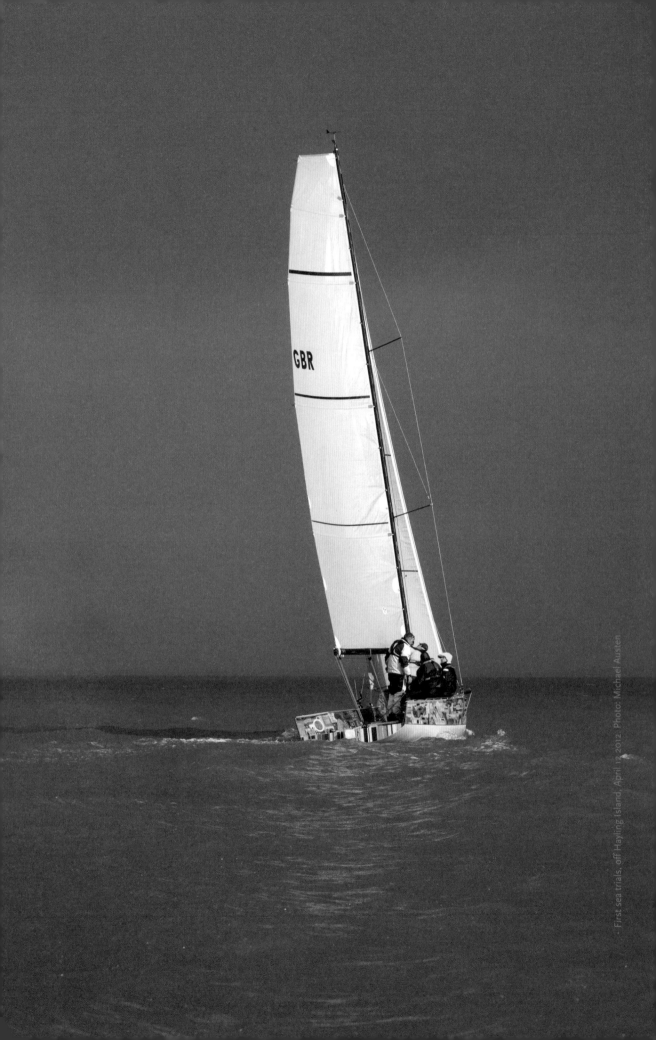

THE LONE TWIN
BOAT PROJECT

The illustrated catalogue of donations and their histories

with distribution tables and more than 1,200 colour photographs

Edited with introductory essays by David Williams

PUBLISHED IN 2012 BY CHIQUITA BOOKS

First published 2012 by Chiquita Books
6 Park Road, Dartington Hall, Devon TQ9 6EF UK

Designed and typeset by Kevin Mount
studio@kevinmount.co.uk
Printed and bound in England by Butler Tanner and Dennis Ltd, Frome

Distributed by Chiquita Books and Lone Twin
www.lonetwin.com
www.theboatproject.com

British Library Cataloguing in Publication Data
A catalogue record for this book is available from the British Library.

ISBN 978-0-9567592-2-1

This book is dedicated to all of the volunteers involved in *The Boat Project*, with thanks for their generous, energised engagement and inestimable help.

1178 Sam Darling, see page 214
I've got a really small boat. It was my great-aunt's. Every summer I come down to Bosham and do some sailing, and it symbolises that really.

THE LONE TWIN BOAT PROJECT 6

'I reckon this is very, very old. It used to be on my great-aunt's mantelpiece.'

CONTENTS

EDITOR'S ACKNOWLEDGMENTS

For their invaluable help during the preparation of this book, my sincere thanks to the following: in particular, Lone Twin – artistic directors Gary Winters and Gregg Whelan, and project leaders Gwen Van Spijk and Catherine Baxendale; the boat design and build team – Simon Rogers, Mark Covell, Jesse Loynes, Ian Davidson, Sean Quail and Mike Braidley; Alice Mount, for her transcriptions of interviews; Liddy Davidson and Ally Wade, for managing and clarifying the details in a sea of information; Sue Palmer, Carl Lavery, Matthew Burt, Bryan Saner, Clare Finburgh, Chris Dobrowolski, Gilli Bush-Bailey, Pete Goss, and Rachel Williams, for their input and support in various ways; Kevin Mount who designed and made this book, and those who provided him with technical and artistic help – in particular, Toby Adamson, Nic Cowper, Julie Depledge and James Longman at Butler Tanner and Dennis.

The plan was to build two coracles, two of those oval river boats covered in a tarred skin that are small and light enough to be carried on the back like a rucksack. At the time, some ten years ago, we were doing a lot of walking. Our idea was to walk across London to the Thames, use the coracles to cross the river, and then continue the walk on the other side, boats on our backs. But it didn't happen. We knew nothing about coracle making – and what we managed to find out meant we'd have had to collect the wood we needed, willow ideally, months ahead and soak it in water, allowing it to become soft and pliable. We thought we could ask local people if we could use wood gathered from their hedges and trees to make what we'd begun to think of as 'local' boats – but it didn't happen. Instead, we made a performance where we used the heat of our bodies, which we'd increased dramatically by dancing for a long time in too many clothes, to evaporate river water thrown at us by an enthusiastic audience. As the water visibly evaporated into a night sky, we announced that we were making clouds. Look, we said, we've become the weather.

The idea to build coracles, or to build a boat of some nature, was given to us by a group of Norwegians in the middle of a May night in 2000. We were on a long walk in the town of Kongsvinger. The Glomma, Norway's longest and widest river, cuts the small town in half. Two bridges about a mile apart unite the two sides. We imagined how many times a person living in Kongsvinger might cross the river in a lifetime, and we decided to pay homage to that repeating action by doing the same, walking backwards and forwards across the bridges, from a Saturday afternoon to a Sunday morning. We didn't walk alone, and by the middle of that night it seemed we'd met the town's entire population, most of whom had heard about our looping marathon on local radio and decided to join in, some staying with us for hours. As we walked and the group increased, conversation turned to the river below us and to boats – how they'd built one as a child, how their father had built one but never sailed it, how an old man in their village built his and then sailed off never to be seen again, how boats were a part of life, how they had opened up the world, how a boat had introduced human to human. In the early hours of the Sunday morning, a

1211 Gregg Whelan and Gary Winters, see page 218
In 2001 we drove to Wales to see a coracle race. We'd thought about making a couple of coracles to carry across London on our backs. But we didn't know anything about coracles. We thought we might meet somebody at the race who could help us, but we were late arriving and the race had finished.

THE LONE TWIN BOAT PROJECT 10

'The winner was an old chap, and he gave us this paddle. He'd broken it in his efforts to come in first.'

group of young people arrived with a small toy boat they'd built for the occasion, and it was named and launched into the river below.

We began thinking about boats after that. We'd learned from previous projects how good it could feel to do things with other people, walk together, dance together, sing together – to do those things we perhaps don't do enough of otherwise. Besides, when you work for a long time with just one person, meeting other people is tremendously attractive. It really does appeal. So, after the coracles that never were, we began to think seriously about building a serious boat: something that people could sail on, something that would take a lot of people to build.

In the course of *The Boat Project* we've met and worked with thousands of people. An army of volunteers materialised. We met just about everyone who made a donation. We were told 1,221 stories, all of which are collected here. The event of each telling, stranger to stranger, was frequently so affecting that we learned early on to have a box of tissues handy. Even the most quotidian tale would somehow move us – the teller and the listener alike. Perhaps that's how things are when something is marked and accounted for; the simplest ritual can be profoundly moving, even if the transaction involves an IKEA shelf. A thousand hands held out a part of their lives in our direction and gave it away. We received each gift gratefully, and, with a workaday egalitarianism, we took a saw to it.

Right from the start, it was clear that it would never be our boat. And were you to ask any of the team who have laboured so mightily to put the boat on the water and whose efforts are imprinted on every page of this book – they'd admit they built it, but they'd probably insist it's not their boat. They don't feel they own it. And now they're handing it over to you. So here it is. It's your boat.
Good luck everybody.

Gregg Whelan and Gary Winters
Lone Twin, April 2012

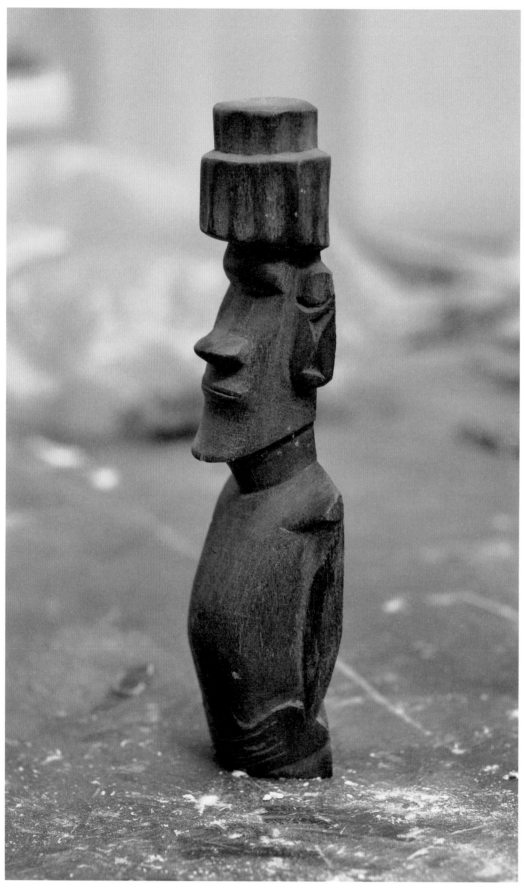

12 Pippa Blake, see page 65

It's from Easter Island in the Pacific. When my daughter was two I did a voyage with my late husband, Peter, from New Zealand to England, across the Pacific, through the Panama Canal. We were only at Easter Island for about five hours, an amazing place. This is a souvenir from there. It came with us on the boat for the rest of the voyage. There are two, but I'm keeping the other one because they're so special.

'It's very significant because it was part of this great sailing life we had.'

This book describes how a boat came to be built from pieces of wood donated by local people in south east England. Over 1,200 wooden items were collected, together with stories about each object's significance. All of those objects and narratives are now housed in the fabric of the boat. They have also shaped this book, which has at its heart a catalogue illustrating every donation and retelling every story.

Conceived and directed by the British artists Lone Twin, *The Boat Project* is a commission for the London 2012 Cultural Olympiad. Combining contemporary art and design, engineering and craftsmanship, the project layers and interweaves diverse communities, areas of expertise, conceptions of art, and modes of creativity, collaboration and participation. This book documents the project from its beginnings in previous work by Lone Twin, to the point of the boat's launch and maiden voyage in the summer of 2012. It describes the design and build process, the integration of the donations, and some of the broader implications of the materials used – in a celebratory mapping of a region's histories, lives and relations with the sea.

The first section focuses on the artists, Gary Winters and Gregg Whelan, examining their conception of the project, and their approach to art making as an inclusive, pleasurable social practice.

A floating archive
Lone Twin and *The Boat Project*

'Lick a finger: feel the now'[1]

'They spoke of the far, the past, the invisible. They spoke of the horizons
surrounding everything which had not yet disappeared'[2]

Gary Winters and Gregg Whelan have been collaborating as Lone Twin
since 1997, when they met as students in their final year at Dartington
College of Arts in Devon.[3] They have produced a diverse body of work that
includes a six-year cycle of duo performance events about water, bodies, jour-
neys and encounters, created in and for specific locations, as well as touring
theatre shows and collaborative public projects. Performances have taken place
across Europe and in Canada, the USA and Australia, in theatres, galleries,
people's homes, and in the open air. They have made clouds from their own
body heat, released a community's messages and desires into the night sky
through a megaphone from the top of a stepladder, and staged an 'ascent' of
Mount Everest by running along a white gaffer line on a studio floor. They have
danced blindfold dressed as cowboys, dragged a telegraph pole on a straight
line through a town centre, and walked, talked and sung with countless
strangers encountered by chance in the street. Although they have made proj-
ects in very different forms and situations, from durational live art to children's
theatre, from new writing to a cycle of musical-theatre plays about love and
loss, their work overall might be characterised by its humour and imagination,
its linguistic inventiveness, a playful invitation to commit and expend effort,
its insistence on interaction, its openness and generosity towards others in the
everyday. Above all, they have consistently conceived of art as a social practice
of conversation, exchange and sharing – of stories, energies, work, journeys,
songs, hopes, laughter.

In 2009, Lone Twin were awarded a major Arts Council commission as part
of the 'Artists Taking The Lead' initiative for the 2012 Cultural Olympiad. One
of 12 regional awards, Lone Twin's *The Boat Project* was selected to represent the
south east region of England. At the simplest level, they proposed to build a
boat from donated pieces of wood, taking a photograph of every donor and
recording the story they told about each piece. The aim was to construct a sea-
worthy vessel out of a collection of stories. It was to be a floating archive of
materials of personal and historical significance, celebrating the region's long
association with the sea as well as a diversity of lives lived and ongoing. On the

face of it, building a boat seems to suggest a radical shift of direction for Lone Twin, a surprising new departure into unfamiliar practices and conceptions of art. On closer consideration, however, underlying continuities with earlier interests and ways of working become apparent. As Winters points out, the seeds of such an undertaking were already there in their fascination with spaces of encounter, collaborative group activities and the telling of stories: 'In much of the earlier duo work, we've attempted to gather a group around the activity of the pieces – walking, singing, dancing, cycling, staying up all night – and to explore the democracy of that moment. Those pieces were also about the image of a group of people doing something together, and the question, 'What happens when people come together?' We have always been interested in what performance or a gathering could produce. Rather than something purely internal or hypothetical, it could be something physical and have a life, or a job, of its own. But whereas in the past we've collected things with people we meet, stories or objects which are then shared and dispersed, one core difference with *The Boat Project* is that we're making something permanent that will go on to have a life of its own, as a civic resource'.[4]

Winters and Whelan say the idea for *The Boat Project* emerged during a cycle of performances called *The Days Of The Sledgehammer Have Gone* (1999-2005), when they explored the body's connections with water, and its intimate imbrication in weather systems and the hydrological cycle. In material, poetic and comic ways, these performances activated the body's own meteorology of sweat and tears and playfully merged them in circulatory exchange with the circuits and flows of river, sea, cloud and rain.[5] In related ways, a boat casts the body into a dynamic relational matrix of materially active elements, energies and rhythms and invites it to improvise: wave, tide, current, wind, wood, salt, sound, weather, sky. Whelan: 'The project began some 11 years ago, when we were in the middle of all the walking and water pieces – attempts to merge our watery selves with other bodies: our bodies of water meeting other bodies of water, lakes, rivers, seas. Those pieces used the idea of a journey as a frame, beginning with a departure and ending with an arrival, each built from a collection of stories that occurred, in whatever way, en route. As well as water, we were thinking about travel, adventure, navigation, wayfinding, hellos and goodbyes, structures that frame moments of togetherness, and so on. In 2000 we were invited to the *Absolutt Galskap* festival in Norway by its director, Sverre Waage. We made a performance where people started making little paper boats and launching them off the bridge we were on, and, with Sverre's encouragement, we began to consider what it would mean to build an actual boat. And it became clear that it would be entirely logical to build one. Earth's human geography, where

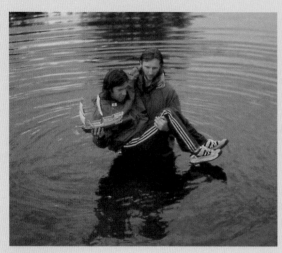

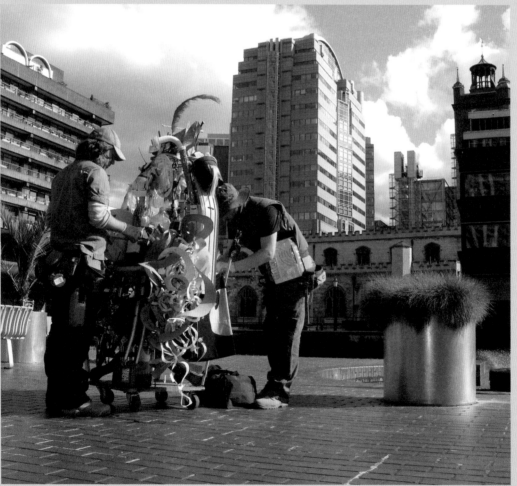

Connections with earlier Lone Twin work: Above: Winters and Whelan crossing the River Chelmer 'towards the new world', *The Days Of The Sledgehammer Have Gone*. Below: Lone Twin's *Spiral* (2007), an eight-day journey through the Barbican, London, when Winters and Whelan collected and transported material along the line of a spiral drawn on to a map of the estate. The accumulated 'snowball of stuff' was dispersed at the journey's end outside the Barbican Arts Centre.

we've settled and thrived, is due entirely to its relationship to water – first, for the fundamental needs of life, and then for everything else. The world met itself, was revealed to itself, by way of journeys made at sea. Ships and boats allowed an entirely new set of narratives to develop; so it became really clear that a boat was the next thing to work on'.

One image from *The Days Of The Sledgehammer Have Gone* series shows Winters cradling Whelan in his arms as he wades waist-deep through a river, ripples arcing around him, while Whelan carries a model ship in one hand. Their text describes the scene: 'In an attempt to keep Gregg's trainers dry, Gary committed to carrying Gregg and a Spanish Galleon across the River Chelmer and towards the new world'. The tone of this image and text is poignant, whimsical and optimistic, suggesting the possibility of metaphorical new horizons in literal (Essex) landscapes, shared journeys and futures rather different from those of historical colonists, and cooperative generosity as a means to discovery – and as a strategy for keeping one's trainers dry. Other Lone Twin projects also alluded or related directly to boats and the sea. *Channel 6* (2005), for example, involved Whelan filming Winters as he attempted to read the whole of Herman Melville's *Moby Dick* as they crossed the North Sea on a decommissioned Russian trawler. These gentle, playful odysseys suggest a disposition and poetic a long way from the emotional register and narratives of much contemporary art that references boats and the sea. One thinks of the tragic mystery of Bas Jan Ader's *In Search of the Miraculous* (1975), for example, in which the Dutch artist disappeared during a 'performance' that was a trans-Atlantic journey between Cape Cod and Ireland on his 13-foot pocket cruiser *Ocean Wave*; or Tacita Dean's compassionate exploration of Donald Crowhurst's ill-fated journey, mental breakdown and apparent suicide on his trimaran *Teignmouth Electron* in the 1969 *Sunday Times* single-handed, round-the-world Golden Globe Race. Indeed, since the Romantics the sea has often been figured as a place of erasure and disappearance, of melancholic disorientation and failure, in which sailors are engulfed by a hostile and sublime 'void'. Such representations are poles apart from the 'glass half full' world of Lone Twin. There may be a loose kinship between Lone Twin's sense of purposeful play and aspects of the work of British artist Chris Dobrowolski. For *Seascape Escape No 1* (1989), for example, Chris built a 12-foot boat out of driftwood with the express aim of escaping from art college in Hull, although it floundered in currents mid-way across the Humber and he had to be rescued by a passing tug. Perhaps the closest tonal connection is with the Swedish American sculptor and public artist Claes Oldenburg in his 1961 manifesto 'I am for an art...'. In this effervescent list-like text that provokes and dilates the parameters of what one might conceive of as

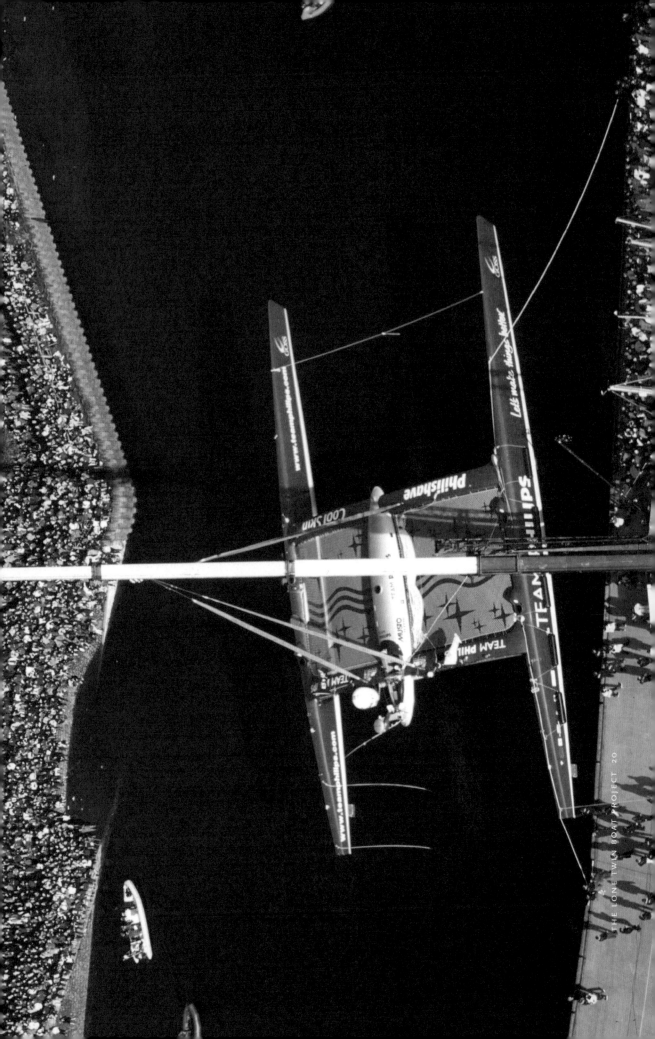

'art', Oldenburg asserts: 'I am for the art of sailing on Sunday, and the art of red and white gasoline pumps ... I am for the art of falling off a bar stool ... I am for the blinking arts, lighting up the night. I am for art falling, splashing, wiggling, jumping, going on and off ...'.[6]

Other more immediate and palpable influences informing the project stem from Winters and Whelan's love of the 'brilliant folly' of sport – its inherent pleasures, demands, dramas, rituals and absurdities[7] – as well as stories of exploration and adventure, many of them drawn from sailing and the sea. For example, over the years they have engaged enthusiastically with material about Pete Goss and his astonishing rescue of Raphael Dinelli, as well as with Ellen MacArthur, Bernard Moitessier, the journeys of Scott, Shackleton and Crowhurst, and recent media coverage of the teenage Dutch round-the-world sailor Laura Dekker.[8] Whelan lived in Totnes, Devon, at the time of the build and launch of Pete Goss's catamaran *Team Philips* in 2000, as did I; and there are evident links here with the nature of community involvement in that project, the sense of a collective undertaking within which a boat became a site of encounter for a host of different investments and contributions. The Goss boat became a focal point for a community, a beautiful and fragile receptacle for people's hopes, dreams and wishes. As Whelan remembers: 'It meant that by launch day thousands of people collected on the banks of the Dart to wish the boat well – it was a surprisingly dramatic and moving event'.

The equivalent investments and contributions in this context occur in the donations of wood and stories, within which personal value is shared and accumulated. Of course, we are not witness to the actual scenes of donation, those precise moments of face-to-face human encounter in a secular ritual where a gift is given and received, and a story articulated. Nonetheless, the boat itself hums with something of their intimacy and emotional complexity. As Whelan suggests: 'It's very special, this moment when more than 1,200 people in turn speak to a stranger holding a microphone. They stand there ready to share something often intensely personal and moving, and they give something of themselves away, often with a touchingly underplayed drama. I still remember donation 604, p 139 Tim Gillin arriving with the carved head from his father in wartime Singapore strapped to his bike and giving it away, a huge slice of his family's life, and then quietly and quickly riding off again before we were able to say thank you properly. There is something very powerful in this repeated, staged scene. And in what compelled people to do this – to make the decision, to leave home with it, and then to give something away. This is the heart of the donations for me, in conjunction with the actual material for the boat, with each object being a visible signal of life: it's the heartwood'. Winters makes a connection with

Opposite: After a two-year build, in March 2000 Pete Goss's revolutionary 'wave-piercing' catamaran *Team Philips* was craned into the River Dart in Totnes for its launch in front of an estimated 40,000 crowd. At 120 feet long and 70 feet wide, it was the largest ocean racing yacht ever constructed. Photo: Rick Tomlinson

earlier Lone Twin projects that have attempted to catalyse and elicit personal responses and exchanges: 'One shouldn't underestimate the importance of these intervals of vocalising and storytelling, which are a hook back into some of the other work. They are often a release, physically and emotionally, a breath, a sigh, a getting rid of or clearing out. And in their infinite differences they derive from the central invitation at the heart of the project: asking a question to crack open these responses, at all levels of significance'.

As their thinking about *The Boat Project* evolved, informed by Lone Twin's collaborations with professionals from different fields – a speech writer, a town crier, choreographers, an animatronic costume maker for their children's show *Beastie* – Winters and Whelan increasingly recognised the value of working with specialist others. As well as providing opportunities to learn, such collaborations allow a wider range of possibilities in terms of form and context, and, in Winters' words, 'diffract the "brand", which for us is great'. Furthermore, with all sorts of temporary 'communities' implicated in and spiralling out from *The Boat Project* – the donors of wood and stories, the core build team, a large number of local volunteers, regional boating and art connections, the broader Olympic context – the building of a boat sustains Lone Twin's long-term conception of and commitment to art making as a mechanism for the layered social choreographies of interaction, exchange and diverse kinds of participation. Whelan: 'Once we were fixed on wanting to build the boat, we realised that we couldn't do it alone, that it needed people. In addition to the wood donations we needed people to actually build the thing, to design it, to put it together. So it needed a committed community of folk who could all invest in the value of the task, who could see that if we managed it we'd have done something quite dramatic, and that we'd tell a great story together. Then there's the huge group of people who gave something of themselves to the project, now re-assembled and arranged in object form as a boat. There are the fantastic volunteers we've had, and their input has been invaluable. The project is about all of those people, it's about what those people came together to make, and what coming together achieves. In very simple terms it's about what we've been doing with our lives, whom we've loved, where we've lived, the jobs we've done, our parents, our friends, our children, and our marking of those people and events. As art, one might think of the broader project in terms of a kind of social sculpture; but the important thing to grasp is that the sculpture isn't the boat itself. The idea of sculpture lies elsewhere in the project, in the space that it offers to meet and talk and do something together. The boat becomes a place where stories and lives meet and are held together, then embark on a new set of journeys together. The material objects and all they contain are diverted from their old path and set out on a new one – they go towards a new world'.

In the late summer of 2009, Lone Twin started to look for collaborators. Emily Cummings of Forma, the producers of *The Boat Project* in its early days, soon made contact with Mark Covell. Having trained as a traditional boat builder and worked in the marine industry throughout his adult life, Covell is also a former British Olympian; he won a silver medal in the Star class at Sydney in 2000 with teammate Ian Walker. Since that time he had been working as a commentator and on-board documenter of elite international competitive sailing, including the Louis Vuitton Cup, the Volvo Ocean Race and the Indian Ocean Five Capes Race. Covell: 'I'll never forget when I had that original call from Emily. She described what Gary and Gregg wanted to do, and explained that nobody to date had said it could be realised. So she was feeling somewhat frustrated. Although I didn't know exactly how to do it, I immediately thought it had to be possible. "No" wasn't an option. I wasn't quite sure how, but I had the beginnings of an idea. So I started making some phone calls to the right kind of people'. When Winters and Whelan were introduced to Covell, it was clear that he had the requisite skills, energies and flexibility to take on the central role of technical manager. Whelan remembers: 'He was obviously the man for the job – we met him just before he went off on a long voyage across the Indian Ocean, and he's got a lot of life to him. Not only did he have a clear idea of how the thing could be done, in terms of the technicalities of the build; he also understood the project completely. He was as interested in the stories, the donations, the people we would meet, as much as in building a boat. It's impossible now to imagine the project without Mark, he quickly became the centre of it, the life of it. He's also the only person we know who's been chased by pirates'. As I realised when I first met him at the London Boat Show in 2011, Covell shares Winters and Whelan's enthusiasm for stories, adventure, humour and music, as well as a convivial ease with other people.

The emerging parameters of a brief for the boat's design suggested a particular kind of designer and core build team: experienced professionals able to combine pragmatism, a commitment to the contemporary, an openness to collaboration, and a willingness to engage with the unpredictable. After exploring various possibilities and expressions of interest, Covell felt that Lymington-based designer Simon Rogers was ideally placed to take on such an unusual commission: 'Simon is very passionate, and I needed someone who was going to get on board. And when I called him he was enthusiastic from the outset'. As a life-long sailor, an apprentice served shipwright, and an award-winning designer with over 20 years experience, Rogers is recognised internationally for his high-performance sports boats. His diverse body of work has included the Artemis 20, a competitive, functional and beautiful boat equally accessible to disabled and able-bodied sailors, and widely used in teaching, training and

racing. In addition, like Covell and the members of Lone Twin, Rogers was excited about the Olympic context, and the possibility of being involved in a maritime project associated with the games – a project in which, in his words, 'engineering meets art and sport in a water-based context. When Mark approached me, we immediately clicked on this – and likewise with Gary and Gregg when we met up a few weeks later; we instantly hit it off and were on the same page. I've known Mark for a long time, and he's a tremendous boat builder and sailor – he understands about boats. He's also an absolute perfectionist. And between us, from a technical point of view, we have all the bases covered. There's a high level of trust'. [9]

NOTES

1 Annie Dillard, *Pilgrim at Tinker Creek*, New York: Harper Perennial, 1998, p. 99.

2 John Berger, *And our faces, my heart, brief as photos*, Writers & Readers: London, 1984, p. 34.

3 For detailed discussion and documentation of all of Lone Twin's work from their earliest projects in the late 1990s to the beginnings of *The Boat Project*, see David Williams and Carl Lavery (eds), *Good Luck Everybody: Lone Twin – Journeys, Performances, Conversations*, Aberystwyth: PR Books, 2011.

4 All quotations from Gary Winters and Gregg Whelan are drawn from interviews, conversations and emails with David Williams over a two-year period, 2010-12. Carl Lavery was also central to many of the earlier exchanges, both formal and informal.

5 At one level, Lone Twin's early fascination with the relations between bodies and water spills out from the fact that approximately seven tenths of the human body is made up of water, roughly the same proportion of the oceans on the earth's surface. For a brilliant discussion of related ideas, and an eloquent meditation on the sea and its meanings in human experience, see James Hamilton-Paterson, *Seven Tenths: The Sea and Its Thresholds*, London: Faber & Faber, 2007.

6 Claes Oldeburg, 'I am for an art...', in Kristine Stiles and Peter Selz (eds), *Theories and Documents of Contemporary Art: A Sourcebook of Artists' Writings*, Berkeley: University of California Press, pp. 335-7.

7 Steven Connor summarises the paradoxical allure of sport in terms that Winters and Whelan would recognise – as 'a striving in the lengthening shadow of exhaustion', within which 'triumph and disaster; everything, nothing; important, unimportant' coexist; *A Philosophy of Sport*, London: Reaktion Books, 2011, p. 16, 48.

8 Other water-related figures much discussed by Winters and Whelan include the Slovenian endurance swimmer Martin Strel. In 2007, Strel swam over 3000 miles along the Amazon in 66 days, from Atalaya in Peru to the Atlantic Ocean at Belém in Brazil. His astonishing and bizarre journey is documented in John Maringouin's film *Big River Man* (2009).

9 All quotations from Mark Covell and Simon Rogers are drawn from recorded interviews conducted by David Williams in Lymington and Emsworth in 2011.

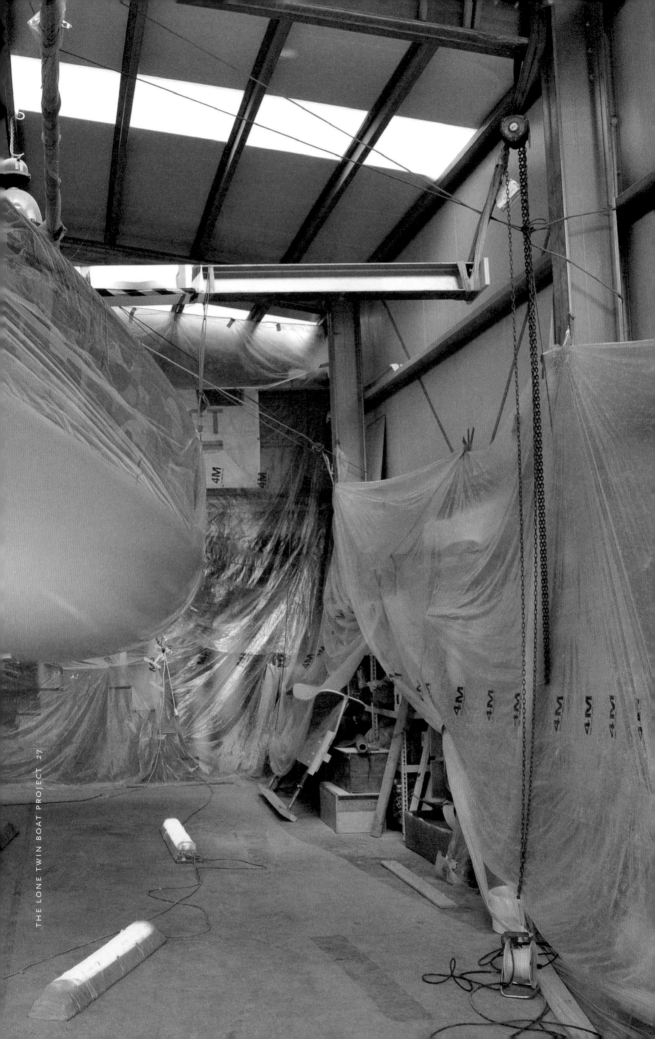

389 Clare Nias, see page 112

I've brought you a maquette of a hand. It's supposed to be for artists to draw. It has articulated fingers, and is probably just about the right scale. I'm an artist and I like to work quite hands-on, so it's literally about what I can do with my hands and what I've always done with my hands, creatively.

THE LONE TWIN BOAT PROJECT 28

'I've brought you a maquette of a hand.'

A tiny elephant stands in the shadow of a bleached horse's head between a tree and a spirit level. A helicopter hovers over a minute hillside house and a violin. A clothes hanger, clothes peg and rolling pin float in orbit around a miniscule train. A tiny cat stands transfixed with its back to two overlaid electric guitars. And an aardvark trundles stoically along beneath a tennis racket and a cricket bat.

As one wanders around the hull in the final stages of the boat build, poring over the intricate detail of the topsides, a composite multi-dimensional landscape unfolds. It's like a tour through layered times, places and realities, within which mysterious stories are suggested or withheld. The topography of this landscape, peppered with animal life, contains loose constellations of objects related to sport, music, domestic tools and so on; but such zoning remains fluid and never hardens into a schematic principle.

In order to get to this point, how does one actually make a boat out of stories and lives? In the following section, the central voices are those of the designer Simon Rogers and the build manager Mark Covell. The focus shifts to the build shed in Emsworth – the project's 'engine room', and the scene of a collective labour of love.

Many hands

The design and build of the boat

'no other tool is made with so much honesty as a boat ...
the builder of a boat acts under a compulsion greater than himself' [1]

'and how, unwittingly,
they planned each afterlife ...
carving timberwork with hidden signs,
seasons and gifts that someone else would find' [2]

In his office at the boat shed, Mark Covell was ready for another working lunch. A pile of sandwiches balanced precariously on a wooden offcut 'plate', a steaming mug of tea, laptop on, mobile at the ready. He began by describing his initial discussions with Simon Rogers: 'We worked organically – we literally grabbed a big piece of paper and a pencil, and just threw ideas down; and we had this whole thing designed in the very first meeting. The way it looked, the form, the size. My notes from that first day were pretty much how the final design turned out a month or so later once it had been cleaned up and turned into blueprints'. And by the late autumn of 2010 the shape of a complementary collaborative alliance for *The Boat Project* and detailed working plans for a *modus operandi* were in place. Rogers was responsible for elaborating the boat's design; Covell drew together a build team and appropriate resources, and oversaw the day-to-day logistics of the boat's construction. Winters, Whelan and the Lone Twin team managed the donation process, the volunteers, and community engagements and cultural events around the project as a whole. Winters and Whelan also kept closely in touch with the build team as the form and look of the boat emerged, and they supervised approaches to the use of the donations.

Covell listed some of the pragmatic requirements the boat's design had to incorporate, in part to facilitate its legacy period as a civic resource: 'Simple to sail, cheap to run, easy to throw on and off the trailer, with a mast that can be pushed up by a couple of people – that was our mission, and it had clear implications'. From the outset, ease of transportation by road proved a determining feature for the overall dimensions of the boat. 'It could have been any length', Rogers suggested, 'but it had to fit on a trailer; European regulations stipulate that the maximum beam is 2 metres 55, and we're at 2 metres 53. Obviously we wanted to stay within the weights of what was allowed on the road. It needs a 3.5-tonne towing vehicle, which regular 4x4s can manage. And at the same time we wanted to be able to move it easily and quickly'. Ease of transport in turn called for a lifting keel system, allowing access to shallow water, the possibility of hauling out on slips without the need for a crane, and adaptability to diverse sailing conditions – sea, lakes or inland waterways.

Secondly, the boat needed to be accessible and pleasurable to less experienced sailors. It had been conceived as a 'public boat', a resource available to as wide an array of people as possible – rather than as a pure racer with the structural compromises and infelicities that the singular necessity for speed through the water would entail. Therefore Rogers's design privileged simplicity and speed of operation. For example, it incorporated furling gears to enable the jib and mainsail to be hoisted, dropped or adjusted quickly and easily. 'There's nothing there that's going to bite you or be horrible', he points out, 'the winches are very small, the loads are all very small, and it will sail in a nicely balanced fashion'.

Thirdly, during early discussions with Rogers, Covell emphasised the importance of providing a 'social space'. In addition to the need for an open cockpit area, he requested that the deck space should be free of clutter and complexity, and that it create the conditions for convivial interaction: 'A lot of boats have things in the way: thwarts that you have to step over, and so on. We could have pushed back the cuddy [the small deck-house or cabin], created far more space down below and had a much bigger foredeck. But we were looking for it to take six or seven people who could potentially sit on the rail, and it would have been very cramped. The boat can actually be sailed by two people, but it's more pleasurable to sit with a number of people all experiencing the same thing; and we really wanted the experience to have a sociable aspect'.

Finally, the goal was to produce a 21st century boat, reflecting the design dynamics and aesthetics of modern sports boats, and incorporating contemporary technologies; the team had no interest in creating something retro in this context, a historical reproduction such as a clinker-built vessel with overlapped boards, big overhangs, steam-bent frames, and so on. Rogers: 'It's very much a boat of our time. In terms of its form, for example, the chines of the hull [the angles of its bottom] are in vogue right now in high-performance yachting circuits. It's not as light as one could make it, with the donations and the fact that it's made out of wood, but it has a planing hull so it will go quickly without pushing a lot of water around. It's a very efficient, low-drag shape, with a fairly large sail area. It will be easily driven, light on the helm, balanced to steer, and a pleasure to sail. Fun, fast and exciting at all levels'. Covell underlined the boat's generic similarities to contemporary racing yachts, detailing the features it has in common with successful competition boats internationally: 'It has a very wide stern that is open, a little sleek cuddy forward, slab sides in a chine that it sails on – hard corners. It's very light in displacement, with wide flat sections aft to help her get up on the plane. The keel structure's the same as the ocean-going Volvo boats, although of course it's less than half the

length. The sails are the same configuration, and there's a carbon rig with a fathead main, and a fixed bowsprit. In other words, it's very contemporary'.

Given the unpredictabilities of the donation process – the impossibility of knowing what kinds or quantities of wood would become available at the boat shed – the approaches to design and build had to embrace a certain flexibility within constraints. In particular, as Rogers pointed out, guiding restrictions and principles related to overall weight and the need to integrate as many dona- tions as possible as structural components: 'Normally we would know exactly what everything is going to be built of, and in this context we've had to accept that certain things will be different. When we designed the boat, we assumed certain specific gravities for certain materials that we needed in order to make the boat float and do its job – and then made an allowance within the structure for the donations. Early on, we decided that where a donation is placed on the boat is irrelevant. It was unpredictable in terms of density; some of it might be very light, or very heavy, but we knew it was going to be wood. So we knew it was unlikely to have a specific gravity greater than one, in other words that it was likely to sink. There are a few woods that sink, but not many. And it would be an extremely unlikely scenario to get 40 square metres of *lignum vitae*![3] So we were able to make certain assumptions. We were looking at nearly 400 kilos of donations – and we'll be somewhere close to that in the end. Obviously when we designed the boat we had to know what it was going to weigh at the end in order to get the displacements right and actually get the boat to float correctly'. During the build, Mark Covell's team would have to build as many of the struc- tural components as light as possible, using techniques one would employ to build 'an ultra-light racing machine' in order to offset the mahogany, ebony and other woods not usually present in this type of boat: 'I've had to build down to weight just as much as I would have had to with a race boat'.

When asked about the possibilities and difficulties of exclusively using wood, beyond its additional weight, Rogers responded: 'It's a very simple construction method which we could only really do in wood, because of its flex- ibility and strength, and the fact that it's unidirectional; there's a longitudinal stiffness down its grain, and it's relatively stiff in the fore and aft plane. If you were making a fibreglass boat, you'd have to make a full mould with a perfect surface on it. So what's really good about wood is that you can form a shape very quickly and inexpensively'.

By Christmas 2010, a definitive design for a 30-foot two-tonne day boat was in place, and formal planning approval had been received in the form of the RCD certification: the 'Recreational Craft Directive', a European legal require- ment for any boat accessible to members of the public. And in February 2011,

The build shed at Thornham Marina, Emsworth, during the first months of 2011: placing MDF frames around a centre line, and initial work shaping the hull by assembling edge-glued cedar battens.

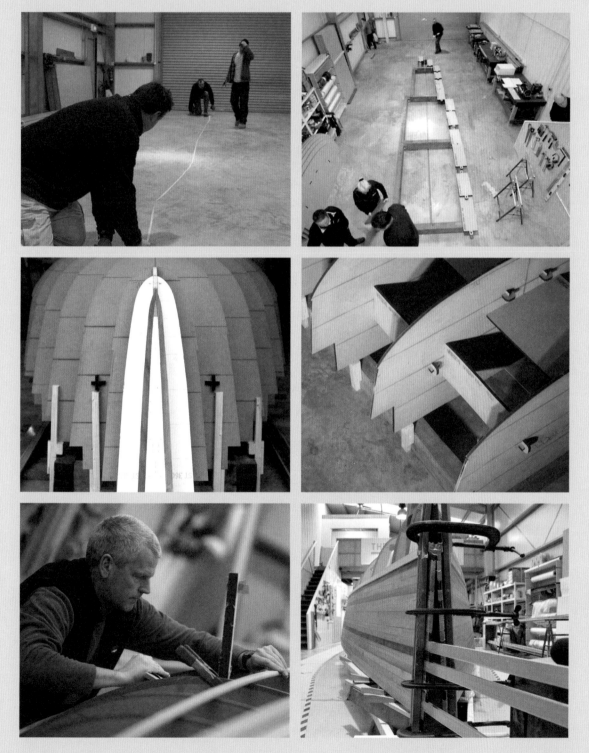

the core build team of Mark Covell and Jesse Loynes, supported by a growing community of enthusiastic local volunteers, started work in the project's base, a cavernous industrial prefab in a marina outside Emsworth, a few miles from Chichester on the English south coast. Soon Covell and Loynes were joined by former volunteers Ian Davidson and Sean Quail. As donations started to accumulate and the boat itself began to take shape, the shed took on the attributes of a buzzing social space and active learning environment. For Winters and Whelan, the creation of a dynamic meeting-and-making place was central to their conception of the project. Whelan described the importance in this context of Covell's open, energised approach to the managing of the build site and his enabling engagement with the volunteers: 'Mark has given jobs and training to anyone who wanted to get involved, and generally he's run the shed as a space where people are welcome, encouraged to learn things and contribute to the point where we just wouldn't be where we are now if it hadn't been for them. It's remarkable how so many people have given considerable amounts of their time to the project. For us, this is a key part of the build process – and of the project as art; it's central to Lone Twin's approach and concerns. In some ways it's like some of our earlier projects: strangers coming together to do something together. Many hands have built this boat, many strangers have become friends, and many will share in the boat's legacy'.

The first stage of the build itself entailed the placement of precisely shaped transverse frames, laser cut MDF formers drawn directly from Rogers's plans and the blueprints of draftswoman Hali Barber. Around these building moulds, battens of western red cedar strips from Robbins Timbers in Bristol were bent and glued along their edges: a process known as 'edge-glued strip planking'. Each batten had a bull-nose and convex bull-nose edge, a bead and cove form allowing them to be inserted into each other, 'like a moon fitting into a half-moon', before the seam was epoxied. The cedar soon assumed a natural curvature as the long battens took up the fair between frames to produce the smooth, continuous form of the hull. This surface was then covered in a thin layer of glass fibre, before the structure was chain-hoisted and flipped over, the internal frames were removed, the surfaces faired and the inside fibreglassed. At that point, with two 'skins' in place either side of the core material and the hull already relatively stable, the outside was filled and faired. Next, the internal structure – a hog along the centre-line and rib-like frames emerging from this spine in the form of plywood bulkheads – was inserted along the length of the boat, followed by a deck of high-density laminated foam.

Simon Rogers outlined the engineering implications and functions of this structure: 'Firstly, the glass skins take the load. On a beam, the top and bottom

Inserting the last straight plank to complete the cedar hull, and turning it to allow the next phase of the work to begin; using a bandsaw to cut calibrated slices of objects, and the first placement of some of the donations on the topsides. Overleaf: time lapse sequences showing the hull construction, and the glassing of the interior.

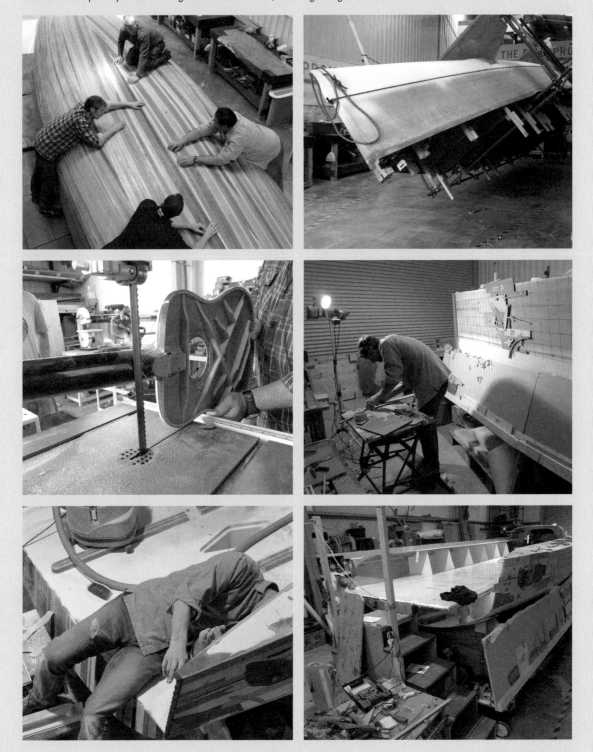

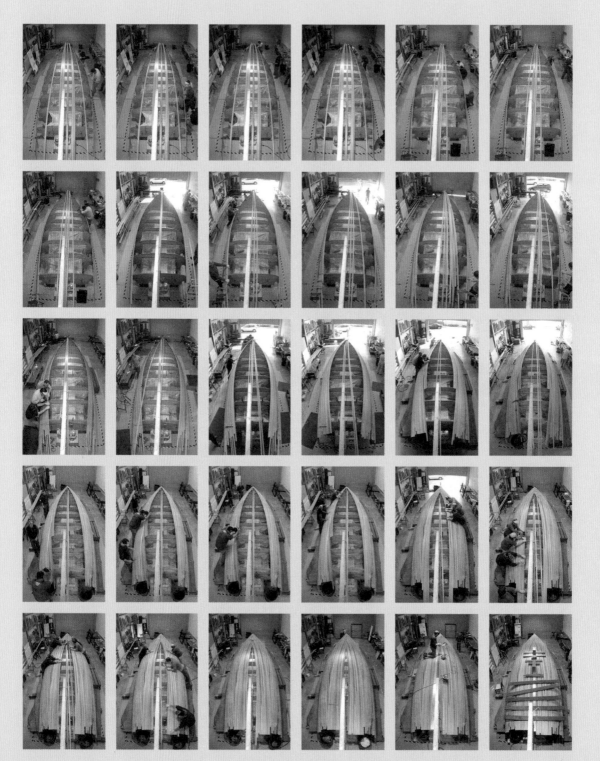

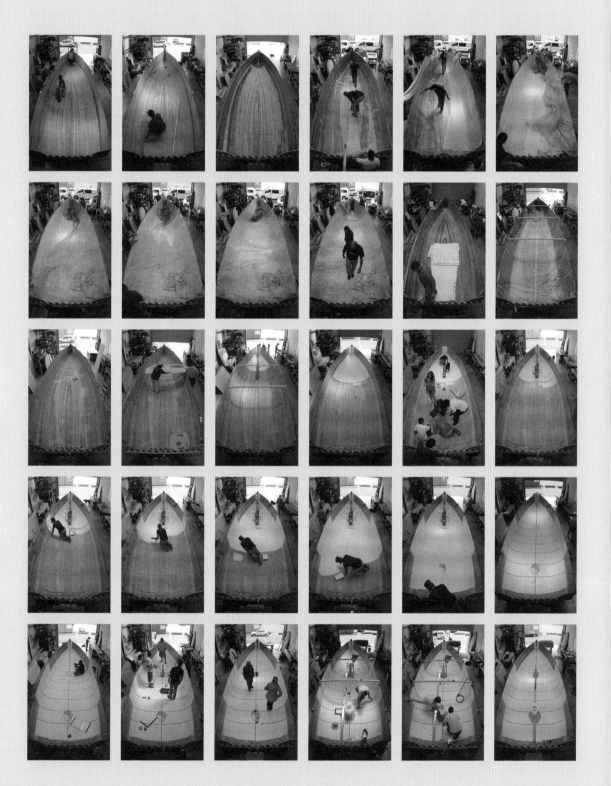

surfaces do the hard work; and the bit in the middle, the core material, as long as it doesn't crumple or sheer, holds the two laminates apart – just like an I-beam, a steel RSJ. So that does the tensile work, and the core material deals with the sheering loads. Wood is a good material in this context; as long as it keeps the skins at the correct separation and doesn't sheer, then it works very well. Secondly, the glass skins and the epoxy keep the water out. It produces an almost perfect barrier that waterproofs and protects the wooden core, sealing it almost entirely. It's like a skin, a polythene membrane. And we can choose what we put in the middle, as long it does its bare essentials'.

For the cuddy, rather than using foam, Covell and his team decided to employ the epoxy system to fashion something unique, an exquisitely detailed, curved dome structure. They used strips and planks from a range of different donated woods, including a piece from Sir Alec Rose's *Lively Lady* and another from the new Olympic velodrome in London. In relation to such decisions, Covell spoke appreciatively of Rogers's generosity and lack of preciousness, and of the trust in the build team implied in the designer's willingness to concede creative agency and initiative: 'Whereas in most build projects you would know months beforehand the exact dimensions and component materials, Simon said he wouldn't even give us drawings for such things. He wanted us to wait for the obvious material to come through the door, pick it up, turn it round, check that it's the right moisture content, and make it out of that. If you want me to do the numbers on it, he said, then shout. All you need is the back of an envelope for some quick sketches; just make it how you want to make it.'

Finally, the team turned its energies to the labour intensive process of integrating the majority of the donations. The intricately detailed and time-consuming placement of hundreds of 10mm slices along both faces of the hull served to reinforce the topsides for fender impact, and to produce the boat's unique aesthetic finish and burnish. Covell affirmed his commitment to the creative input of his team of collaborators, encouraging them to use the resourcefulness of *bricoleurs*, responding to what came to hand: 'One of the most important characteristics of this project is that it is fully the product of the individuals who are working on it. If different people had been involved, you would see very different responses and solutions. You can't say that of many construction projects. An architect designs a bog-standard house, and a bricky turns up to do the brickwork. You could have a hundred different brickies and it will still be a wall. For this project, we have specific builders and specific volunteers, and when they pick up a piece of wood, they put their individual touch in to it'.

Covell also emphasised the structural importance of the donations, rejecting any suggestion that they simply constituted a decorative laminate or veneer.

'The sides of the boat need to incorporate the donations in order to make them sufficiently strong; the donations are functional, it's the skin on the flesh. I feel very strongly that the boat is the donations, they are completely integral to the boat's structure'. Indeed, as well as the bow and the cuddy being constructed entirely from donations, they were also used in the planking, the beam shelf and the hog. The stem – the backbone of the boat, its centre line – was modified to incorporate timber from HMS *Victory* and *Warrior*. In Rogers's words: 'Wonderfully dense, strong, stiff pieces of oak that are several hundred years old, with all of their associated history. It's what the project's all about. It's an extra ten kilos of weight in the bottom of the boat, but the incorporation of such materials is the point of the project; and that's the fun part too – working with these historically and personally laden materials'.

For the topsides, Loynes, Davidson and Quail were encouraged to make individual choices by responding to the triangulation of each object's form, story and its adaptability to a graphic form. The initial difficulty stemmed from needing to translate three-dimensional objects into two, re-shaping and flattening them to produce something like a CT scan within which, wherever possible, the integrity of original forms and functions could be retained. Sometimes by lifting out a characteristic part to represent a whole – for example, the scroll at the end of a violin's neck as legible *pars pro toto* – sometimes by hybridising objects to create new aggregations through a process of creative re-imagining. For example, the body of a violin lacking a neck was montaged with a slice of a recorder to produce a new musical object echoing the violin's original shape. And the empty space of a soundhole in the body of an acoustic guitar was filled with a lateral ring-shaped slice of a didgeridoo framing a bundle of drumsticks dropped into the remaining space like asparagus tips.

The team deliberately chose not to impose any design plan on how donations were fitted together, and adopted Winters and Whelan's suggestion of an approach analogous to dry-stone walling. Winters: 'We wanted to approach the design of the topsides in ways that were pragmatic and intuitive, and allowed for an element of improvisation and chance. We used dry-stone walling as a loose model because it encourages decision-making of a very practical kind; you use what's at hand, try things out, shuffle them around until you find shapes, places and relations between things that work. And out of this hands-on, trial-and-error process an overall aesthetic emerges organically'.[4] During my visits to the build shed during this period, the value of the ongoing dialogue between artists and boat builders became self-evident; and over time their collective negotiation of this complex process allowed different compositional,

516 Margaret Wozniak, see page 129

These two oars have come from a traditional 18-foot clinker-built motor launch called *Margaret*, after my mother. It was bought by my dad in 1934 from a boatyard in Bosham. After the war it was put in our garden, but the children got in and did a lot of damage. My dad tried to restore it but didn't have the inclination as he got older. He would never let anyone buy it though.

THE LONE TWIN BOAT PROJECT 40

'It was bought in 1934 from a boatyard in Bosham.'

visual and craft sensibilities to inflect and complement each other, and a shared aesthetic to emerge.

Ultimately a large number of donations – furniture, planking, objects that didn't lend themselves to pictorial shapes – were cut into oblong panels to construct a richly grained and coloured 'ground' against which the figures of particular objects could be laid. Viewed from a certain distance, the honeyed ochres and textures of this paneling suggest a lateral trajectory along the side of the boat. It discreetly echoes the boat's forward momentum, as does the placement of slightly darker hues at the front melting into lighter colours at the back. Moving slightly closer, one begins to perceive that the forms emerging from the panelling coincide with the horizontal dynamic or sit in counterpoint; for example, the melodic lines of a diagonally placed group of hockey sticks on one side and walking sticks on the other suggest fluidity and lapping waves.

It is only when one moves even closer that the pictorial objects flare into appearance in their intricate detail, their colours subtly lifted with varnishes during the finishing. Immediately apparent is an overwhelming compulsion to touch them, to trace their individual outlines hovering in a limpid medium that is somehow painterly and sculptural, tenebral and light-filled, as if one were trying to retrieve them from water or a dream. The aesthetic effect of this folk art cabinet of curiosities is reminiscent of the chromatic palette and characteristic subject matter of certain works of Cubist collage – in particular by Georges Braque and Juan Gris. At the same time perhaps, it also suggests something of the naïve dream-like kinships, surreal shifts of scale and lyrical landscapes of Marc Chagall's image worlds. In the transom, at the back of the boat, vertical strips of wood of diverse shading and grain are joined together, with no other objects inlaid, to produce the elegant economy of something like a Paul Smith stripe effect.

During the build, Covell worked out a way of registering the location of each donation within the boat, so enabling individual donors to track down and reconnect with their wood. Using the rudiments of cartography – longitude and latitude, the cardinal points, the grid reference system – he conceptually reconfigured the boat itself as a globe: a line around the hull at the bottom edge of the donations as the equator, the stem as the Greenwich meridian running on a vertical axis north to the top of the mast and south to the keel bulb, the starboard side as west, the port side as east. Managing of the system was logistically quite complex, but it puts the donations right at the heart of the project. For it affirms each donor's place and implicatedness within a community of traces of other lives and stories. And the poetic proposition – to map fragments

into a newly reintegrated structural whole – magics together a floating 'world' where, at least potentially and imaginatively, all of life is gathered.

Covell confessed he underestimated the power of the stories. 'You could have booked me in to turn up at the shed, and presented me with a pile of timber without telling me any of the stories, and I would have got going. But because we know the stories, and I've often been there when the stories were being told and tears were rolling down people's cheeks, it gives the build a completely different feel and flavour – the fact that you know where so many of the bits of timber you're handling have come from, or what they've done in a previous life. For me, that's the chill factor; it makes the the hairs on the back of your neck stand up, when you come to work. Before you put a saw through a piece of timber, you need to know that, for example, some troops died on the deck of that ship in Dunkirk; and you have to think about them. There are few trades in this world where your day-to-day materials carry such rich and dense associations, maybe an archivist in a museum gets it, but it's not something I've come across before. It turns everything around, such complex emotions and histories. It's very humbling at times – and every day I think about this'.

As work on the topsides continued in the shed below us, Covell described the final stages of the build prior to launch. His excitement was palpable and infectious: 'After finishing, fairing and polishing, it's a case of rigging the boat: stepping the mast, setting the winches, putting in all the blocks, stringing the boat out, putting through all the ropes and sheets. And then we're in to the sea trials in April, prior to the launch in May, and the final preparations for the maiden voyage in the summer.' Finally, he outlined his wishes for the boat's life in the longer term, after the Olympics and Lone Twin: 'I'd love the boat's legacy to be about giving people the experience of sailing a fun, exciting vessel. Just that: wind through their hair, the joy of the experience of sailing. And then them having that little twist at the end when they step off the boat and look back along the pontoon, that little chuckle of incredulity when they realise they've just taken an art work for a sail. Leading on from that, I'd also love to see this boat in a gallery with other people who have turned up to look at it as an art piece in its own right. Not something flying down the Solent, but as a sculptural invitation to engage with the stories, the craftsmanship, and the form. If the boat can do those two things the project will have been fully successful, and I'll be a happy man'.

NOTES

1 John Steinbeck, *Log from the Sea of Cortez*, London: Mandarin, 1990, pp. 76-7.

2 John Burnside, 'Archaeology', *The Asylum Dance*, London: Jonathan Cape, 2000, p. 54.

3 *Lignum vitae* ('wood of life'), also known as guayacan, greenheart or ironwood, has the highest density of any trade wood and sinks easily in water. Now listed as an endangered species, in the past this highly prized material had been employed to make components in early pendulum clocks, ships' propeller bearings, mortars and pestles, truncheons and lawn bowls.

4 In 2006, during a presentation to students at Dartington College of Arts, the poet Alice Oswald talked of each line in a poem as a 'stone', and of the poem as a 'dry-stone wall': a composite entity, hand-made from found materials, within which each component has a certain self-sufficiency, a suchness to be encountered and contemplated in relation to the whole. In a related vein, some years earlier the poet William Carlos Williams articulated a pragmatic mechanics of composition that is pertinent to the poetic effect of the boat's topsides: 'We forget what a poem is: a poem is an organisation of materials'. Quoted in Linda Welshimer Wagner (ed.), *Interviews with William Carlos Williams*, New York: New Directions, 1976, p. 69.

THE LONE TWIN BOAT PROJECT 43

Over the page: core build team members Jesse Loynes (left) and Ian Davidson begin 'dry-stone walling' the donations to the topsides

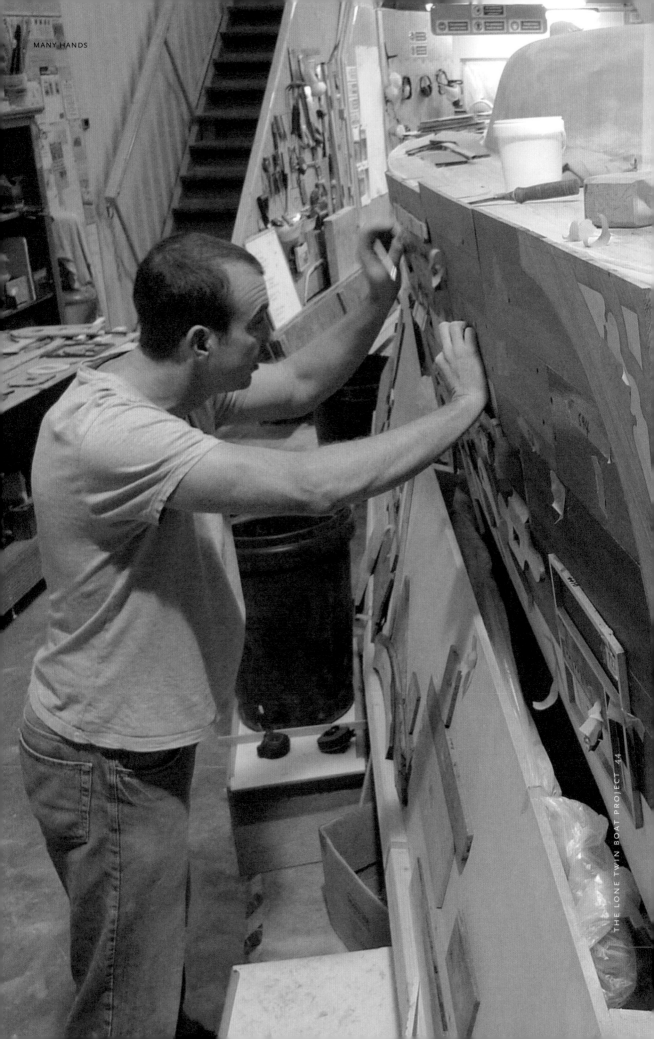

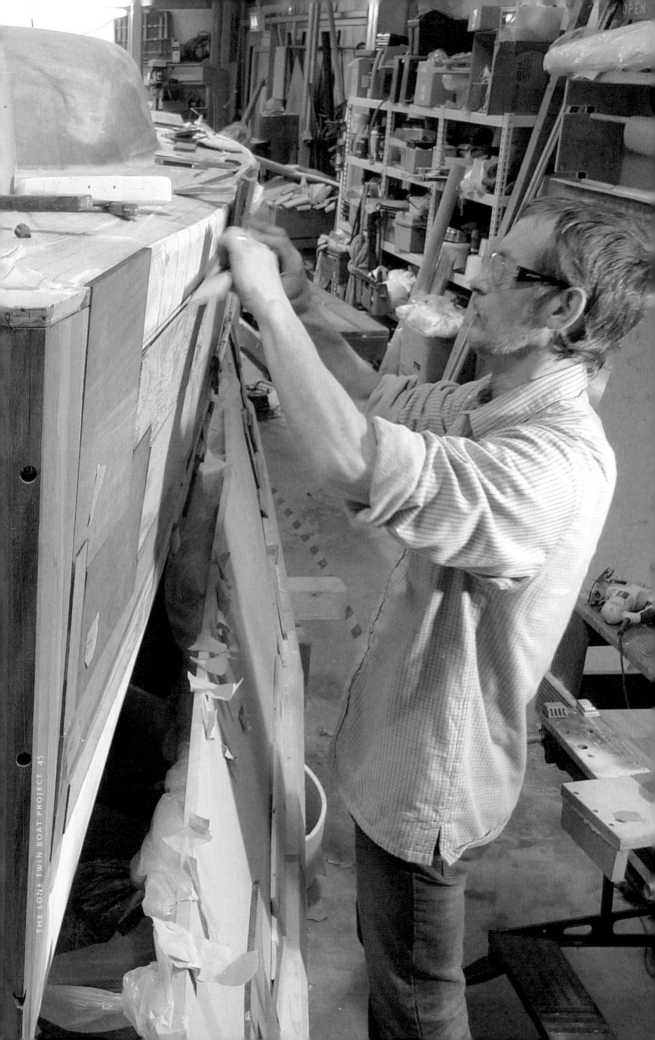

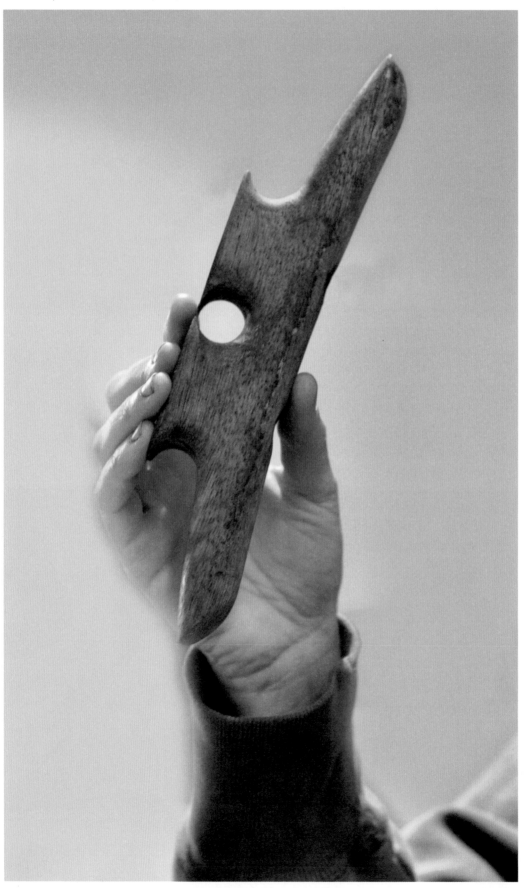

466 Michelle Hale, see page 121
This is a teak cleat that's just come off our boat, *Vivienne S*. We've been working on it for about a year and a half and have stripped the hull back, done a lot of painting, and we're currently fixing the engine. It had a sad life before we got it; it was in the marina at Gosport for about ten years and had been severely neglected. We bought her on eBay.

THE LONE TWIN BOAT PROJECT 46

'It's been a bit of a labour of love. It's a Nantucket clipper, so it's quite a handsome looking boat.'

The boat provides a new home for the fragments of almost 50 houses, with 20 beds and cots, 30 tables and desks, 18 chairs and stools, three egg cups, three lace-making bobbins, two darning eggs, and a jam spoon from Lapland. It contains wood from 17 churches, three theatres, two piers, two ballet schools, two chicken houses, two lidos and a whaling station. There are pieces from 148 other boats and ships, more than 60 toys and games, 40 sports, 26 musical instruments, 13 walking sticks, seven carved masks, five vehicles, 36 signs and name plates, and more than 40 boxes and cases. The 33 animals built into the very fabric of this new ark include elephants, cats, giraffes, avocets, fish, a gazelle, a tortoise, a donkey, a heron, a turtle, an owl, a penguin, a lemur, a crocodile, a rhinoceros, a mouse, a duck and an aardvark with a missing ear. There are carvings of wings, hands, roses, eggs, dice, a heart and an aromatic acorn.

In this section, the discussion turns to the material of the donations, the 'matter of the matter', and suggests how one might begin to orient oneself in relation to so many disparate wooden things. It acknowledges some of the buried histories and 'voices' of the material itself, and opens out on to broader questions of the personal and cultural significance of such a collection. Finally, it leads into the catalogue of donations, listing them in the order in which they were received and indicating where they are to be found on board.

A congregation of wood
The donations

'No ideas but in things' [1]

'I am large, I contain multitudes' [2]

Between February and August 2011, over 1,200 donations of wooden objects, each one accompanied by a story about its provenance and a photograph of the donor, were collected and meticulously catalogued inside *The Boat Project* build shed in Emsworth. At first acquaintance it seemed as if the garages, lofts and sheds of a whole street had been put out on the pavement and labelled. Some of the objects were exotic and puzzlingly unfamiliar; many were insistently ordinary and everyday. Numbered or not, this collection seemed arbitrary and bewildering; that was certainly my feeling on first seeing everything laid out on the apron of the build shed during a long day of stocktaking in the summer sun in August 2011. The sprawl of stuff, the flotsam and jetsam of countless lives, was mesmerising and dizzying. I wondered how we would ever find our way through the mess of information to the economy of form of a boat, let alone a book. How might we attend to the particularities of each object – from the smallest, a cocktail stick, to the largest, an eight-foot plank from a yew tree – and at the same time recognise and do justice to the possibilities of a new entity incorporating all of them? It reminded me of Bob Dylan's musings on finding his way and voice in New York in the early 1960s: 'I needed to learn how to telescope things, ideas. Things were too big to see all at once, like all the books in the library – everything laying around on all the tables. You might be able to put it all into one paragraph or into one verse of a song if you could get it right'.[3] Where were our paragraphs and verses in all of this?

On closer consideration, however, these wooden fragments begin to align themselves in particular patterns, and echoes and refrains emerge. One soon realises that collectively they constitute an extraordinarily resonant register of cultural, social and political life in the South East over the past century or so. Firstly, they signal the ubiquity, versatility and durability of wood as a material and resource in human endeavour and interaction: wood as a core substance in our lives, 'one of the wonders of the universe ... the ultimate composite' fashioned over many thousands of years.[4] In handling these objects, as on the days of stocktaking and number checking, one can forget all too easily that each of them stems from the wood of an individual tree – each one, in its first life as

tree, generated from 'recycled sunshine and rainwater'.[5] The trajectory over time of every one of those trees, from seedling to sapling to mature tree, in itself represents a small miracle of survival and transformation. 'How long does it take to make the woods? As long as it takes to make the world'.[6] Years of resilient unfolding, seeking the sunlight in an environment that is symbiotic and competitive, before the interventions of the loggers, the mills, the saws and chisels and lathes. As the American essayist and nature writer Annie Dillard suggests, 'the trees especially seem to bespeak a generosity of spirit'.[7]

Secondly, these donations provide a mapping of the proliferation and circulation of objects – the multiform 'second life' of trees[8] fashioned and mobilised through industry, commerce, craft, domestic resourcefulness, the exchange of gifts, travel. They also reflect the auratic allure of certain objects, their capacity to act as magnetic attractors and receptacles for meanings, memories, losses and hopes. The stories collected reflect something of that investment in such objects and their charged resonances, the 'dreamlife' of things from the personal and playful to the historically significant. Like the annular growth rings recording the passage of time within a tree's trunk, the artefacts ripple outwards spatially and temporally: from the domestic and familial, 'the brilliant commonplace of all we take for granted'[9] (the stuff of home, its furniture, ornaments, ritual tools of cooking and eating, entertainments and games, memories of births and deaths, its gardens, backyards and sheds); to the wider communities of education, work and industry, religious observance, creativity, sport and leisure; to colonialism, international trade, the military and war; to the connective openings, trajectories and pleasures afforded by travel.

In the introduction, Gary Winters and Gregg Whelan describe the potency of the actual moments of donation, and frame those encounters as an 'emotional heart' for the project. In a subsequent conversation Whelan outlined his sense of the donations offering an emotional and experiential taxonomy of lived events and relationships: 'The stories and objects we've collected talk of encounters with loved ones, great journeys, domestic lives lived simply, lives taken too early, personal triumphs and achievements, separations, difficulties and disasters, and happiness. Looked at in this way, the boat is a sign of the richness and complexity of life itself'. As Sherry Turkle has suggested, many objects are in themselves evocative 'markers of relationship and emotional connection', 'companions to our emotional lives', intimate and active 'life presences' that bring together thought and feeling.[10] And one might legitimately choose to engage with many of the objects here *affectively*, opening to them as a kind of temperature gauge or anchor of feelings and desires. In particular, one might sense something of the currents and undertows they contain

88 Sandy Wells, see page 73

I've brought a bit of an ancient 14-foot dinghy called *The African Queen*, which I sailed around for ten years or so from the mid-1950s. It was too narrow to be a good sailor in stronger winds, you needed to reef early; so I sold it on to somebody in Emsworth and bought a bigger boat. One day the hull of *The African Queen* reappeared in Prinsted, abandoned and derelict. It blew ashore in a gale and broke up on the sea wall.

'I saw it there and picked up a souvenir; and here it is – my poor old boat.'

as *sites of experience* through close attention to the nature of the donor's personal investment and their own rationale, explicit or implicit in their story, for seeking to re-float this object within the world. It's evident that many of the donations endeavour to memorialise and re-animate an object in a vicarious 'second life', while still trailing aspects of the emotional or historical significance from its previous incarnation(s). At the moment of being given away, memories return and are resurrected performatively in and through things – as keepsake, memorabilia, relic, marker, document, *memento mori*, or celebratory trace. In this way, the gift-objects become talismans of continuity hitching a hopeful ride on a new journey, and cast memory into the future as possibility.

For my own initial orientation during the early research for this book, I organised the donated objects into 21 broad categories in terms of their original functions, each of these taxonomic 'paragraphs' recognised as wholly porous and provisional. '*Assorted timber, pieces of trees, driftwood*'. '*Cases, boxes, chests*'. '*Signs, name plates, plaques*'. '*Structural components of houses*'. '*Furniture*'. '*Frames and mirrors*'. '*Kitchen implements and eating utensils*'. '*Animals*'. '*Ornaments, masks, figurines and other carvings*'. '*Toys, games*'. '*Jewellery and miscellaneous domestic*'. '*Churches*'. '*Other architectural structures – garden, school, civic spaces etc.*' '*Vehicles*'. '*Sporting equipment*'. '*Musical instruments*'. '*Tools*'. '*Made in DIY, woodwork, art class, shed etc.*' '*Named boats*'. '*Other boats*'. '*Uncertain*'.

Inevitably most of these categories can be further broken down into diverse sub-categories, within which a particular functionality or characteristic is specified. For example, the deliberately catch-all '*miscellaneous domestic*' contains 13 walking sticks, two of which, in addition to their assumed function of supporting the relevant walkers en route, served as surfaces for inscribing the passage of time. The wood of both sticks – one used while walking the Appalachian trail, the other while on voluntary turtle watch on a beach in Crete – was scored and notched to count each passing day. Or, for example, the '*Made in DIY, woodwork, art class, shed etc.*' category includes a range of unfinished objects, that familiar class of the never-fully-realised or half-done-and-abandoned. These works-in-progress were left forgotten and suspended in time, as if tacitly awaiting a subsequent re-animation of their dormant potential as structural components within a wholly new context.

donation 1192, p 216
donation 346, p 106

This taxonomy offers just one possible approach to cataloguing the materials gathered, and a rather dry one at that – and of course there are many others, each of which enables buried histories, geographies and associative connections potentially to surface for the reader in different ways. Social historians, anthropologists of material culture, forensic archaeologists, cultural geographers and folklorists, as well as ecologists, botanists, arboriculturalists

and dendrochronologists[11] would all produce quite different specialist tax-onomies of such collections. Each of them would deploy a range of knowledges and organising lenses that no doubt would be generative, illuminating and valid, and at the same time (like all taxonomies) inevitably partial, compro-mised and leaky. In the end, my own functional listing has not been retained as a structuring device in the archive of donations that follows. Instead this section tries to offer readers some other perspectives through which to begin to find their own ways through the plethora of disparate materials and to locate the 'wood for the trees' – in order to explore, get lost and discover their own routes, connections and 'songs' freely and on their own terms.

One might choose to focus, for example, on the particular kinds of wood.[12] Their structural and aesthetic qualities, their strength, flexibility, figure, colour, fingerprint-like grain, or age; or their multiple lives and protean identities through prior recyclings – the cot foot stand that later becomes a garden plant holder, the salvaged planks from a shipwreck employed as shelves in a potter's studio, and so on. One might also consider the original provenance of each item of wood, if known. In terms of a geography of sources, it is noteworthy that there are objects from all over the world, as well as the bottom of the ocean (from the *Mary Rose* and other wrecks) and outer space (part of NASA's Skylab). These radically dispersed locations attest to complex socio-political histories of colonialism and military intervention, as well as the circuits and flows of commerce, tourism, exploration, adventure – and of the sea itself.

donation 1124, p 206
donation 728, p 154

A number of donations were pieces of driftwood, *objets trouvés* of uncertain origin gathered from shorelines around the world by walkers and beach-combers, each one sculpted over time by the sea into a map of the movement of water around its grain. The bleached, abstract forms of these disembodied components of things (including boats) are suggestive, mysterious and often beautiful. One can only guess at what they withhold, their eroded past lives and 'washed up' histories in the hands of unknown artisans and craftsmen. As Roger Deakin proposes in *Wildwood*, each piece of driftwood – in itself, as floating traveller, perhaps the seed of the original idea for the fabrication of boats – comprises a 'silent story', carrying 'its own secret history that begins with the seed of the unknown tree it came from, continues with its life as part of something made and nears its end with a voyage across the sea, perhaps halfway round the world over many years'.[13]

The philosopher Martin Heidegger once suggested that the cabinetmaker's attunement and responsiveness to the particularities of different woods, and to 'the shapes slumbering' within them, offered an instance of understanding thinking itself as a craft.[14] And I have often been struck by how carpenters and

THE LONE TWIN BOAT PROJECT 53

555 Arthur Mack, see page 133

HMS *Invincible* began life as the French warship *L'Invincible* at Rochefort in 1744 and was the elite fighting ship of the day. In the spring of 1747 she was escorting an outward bound French East India convoy when she was intercepted by a British squadron, led by Admiral Anson, off the north coast of Spain. Though hopelessly outnumbered, she was the last ship to strike her colours at the Battle of Cape Finisterre. As a British prize, HMS *Invincible* was the flagship of three admirals, took part in two French wars and served as far away as the West Indies and Nova Scotia. On February 19, 1758, bound for Nova Scotia, she ran aground on Dean Sand and sank in a gale. Arthur Mack found her in 1979 after snagging his nets at Horse Tail in the eastern Solent ...

'These are from HMS *Invincible* – a pulley-block spindle, a fid for the riggers and part of a gunpowder barrel.'

384 Johnny Johnson, Maeve, Finlay and Paul Hogan, see page 112
I became separated from my mother when I was 12 and never saw her again. When I had
children of my own she found out, and sent a set of bricks in a walker from Australia...

THE LONE TWIN BOAT PROJECT 54

'This little blue brick brings everything together: my mother, father, and children.'

craftsmen, including Jesse and Ian at the shed, explore a new piece of wood through a tacit set of knowledges that is grounded in a dexterous coordination of hand, eye and a quality of touch that is both manual and visual. They will roll it in the hands, feel its weight, sense the play of light on its figure, run fingertips and palm over its surfaces and creases, its knots and burls, sound out its resonances by tapping it gently (embodied skills not wholly unrelated to those required in sailing). In an essay about toys, the cultural theorist Roland Barthes describes 'the pleasure, the sweetness, the humanity of touch' elicited by wood, as opposed to molded, disposable plastic. He writes affectionately of wood as a 'familiar and poetic substance', an 'ideal material because of its firmness and its softness, and the natural warmth of its touch ... Wood makes essential objects, objects for all time'.[15] Many would share Barthes's enthusiasm for the texture and temperature of wood, and instinctively recognise the mysterious and sensuous invitation to pleasurable tactility it extends to master craftsmen and amateur enthusiasts alike. However one of the constants and certainties in this project is that no objects are 'for all time'; every thing transforms and assumes new identities grained and shadowed by its past lives, and wood itself, the 'fifth element', is one of the most fluid shape-shifters of all.[16]

Then there are those many artefacts that suggest functional extensions of the self, and relate to particular parts of the body, above all hand, but also foot, mouth and face. Indeed, all of these objects can be approached in terms of how they intimate and implicate the human body in specific ways, both in their original making and in their day-to-day deployment as door, banister, axe, hairbrush, cricket bat, oar, tiller, pencil, spoon, tooth pick, tray, mask, tent peg, pew, floorboard, bed, clog or jewellery box.

Unsurprisingly, this new boat is also buoyed with timber from many other boats, shadow vessels like homunculi resident within this new host. Alongside 53 pieces from unnamed craft and seven from model or toy boats, it also contains material from 95 named boats, many of them of unquestionable significance in the history of British shipping and competitive sailing. They include the Mary Rose, HMS Victory, the SS Olympic (the Titanic's sister ship), Lively Lady (the first boat to sail around the world), the SS Great Britain, RMS Mauretania, HMS Warrior, HMS Invincible, HMS Ganges, HMS Iron Duke, the paddle-steamer Medway Queen, the Prince of Wales, Robin-Knox Johnston's Suhaili, Pete Goss's beautiful and short-lived Team Philips, Ted Heath's ill-fated Morning Cloud III, and the recently decommissioned Ark Royal.

Embedded deep within this accumulation of wooden artefacts, one might suggest, lie the material traces of a profoundly human and irreconcilable tension – between the impulse to dwell, to make a 'home', and the impulse to

travel, to ride on fresh winds away from home: the dynamic, unresolved axis of the braiding of place and self that is articulated in the homophone 'root' and 'route'. A boat of course contains the possibility of both refuge and movement, home and elsewhere. In the very form of the relationship between mast and hull, a boat seems to reflect John Berger's notion of home as a cruciform *axis mundi*, 'the centre of the world ... the place where a vertical line crossed with a horizontal one. The vertical line was a path leading upwards to the sky and downwards to the underworld. The horizontal line represented the traffic of the world, all the possible roads leading across the earth to other places'.[17]

Ultimately the building of this boat produces a new composite object made out of old things: an exquisitely crafted yacht, a buoyant and mobile *bricolage* sculpture, an archival repository of stories and memories, and an enduring civic resource. Within its form, many objects, times, places, ideas, collective and personal identities congregate and jostle. And it is a testament to the degree to which *The Boat Project* has captured the imaginations of so many people in the region – an area steeped in histories of engagement with the sea – that contributions of such diversity and resonance have been made. At the same time, some of those objects and stories that lay a more modest, personal or even casual claim to 'significance' come to mean and matter to us in other ways than those weighted with unquestionable historical and personal gravitas. Paradoxically, perhaps we recognise something of the human intimacy, the emotional and mnemonic complexity within the very ordinariness and immediacy of some of these residual traces of the everyday, for they too seem to possess the pull of a larger world, the possibility of what Marcel Proust called 'the power of expansion' in 'the vast structure of recollection':[18] the packing case, the favorite tree blown down, the charred chair strut, the old guitar, the chopping board, the grandfather's cigarette box, the jigsaw with pieces missing, the olive wood good-luck charm ('touch wood'), the hand mirror, the wood from the mother's sewing machine, the unfinished DIY table, the child's mobile with its flying cyclist missing a leg and part of one wing, and the young boy's favorite stick.

In the *catalogue raisonné* that follows, all of the donations are listed numerically in the order in which they were received. This listing is necessarily a full and democratic register of this 'congregation'[19] of wood, with each of the stories distilled into a compact essence. A few stories are given more space on other pages but this is not to privilege their 'significance'. They are simply intended to highlight something of the diversity and flavour of the gifts, emotions and lives held within the boat. They punctuate these introductory essays to remind us that they are the true material of the account, and each stands in

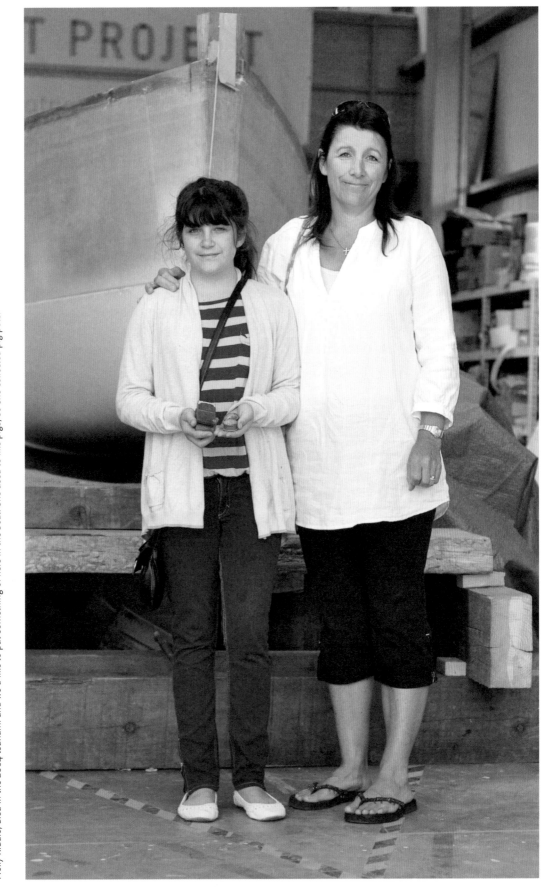

THE LONE TWIN BOAT PROJECT 57

801 Maisie and Sally Riddle, see page 164

There's two pig pots and a peg. This peg used to be part of a little game – you'd put it on a ladder and it would fall down. Maisie's sister, Holly Riddle, died in the 2004 tsunami and we'd like to put something of hers in the boat. She used to like pigs, so she collected pig pots.

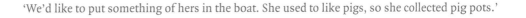

'We'd like to put something of hers in the boat. She used to like pigs, so she collected pig pots.'

for numerous others as a representative. A number of them present close-ups of objects and donors' hands in the act of giving, and, as a refrain marking repeated acts of generosity, perhaps these 'still life' images offer the reader a rhythmed series of moments to pause and reflect. To a degree, the selection also reflects an open and plural understanding of 'significance' in this context, for some have broader social and historical connections, while others are more discreet and everyday in their dramas. The original intention was to give over more space than we now do to the arresting historical 'back stories' associated with some of them. In the end, we decided to leave most of those for the reader to uncover, and instead to enlarge upon the lived stories and attend to the personal resonances contained in a pig pot, a kitchen spoon or a spinning top.

NOTES

1 William Carlos Williams, *Imaginations*, New York: New Directions, 1970, p. 110.

2 Walt Whitman, 'Song of Myself' (1855), *Leaves of Grass*, New York: Bantam Books, 1983, p. 72.

3 Bob Dylan, *Chronicles: Volume One*, New York: Simon and Schuster, 2004, p. 61.

4 Colin Tudge, *The Secret Life of Trees*, London: Penguin, 2005, pp. 81-2. 'Although we can grow trees, and some people can fashion them in many marvelous ways, we could not have designed such a material with such micro-architecture in a thousand years, or ten thousand, and indeed have not done so; for even our most remarkable modern synthetics do not begin to compete, in versatility and functionality and beauty, with what nature has provided. Such is the power of evolution' (ibid., p. 91). It is interesting to note, in passing, the degree to which trees and wood have taken root in our language in metaphors that seem germane here: 'the tree of life' common to the discourses of both Darwinian evolution and religions worldwide, 'the family tree', 'a chip off the old block', and so on.

5 British furniture designer Matthew Burt, in a personal email, 1 August 2011.

6 From Wendell Berry's 1987 poem 'How long does it take to make the woods?' in Alice Oswald (ed.), *The Thunder Mutters*, London: Faber & Faber, 2005, p. 156.

7 Annie Dillard, *Pilgrim at Tinker Creek*, New York: Harper Perennial, 1985, p. 114. Elsewhere in the same volume, Dillard writes: 'Trees stir memories; live waters heal them' (p. 103).

8 The notion of the first and second life of trees is drawn from the Japanese-American furniture designer George Nakashima's exquisite book *The Soul of a Tree: A Woodworker's Reflection*, New York: Kodansha International, 1987.

9 John Burnside, *The Good Neighbour*, London: Jonathan Cape, 2005, p. 78.

10 Sherry Turkle (ed.), *Evocative Objects: Things We Think With*, Cambridge, Mass.: MIT Press, 2011, pp. 5-9.

11 Dendrochronologists are scientists who read and date climatic histories through the analysis of tree-ring patterns.

12 The boat includes at least 63 known kinds of wood from around the world: afromosia, alder, American black walnut, American white oak, apple, ash, bamboo, beech, birch, boxwood, East African camphorwood, cedar, cherry, chestnut, crab apple, Douglas-fir, ebony, elder, elm, eucalyptus, hawthorn, hazel, hickory, holly, iroko ('African teak'), iron bark, jelutong, juniper, New Zealand kauri, laburnum, leylandii, lime, mahogany, maple, monkey

puzzle, oak, obeche, olive, opepe, padauk, pear, pine, parana pine, plum, plywood, redbeckia, redwood, rosewood, Russian oak, sandalwood, sapele, satin wood, sequoia, silver birch, spruce, strawberry tree, sycamore, teak, walnut, willow, yew, yoshino cherry and zebrano (zebra wood). A number of these woods from tropical, temperate and boreal forests internationally are now listed as endangered and protected species.

13 Roger Deakin, *Wildwood: A Journey Through Trees*, London: Penguin, 2007, p. 186.

14 According to Heidegger, the cabinetmaker, sensitised to the ways in which particular pieces of wood 'speak', 'makes himself answer and respond above all to the different kinds of wood and to the shapes slumbering within wood – to wood as it enters into man's dwelling with all the hidden riches of its nature' (Martin Heidegger, *What Is Called Thinking?* New York: Harper & Row, 1968, p. 14). To the best of my knowledge, a history of the intimate relations between trees, wood and thinking still remains to be written. It might include, for example, Aristotle's acorn and oak, Buddha's sacred fig (the Bodhi tree), Newton's gravitied apple, Berkeley's immaterial falling tree, Sartre's existential chestnut in *Nausea*, and Deleuze's rejection of the 'arboreal' in favour of the rhizome, as well as Heidegger's notions of the dwelling, the clearing and 'rootedness'.

15 Roland Barthes, 'Toys', *Mythologies*, New York: Hill and Wang, 1972, p. 55. Cf. Japanese novelist Junichiro Tanizaki's suggestion that wood can acquire 'an inexplicable power to calm and soothe' (*In Praise of Shadows*, London: Vintage, 2001, p. 12). It's perhaps pertinent to note that Roger Deakin's working title for his posthumously published collection *Wildwood* was 'Touching Wood'.

16 The great pastoral and war poet Edward Thomas, echoing Chinese mythology, conceived of wood as 'the fifth element', with all four of the others implicated in its growth or destruction.

17 John Berger, *And our faces, my heart, brief as photos*, London: Writers & Readers, 1984, p. 56.

18 Marcel Proust, *Remembrance of Things Past*, trans. CK Scott Moncrieff and Terence Kilmartin, New York: Vintage, 1981, vol. 1, p. 51.

19 I have borrowed this term from the celebrated wood sculptor David Nash, who uses it for the many pieces of wood gathered in his studio at Capel Rhiw in Blaenau Ffestiniog, Wales. In his wonderful chapter on Nash in *Wildwood*, Roger Deakin describes his first impressions on entering Nash's studio – and I am reminded of my own responses at the boat build shed in Emsworth: 'I shall not forget the sheer drama of the exuberant throng of Nash's work that fills the tiered space literally to the lofty ceiling. Moving through the chapel, I mingle with the wooden multitude, "the congregation", as Nash calls it. It is like meeting the family, an unusually big one, exciting and daunting at the same time: impossible to remember all their names, only a general impression that you want to get to know them much better one by one in due course'. Roger Deakin, *Wildwood*, op. cit., p. 153.

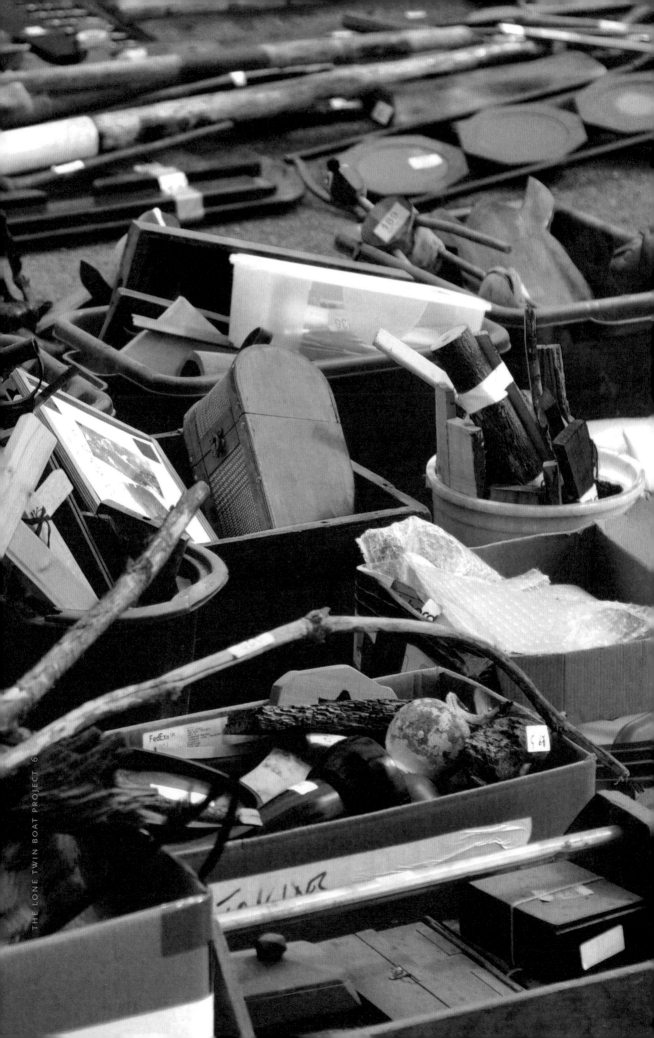

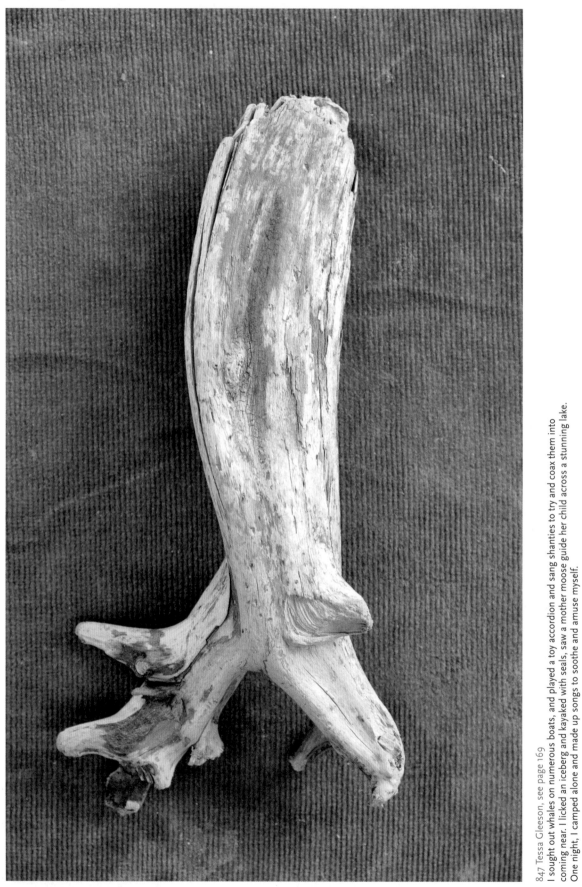

847 Tessa Gleeson, see page 169
I sought out whales on numerous boats, and played a toy accordion and sang shanties to try and coax them into coming near. I licked an iceberg and kayaked with seals, saw a mother moose guide her child across a stunning lake. One night, I camped alone and made up songs to soothe and amuse myself.

THE LONE TWIN BOAT PROJECT 62

'I found this driftwood whale there, and brought him home.'

Almost all of the donations for *The Boat Project* were presented in person at the shed in Emsworth or at public 'donation days' in towns across the region during the first half of 2011. A few pieces came by post or were left outside the door. This was the admissions routine: on arrival, and after an initial conversation, Winters, Whelan or one of the production team recorded an interview with the donor. Photographs were taken of the donors and their objects – usually a full-length portrait and an object close-up. A numbered ticket was then attached to the object, and an identical one was pasted to an index card. During and after each interview the numbered index card for the donation was filled in, registering the names of the donor and any other people or animals included in the photograph, along with contact details and a short description of the object, including the number of pieces, its distinguishing features and so on. These data were then entered into an online spreadsheet. Meanwhile the digital photographs and sound files of the interviews were numbered and archived. Noah might have approved! Later on, each interview was transcribed in full before being edited to fit the 100-word spaces available here.

Catalogue of donations

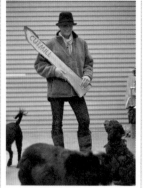

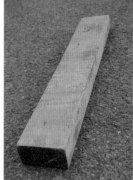

1 Sam Dew
This was a door that had a mirror on it; I assume it was originally from a Victorian wardrobe. My partner helped me break it last week, he fell into it. I inherited it from my grandma and she gave it to me when I moved into my first home. She just had this knocking about, but I've no idea how long she had it for. I've had it for nine years. I kept the glass, because at home I can mount it onto the wall – although that old Victorian glass is so heavy.

2 Carol Plunkett
This is a bowl made by my brother-in-law. He got into wood-turning sometime before his death and this is one I've kept. He died last year. He'd moved to France. He was a train driver and a musician and songwriter, and this was something he did in his spare time. So I've kept this and sometimes used it as a sweet bowl. It's a lovely object, and I know he'd be pleased to think it was sailing round the coast. His name was Martin Nasey (known as 'Nipper'). He's a legend in the Chepstow and Newport area of South Wales.

3 Tikki O'Connell
It's from a walnut tree my mother planted when my nephew Jack was born. Only it didn't fruit, so she cut it down. I started a woodworking course so I had the tree planked up. My mother wanted a nameplate for her house, Cutmill. When I gave this to her she said, "No, it's two words: Cut Mill". So I made another one for the house, this one was left. My mother died in March. She was a boat builder, based in Emsworth; that's where I grew up. So somehow this has got to go on your boat!

4 Anne Bone
This is a piece of plank from the site of a new museum that we're building in Chichester. It's a project that I've been involved in for 20 years, but finally last December the District Council decided to actually go ahead and build it. It's part of our development culturally, and the plank represents our past. But it also represents the future, because the new building is very much 21st century. It's going to be the heart of the museum service for the community.

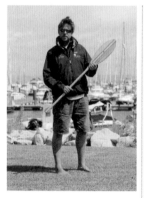

5 Ant McMahon
I've brought you a piece of exam material from the boatbuilding course I did about seven years ago. It's made of strips of mahogany and some pine. It's been in the corner of the bedroom. Several years ago it was going to be donated to a sailing club I worked at, as a prize for a kiddies' race – it was going to be the bosun's paddle. But it didn't make it through.

6 Liz Whitehead
It's a hand-carved Lithuanian spoon, which I bought in a market in Vilnius in the late 1990s from the guy who made it. It was the first major holiday I went on with my partner. I was an artist and didn't have any money; we're getting married next year. I originally trained in 3D design and I'm really interested in domestic objects. Lithuania has a long history of woodcarving, they carve everything. So everyday objects are imbued with the hand of the maker. I've used this spoon quite a lot, mainly for cooking and salad dressings.

7 Steve Mannix
These are three pieces of wood from my granddad's shed. I used to sit in the shed with my granddad when I was little. It was in North London. Since then the shed has been dismantled. I was going to rebuild it but I just haven't got around to it. He used to go to his shed to escape all the massive matriarchs in the family!

8 Viv Williams
This comes from a boat, *Symphony*, number V33 owned by Anthony and Gill Robinson. It's the block that takes the weight of the mast and distributes it over the hog of the boat. This one was replaced recently. The Sunbeams were classic boats, one of the most glorious to sail that I've ever come across. They were designed by Westmacott in 1923. We've been friends with Anthony and Gill for ever, but their son Ian ended up marrying our daughter Ros. Nothing to do with us at all! Now we've got joint grandchildren.

'He'd be pleased to think it was sailing round the coast. His name was Martin Nasey (known as Nipper).'

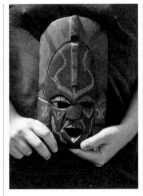

9 Lucy Williams
It's a very small bead for making jewellery. My sister, who's also my best friend, moved to Australia about six years ago and I went to visit. While I was there I made us some necklaces with one of these beads as the centrepiece. I bought three beads in all. She is still living in Australia. Recently she's fallen pregnant, and so this is the third bead: the little baby is the third bead! It represents our bond. I'm going for a month in March, when she has the baby.

10 Emma York
After I met my friend Polly we spent a year working and living together before I left to go to Australia –which was where I started my sailing career. For ten years I worked, sailed, taught, did training courses – and then last year I came home, to a proper job. This was Polly's going-away present to me. There was an image of me and Polly together in this frame, and I took it to Australia with me. Over time the picture changed to my parents, my sisters, a collage, all sorts. Polly is now in Kenya teaching children.

11 Craig Willcock
My parents always go on holiday and bring things back. They brought this back for me from South Africa, where my grandfather lives, and I thought, oh God, not another one! I was going to take it to a charity shop at first, but over the years I've actually grown to like it. It's been in my living room for the last two or three years. I thought, as a tribute to my parents, it can voyage with *The Boat Project* and be on display. So my parents can be a part of the Olympics.

12 Pippa Blake
It's from Easter Island in the Pacific. When my daughter was two I did a voyage with my late husband, from New Zealand to England, across the Pacific, through the Panama Canal. We were only at Easter Island for about five hours, an amazing place. This is a souvenir from there. It came with us on the boat for the rest of the voyage. My late husband was killed by pirates. So it's very significant because it was part of this great sailing life we had. There are two, but I'm keeping the other one because they're so special.

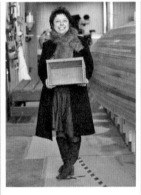

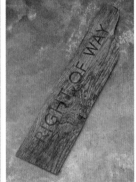

13 Sarah Jane Blake
When I was little, my friend told me that this wooden mouse came from a witch's garden in New Zealand, and we'd stolen it together. Haunted by this story I believed the mouse had good magical powers, not bad ones. As I grew up the mouse disappeared – a symbol of childhood. Years later I found it in the attic, it's been living in a dancing clown musical box next to a picture of my late father, who was a sailor. I thought perhaps it had been looking after him, a tiny faded memory alongside one so much bigger.

14 Cat Loriggio
It's a nativity crib made by my next-door neighbour, Basil. He was a Polish soldier who escaped from the Red Army during the war. He used to tell me romantic stories about it as if it was a delight. As I got older, I started to learn the truth. My granddads were dead, my Italian grandmother didn't speak English and died when I was very young, and I didn't like my other grandmother. So I adopted Vera and Basil as my grandparents. They used to come over for Christmas. A big part of it was about making the nativity scene.

15 Tom de Wit
Throughout my life I've been a bit obsessed with going where you're not allowed to go. I'm also fascinated with the framework that keeps rights of way open. A friend of mine, who was an IT consultant, retrained as a countryside ranger. One day he happened to mention that they sometimes change these signs. I wanted one, and badgered him for ages. I had it at home and was torn, because I like it; but I thought it would give me that personal stake in the boat. I'll feel proud when I see it because I'm giving part of myself!

16 Mark Woodley and Darren Coglan
It's from an 18-foot Lower boat, the local build from Newhaven. They're not there anymore, but nearly 80% of the boats on Hastings beach once came from Lower's yard. There are only four left on the beach now. They say you used to be able to walk from one end of Hastings beach to the other on the boats. But not now. I've been fishing off the beach for over 30 years. We're at a dodgy age to change. We want to stay fishing, but at the end of the day you have mortgages to pay.

'Recently she's fallen pregnant, and so this is the third bead: the little baby is the third bead.'

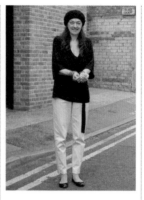

17 Keith Pettitt
This spoon is one of two that I got towards the beginning of living in a bedsit, which I've been in for 15 years now. It's a record for me living anywhere, in any one place. So it's just a memento, really, of living in Margate in the same bedsit for a long time. Before that I lived for 13 years in Ramsgate, so I've been in this area since 1975. I've brought two spoons. I don't really use them, they're just littering up the place. I like to simplify my amount of possessions, usually around Christmas time.

18 Chloe Barker
This stretcher has been with me for five years. I stretched it three times, and there's a painting underneath that I've painted over. It moves around with me everywhere I go, but I still haven't made another painting on it. It's really badly stretched and poorly finished, and I thought it would be better off becoming part of a boat. The painting underneath was one of my line paintings; it's of a building in London. So that's the story. It's been with me to about five different houses in Old Street, Hackney, East Dulwich, Camberwell, Margate.

19 Jan Wheatley
I use these pencils until they get down to this size. I use them for drawing, I write comic books. When they get to this size I can't really use them any more, but I just can't bear to throw them away! So I keep them in a tin. I find that the pencils I get from other places break really easily when I sharpen them; I don't know if it's because they're not good quality. But these WH Smith pencils don't seem to break. So I get more use out of them.

20 Bob Barrass
I was walking along the beach between Dumpton Gap and Ramsgate three or four weeks ago with my dog, Katie. I was throwing a ball for her, and was looking for some wood that I could use as a bat to whack the ball rather than trying to project it with my arm. I found this little bit of driftwood, which looked to me as though it had originally come from a boat. So I picked it up and it made a suitable bat. I brought it home, dried it out a bit, and then I heard about this project.

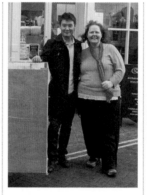

21 Tina Burbridge
It comes from the top of a unit that we've only really used the bottom part of. It's a sideboard cupboard that we bought a while back. We've had it for some time. We keep music stuff and all that in the bottom half – CDs and records and things like that.

22 José Gibbons née Brooker
This is a practice woodworking joint. I made these practice joints during a woodwork course in the early 1980s that was held at the building school in New Street, Margate. I hope this 'frame' will be of use in the boat. I went on to make a spice rack and a toy box. Woodwork runs in the family. My brother is a carpenter, as was my father.

23 Anne-Marie Nixey
This plywood crate was used to ship furniture from China. It was the sixth shipment to celebrate the third anniversary of our shop Qing in Margate. We sell a range of items from the orient including home furnishing, art, jewellery, gifts and books. When Mao Ping and I started Qing, we really wanted to show Yue, our furniture designer's work, but never knew how to get it over here. Not coming from a commercial or business background Qing has been a whole story and journey in itself.

24 Celia Edgington
This daggerboard is from the Mirror dinghy I had when I was about 12 years old. I have many happy memories of sailing it, *Swallows and Amazons* voyages around Chichester harbour. Later I moved on to another boat called a Topper, and the Mirror went off to family friends. About three years ago we dug it out of their garden where it was rotting away; we renovated it, and managed to get hold of a new daggerboard. Now I sail it with my son Max – not that he's a terribly keen sailor, he just does it to keep me happy!

'I've brought two spoons. I don't really use them, they're just littering up the place.'

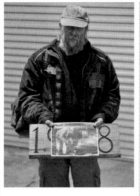

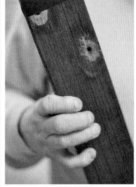

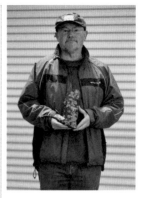

25 Catherine and Molly Baxendale
It's a short oak hat stand I made for my GCSE art project. I got an A but wasn't that pleased with it, so I left it at school. My mum worked there as a teaching assistant, and she brought it home two years later. I tried to leave it with her when I left home, but mum made me take it to London. Then I tried to leave it again, in the cellar of a house I was sharing with some friends, but they kept giving it back to me. It just keeps coming back.

26 Chaz Shaw
It's the top beam of a lock gate made by the late Peter Fletcher – a master mariner, master carpenter, a very clever man. He built a 35-foot Ferro job at the end of his garden, and ended up steam boating; he was a water man. I work for the National Trust, and one of my jobs is to renew lock gates. I cut this out of the gate at Unstead on the River Wey after he replaced them with new ones last year. The thought of a little bit of Fletcher bobbing around out there would be great.

27 Alan Priddy
Our charity, Around and Around, has donated the inner slats from the forward cabin of *Lively Lady*. She's undergoing a refit from us at the moment. She's about 65 years old, one of the oldest circumnavigating boats in the world. She was built in a bedroom in Calcutta, in a palace. As the boat grew, they knocked down the wall; and she was finished off in the laundry room before being floated down river. These pieces have done at least two circumnavigations: one with Sir Alec Rose, one with us – over 100,000 miles.

28 Bill Woods
It's a willow tree we planted when the children were born, about 28 years ago. It's now about 50 feet tall. It got so big, so low, that you couldn't walk underneath it. So we did a bit of hacking in that frosty weather.

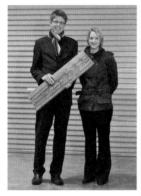

29 Rowan Wallis
I've brought a simple plank. It was borrowed from a friend to prop up my old bed, in the last few days of its life. It did a good job, but now I've invested in a new bed.

30 Tom Lord
I've brought a pair of drumsticks. Throughout school and college I played the drums. I had a band in the local area and we used to do various gigs along the coast, and try to make a name for ourselves. I've not played in a few years, and the drum kit's been locked away at home while I've been off at university. Our band did mainly covers, rock music that everybody knew.

31 Shirley Joyce
It's a piece of a hanging fuchsia bush. This bush was given to me when I bought my first home; I was then on my own. I have taken a cutting every time I have moved home – now with a husband! – and it has been replanted and grown into a huge healthy bush. It's become a lovely memory and symbol of continuity. The old lady who gave me the original cutting, who was a friend of a friend, would be surprised and very pleased.

32 Ted Palmer and Mike Carter
These are floorboards that weren't used very much. They are oak, and they are from either my daughter's flooring or my own. We've both had accidents with flooring of late, and we've both removed floor and stored it. The accidents were with water, as a result of bad roofing.

'The thought of a little bit of Fletcher bobbing around out there would be great.'

33 Alan Joyce
It is part of a case of wine that has travelled with me for many years. Nature's bounty returned to the deep.

34 Lyn Davies
It's a bit embarrassing really. I used to be in Havant Hockey Club and somehow I ended up with this. And I've never known what to do with it. I was the secretary, so I suppose that's why I got it. It's just decorative, and it's been stuck in my cupboard for donkey's years. Those are the team colours – green and white.

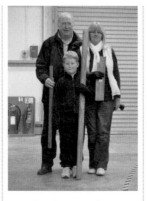

35 Keith and Karen Holmes with George Boxall
All of the wood is ash, and it was part of a hand-built kitchen that we once had. This was a door. If you look at the stern of the *Victory*, that was all made of ash; you had to steam it and curve it. Our new kitchen isn't real wood any more – awful, isn't it.

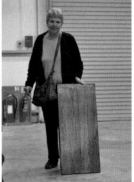

36 Mary Milton
In the 1970s I worked at the old sailing centre in Langstone Harbour, as a dinghy instructor. There were lots of old wooden World War Two shacks that had once been the sailing centre. They were rat-ridden, but somewhere amongst it all I found this wood. I made a table but it was a bit wobbly, and I never really used it because it was too heavy. So it sat in the roof of the garage for years. My husband used to use the legs as a weight to hold his paper down when he was in the garden.

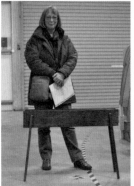

37 Helen Hinton
This was made at school by my late brother. It's his sixtieth birthday this year, so it was made quite a long time ago. My father hasn't got room for it. I haven't got room for it either. I haven't had any children, so I've nobody to pass it on to. I think my dad was a bit sentimental about it – it's been stuck up in his loft.

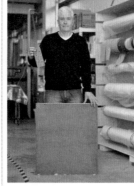

38 Brian Turner
I've worked with all the boat companies along the south coast. Now I work for BAE. This was an offcut from Halmatic before they moved to Southampton. They just said to the fellas, whatever's there, instead of throwing it out, take a piece. It's been in the shed. This is a template from a rib.

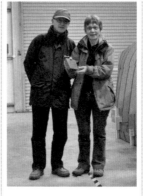

39 Paul and Stella Underhill
This is a newel post cap, from the stairs. It's about 35 years old and it came from our first house, when we got married. I think it came off and we put another one on instead. We took it as a spare, really, because it's not something you can easily make. So we've carried it around. I'm into timber, and I've done a bit of antique restoration. My father was in timber for about 50 years with the same company, so I've always been around wood.

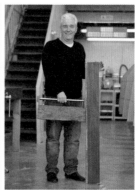

40 Brian Turner
That's off a fireplace, when we first moved in to our current house. But I've knocked it out and it's been in the shed. And this is a toolbox I used at work at Halmatic, right up until their move to Southampton.

'My husband used to use the legs as a weight to hold his paper down when he was in the garden.'

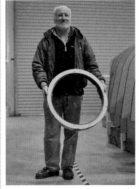

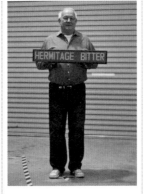

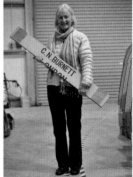

41 Robert Vince
About three years ago a great friend of mine, a balloonist, decided he wanted to sail across the Atlantic on a raft. But he's 83, and his three compatriots are in their seventies; they're all nutters, to be honest! They left from the Canaries a week ago, going across to Bermuda. I email them every five or six days. I love boxwood; a branch fell off this tree and I convinced the post office man to let me have a piece of it. He gave me two or three pieces. If you wet it there, it's the most beautiful colour.

42 Dave Mellish
This was given to me by a friend, to put into my garage. It's a round window frame. It was to go at the gable end of the garage, above the doors. He's passed away – his name was John Davies. We grew up together. He was a character, a likeable rogue! This frame is like a circle of life, to keep it going.

43 Malcolm Roberts
I used to own the Sussex Brewery in Emsworth, and this was the last bitter that we brewed there. We stopped brewing in 1988. Since then it's just been a pub and restaurant and all the rest of it. There was a brewery there in the 1600s, just serving the village – and probably with very cloudy stuff!

44 Carolyne Curties
This is from north China. We came home in 1949 when the Communists took over, but we left my father there. He couldn't get any money out of the country, and inflation was 1,000%; so he bought jade, porcelain and scrolls, and shipped them in a teak crate. This is the last piece – and this is his name. He wrote about it in his autobiography, *On The Edge of Asia*. We were in Southampton and didn't know what had happened – when one day he turned up. He made a work-bench and fixtures for his boat, *Blackbird*, out of the rest of the crate.

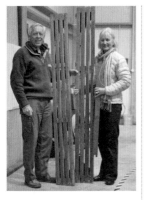

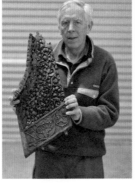

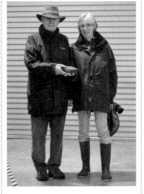

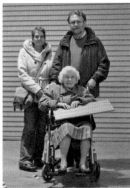

45 Richard and Carolyne Curties
This is a piece of mahogany from our National 18, which we bought before we were married, in 1968. We sailed her for about 12 years, but she eventually became 'nail sick'; that's when the copper rivets bruise the wood and then become slack, and the boat leaks through the rivet holes. You can mend each rivet, but there are thousands of them. She had a Viking funeral in our garden, and these thwarts from the boom crutch were saved from her.

46 Richard Curties
When I was a medical student in London in 1967, I acquired a fully carved Chinese loveseat. It had two seating areas facing each other. When I was working in hospitals I wasn't able to look after it very well and it deteriorated and fell apart. This is one of the remaining pieces.

47 John and Angela Brown
This came from Coombes Yard in Bosham, which is now a housing estate. I was raising an anchor windlass on a Westerly Seahawk up to deck level, and I used a lot of these – this was the pad underneath. Because the Seahawk had an anchor winch in the well, a manual one, which proved to be absolutely useless in the Med. So we raised it to deck level, and replaced it with an electric one.

48 Betty, David and Jacquie Penrose
This is a part of an old wardrobe that belonged to my grandfather. It was a huge, traditional gentleman's wardrobe that was made to disassemble. It would have been part of my grandfather's house up in Scotland, just north of Glasgow, where I was born – and it came to me. But we've never had a house big enough to take this thing! So I'm afraid we've just let it go. We've got various other bits, I think they might have been turned into chopping boards or one thing and another.

'She had a Viking funeral in our garden, and these thwarts from the boom crutch were saved from her.'

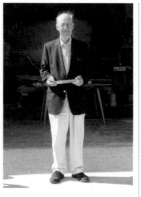

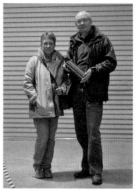

49 Brian Wakeford
These cherry planks came from a friend who owned a joinery factory in Waterlooville. When the business closed he let me have whatever I wanted from the stock. He knew I was always on the look out for hardwood as I am always making things from wood. I was going to make a couple of little tables from the planks but I never got round to it.

50 Brian Wakeford
When my mother died about five years ago, I donated a garden seat in memory of her to go in the churchyard of the Holy Trinity Church at Blendworth near Horndean. Somehow somebody managed to drive into the seat and damaged it, so I had to replace some of the slats. These are the slats that were broken and which I took out. The repaired seat is still in the churchyard and is very special to me.

51 Jeffrey Smith
This is stainless steel off my twin-screw diesel job, *Camp de Mar*. It was named by the owner, whose company did some development at Camp de Mar in Majorca. In the confectionary industry where I once worked, CDM was also the nickname for Cadbury's Dairy Milk. I was with the opposition, Mars and Maltesers. Cadbury's once produced a straight competitor for the Mars Bar, but the manufacturing cost was the same as the retail price: one shilling. Mars were only making a penny profit, but they sold millions.

52 Gil and Carol Carter
In 1990 when we lived in Surbiton, we were clearing out the Thames Sailing Club car park and there was this old shattered length of mast. That's one of two sections I cut off. It's probably the mast from Fred Sigrist's *Caprice*, which is still sailing but with a glass fibre mast. Sigrist and Tommy Sopwith of the Sopwith Camel were members of the sailing club in Surbiton. They both experimented with a rolled veneer mast because it gave added strength. It was the same construction they were using on the aircraft.

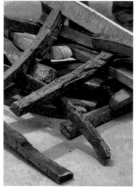

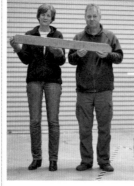

53 Ali Beckett and Gary James
These are the ribs of the *Terror*, one of the Victorian oyster fleet. Emsworth used to be a really important centre for oysters, but in 1902 the Dean of Winchester died after eating Emsworth oysters at a banquet. The beds had become infected with sewage and the resulting typhoid outbreak pretty much finished the industry overnight. The *Terror* was mouldering away in a greenhouse at Westbourne until, in 2003, Chichester Harbour Conservancy raised funds for the restoration. For three years she was in a boatyard almost next door to where she was originally built.

54 Ali Beckett and Gary James
The Chichester Harbour Conservancy has various notice boards around the harbour, always at key launch points, and this was one of the header boards with our name engraved into it. This one came from Emsworth, and was the notice board that a lorry reversed into last year!

55 Steve Gilbert
A cocktail stick. I lost my cherry on this.

56 Paul and Judy Covell
This is a real tennis racket. The game goes back to about 1100 with monks throwing balls to each other, then hitting them with gloved hands. Later they put string across their fingers, then extended that on to a piece of wood. That's how the tennis racket developed. The original French name was 'jeu de paume': game of the hand. There are very few real tennis courts in England, but the squash club on Hayling Island where I live has one. I used to walk past this silly game, then one day I had a lesson; since then I've been hooked.

'That's one of two sections I cut off. It's probably the mast from Fred Sigrist's *Caprice*.'

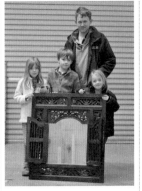

57 Keith Rodwell
It's a piece of African hardwood. I acquired it in the 1960s from the site of a textile mill being built at Juapong in the Volta region of Ghana. I've used it as a rather heavy cheeseboard in my homes in Ghana, and then in London, Surrey, Kent and Sussex.

58 Malcolm, Anna, Iona and Hamish Morley
This is a butcher's block that my brother gave to us as a wedding present. It never really got used as a butcher's block – it was a fish tank stand.

59 Malcolm, Anna, Iona and Hamish Morley
This was another wedding present. We lived in a really rickety old cottage and it just really suited that house at the time. It's from a very good friend of mine, Jonathan, and his wife Penny. In our last house it lived in the attic for seven years and was never looked at, and it doesn't really suit our house at the moment either.

60 Lucy Palmer
I've brought some teak from Jodhpur in Rajasthan, India. I had a friend there with a supply of abandoned teak from old carts and things. We had the idea of starting a flooring business. My friend had a sample made up; the teak was sanded and joined together, then sent over. But it didn't seem like it was going to be a goer economically. I gave the sample to my dad to see if he could do anything with it, but he thought it was too nice to use as a shelf in his tool shed.

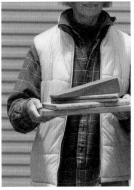

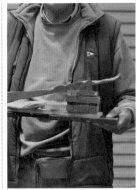

61 Eddie Ault
I've been restoring my boat *Old Florence* in recent years. I bought her from Roy Smith, former president of the sailing club, a lovely fellow who died a few years ago. Lately the keel became too weak, so I've made a solid, six-inch deep keel. It now means that she doesn't point to wind at all, but she doesn't leak as much as she used to! This is the old keel, with bits of the gunwale too. Now I'm slowly redoing all the rivets. Trying to keep her afloat, keeping her going. She's still there, and she still leaks!

62-66 Jill and Jonathan Barker
This is a mahogany mounting block. I made it in 1972 on our Galion 22, for one of the first auto-helms. It took us down to Ushant. This is a spruce offcut from a mahogany prop shaft clamp. It was an important 'boat bit' in its time, but I can't remember what! Here's a mahogany prop shaft clamp from our Rival 32, and two bits of mahogany driftwood, picked up on the foreshore of Chichester harbour.

67-69 Jill and Jonathan Barker
This is a well-used chopping board that has also done duty more recently as a house nameplate. I inherited a workbench from my father, (the painter John Barker). He made it in about 1939. It has a Record vice on it, as so many of them have, with two mahogany cheeks. I replaced them just recently, so this one's been liberated. This is a mahogany ski mount. We had a Triumph TR3A when Jill and I were first married, and in 1965 we went skiing in the Alps.

70-72 Jill and Jonathan Barker
On 23 October 1991, Jill was hunting with the Garth & South Berks foxhounds. She was in at the kill and was presented with the brush. I mounted it on this piece of pine. The main part of this oar now serves as a 'stiffener' in the bottom of our inflatable. Back in 1971 it was used by Jill's father to scull a tender. And this came from a plank of fine walnut which was given by Edward Barnsley, the furniture maker, to his friend Bill Wills, who brought it with him to Emsworth when he retired in the 1980s.

'It never really got used as a butcher's block – it was a fish tank stand.'

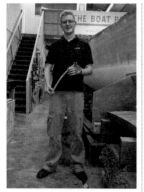

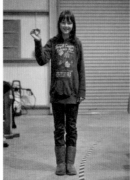

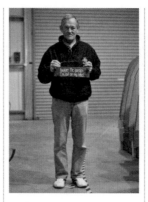

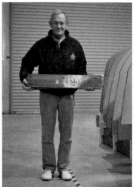

73 Hamish Cook
I made this tomahawk a couple of years ago from an oak log that was sat in a friend's fireplace waiting to be burnt. I noticed how the different colour in the wood looked similar to an axe blade. We cleaned the edges of the log with a plane and cut a number of slices from it with a circular saw. I whittled the handle from a length of hazel. The two pieces were then joined with matchstick dowels and wrapped tightly with leather thonging. From every piece of firewood, driftwood or broken chair, artefacts can be made that bring joy to people's lives.

74 Emily Covell
A piece of lead. I think it's a fish weight, from Thorney Beach. Me and my dad and my brother were walking along and we were looking for stones and I found it. Dad said it would be good because you need lots of lead, for the keel.

75 Malcolm Lasham
This sign belonged to a friend of mine, Mike Hobden, who died very suddenly last March. He was a biker, and it says, 'Bugger the garden, I'm out on my bike!' It was hanging on his shed where he kept his bike; he was always out and about on it. He had a Yamaha FJ1200, which he used to love.

76 Malcolm Lasham
The other bit is just door thresholds. I'm a carpet fitter and I say, it's better than burning them. Now they're replaced with metal bars.

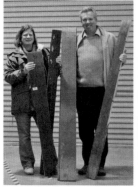

77 Richard and Glynnis Bradshaw
These boards used to be the floor in Holy Trinity, Blendworth. We're doing refurbishments up there, and we demolished a lot of it. Half the wood we had to sell; that's the way the church works, you've got to sell it if you can. A load of it was not saleable though, and we were going to take it to a skip. The church is almost 160 years old, so the wood's about the same age. You can see heel marks all over these pieces. Underneath them we found a sixpence from 1922 and a ten pence from 1970.

78 Peter and Araby Hibbin
I was a furniture maker, several years ago. This didn't really mean anything special, it's just a very nice piece of padauk, a wood that I used occasionally to highlight a nice feature. It's a lovely violet red colour, with a beautiful grain.

79 Richard, Harriet, Susan and Alistair Cope
It's a piece from my old bunk bed. I slept in it for about ten years. Now it's cut down to a normal bed. This is one of the legs. I didn't like being up high – it got too hot.

80 Mary Milton
This was the old mantelpiece from the lounge of our bungalow when we moved in 21 years ago. We had the gas fire replaced, so it's been sitting in the garage for all those years, gathering dust.

'He was a biker, and it says, "Bugger the garden, I'm out on my bike!"'

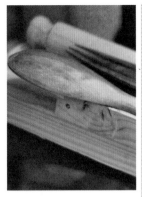

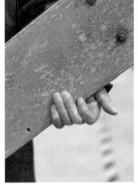

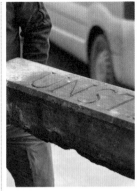

81-84 Mary Milton
I'm not sure what this is. It's been in the garage for a few years. This a wooden shelf that we bought and never used. It's been sitting in the garage for years. Here's a few table legs from a table I bought many years ago. I don't know what happened to the table, it probably fell to bits. It was only a cheap thing. This might have been something, I'm not sure.

85-87 Mary Milton
I bought this for a pound at a bargain basement when I moved into my first house, back in 1981. I made mince pies, jam tarts and scones. But I don't do baking any more. I don't know whether these chopsticks are wood, they're just from the Chinese take-away. The Mandarin, in Emsworth. I was a 'Ten Pound Pom' in 1971. I went out to Australia in July and we spent two and a half years there. I came back by boat. The journey took just over a month, and en route we stopped in Tahiti and I bought this.

88 Sandy Wells
I've brought a bit of an ancient 14-foot dinghy called *The African Queen*, which I sailed around for ten years or so from the mid-1950s. It was too narrow to be a good sailor in stronger winds, you needed to reef early; so I sold it on to somebody in Emsworth and bought a bigger boat. One day the hull of *The African Queen* reappeared in Prinsted, evidently abandoned and derelict. It blew ashore in a gale and broke up on the sea wall. I saw it there and picked up a souvenir; and here it is. My poor old boat.

89 Steven Stewart, Chaz Shaw, Tony Hattley, Pete Young and Josh Dalton
Unstead lock is just below Godalming on the River Wey. It was one of the last gates built for us by our in-house master craftsman, Peter Fletcher. When we replaced the gates, we wanted to keep a piece in memory of that. So this is one of the last pieces of the last gates made by Peter Fletcher.

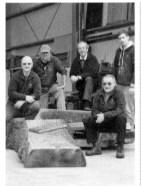

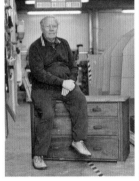

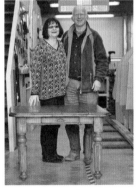

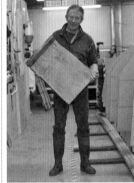

90 Steven Stewart, Chaz Shaw, Tony Hattley, Pete Young and Josh Dalton
This is a piece of elm and it's at least 100 years old. It would have been a sluice board on a lock gate or a water-control structure. Charlie found it recently, while he was dredging at one of our docks. He pulled it up, and it had sat under there for many, many years. The large cut pieces of timber come from a tree that fell over off one of the banks of navigation. They tend to fall across the navigation and we get in as a maintenance team.

91 George Blagg
To the best of my knowledge this chest of drawers was made in about 1880. I can remember it in my grandmother's house. Then it came into my mother's house, then into my house, then into my daughters' houses; and the most recent place it's been is with my granddaughter. She's just gone to Australia, so they're emptying the house. My son-in-law, who is a builder, saw it yesterday and said it had old-fashioned nails in it. It's certainly been five generations in my family.

92 Alyzn and Stephen Johnson
We've brought a Victorian table, which we had when our children were growing up. It came from an old house in Rowland's Castle where a lady had died. A friend of mine bought the house and the table was left there, so she gave it to us for our children. It's been in our house for at least 25 years. It was our kitchen table, for everything – homework, the lot! Now the children have all left home.

93 Robin Yeld
It's the pub bar from The Old House At Home, Chidham. It was removed around four years ago when the new bar went in. I asked John the landlord what he was doing with the wood, and he said I could have it. So I rescued it. I've used some of it in my camper van and this is the last bit. I lived next door to the pub for 42 years, so I've leant on that bit of wood a lot, I should think! It's a great community pub.

'One day the hull of *The African Queen* reappeared in Prinsted, evidently abandoned and derelict.'

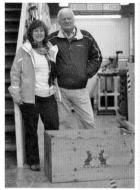

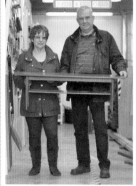

94 Rod and Sarah Till
This is from our son and daughter-in-law, Edward and Sophie Till. It was found in the loft of their relatively new house. We assume it was a baby's toy box, or for storing clothes underneath the bed. It was left by the people who owned the house before, tucked away in a corner.

95 Jenny and Dave Carter
It was a wedding present in October 1968, so this little table is 43 years old this year. We've just changed all our furniture and it's been up in the loft for a couple of years. It did many years of service in the living room, with the kids falling over it and all sorts of things. We even had a cat that used to like to sharpen her teeth on there.

96 Faye Bowreman-White
This is 'Henry VIII'! He is a wooden lion who has moved with me from house to house for many years. I think we acquired him 30 or 40 years ago in Surrey or Sussex, and he used to sit on the side of a lovely old fireplace. I'm now in a smaller house and I'm afraid he has been outside by the garden shed for the last couple of years. I was going to polish him up to bring him inside again, but then I decided to give him to you for the boat.

97 Richard Bown
This was given to me when I was nine or ten, and living in Birmingham. I used to sail it at Canon Hill Park, where there was a small boating pool. But the time I had the most pleasure from it was when I was in Anglesey, where we stayed with my cousins on holiday. There were lots of people of similar ages and with various types of boats. We used to sail them on the sea sometimes, but more often in the rock pools after the tide went out. Some had motors but mine was a boat with sails.

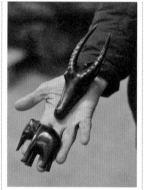

98 Sue Palmer
This is from an apple tree in my garden in Glastonbury, Somerset. I've lived in the house since 1982, when I was 18. The tree was dying when we moved in, but gradually I've pruned more and more off it to keep it standing. It's decrepit and cankered, but still there: a fruit-bearing tree with a root in the Isle of Avalon, the 'isle of apples'. They built a Somerfield in the late 1980s across the road, where there used to be an ancient orchard; and they just erased it. I thought, the apple tree in my garden's quite important.

99 Sue Palmer
This is an electric guitar that I bought in Totnes around my fortieth birthday. When I was 17, electric guitars were really important to me, fundamentally influential to my state of being. I stopped playing in my mid-20s but I wanted to start again, so I bought this as a symbol of me restarting. I can't really use it properly because it's so heavy. So I've kept it for ages without playing it. I wanted that Patti Smith-PJ Harvey-girl-band kind of music to be part of the boat.

100 David Williams
I've brought you three animals, all of which come from my aunt Mary's house, which I helped clear out when she moved into a home. An elephant, an antelope, a tortoise. They're traces of the Williams family's murky colonial past! These two are from Africa, from the 1950s, when my father first went there. He gave them to my aunt, and they were in the room that I stayed in as a child. They are probably about 60 years old; they're from Zambia. The tortoise is from Burma, my aunt was there just after the war. She really loves tortoises.

101 Paul Strickland
The brass plates represent *time*. They're from my granddad's old clock, made in the 1930s. It was broken in 1950, just after the war. The balsa wood represents *light*: the least dense wood. It's from a dear friend who has now passed away, a great model maker. The third item represents *travel*. It's a molding from a clock, with the wooden triangle's connection to the case. The wood came from a master clock used in South Africa and made in the UK. The Clocktrust thought these items would resonate with *The Boat Project*.

'I wanted that Patti Smith-P J Harvey-girl-band kind of music to be part of the boat.'

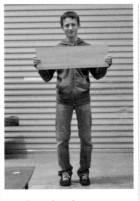

102 Lisa Edwards
It's my old school pencil. I used it in every lesson.

103-104 Carleton Edwards
These are floorboards. I'm working on my house, and this is a spare one. I did the whole dining room with them. And this is a port box. It was given to me last Christmas. The port's still in the process of being drunk.

105 Chris Edwards
This is from our newly fitted kitchen.

106 Anna Hennings
It's a trapeze toy. We bought it on the beach in Tobago six years ago, and it was on that holiday that my daughter was the victim of a serious attack. So when I see this now it always reminds me. But she's moving on and I wanted to let it go now. She's very brave, and she's just had a tattoo done that says, 'What doesn't kill you makes you stronger'. She told me yesterday that she was moving on and wasn't going to let this dictate her life any more.

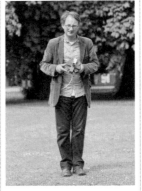

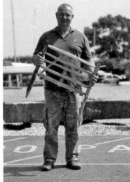

107 Fiona, Matthew, Evan and Jacob Wilkie
Our study was always inside our house, but then when we had the children we ran out of space. We both write, so we built a writing shed in the garden, which had to be rebuilt because it was leaking. And the day we planned for it to be rebuilt was the same day that Fiona went into labour, so it was kind of officially the day that we were going to lose the study. The new shed was built on that day, and these are the offcuts from the old one.

108 Ian and George O'Mahony
It's a kitchen cupboard door; this one's from under the sink. I made it about 20 years ago. I made the whole complete kitchen. I'm an electronic sales engineer, but I did carpentry and home maintenance at school – and the rest is history!

109 Rupert Rowbotham
This is a mahogany lamp base, I made it at school in 1985. I was very proud of it when I first made it, probably the first thing I made out of a serious wood like mahogany. You can still see the pencil markings on the side, and some dodgy sawing marks. I remember sanding it forever to get a beautiful soft finish. It had a wooden lampshade on top as well, but it burned; obviously wood's not brilliant for a lampshade! I've never been able to throw it away, because I remember how long it took me to make.

110 Andy Mackenzie
This is a mini split chestnut hurdle made by volunteers for Nymans Garden in Handcross, West Sussex. It is made from sweet chestnut which has been sourced from sustainable managed woodland in the High Weald. Revival of coppicing benefits wildlife, birds, butterflies and so on, and crafts which, in turn, provide funding. Such crafts can be for ornamental use in the garden, made using traditional methods. This is a scaled down version of old industry, adapted to a new age.

'She's just had a tattoo done that says, "What doesn't kill you makes you stronger".'

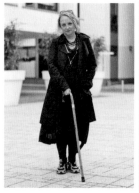

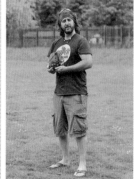

111 Sarah Pickthall
I've brought my father's walking stick. He became disabled with Parkinson's. I remember him being very proud about using a stick, then becoming more dependent on it. There are quite a few pictures of him standing with my kid and using this stick. When he died my mother offered the stick to me, because I use a stick sometimes. It felt really awkward; I didn't really want to use it because it was his. He built a boat himself when we were small. He was a pilot, but he used to work in this hangar.

112 Nick Jenkins
I've brought a small African mask. It comes from Nairobi. I've never been to Africa, and I think it was given to me by one of my early girlfriends in about 1985. She went on holiday when I was 16 and I remember being really upset. But she brought me back this mask. It's moved house with me five or six times, and I've neglected it enormously. It's just sat on a bookshelf. I'm not emotionally attached to it, to be quite honest, but it's been with me for years and I've looked at it every day.

113 Adrienne Shields
I'm a teacher at Chalkhill Education Centre. The kids all have mental health difficulties, and I've run lots of workshops, using these pencils. Hopefully it's inspired people, lifted their spirits and given them a higher self-esteem. I've brought along some letters from the students. Hannah's been there for almost six months, she's suffering from anorexia. She's made some really good friends there, and has completed an arts award. Fatima says the pencils have helped her to write out her feelings and overcome the final hurdles.

114 Ruth Dudman
This was part of a boat, an old oyster smack that came to Shoreham, which is where I live now. It used to be moored where the boat that I live on is moored now, and its hull is still upside down and in pieces next to my house. I walk past it every day. The main hull is next to our front door – I feel like it's dangerously close, because when the tide comes up and our boat floats, the oyster smack doesn't. It looks like it's going to come down on top of us! But it never does.

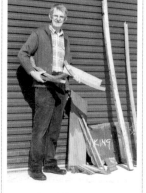

115 Sara Hopkins
I'm community liaison manager for the Littlehampton Academy, and this is a handrail from the school when it was the Littlehampton Community School. A couple of years ago we became the Academy, and I like to think this is a little bit of the old school, something from those thousands of children that would have gone down the stairs rubbing their hands on this handrail.

116 Karen Poley
When I first moved into my flat, me and my sister got a bag of kindling and we found this piece of wood in it. It has a sort of big eye-hole in it, and it's like the beginning of a branch - I just really love the way that the wood goes in, it's beautiful. It actually comes apart, so there are three sections to it. I've played with it for years, just turning it round and round, then I take it off and play with it – isn't it amazing! My partner calls it nature's nuts and bolts.

117-119 Dave Thompson
This is the top of an aerial mast off a German First World War submarine. In the late 1920s, my next-door neighbour, Dick Watts, and his business partner, Lacey Twine, bid for the scrapping rights and had it towed into Chichester Harbour. Dick was the only man to have entered Chichester Harbour on a submarine! This is oak from the beam shelf of *Valerie*, a Portsmouth shellfish dredger built in about 1920. And this is a Canadian Rock Elm apron from a Victorian day racing boat called *Arrow*.

120-121 Dave Thompson
These are off a boat that came to the Sea Scouts in the late 1950s. It was kept in a barn, and at some stage someone cocooned it in fibreglass to stop it leaking. My brother and I stripped it all off and reframed it, and when we were scraping it we realised its original name was *Golden Wings*. There's an ash tiller extension, and a small piece of mahogany from the cockpit. This is from HMS *Nelson*, a shore-based establishment in Portsmouth. Part of the building was a prison block, demolished in 1976 or 1977. All the floors were this gorgeous pitch pine.

'I walk past it every day. The main hull is next to our front door – I feel like it's dangerously close'

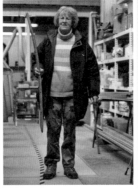

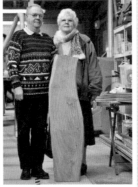

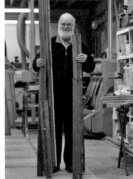

122-124 Dave Thompson
I restored a Morris Traveller for nearly 28 years and this is an offcut from one of the laminated rear wheel arches. It was my little pride and joy. I sold it to a very appreciative gentleman on the day of the total eclipse of the sun. This is the transom of the pulling gig *Viking* wrecked in the Great Storm of October 1987. And these are off a boat that I built with the Southbourne Sea Scouts. Sir Alec Rose had launched and named the boat for us in 1979 – such an unassuming bloke, approachable, talk to anybody.

125 Gill Hibbs
This is part of the framing that went round the windows of the clinker-built fishing boat *Ella Jane* that my husband and I had. She was kept here at Thorney for several years, but sadly was damaged in the great storm and I ended up having to sell her. She was never fixed properly after that, just too much work. We bought her in 1972 and I sold her in about 1990. The man who bought it died and I've lost track of what happened to the boat.

126 David and Christina Ferrier
We bought this plank at a steam rally fair in Bicester in August 1977. We watched the plank being cut from the tree, paid a pound for it, carried it to the car. It was going to be a coffee table, but it never happened. It's travelled around with us ever since. It's been in David's workshop since 1993, never touched. I've grown attached to it, it's lovely. 1977 was the time when you had a log table coffee table, with four little round wooden legs. David was a carpenter before he joined the army, so he knows his wood.

127 Peter Mills
I've brought five pieces of mahogany that were a window frame. We've got a bungalow in Porchester. When we moved in in 1976 we had to have new windows put in to get the mortgage. This is what they put in. We changed them for modern ones, and I got them to leave this behind. Originally they were going on my cousin's woodburner, then I see *The Boat Project* and I think, ah, they might be able to use that. They're still as solid as the day they were put in; and they were rubbed down and varnished most years.

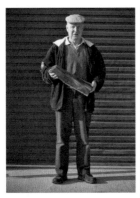

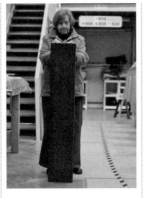

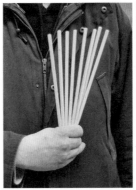

128 Derek Flahey
I have here a piece of yew I found in Chichester woods in the storm of 1987. I was intending to do something with it, carve it into some sort of shape, but I just rubbed it down, smoothed out the grain and polished it up, and I just used it for display purposes. I like working with wood. I've got tree roots that I've polished up in the past; I've got one in my garden, and I've got a small one indoors. We display things on it, like teddy bears.

129 Margaret Lynes
My husband made a fire surround and this is the mantelpiece. He made it for our house in Havant 30-odd years ago. He wasn't happy with it, so he took it all to bits and made another one! He was in the navy – an electrician – but he enjoyed working with wood.

130 Mark Lockwood
Every time I got a Chinese take-away from various places in Havant, I'd keep the chopsticks. I collected them over several years, but I've never really thought of a use for them. Crispy Chilli Beef was a personal favourite.

131 Susan Hay
I used to play hockey at school, I loved it – I used to like beating people up round their ankles. When I was at school we didn't have knee or ankle protectors, you just got massive haematomas on your legs! It was terribly cruel. I've kept this for many years, in my bedroom, in case I get broken in to. But then there have been so many cases of people attacking a robber and getting done, I thought it's probably better that I haven't got it, because I'd probably quite enjoy beating someone up with it!

'1977 was the time when you had a log table coffee table, with four little round wooden legs.'

132 Bill Kronfeld
This is a piece of American white oak, the other end of which forms the mantelpiece of the house that we built about 15 years ago. I managed the build, lived on site and employed my own carpenters, bricklayers and so on.

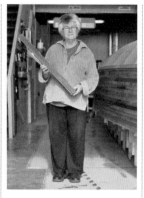

133 Anna, Ben, Josh and Saskia Fawcett, and Florence and Felicity Brellisford
We have a house that we built, up near Rowland's Castle, and this is wood left over from the build. I think they were the joists of the house. It took us about 18 months, but now we're in and it's great – we love it!

134 Belinda Cook
This is a piece of American oak from the floor in my family's house at Sandy Point on Hayling Island. Built in 1937, the house is called Landfall. It was well known by loads of people in the past. Round-the-world yachtsman Sir Alec Rose and John Illingworth, the naval architect based in Emsworth, both walked on this wood. Mark Covell used to visit us with his family as a child; he did Scottish dancing on this floor. The whole family enjoyed sailing, and loved charades. If the wood could talk it would tell lots of stories!

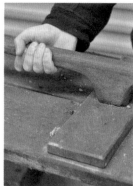

135 Mark Wood
I used to travel the world as a windsurfer, and was World Champion in 1986. In the 1990s I had to find a proper job and I became a director of a company which distributed surfing kit. We had a showroom in East Wittering; it needed some shelves, so I went to a colleague who specialised in driftwood. These pieces from a container ship were salvaged from East Wittering beach in 1997. We hung clothes and sandals on them, they looked great. Since then the shop's been refitted, and they've been in my garage for a special occasion. This is it!

136 Keith Rodwell (on behalf of Petrina Rodwell and Debbie Stark)
Petrina: This is the top of a chest of drawers, the top of which my mum used for changing my nappies in the 1970s.
Debbie: This is the top of a chest of drawers from which, at the age of about two months, in the 1970s, I rolled off on to the floor whilst having my nappy changed!

137 Mike Braidley
The piece of iroko had been left in the garage of a house I bought from Nigel Pusinelli who was a local legend around Chichester Harbour. He acted extremely honourably during our house purchase and was a real inspiration to me. Without his help we wouldn't have been able to make the move. He was known by everyone connected with the water around Emsworth, and a key figure in the local sailing fraternity. The thought of having a memory of Nigel in *The Boat Project* is a great pleasure.

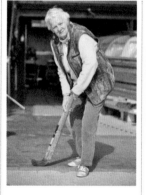

138 Gretta Pescod
I've brought two hockey sticks. I have lived in Emsworth for the last 40 years and I played sport all my life. I played for Havant Hockey Club, and we used to go to Holland because we had a link with another hockey club there. I played left inner – but I think they call it 'inside left' these days.

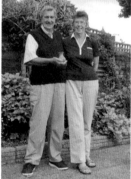

139 Ann and Jack Mundy
Our wooden pot was bought in a little shop in Honiton en route home from a West Country holiday about ten years ago. There were lots of pots in the shop window of all shapes and sizes, but this is the one we liked best. It's made from 100 year-old oak from Plymouth Dockyard. Jack worked with wood and said he could have made one if he had had a lathe, but we bought it – for £5. It has been in the cupboard ever since. We're delighted to give it to *The Boat Project*.

'Mark Covell used to visit us with his family as a child; he did Scottish dancing on this floor.'

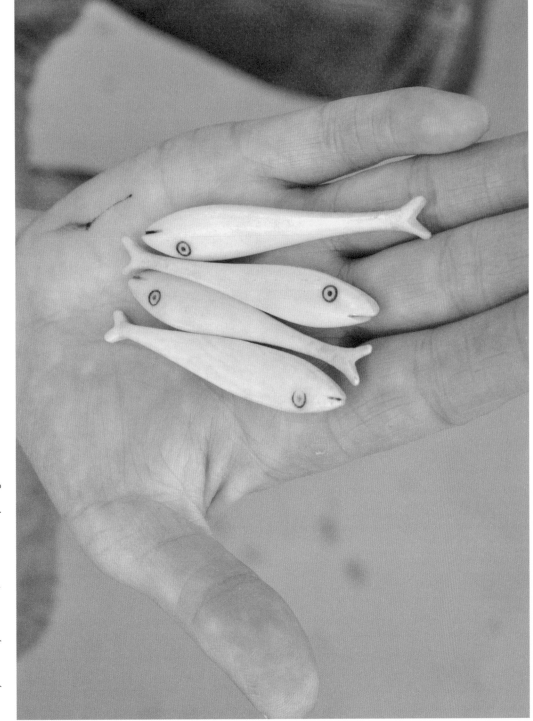

THE LONE TWIN BOAT PROJECT 79

171 Lizzie Dymock, see page 83

These are ox bone or ivory fish that were used as gaming counters in the 18th century. My brother reckons they would have belonged to my great-great-grandfather originally, who surveyed India for mapping. Apparently the boats in Turkey have an eye in the bow, which is for safety and good luck.

'My grandmother had lots. She was a missionary in Zanzibar.'

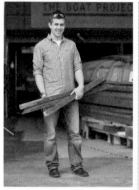

140 Dave Bulger
It's part of the framework from an old shed. We moved into our house about a year and a half ago, and it was very much in a state of disrepair. We're slowly going through it, piece by piece. We've recently built a new shed out of old scaffold planks, so it's all recycled. The shed turns into a bar during the summer, for barbeques and things. It's very popular with my friends!

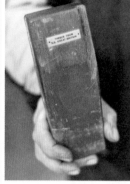

141 Chaz Shaw
A wedge-shaped piece of wood from the SS *Great Britain*. They were being sold off as souvenirs when she went back into dry dock in Bristol for the restoration. It's donated by Charlotte Johnson, and it came from her mother originally, who's now passed on. She's been using it as a doorstop, I think. Poor old Brunel!

142 Chaz Shaw
It's a piece of elm from the bottom of an old working narrowboat, a butty – they're the ones without the motors. The bottom was redone a few years back, in steel. You just can't get elm like that any more. The boat starred in the film *The Bargee* with Harry H Corbett, quite a famous boat, really. It now works as a horse-drawn trip boat. I'm giving it to you on behalf of Jenny Roberts.

143 Jennifer Surman
This is from a swing boat. You pull the ropes and it just goes higher and higher. They're from 1920, and my family bought them for £5.

144 Jennifer Surman
This is from the gallopers– not a carousel! Gallopers go clockwise, carousels go anti-clockwise. This was burnt about six years ago. We put it up at Petworth every year at a charter fair. That year the boys put it up, put the roundings on – which was a big curtain around here – and somebody set fire to it. So all the middle was absolutely burnt out, and this is a bit of the charred remains. It was completely ruined. But my five brothers, and lots of helpers, put it back together again. The horses were badly burnt too, but they survived.

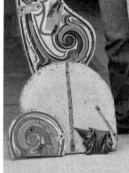

145 Jennifer Surman
A 'Chair-O-Planes' seat. This is one of the very old seats. They repair it each year, we all pitch in and paint. We never throw anything away.

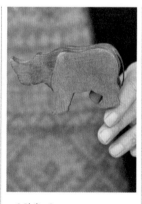

146 Philip Surman
Williez is about 50 years old. A girlfriend gave him to me in the 1960s. He's named Williez because of the Anglo-Saxon chronicles, which have a poem which says, "Them that farts on hillez, farts where they not Williez". I was a bit obsessed with that at the time, because when rhinoceroses defecate, they twirl their tail and spread it. It's been on the mantelpiece for 50 years.

147 Angela Eames
It's the nameplate off my grandmother's house in North Street in Emsworth. The house was built in the late 1800s by my grandfather. My mother was born there and I lived there until I was ten. When the house was eventually sold, some butchers took over the front. The stables are still there, but the yard in the front has three shops on it. Now it's a hairdresser's. I went round and asked if I could have this nameplate, and she let me have it along with the old door knocker. I didn't want it to just disappear.

'I went round and asked if I could have this nameplate, and she let me have it along with the old door knocker.'

148 Paul Stephens
This is part of the transom of Mirror dinghy number 3700. It was built by my father in Cornwall in the 1960s, when I was about eight. A lot of my early independent sailing experience took place in this boat – it's been a very durable boat design. I re-bottomed it on several occasions but it's finally past the stage of repair. I've sailed it all my life. My father was always building boats, and I've spent the rest of my life repairing them!

149 Audrey Constant
My father started farming in Sussex in 1921, and we're still there. This is from one of the old poultry barns; now they're in the fourth generation. We've sold a lot of the farm but the house is there. My daughter's come to live beside us with her husband, and I'm still keeping poultry. I'm potty about poultry! The barn was falling to pieces, so we built a new one. I can't get chickens out of my system. I keep thinking I'm going to give it up, when I go out in the rain, but I still love it.

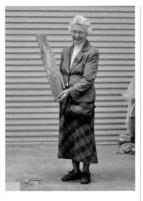

150 Anne Stephens
I've got the last bit of my old Heron dinghy. I was brought up sailing in Christchurch and Poole harbours on an old Heron dinghy. All the things you learn about sailing as a child happened with me in this boat. I lived with her and sailed in her for about 20 years. Eventually I gave her to a couple of old gentlemen. They wanted to look after her, so she went on to a good home. This is the last bit I kept of her – my bit – the handle, which you used to pull her along.

151 Enid Caddy
This was the first sideboard I had, when I got married in 1939. It was made to measure. Over the years it has always stayed in the garage, because it has lots of compartments inside. It's still part of my life, and I'm 95 now.

152 Alfie Winters
My great-granddad's tool that he used when he was a carpenter. It's called a mortise gauge. I like making buildings out of lego – I've built a block of flats at home.

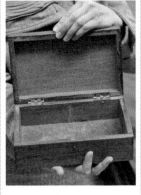

153 Jenny Roberts
I've recently moved to Brighton from Oxford. I was in Oxford for ten years, and all my family's there, so moving's quite a big thing. This box represents then – my past. It's me moving on.

154 Chloe Barker, and Dave and Peggy Philpot
This is a fertility symbol. We adopted Peggy, so we don't need our fertility symbol any more. For eight years we hoped it would work, but it didn't. It sat on our mantelpiece all that time. Peggy has been with us for three months and it's going alright. It makes things a bit different – it blows your mind!

155 Roy and Janice Winters
We've got a clog that my father-in-law bought over 20 years ago in a little old junk shop in Appledore, on our way to Camber Sands on holiday. It was in a pretty bad state anyway. He took it home, cleaned it all up, polished it; and he used to have little violas growing in it on the window sill. It looked very pretty. He died over 20 years ago and we put this away in a cupboard and forgot all about it. We're donating it as a memorial.

'This is the last bit I kept of her – my bit – the handle, which you used to pull her along.'

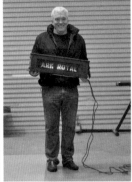

156-157 Paul Bedford
This is the house name for Polhawn, a small cove in Cornwall where my parents were courting immediately after the horrors of the Second World War. My parents have always kept that house name wherever they've gone. About 20 years later, as a child on the same beach, I found this warning – 'This hangar has a slippery deck' – which I reckon came off an aircraft carrier. It's hung in our shed ever since.

158 Brian Turner
Here's a light cover from HMS *Ark Royal* – she was decommissioned just last week.

159 Graham Johnston
This is from the site of the final gunfight in *The Good, the Bad and the Ugly* – from the very cemetery that hosted the gunfight at the end of that film. It comes from a place called Contreras, in Spain.

160 Graham Johnston
These are from my own boat, which I rebuilt in 1998. This is the original rudder, which had to be replaced; I kept this as a spare just in case. And this is made from the wood of the rebuild of *Hunter's Moon* – my brother-in-law made a shoehorn out of it! It says, 'You'll know you need this when you bend down and look around to see what else you can do whilst there'.

161 John Featherstone
I visited *The Boat Project* recently and was very impressed by your hard work and dedication. I would love it if you could include this postcard somewhere on the vessel (possibly the mast)? It's of value to me as it advertises my debut novel, published in July 2010. On a bittersweet level, it was the last book my dad (a voracious reader) ever read and I was so glad that he enjoyed it – even if he did spot an historical error on page 30. Keep up the good work and best of luck.

162 Freddie Fredericks
We were at Greenham Common peace camp for around 12 years from 1982, every weekend and holidays, campaigning against the Cruise missiles. This mirror is one of the few things the bailiffs didn't take! I was living in Portsmouth, and we used to go up every Friday night and come back Monday morning. That's why we look so baggy and wrinkly!

163-164 Freddie Fredericks
I use the pendulum for water divining and health dowsing. You can also sex unborn babies with a pendulum. And if you're dowsing in a church and want to check the energy line, you can put it in your pocket quickly if a Bishop comes by! And this piece of yew was being carved by one of the Druids at the camp a few years ago, to go on the door of his yurt. It wasn't quite the right angle, so having blunted every tool he'd got, he gave it to me in desperation and started again! It's been on my desk, it's a nice piece of wood. But it just didn't hit the spot for what he was doing.

165 John Kendall
It's an 18-inch rule. I worked at IBM many years ago and saved up a lot of money to travel round Europe in a VW camper van in 1972. I went off for nine months, travelling all around Spain, Portugal, Germany. I don't think I'd like to do it now – too busy.

'I found this warning – "This hangar has a slippery deck" – which I reckon came off an aircraft carrier.'

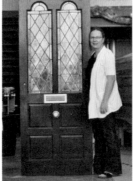

166 Jonathan Townsend
This was a 12-foot sailing dinghy that was a tender to a boat called *Essex Maid*. *Essex Maid* was a pre-war cruiser, one of the larger ones that used to sail from Emsworth. My aunt bought the dinghy when she was about 30, and then my parents bought it for me when I was about 11: *Robin* – my first boat. I used to race it in Emsworth Sailing Club. It's been in the family ever since, and we've used it to teach other generations to sail. But she's finally succumbed to age.

167 Karen Lacey
This is my front door. The house is 100 years old this year, and we were told by the previous owners that the door was original. We've been in the house for six years and we've used the door – obviously – ever since. We had a home energy survey, and because the glass is cracking, and there are gaps at the top and bottom, it lets heat out. We suffered it for a few years but this winter was a cold one. So we've got a delightful plastic one now, that looks very similar, but is warmer and sealed.

168 Katie Lacey
Kindling. It was next to the fireplace. We've got loads more wood.

169 Anna White
I've brought a bedouin tent peg, which I found in the desert in Morocco in 2004. It was just buried in the sand. I've carried it around with me everywhere, and had it on the wall at home. Now I'll always know where it is.

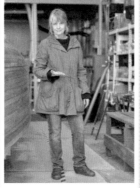

170 Jack White
Some train track, for wooden trains. It's from my first train set. Daddy's got an electric one that goes on the table.

171 Lizzie Dymock
These are ox bone or ivory fish that were used as counters in the 18th century. My grandmother had lots – she was a missionary in Zanzibar. Apparently the boats in Turkey have an eye in the bow, which is for safety and good luck. My brother reckons they would have belonged to my great-great-grandfather originally, who surveyed India for mapping.

172 Anthony Dymock
This is the ruler that my prep school mistress used to beat me over the knuckles with. I nicked it, from my torturess.

173 Dave Bulger
This is a slightly damaged guitar. I bought it from my brother's friend when I was about 14, for £50. My first guitar. Unfortunately I dropped it a couple of years later, snapping the head off. I didn't want to throw it away, and I've always thought I might put a new neck on, but I just never got round to it.

'This is my front door.'

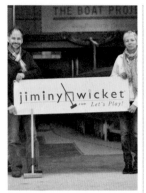

174 Andrew and Lesley Creasey
Me and my brother set up a company, Jiminy Wicket, that gives people suffering from dementia somewhere to go to have a game of croquet. It just creates so much fun and jollity and well-being. We had the idea about four years ago after our father's diagnosis, and we've now got a global plan. It's social, and it gives people a sense of control in a world where their control has gone. This is one of the mallets, and each mallet has the colour of the ball you're playing with.

175 Paul White
I found these old tennis posts in the garage, and they were literally in my trailer waiting to go to the tip. They were used at my parents' last house, where they had a grass court. Then they came with us from our old house, thinking they might be useful one day. I think they're from the 1930s.

176 Tom Frosdick
I've brought my son's old climbing frame. His name is Bertie and he's had it for about ten years. Now he wants a trampoline.

177 Gillian and Michael Penfold
I bought this breadboard for my bottom drawer at an old hardware shop in Hastings called Mosley's, which has since closed down. I bought it for myself, for my marriage on 3rd October 1963. I used to look in this shop every week while I waited for the bus, choosing the next thing I was going to buy for my bottom drawer!

178 Zoe Castro
My first wooden spoon. This spoon was given to me by my teachers at nursery. I made it look like a chicken by putting on two googly eyes, a pretend beak and colourful feathers. I also used to play with it all the time until I lost all the decorations. I have so many fond memories of playing with it.

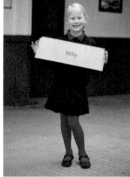

179 Milly Clout
This is from my old doll's house. I got it when I was four, from Father Christmas.

180 Christian Whiteley
I got it in France last summer, when I went exploring on my bike. I call it the 'shark's hat'. Because if you hold it one way it looks like a shark, and if you hold it the other way it looks like a pirate's hat.

181 Isaac Hall
I found this on Hastings beach, it was from a bonfire. It's been in a little chest and I've always taken care of it, I've washed it every week and stuff. But this year I just forgot about it, and then I found it again.

'If you hold it one way it looks like a shark, and if you hold it the other way it looks like a pirate's hat.'

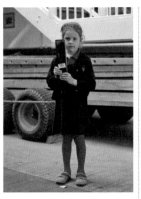

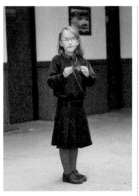

182 Robin Daly
A piece of wood from the pier. I got it on October 5th 2010, the day of the fire. There was smoke in our garden. Lots of people were sad. We miss the pier.

183 Mimi Luscombe
This is from my new floor. My parents bought it for their living room floor. When we bought it, one side was covered in a thick yucky tar that mummy had to scrape off first.

184 Daisy Crabb
A piece of driftwood from Winchelsea beach when I was three. It was a sunny day and I was walking with my mum. We turned it into a boat and had races in the puddles with my friends. I've kept it on my shelf ever since.

185 Gabriel Harrison
A piece of a pirate ship from my back garden. It's been there for a hundred years. It has 13 cannons.

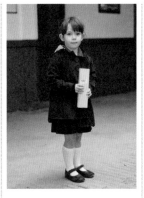

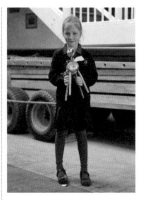

186 Barney Oliver MacKew
My dad got this off our roof. This wood is 300 years old.

187 Ellie Hildyard-Woods
One day my grandpa came home with a big pile of wood in his car. He was going to build some shelves in his shed. The next day my grandpa asked me if I'd like to help him with his shelves by passing him the screws he needed. By the end of the day the shelves were done.

188 Michal Paderewski
This was the first time I used a hacksaw. Daddy helped but I cut it myself.

189 Matilda Cordell
It's a reindeer. My daddy makes them at Christmas. He's still got lots more.

'My dad got this off our roof.'

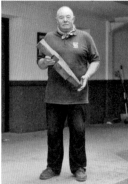

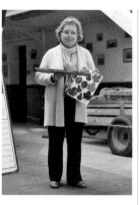

190 Alfie Mason
These are letters, they say my name. They're from my old house. They were on my bedroom door.

191 Mick Barrow
I'm an ex-fisherman, retired now. I was in the lifeboat crew for about 30 years and I've brought this timberhead from my boat, which is retired and all! My boat's called *Conqueror*, as in William. We had it built in 1974 and it retired the same time as me. There's usually one of these on each side, and you tie your rope round it. I shan't be using it so you're quite welcome to it. You can have the boat and all if you want it!

192 Brenda Wilson
I've brought you a part of the fixtures and fittings of the Shirley Leaf and Petal Company factory and museum, on Hastings High Street. We were 100 years old last year, and I've got the total history of artificial flower making for the last 150 years. It's unique – it's the only one you will see in the whole of Europe. We've got 10,000 tools of the trade. We're famous for being involved with epic films, *Gladiator* and those kinds of things, and we do all the national theatres in this country and abroad.

193 Sally Walton
I believe this is an oatmeal roller. I've had it for about 35 years but I've yet to roll any oatmeal with it. Well, I did try once but they just went everywhere. I don't think I had the right kind of oats. But I always have it around and insist it goes with us wherever we go. It would be great for a foot massage on the boat.

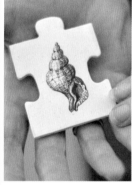

194 Phil and Alicia Askew
We bought our house in St Leonard's about seven years ago, and when we first came here we walked down to the beach and we found a bit of driftwood. We thought it was a really nice bit of driftwood, because it could be a nose off a shark, or a beak off a bird, or something like that. We've had it sitting in our fireplace at home ever since. It's very characterful, with knots and marks on it. It's a great thing, to walk along a beach and see what you can find.

195 Helen Hunt
I've got a jigsaw puzzle piece for you. Recently I've been painting and drawing miniatures on jigsaw puzzle pieces, and I quite like the idea that this one, which is a picture of a seashell I picked up on St Leonard's beach, will actually return to the sea. My own jigsaw piece will be fitting together with the other pieces of donated wood to create something whole.

196 Jill Taylor
These are some wooden jointed legs from a very old doll, over 100 years old. The doll's got a tiny little head that didn't come with it. It belonged to my great-aunt. She had terrible rheumatoid arthritis and she used to let me play with this doll, when I was little. Whenever I look at it I always remember my aunt in her wheelchair, and then I think, actually, she was once a happy healthy little girl with proper working limbs, at one time.

197 Alexandra Leadbeater
I spent three weeks on an artist's residency in Florida, just after Hurricane Katrina had devastated the coastline. I found a plank there, painted it to look like a sea, then cut it into seven pieces to make seven seas. They hadn't discovered the Atlantic when they named the seven seas, so this left-over piece I named the Atlantic. I also printed quotations on to little wooden sticks. They don't have lollipops in America, they have popsicles. This is actually a tongue depressor. It says, 'In one drop of water are found all the secrets of all the oceans'. It's Kahlil Gibran.

'I shan't be using it so you're quite welcome to it. You can have the boat and all, if you want it!'

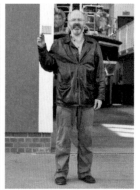
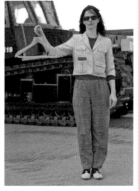
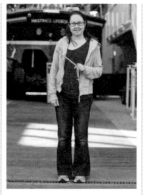

198 Kim Clarke
I've brought a sparge tap from the newest Hastings brewery. We've just set up a micro-brewery called 'Hastings Brewery'. It's only been going for a few months but it's taking off really well. We've got it in five local pubs and everyone seems to be enjoying it.

199 Kim Clarke
This is from Sambalanco, Hastings's very own community samba group. It's an agogo bell stick. We use it to play the agogo bell at the Hastings bonfire night and lots of other performances over the past year. It's seen a lot of parades and processions.

200 Didde Molly Haslund
The hanger is from my flat in Copenhagen. It's been there for the 20 years since I moved in, and it has always been a little bit annoying, because it has this shape; it doesn't fit with the other hangers. I have always wanted to get rid of it! I thought, why not turn it into a boat?

201 Guy Dartnell
It's a dovetail joint I made in school when I was 11. It was our first day in carpentry doing dovetails. Apparently they're the most difficult things to make. This was my first shot at it, and I got 9.9 out of 10; it was signed by my teacher. Since 1971 it's been in various places as a bookend. I excelled, but strangely enough, I didn't find my calling. Nowadays I really regret that I don't still do carpentry, because the people I admire most are performers, like Barnaby Stone or Bryan Saner, who also make things out of wood.

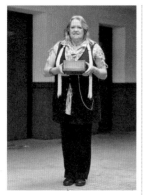
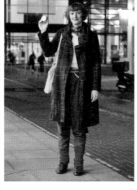
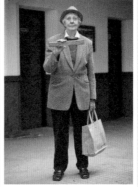
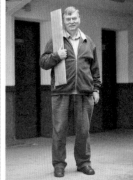

202 Pamela White
I'm donating this sequoia box that my father got when he was in Nova Scotia. He was a master gunner in the Royal Navy, he escorted the *Dingledale*. Fuel ships, then the supply ships, then he was on the big destroyers. He bought this box for my mother. She kept keepsakes in it, and back then it had this wonderful smell. None of them are around now sadly, but they were both in the navy, that's where they met. I feel they would get a kick to know that something's still going to sea! Even if it's not them.

203 Nina Tecklenburg
This is the French version of a dice that I know also exists in German. It's from my French grandma, and whenever she and my grandpa, who was German, prayed before having something to eat, they would roll this. Whatever was on top they would pray together. It's a pre-food prayer dice! When my grandma died, the whole house was cleared. My brother took the German dice, I took the French one. My grandmother was very into objects, and she's in all the objects that I have from her. So now I give a piece of her to you.

204 Elaine Neame
This is a bit of olive wood, from Bethlehem. I used to organise exhibitions and I had to do an exhibition of flowers from the Holy Land. I had to find artefacts, bits for people to look at, and this is a piece I have left. I think I found it in a second-hand shop, for about 10p!

205 Dick Edwards
It's a piece of decking timber, from a Hastings cottage called The Piece of Cheese. Two brothers called Starr built a terrace of cottages in the old town and, for a £5 bet, one of them added 'The Piece of Cheese' on a triangle of land left over. It was a workshop until about 1960, then a residence, and a café. It's the only three-sided cottage in the country, and the second smallest. I went to London one day, seven or eight years ago, and when I came back I said to my good lady wife, 'What have you been doing today?' and she said, 'I've bought The Piece of Cheese'.

'I said to my good lady wife, "What have you been doing today?" and she said, "I've bought The Piece of Cheese".'

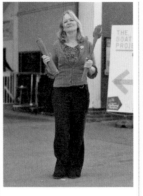

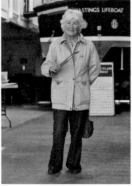

206 John Trafford
This was a wedding present on 14th May 1949. It's been well used, but we've got a new one now. I had two breadboards as wedding presents, and my daughter's using the other one. She told me the other day that she saw one identical, in the same condition, going for £17.

207 Jan Cope
I used to do a lot of travelling, and this comes from Fiji. I think it's a shoehorn, but it could also be a back-scratcher, I'm not exactly sure. It was in a pair originally and I got them to put on the wall; but I thought it looked a bit creepy, it's like a real hand. So it was a bit redundant, although I have used it occasionally as a shoehorn. I used to go for all these creepy looking things, and masks – the uglier the better at the time.

208 Jan Cope
This belongs to my mother, Betty Cope. It's the rolling pin that belonged to her mother, who used to bake a lot of nice cakes and pastries for all the relatives and friends who used to come round for tea. So my mum used it for quite a while. Now she's given up baking.

209 Ann Russell
It's a piece of wood for making nets, which I picked up about 25 years ago when I used to draw the boats on the beach. I had some pictures of Brighton and London. There were masses of boats in those days. It's a shame now, there are hardly any boats left.

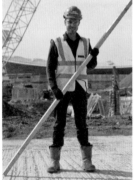

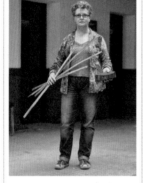

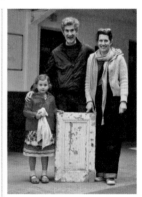

210 Oliver Evans
I work for ISG as a construction manager here at the Olympic Park, and this is a piece of Siberian pine left over from the construction of the velodrome. It came in six-metre lengths and each piece was fixed individually to a pre-installed truss below it. All the nails are hidden from view once it's completely installed. We had a team of about 15 Irish carpenters working on the project. It took about three weeks to install, and the whole track went in over three months. Around 58,000 metres of track timber; 50,000 nails.

211 Sineid Codd
This came out of our ceiling when we bought a flat. We were advised to take the whole ceiling down, but we wish we hadn't now because the soundproofing would have been better if we'd left it.

212 Sineid Codd
This small slice of log came from one of the seven leylandii that were overshadowing the garden and making it very, very dark. A great guy, a sculptor who lives nearby, came and chopped down the leylandii for us, and we've had an amazing supply of logs and brilliant fires for the last few years. People say it's not good, but the flames are fantastic! Now it has let the sunshine in and everything's starting to grow in a better shape, instead of running away from the darkness.

213 Richard, Lucinda, and Betty Butler (missing Marcus)
This is from our house on Tackleway, which was built in the 1890s. It's not much of a story, but it is wood. We moved in eight years ago. We wrenched this out when we put in our bathroom.

'I used to go for all these creepy looking things, and masks – the uglier the better at the time.'

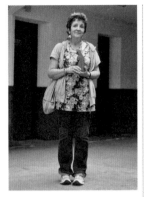

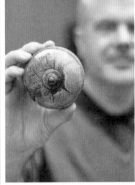

214 Maggie Hart
I made this at college a long time ago. I picked out the piece of wood that I thought was the nicest, but unfortunately it turned out to be the hardest. So everybody else made these amazing things and I ended up with that, after four weeks. I called it 'The Pregnant Nun'. It turned up when my dad moved and cleared the house out.

215 Derek Brown
I've brought a palette with paint colours on it. I've done a lot of paintings around Hastings, and these are the colours I've used here. I don't use it any more though, I use a modern thing instead, where you tear off the sheets. I'm a set designer for film, but I studied fine art, and I didn't really paint until I came to live here, but when you come to Hastings the sea is such a force that I had to do something. So I picked up the oil paints and painted the constantly changing seascape.

216 Sven Harding
We bought a house here four years ago that was a bit of a knackered old wreck. This – which we think is the end of a curtain rail – was just lying around with tons of junk. We spent about a year and half restoring the house, doing it up, and this is one of the things that we couldn't find a use for. Our house is on the straightest road in the old town of Hastings. It's called The Croft. It's so straight because it was a rope walk, where they used to bind the rope for the fishing boats.

217 Yasmin Ornsby
I work for Hastings Fishermen's Protection Society. When I first came to work in the office, these objects were on my desk. I don't know what they are, and no one else knows what they are. I've had them for four years, I use them as paperweights. Then they get put on the filing cabinet, and then someone else picks them up and says, 'What are they?' And no one knows.

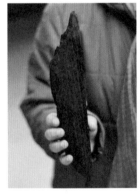

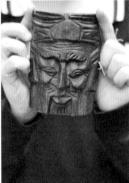

218 Yasmin Ornsby
On the day that the Hastings pier burned down last year, I was on the Blue Stade – that's the fishing beach. A couple of boats had to go and collect nets, and this was washed ashore. It's a part of the pier.

219 Yusif Smallman
A piece of wood and a pencil. The piece of wood came from a chopstick that I found in my desk. I found the pencil in my desk too.

220 Sophie Cutting
Two pencils. I've had them since Year 3, and they're my lucky pencils.

221 Louis Choron
When I moved into my new house they left this mask, with lots of others. I think it would be something to hang up, because you wouldn't fit it on your face.

'I think it would be something to hang up, because you wouldn't fit it on your face.'

222 Freya Maslin-Brown
I got these pencils from W H Smith's and I've been writing with them in my spelling test. I got them all right!

223 Hannah Skilton
I have two more pencils that are exactly the same as this. I wrote with this one before, and I don't know what else to say.

224 Emily Paice
They're my favourite pencils. I've had them quite long, from the start of this year.

225 Finlay Acuna
It can hang anything you like on it. My granddad made it in Germany. I hang key rings and coats on it.

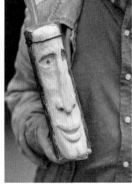

226 Josephine Ho
A pair of chopsticks. I've had them for ages. I brought them because they remind me of my childhood, and also because I was brought up using chopsticks. They remind me of Chinese food and of my parents as well.

227 John Goddard
I thought you might like a wooden Indian! I got it out of the log basket. Every time we have a delivery of logs, anything that speaks to me I take out and carve.

228 Peter Chowney
This is a walking stick. I gave it to my grandmother for her birthday in 1963, after the long, cold winter. So it's been in my life for 50 years. She died in 1970 at the age of 93. She was the daughter of an Armenian-Romany gypsy who was expelled from Armenia and escaped here on a sailing ship. My mother inherited the stick when my grandmother died, and it got passed down to me eventually. It's been sat in the garage ever since.

229 India Boxall
This is from a cabinet. The cabinet doesn't really mean that much, but it's my grandma's and it got destroyed. These were the last remaining bits of it. I'm studying art, and I just found this paintbrush – it's all hard and destroyed, because I didn't clean it very well.

'Every time we have a delivery of logs, anything that speaks to me I take out and carve.'

230 Pia Carpenter
I'm India's cousin and this is another piece of grandma's cupboard. And this is a piece of wood that I found in my mum's shed – my dad built our house and this was a bit that was left over.

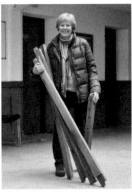

231 Caroline Eaves
I've brought you some pieces of the West Pier in Brighton. In 1970 there was a really big storm that blew down the end of the pier. Lots of people were scavenging on the beach, and this was scavenged by a carpenter – he made me a table and a workbench, and his name was Mike Daffern. I had the table until a few years ago, when I dismantled it because it was really heavy and big to cart around. But the table's lived in London, Brighton, Bristol and West Wales – and finally Hastings.

232 Cllr Jeremy Birch
I've brought a plank from my home. I took it from the loft where my son lives. Now you can have a plank to send any culprits to walk, if they don't work hard enough on the boat!

233 Christine Lazell
The old family bath brush. Just the handle of it, because the other bit had got worn out. Five children were bathed with this. Now they're in their thirties and forties.

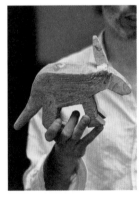

234 Chris Broughton
I've got an aardvark that I made when I was about 11. It's probably the only thing I've ever made out of wood. It's a failure, as you can see. I think the ear broke off before it even left the workshop, and it's lost a foot somewhere along the way as well. But it's just followed me around throughout my life, making me feel a little bit sad, because I couldn't look after it properly. I was never cut out to be a carpenter.

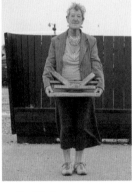

235 Laetitia Yhap
For about 25 years I painted the fishing community down here in Hastings, and had a lot of exhibitions. That was from the 1970s to the 90s. Because the paintings were not rectangular I didn't often use an easel, they had to be done on the wall. But when I did use an easel I had to make these support pieces to adapt it so that I could prop up a painting. I'm giving them to you because I don't do it any more – I do Chinese calligraphy instead.

236 Jenny and Lilu Edbrooke
This is a paintbrush that my mama used for her artwork. And now that I've got a little daughter I've passed it on to her, and she's been using it for her artwork. So it's quite a simple story.

237 Michael Hambridge
This is part of a little revolving seat that looked like an hourglass, it was part of a bigger sculptural installation. I'm the public arts officer at Hastings Borough Council, and this was the first commission I raised money for. It's now a fantastic bit of artwork in the woods. This bit came off, so the artist put in another piece of wood. It's been a paper holder on my desk ever since, but we all have to hot-desk now, so my normal messy desk will soon be gone and there'll no longer be any room for this.

'It's been a paper holder on my desk ever since, but we all have to hot-desk now.'

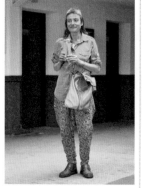

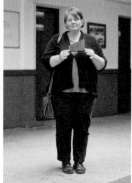

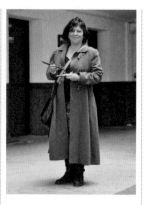

238 Mary Upson
It's a little Buddha figure that a friend gave to me about 20 years ago. That was when I had quite a boring life. Since then I've done lots of things, and now I do my own woodcarving. The friend who gave it to me, she can't get out and about much now, and I thought it would be nice if this could get out and about for her.

239 Cath Tajima Powell
I've brought a piece of decking, which comes from my friend Claire's house; she's my neighbour. I moved to Hastings two years ago from Japan and I made friends with Claire. She was my first friend and my best friend that I made in Hastings, and this is a bit of her garden.

240 Claire Sandaver
My family live in Thailand, my husband is Thai. We were there last year, and my children really wanted these wooden Thai pens. But now they are disregarded on the bedroom floor. I insist on using chopsticks and buying chopsticks from Thailand whenever I go, and I'd like to donate a pair of quality Thai chopsticks as well.

241 Jasmine Oakley
A piece of the stairs from my old doll's house. It broke off. There are new stairs in there now – daddy made them. I've got thousands of dolls in my house!

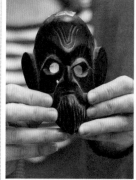

242 Ben Oakley
This is a train without wheels. I made it when I was younger, at Playdays in the Park.

243 Anne Taylor
I bought this at a boot sale a long time ago, and I've never been sure about it, whether it's nice or not. I couldn't make up my mind. So I haven't put it up. But I've kept it, I didn't want to just get rid of it. It's strange how you get attached to things. I've kept it in the garage all this time, so it's obviously meant something to me.

244 Sonja Padgett
It's a small piece of driftwood that I found on the beach in Hastings when we first moved down, six years ago. It's brought me so much luck and happiness here that I would like your boat to have the same. I know it's only small, but it's the luck I want you to have.

245 Donna Jensen
The chair was my grandfather's, when I was very little. Then I inherited it from him. And when I had my daughter, I used to rock her to sleep in it.

'Daddy made them. I've got thousands of dolls in my house!'

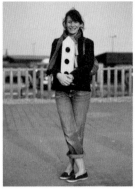

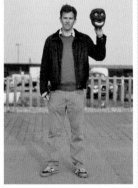

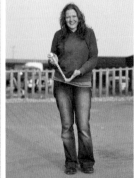

246 Tush and Pat Hamilton
This has come out of the sea, it was caught in the nets. I've had it about five years. It was caught about five miles out by trawler, in a trawl net. It's obviously part of a boat; we think it's a sternpost of a boat about 15 foot long, but it's difficult to tell. When we had our fish shop in the old town it was like a museum, we had all sorts of gear – canon balls, old lamps, propellers – all of it came out the sea.

247 Rebecca Child
This is a three-storey bird box. It was made by my dad. One spring, while we were sitting in the garden, this was hanging on the wall not more than ten feet away, and we watched a whole family of robins – five baby robins in a row – fledge from this very bird box.

248 James Davidson
This Sri Lankan mask was a gift from my dad. I think each mask represents a diseased demon. So if you go to your doctor or spiritualist in Sri Lanka, they order a mask to represent the demon of whatever you're suffering from, and then perform an exorcism ritual with the mask, in order to expel the disease. I don't know what this particular demon represents. My dad spends a lot of time in Sri Lanka working there. We spent a little time there just the two of us, about three years ago. It's a little memento of that time.

249 Jacqueline Ede
I have brought you a recorder. I'm really glad that you'll be taking it, because my three year old and one year old absolutely adore the noise that it makes, but I'm not quite so keen. Especially not at the weekends. We constantly hide it, put it on shelves and so on, and they have forgotten about it for about a month. So I think now is the perfect time to get rid of the recorder, surreptitiously.

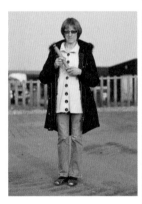

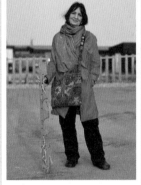

250 Lesley Nimmo
I've lived in Hastings five years, and I've brought along a rolling pin. It's been in my kitchen drawer. I didn't buy it, I think it's inherited. I have never used it, and I do not intend to use it.

251 Angie Braven
This held the organ stops up – a beautiful old organ in St Mary in the Castle in the middle of Hastings, just along the seafront there. In the 1980s the council would have let it fall down, after the Greek Cypriots had stopped using it. So my husband got in touch with the Queen Mum and Prince Charles, who he was working with at the time, and they wrote letters. Then English Heritage got involved, spent millions doing it up – and now it's beautiful inside. I hope the council doesn't let it fall down again.

252 Pat Bowman
This is a paper knife made from some form of Australian wood, possibly eucalyptus, which was crafted in around 1990 by the late Joy Helm of Frankston, Victoria. She emigrated in 1960 but remained staunchly a British citizen, unlike her husband. Both visited Emsworth a number of times, the last visit being in 2003 a year before she died. Joy was a part-time secretary to Dame Elizabeth Murdoch, famed for her vast contribution to culture and charity in Australia – unlike her son, Rupert!

253 Gary Usher
It's just some driftwood. It was pretty close to the tide line. I go down three or four times a week, picking up bits and pieces.

'I don't know what this particular demon represents. My dad spends a lot of time in Sri Lanka.'

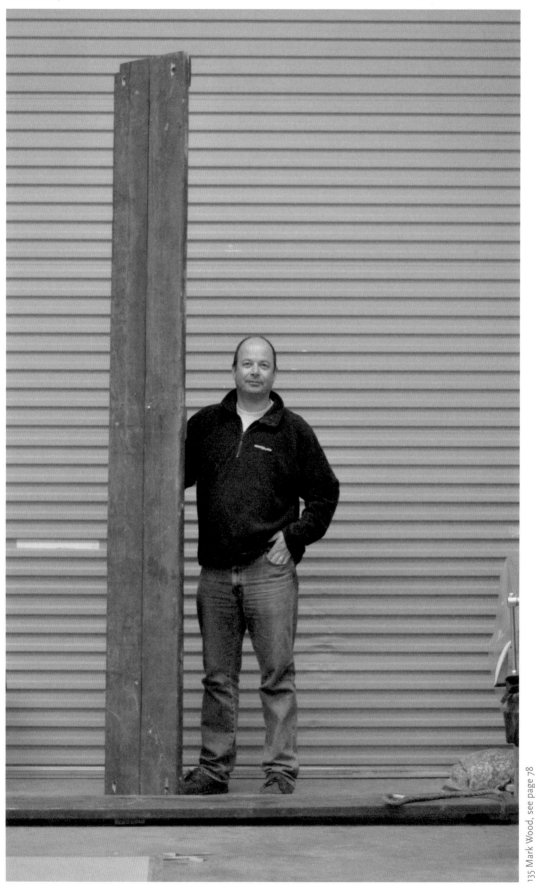

135 Mark Wood, see page 78

I used to travel the world as a windsurfer, and was World Champion in 1986. In the 1990s, I became a director of a company which distributed surfing kit. We had a showroom in East Wittering – which needed some shelves, so I went to a colleague who specialised in driftwood. These pieces from a container ship were salvaged from East Wittering beach in 1997. We hung clothes and sandals on them.

'They've been in my garage for a special occasion. This is it!'

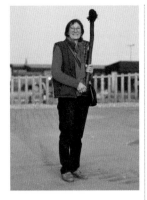

254 Sue Palmer
We have a bonfire society here in Hastings. We have a bonfire procession in October and we process through the streets with lit torches. This is one that has been lit and has now had its life. It's part of Hastings tradition – you couldn't get anything better than this!

255 Helen O'Brien
Two bits of my house. We've got a really old house, and it was bought for Wellington's troops, so these would have been trodden on by Wellington's foot soldiers. We've got little grooves in the stairs where they used to go up and down.

256 Lesley Cornish
It's a piece from a piano that we reluctantly dismantled because we couldn't give it away to anybody. It's too big and monstrous. It was in our house for 30 years. Nobody played it anymore, and some of it didn't work. I've kept all the keys because I can't bear to throw them away – they're all beautiful.

257 Lorna Crabbe
I've brought in a nativity stable that my great uncle made for me, when I was very small. It's covered in cotton wool to replicate snow. I used to put it up at Christmas every year. But I didn't last year – I thought at 33 maybe it was time to move on!

258 Grace Collett
This came from a futon. It was in our family living room for quite a long time, and in the living room we'd have a fire and we'd always watch the telly or watch films. We've shared many films on this futon, and this is a plank of it. The futon broke, but it was second-hand from my aunt.

259 Vanessa Boorman
This is on behalf of Crest Playgroup, Hastings. We had a little boy who used to come to our playgroup and who died of a brain tumour. We bought a table in his memory. This was a few years ago. Now the table's broken and it's not safe for the other children, but we want to carry on that memorial to him. His name was Leo.

260 Harry Hildreth
The neck and head of my first guitar. It doesn't work – I left it against a radiator and the neck warped, so I don't need it any more. It was the first one my dad got me, my first electric guitar, when I was about 15. This is the one I learnt all the Led Zeppelin stuff on, and Rolling Stones, Chilli Peppers... Bedroom rock!

261 Steve Barrow
I'm renovating a boat for the Hastings Fishermen's Museum. It's an old Hastings fishing boat, and this is the breasthook, the bit that forms the bow and goes up against the stem. The boat's from about 1954, it's been at Hastings all that time. It's called *The Valiant*, and there's quite a story behind the boat, a little bit tragic – it was in a collision with a coaster once and somebody was killed on it.

'This is the breasthook, the bit that forms the bow and goes up against the stem.'

262 George MacDonald
This is a selection of used and abused drumsticks. Some sticks may last me a few months, some may last me a day – it all depends on the stick, really.

263 Harrison Caruana
This box comes directly from my grandfather's banana farm in Alicante. He started off growing bananas in Malta, moved to a better climate, and Alicante is perfect banana-growing weather. Unfortunately I'm not much of a fan of bananas, I've had too many my entire life. Half my family's Maltese, the other half are from Ipswich.

264 Helen, Bella Rose and Poppy Sharpe
It's a bit of driftwood. It was just what I had outside, it was on our doorstep. I think my husband found it, with a view to using it for something.

265 Sue Goodhand
It's a tree root I took from the Powdermill Reservoir in the 2001 drought, when it was very low. My brother's the water bailiff there, so I could walk where water would normally be. It was fascinating to see all these roots. This one was loose, so I took it. I had it indoors for ages; it looked so beautiful, a bit like an antler. It's still really solid. Probably been there hundreds of years, under the water. It's perhaps my most personal bit of wood, but my family aren't going to know what it is when I snuff it.

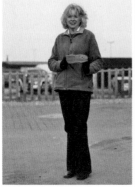

266 Angela Lapworth
It's just a piece of wood that I found on the beach, years ago. Actually I think it was something to do with a fishing boat, by the look of it. I was having a very hard time, with family and things like that, and I spent a lot of time wandering around, for hours, and I just came across this on one of my wanderings. I thought it looked like a fish.

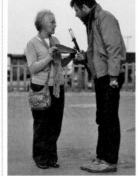

267 Myra Rowe
This is a piece of burnt wood I found on the beach on Christmas Eve. It's probably from Hastings Pier, which burnt down on 5th October 2010.

268 Matthew Locke
I'm a scout leader, and this is a patrol tent pole. It's one of the larger poles we have, from one of the larger tents we take on our summer camp. It's a spare pole now, but it has been around the country a lot over the last 20 years. Cornwall, Blackpool... It's probably had a few hundred scouts camping under this over a long period of time! We've got some newer poles now, and plenty of spares as well.

269 Kevin Boorman
I've brought a very small four-bar gate. It was actually more of a fence really. It was in my garden until my sister nearly garrotted herself on a clothesline, she fell over it, and broke this – so it's a broken four-bar gate now. Actually I bought it at the Sussex Country Fair a few years ago, so it's like me, born and bred in Hastings.

'This box comes directly from my grandfather's banana farm in Alicante.'

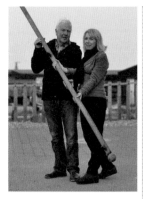

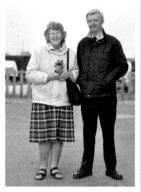

270 Alex and Bob White
We bought a house about a year ago, and it's reputed to be the old jailhouse. What is now Bob's studio – out the back – was the old wash-house. So a kind of one-stop shop. The studio had all sorts of things in it, and this was one of them. I suspect it was some kind of Victorian blind.

271 Mr and Mrs Forsythe
It must be at least five or six years ago, we had a lovely day out in Eastbourne, and I saw this in a shop and brought it home. We've used it for all sorts of things. I've used it as a doorstop, I've used it as an ornament, I have the grandchildren play with it – it's been everywhere. Every boat needs a cat – although it looks like it's been shot!

272 Michael Wilsdon
I'm a retired naval architect, and this particular piece of wood is part of a storage system that was used in my second museum. It was a rack for storing objects awaiting display. I've had three museums: Kew Curiosity Cabinet, preceded by Kew Transport Museum, preceded by the Kew Coal Fired Bakehouse Preservation Project. Although the second museum has gone, I've still kept the storage system.

273 Joy Collins
It's a little olivewood rosary. It was a gift from a great friend called Beatrice, who now lives in New Zealand. We knew each other through church, and she moved there to be close to her daughter. Her daughter is a great yachtswoman, and she and her partner sailed from New Zealand to Hastings to visit mum and then sailed back again, and mum went part of the way. I usually have it in my handbag, so I carry it everywhere.

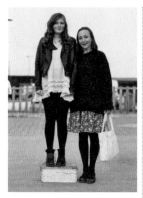

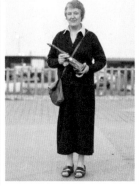

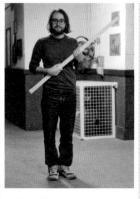

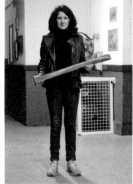

274 Anna (and Imogen) Hambridge
It's a step from my granny's house in Pett. The house will probably be demolished, because it's all being sold. The reason we all live at Pett – and it's sort of our favourite place – is because granny came down there in the 1920s or 1930s. We had all our holidays there. Now we live just up the road from there, we moved in this week. So I was able to run round her garden and find something. All the children would step up onto this to get to the sink, because she had a very high sink.

275 Susan Donovan
This is an unusual clock. My partner found it when he was browsing in an antique shop. He like things like this. I've had it in my fireplace for a few years, and he loves it but I'm fed up with it! We've got different artistic tastes. He's away in Egypt at the moment. He'll be very upset when he sees it's gone.

276 Tim Gadd
I've brought you an element of a floorboard that is part of an ongoing un-decoration project! This is part of the updating. Arduous, and expensive. What we're giving away here is part of our foundations.

277 Amanda Nicol
I've brought the footrest of my old desk, which I bought in London when I was skint. I was living in a council flat, carried this desk home, and I've had it for nearly 20 years. Somebody must have rubbed their foot along it for many years, it's absolutely beautiful. I couldn't fit my desk into the new house, so I got rid of the drawers and kept the top for a coffee table. I couldn't bring myself to throw this bit away. I wrote a novel with my feet on there, so it means quite a lot to me.

'He's away in Egypt at the moment. He'll be very upset when he sees it's gone.'

278 Rosa Maroney
It's a part of a eucalyptus tree from Tim Gadd's mum's garden. She cuts it back every year and gives me the pieces so I can make things from it. I've made mobiles and things from the other pieces, but I haven't got around to it with this one yet.

279 Jill Levick
It's a piece left over from fitting out my narrow boat, which I lived in for ten years. The boat was called *Touchstone* and it's been all over the inland waterways system. I sold it on the Stratford-on-Avon canal. I thought I would miss it, except that where I live now is somehow still like being on a boat. I love it here.

280 Joan Worthington Wild
I've brought a painter's palette, which belonged to my late uncle, Bert Callan. Years and years ago he took me to art classes and really I haven't stopped since, and I have him to thank for it. I haven't used this one, it's exactly as he cleaned it and left it.

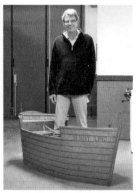

281 Keith Challis
This is a miniature galleon. It was built from reclaimed timber donated by the Hastings and Bexhill Wood Recycling Project, and it was actually built by Digger, who was a regular customer at the Jenny Lind, for the great Hastings Old Town Pram Race 2009. It was placed on a gurney for easier pushing by the Jenny Lind pub race crew. This piece is donated by the Jenny Lind Inn, Hastings – and good luck!

282 Eoghan and Lize McCarron
I've had this for about 20 years, I think it was a holder for a coffee grinder, or some kind of grinder. I always kept thinking, 'I'm going to find something to put in to this'. And I haven't.

283 Jane Runchman
This is a pencil from my childhood pencil collection. I've had this since I was about ten, and it's my birthday today and I'm 41. The collection was in my mum's loft for a long time, and when I moved down here I thought, right, I've got to get all the rubbish out of my mum's loft. This one is part of a set of pencils and they're in a box with this same pattern. Never used – you can't use a pencil collection pencil! They have to be pristine. All the other pencils are in my drawer.

284 David Carter
One is a mantelpiece shelf, and one's a television shelf. They come from our bungalow, which we moved into 20 years ago. They were already there, and we took them out and replaced them.

285 Tristan Payne
They're table legs. They come from the table in the living room. It has the TV and trophies on it. We only got it yesterday.

'They come from the table in the living room. It has the TV and trophies on it. We only got it yesterday.'

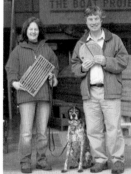

286 Richard Underhill
I used this slide rule for a lot of calculations for my joinery business, and also for working out the invoices. It was in general use from about 1948 onwards. It'll do any calculation you want.

287 Julia Lampam and Massey
I've brought you my old lacrosse stick that I haven't touched in over 20 years. I played lacrosse at school from the age of ten, then through polytechnic and afterwards. But I wasn't fit enough to play the game any more. I love it, it's such a dynamic and fast game. I was quite good at it. I have to confess that I've broken someone's nose, as the result of them missing the ball I threw to them. You could tackle people in any way you wanted, except around the face. Very rarely did you see anything really nasty though.

288 Bernard and Sharon Justice
This is the frame of a bed mattress, from around the 1920s; it's pitch pine. We've taken it off the bed because the springy bit in the middle was definitely dead. We've removed that but it seemed a shame to throw this bit away. We're still sleeping on the rest of the bed, because we've had a new frame made. This would once have had what were called 'horsehair biscuits' on the top. It was in our family for over 40 years – generations have been passed on through it.

289-290 Adrian and Ros Oakley
This round breadboard is off our little boat. It's broken in half. The boat's now been passed on – so, big memories of the boat. I think the previous owner had the breadboard made. And this slatted breadboard was bought in France. We bought it when we had our first house, about 21 years ago. It's been mended, seen a lot of bread, been burnt. It's moved houses with us. Various arms have fallen off. We have a reserve one, the same model, but I can never bear to throw this one away!

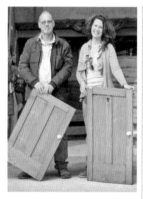

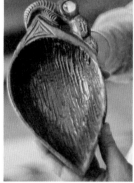

291 Fran Wright and Victor Twine
We have brought you two original doors from what was grandly called our 'breakfast room' at home in Southsea. About six years ago we knocked the kitchen through and couldn't incorporate the doors into the new kitchen, and since then the doors have been sitting in the forecourt, gathering dust. We've been looking for something to do with them, we might even have put them on the barbeque a couple of years ago. I'm really glad we didn't.

292 Victor Twine
I've brought the wooden acorn that's used as an air freshener in a car. You load it up with oil, which is always vanilla. This first started life with me in my Subaru, which I imported from Japan. It was a beautiful car at the time and was my pride and joy. The acorn's travelled with us through the other cars we've had since then.

293 Janice Sparks
I'm bringing a carved dish that I was sent as a wedding present from New Zealand many years ago, in 1974. It was from my ex-husband Steve Duke who died last May – he was 61. The gesture's also from our two children, Rachael and Katy. The bowl was carved in Rotorua and carries a traditional Maori bird on the side of it, whose eye is made from abalone shell. I've used it for sweets, for trinkets – it's had all sorts of different uses over the years.

294 Viv Williams
This is part of the name board of a Morecambe Bay prawner, originally named *Laura* after the daughter of the fisherman who had the boat built in 1908. It was then bought by Edward Delmar Morgan, who wrote the book *I Bought a Prawning Boat*, and named his daughter Laura after the boat. I bought the boat in 1965 as part of a syndicate, and owned it until 1979. We called our daughter Philippa Laura, after the boat. Now Phillipa's just had her first daughter and her name is Laura Jo. So the name Laura runs right through from 1908.

'This would once have had what were called "horsehair biscuits" on the top.'

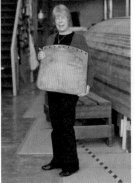

295 Pamela Knight
My husband was the village policeman and he liked to make things out of wood. Many people gave him bits of wood, and he set to work. He'd never made a Windsor chair before, so he started off and he shaped out the seat. This old man used to come along and every time he saw the garage door open he used to come in and see how the chair was taking shape. Except that it wasn't! It really didn't. And then my husband died. He just couldn't work out the angles for the spindles.

296 Nancy and Frank Astell
This boomerang was made by our daughter's brother-in-law in Bendigo, Australia. He used to make them commercially. We've never been able to make it return! We've tried. We went over to see the rest of the family – to Melbourne, and then to Bendigo. They were downing innumerable cans of beer!

297 Nick Letheren
The oars have been in the family, at the back of mum's shed, since before my time and I'm now 51. My dad had them; that's all I really know. I reckon he enjoyed them as a student, and he's always been into sailing. He's passed it on to me as well.

298 Antoine Fraval
I've brought some tiny wooden toy trains. They come from a toyshop in Vienna where we have been rehearsing with Lone Twin Theatre. My intention was to get one piece to give to each of the people involved. But the shopkeeper only had three of these, so I changed my mind, and kept them for myself. They've been touring with me, in my suitcase – in the air, on a train, now they're going on the sea.

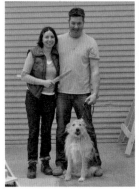

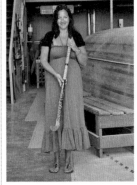

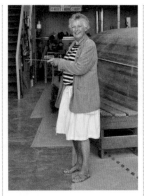

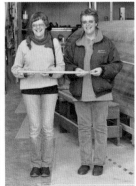

299 Samantha and Richard McArthur, and Spike
It's a piece of driftwood we found when we were on our honeymoon in France. It was on the beach at Barneville-Cartaret, a really nice sandy beach that goes on forever.

300 Liz Roberts
This is my husband David's hockey stick. He played for England for around 15 years. He went to Australia – and he's got a pair of shorts from another player, because they swapped tops and kits.

301 Susan Hay
This is a ruler that I bought many years ago from the British museum. It's got all the kings and queens of England, from Roman Britain in 43 AD to Elizabeth II in 1952. All of them. I've got four grandchildren and we've got four charts, two on one side of the door and two on the other. We've measured to compare their heights, depending on how old they are. So I've used the ruler on the top of their heads.

302 Judy Faulkner and Linda Chamberlain
I've brought you the tiller extension from my father's GP14 in the late 1970s. It's a racing dinghy, and it was called *Shy*. This marks the transition from wood to aluminium in dinghy fittings. He took it off because he replaced the tiller and the tiller extension with aluminium, the latest go-faster technology. For some reason, this has been amongst all the stuff that I've moved from house to house ever since.

'My dad had them; that's all I really know. I reckon he enjoyed them as a student.'

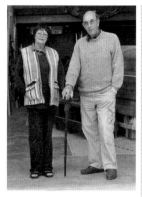

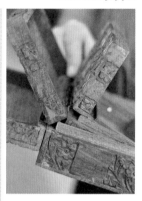

303 Jo and Martin Herman
We bought a house on Hayling Island and when we put in the under-floor insulation we discovered this. The person who used to own our house was a very famous wing commander in the war, so he was much travelled. It may very well have belonged to him. But it might have been left there when the house was built originally, as a symbol of protection. It's an African ebony stick used by village elders to protect from evil spirits. So it's to help you on the journey.

304 David Newson
It's a bit of the dinghy I had, a Fairey Duckling. It was stolen during the winter of 1973, when Thorney Island was occupied by the first lot of immigrants we had down here. It wasn't an RAF base then, it was where they put up 200 Vietnamese boat people. I wouldn't think of blaming them, after what they had been through. No, it would have been someone else. I kept the keel, the mast, the sails, and other bits and pieces in the garage. So if anyone finds *Ugly Duckling* L32, I shall have his guts for garters!

305 Mike, Rosie and Lauren Jennings, and Jimmy the dog
We live in a little terraced cottage in the centre of Chichester. We've been redoing the house over the last two and a half years, and this is a piece of the beam from the roof support that was all rotten and needed to be replaced. The house was built around 1750. The renovations are nearly finished, but there's still loads to do.

306 Graham Rawlinson
It's a present given to me by one of the participants in a creativity course I ran; he came from India. One of the things on the course is different tricks for producing creative ideas. A solution that nature and engineering adopts is to nest one thing inside another, you get extra value that way. It's a nesting box: three boxes, one nesting inside the other. He said, 'This is me. This is my wife. Now she's a part of me. And these are my kids, and they're a part of me'. I liked the idea of sharing his story.

307 Trevor Davies
These are parts of a table that my wife bought from a junk shop in Battersea in 1970, when she was first setting up her flat. It was an Edwardian table. When we got married I said we didn't want old tables in the house, so I cut it up and I kept the wood. And I rather regret cutting it up now.

308 Imogen Edwards
I've brought a plank of wood that my dad gave to me the other day. He tells me it came from a retired minister of a church in Selsey. It's from one of his bookshelves, and what we understand is that it probably supported many Bibles or theological works. We think it's very holy wood! My dad does a lot of carpentry and everyone gives him wood – he seems to be the wood man!

309 Greg Slay
I've brought two pieces of lead that were used for repairing the flashing on our house in Fishbourne. They're offcuts left behind by the roofers, who did a fantastic job. I don't think the roof was designed for these kind of tropical storms we've been getting, or the hugely powerful rain showers that we had last year!

310 Katherine Slay
I've brought Sticky, who belongs to my nephew Edward. We went exploring in North Wales, and Edward found Sticky by a river and peeled the bark off. Sticky was very useful for propping Edward up in the river, and for whacking hollow plants beside the river. On another walk a few weeks later, Sticky was used for whacking seeds off thistles and poking weeds out from stones in dams in the streams. I was told that Sticky needed to be treated with linseed oil, so I did that, as a good aunt. And Edward has given me permission to donate Sticky.

'Sticky was very useful for propping Edward up in the river, and for whacking hollow plants beside the river.'

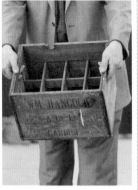

311 Greg Slay
It's a wooden beer-bottle crate from Hancocks Brewery, dated September 1963. I was brought up in Aberystwyth, where Hancock's had a bottling plant. My father used to buy beer from the brewery door. You'd take the crate away, drink the beer, take the empty bottles back in the crate, and get some more. I suspect the company closed the bottling plant before my father could take it back. It was in his garage for years. People don't remember when beer bottles came in wooden crates, it's a piece of our life that's disappeared.

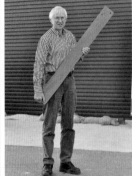

312 Ernest Yelf
This has great sentimental value. When my son was about 15 he was mad on turning, he made his own foot lathe and everything, and he produced some beautiful stuff. But then of course when girlfriends et cetera came along, that disappeared. But my wife and I decided to keep the last two pieces of wood that he was about to work on, and this is one of them. He's a bodyguard now, so he's using his strength in different ways.

313 Kevin Edwards
This is the third life of a railway sleeper. Its first life was as a railway sleeper, second life as a garden border, and this is it's third life. I bought it for a garden border but I think it originally came from Czechoslovakia.

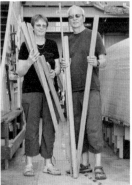

314 Mike Turney and Vicky Sanders
This is our boat. We bought it six or seven years ago, in a fairly dilapidated state. She's a Wharram Tiki 28. We spent a lot of time doing her up, including building a new central pod for her, and these are bits of wood left over from the restoration. We sailed down to Falmouth and got married on her.

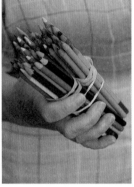

315 Mary Milton
These crayons and pencils belonged to my husband Ray, who died last year. He had a stroke in 1999, three months before he was due to retire. He joined the Emsworth Stroke Club and started sketching, which he found he really enjoyed. These are his sketching pencils. He sketched animals and faces really; he didn't do scenes. He was left-handed and the stroke affected his left side, so he had to start using his right hand for everything. So he used his right hand to sketch with.

316-317 Cheryl and Bob Simmons
We've brought an armoire, which we bought in France about five years ago. It was for the purpose of being an airing cupboard, because we didn't have one at the time. But we now have one. And this coffee table didn't fit when we moved into the new lounge – not in the right way, anyway.

318 Ele Carpenter
This is a spare part from a planter at my friends' house, Judy and Jan Willem, where I've been living – temporarily – for two years! They've been fantastic, looking after me while I've been commuting around the world and moving house. It's a really beautiful spot to sit, outside the back of their house, and in the planter is a huge white rosebush.

319 David Rodgers
This is my wife's father's desk, he was a founding director of ICI. He died in 1993, and my wife's mother then decided that she wanted to move up to Nottingham, to be with her son, and so they cleared the house. His desk was 1960s. Sapele, solid wood. I cut it up and kept the wood, which I've used over the years – on my boat, in my house – and this is the last piece.

'And this coffee table didn't fit when we moved into the new lounge – not in the right way, anyway.'

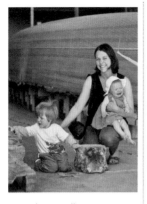

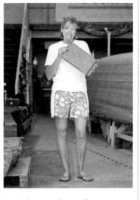
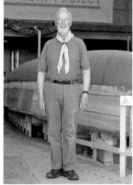

320 Rebecca Ball
We have been staying at my mum and dad's house while they're away in France. They have lots of lovely apple trees in their garden and they recently had one cut down to make into firewood. So this is a tree from my parents' garden. They have cooking apples and eating apples, and they always give us a big bag of apples when they come down.

321 Charlotte Walker
This hairbrush was given to me by my grandfather, Geoffrey Rodway. He was a make-up artist at Pinewood, and he worked on a lot of the *Carry On* films. He used to have to explain the jokes to my grandmother – who was his assistant – because she didn't get them. He was also really into his boats, and when he retired he moved down to Littlehampton and used to take us down to the beach to pick up bits of driftwood and we'd make little sails for them.

322 Alison Pickersgill
We found this on a beach in Thailand. My son works on Coconut Island. And I was walking along the beach one day and there it was, and I thought – Boat Project! It's obviously from a piece of furniture somewhere, but it was just lying there on the beach.

323 Eric Hinkley
It's a scout woggle I wore to the 1948 Olympic Games opening ceremony. Aged 14, I made the woggle from the bowl of a discarded pipe, used by my cousin Gordon. I was a member of the 4th Harrow Air Scout Troop, and one of about a hundred scouts at the trackside. We had to wait until the Olympic flag had been hoisted, then release homing pigeons. I was mortified when one of my pigeons refused to come out and stayed in the basket! The next day I went to scout camp for a fortnight so I never saw any of the games.

324 David Brunning
This is a spar off the first boat I ever owned, a Westerly Centaur called *Melissa Jane*, built in 1976. I've had the spar for some time and I don't really need it because I'm refitting her.

325 Jeremy and Rosemary Grindle
This is a picture frame made of sycamore, which in the 1950s was taken from the panelling of the royal apartments of the old royal yacht *Victoria and Albert*. Before they towed her to the breakers they took everything valuable out of her, including some rather nice wood. So when I was serving on the new one and we finished paying off the old one, the shipwrights made this picture frame for me.

326 Jeremy and Rosemary Grindle
This is from an old rectory in Berkshire, which we bought in 1968. It was the draining board, from a big porcelain sink. After a year or two we modernised the kitchen and took this out. It was used for various things, like the seat for the children's garden swing, and the rungs of a boarding ladder for our yacht. The remaining bit became a galley chopping board, which went with Jeremy when he took his Vancouver 34 across the Atlantic in the 1990s. So it's also been up and down the coast of America.

327 Ingrid Woodburn
My mother was Swiss, and like any Swiss girl of her era she learnt to sew, knit and darn. This is her darning egg. It was mostly for the heels of socks, and you put it into the heel so it gave you something solid to work against. She also collected decorative ones, which she didn't use. They come in all sorts of shapes and sizes.

'He used to have to explain the jokes to my grandmother – who was his assistant – because she didn't get them.'

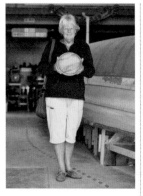

328 Rosemary Curtis
This is a breadboard that was washed up in Bosham Harbour in 1984. We rescued it and we've used it ever since. The boys, now grown-ups, retrieved it. We assume it went overboard off a yacht – we know not.

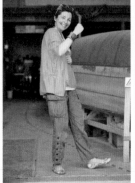

329 Marina Norris
My bangle represents the women in my family. My mum's is from Cyprus and all my family wear big jewellery. I wanted to donate our family wardrobe. In Cyprus when somebody was born, they put their name on the back of a wardrobe and marked off the years. It would be handed down through the family. When my grandmother died we didn't know her age, so we turned the wardrobe around to find out – and discovered we had the wrong wardrobe! So I'm giving this bangle instead. It represents the big-jewellery ladies and those who would have used that wardrobe.

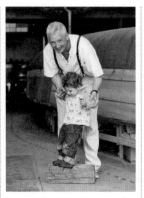

330 Brandon McGuire
It's a piece of oak from the house I grew up in, part of the porch. When I was young, my grandfather gave me a set of chisels. But my father rather coveted them and they disappeared. One day, years after my grandfather's death, I found my father carving with those tools. He whittled away, then lost interest; this was left half-finished. For many years this piece was just lying in the garden. Then, after my youngest son was born, he started playing with it – with wood that his grandfather carved with his great-grandfather's tools.

331 Diccon Dadey
This is the tray that my brother made at school, in the late 1970s.

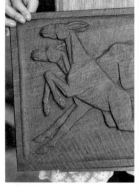

332 Diccon Dadey
Here I have a carving by my mother, made when she was at art school in 1955. It was her exam piece. She died two years ago and we were left lots of bits and pieces, including her woodworking tools and lathe. She made cricket bails and candlesticks.

333 Diccon Dadey
A bit of mahogany. Mum and I collected bits of wood from all over the place because we do love wood. It's just salvaged timber.

334 Robert and Claudia Parker
We're donating the house sign of Pilgrim's Rest, which came from our old house in Hindon, on the Wiltshire-Dorset border. Hindon used to be an old coaching station for pilgrims and other travellers going down from London to the South West. At one stage the house was the old forge in Hindon – where the great fire started that destroyed most of the village in the late 1600s. So the sign probably dates back 400 years. We bought a house in Prinsted and that's where this sign's been sitting, rather redundantly.

335 David Booth
This is the coat rack from my old school – Oak Park Secondary School in Havant. It was taken out before it was demolished. I joined the school in 1957. I was head boy and one of the first students to do A-levels there. I took pure maths and applied maths and afterwards did an apprentice-ship in engineering, eventually joining Rolls Royce in Derby, working on nuclear reactors for the British submarine fleet. I moved on from there to train as an accountant.

'We turned the wardrobe around to find out – and discovered we had the wrong wardrobe!'

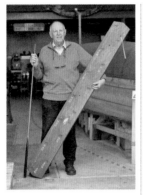

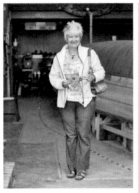

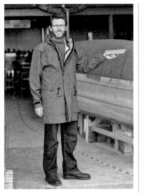

336 David Booth
This billiard cue was won in a tournament by my late grandfather. He passed it to me thinking I might play – but I haven't. He was a chauffeur, and he drove film stars back in the 1950s, including Rex Harrison, to the studios around London. I suppose it may have been that a chauffeur had quite a bit of time on his hands. Perhaps he whiled it away playing snooker and billiards.

337 Jocelyn Booth
This is a Galt toy car which was played with by each of my three children, Alex, Emma and Jessica. Alex is now in his forties, he's married to a Columbian and has his own children, Francesco and Domino. But the toy is now broken, so the children can't play with it anymore. It has a nice shape and I thought it would look nice in the boat.

338 Mick Douglas
This is a bit of ash from Victoria, Australia. I put up some shelves in my home in a couple of rooms, and I docked off a whole lot of this Vic. ash, which are the brackets to support these plywood shelves. I do participatory public projects, too – hence my interest in this one, and I realised that all the stuff I do is to hold something else up, to allow other things to grow. (I also had the thought of ripping something off Captain Cook's cottage ...)

339 Trata Mahoney
I bought this wooden ladle when I was on holiday on the Island of Elba about 25 years ago. It was hanging outside a kitchen shop with all sorts of metallic ladles and ice-cream making equipment. There were two wooden ladles, and I bought both of them. I gave one to a friend who lives in an old farmhouse in Provence, and I kept the second one. I have never actually used it. It used to hang by the Rayburn.

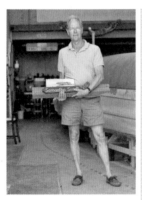

340 Philip Linsell
I was working for the architects on Roman Abramovich's estate at Fyning Hill, near Rogate, and we had to sort out various pieces of hardwood for a fence. The piece I've brought in was rejected because it wasn't the right colour.

341 Philip Linsell
This a small piece of what is left of a hulk near Aldeburgh, in Suffolk, called the *Iona*. Five hulks were brought into Aldeburgh in the early 1800s to sort out a shortage of firewood. Four were broken up, but this one stayed, and throughout my childhood in the 1960s the top half of it was used as a holiday home. It fell into a disrepair and then about 20 years ago the local authority disposed of it by setting fire to it. I've got some bits from the stumps that have been left sticking out of the mud. I use them for wood turning.

342 Philip Linsell
This the nameplate of a vessel that at the time was called the *Samantha Small*. It was a maple leaf clinker-built gaff rig boat that I purchased in the 1990s. It had originally been called *My Rene* – I didn't like that either – and I bought it off a Mr Small. I actually renamed it the *Iona*. I only kept it about five years. Hardwood boats are too much like hard work, I'm afraid.

343 Ian Darking
I'm donating some nails from *Suhaili* which was built in 1967 and was the first boat to sail around the world non-stop – with Sir Robin Knox-Johnston at the helm. I'm working with Robin on restoring *Suhaili* on the Hamble at the Elephant boatyard. We'll be sailing her up the Thames with the Queen to celebrate the Diamond Jubilee.

'I also had the thought of ripping something off Captain Cook's cottage ...'

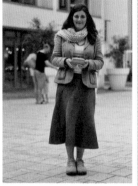

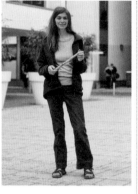

344 Noele Picot
It's a trinket box that was given to my mother, probably in the late 1940s. It was made by her brother-in-law. It's lined with what looks like silver paper from a chocolate box. And that looks like it's come off a camel coat. So it's definitely from a period of austerity! She gave it to me when I was about six or seven. It's always been around. I like its lozenge shape. And I love the fact that it'll part of a boat. You're going to sail past Margate, aren't you? That's where I grew up.

345 Drew Dower
I'm from Saltdean Primary School, just along the coast from Brighton. This is a part of our school. It used to be the old coat racks, for the children. So on the other side we've put our names, and we got every child who's currently in the school to sign it as well. Just over 420 children – they're all on here, and the staff as well. It's a good old plank, we thought.

346 Alexi Francis
It's a piece of driftwood that I found when I was in Crete in 2004, when I was turtle monitoring. I kept a log of all the days before I went home, so it's from about half way before going home. I kind of wanted to go home during it! I've kept it since then. Each morning we had to go and survey certain beaches on Crete, where the turtles come to lay their eggs. This was around May and June. They came the day after I left, so I didn't see any.

347 Darren Lumley
It's the remains of my O-level school project from 1988. It was a cider press. Got me an A as well. But it's blown, it's burst its ring. It's all oak, oak and brass. A plunger goes down through the top here – the screw on the top – and then there are holes around here, and the juice comes out. Then you ferment it and make some really quite terrible cider!

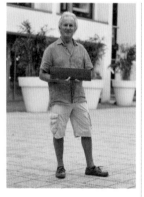

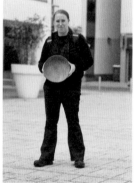

348 Simon Brooks
It's a piece of mahogany out of a Thames river launch from the Edwardian period. They used to sail them up to Oxford, up and down the Thames at weekends, with the Lloyd Loom chairs, and hampers. I used to build boats and one time worked in Weybridge in Surrey renovating Edwardian river launches. This is just an odd piece that I kept from years ago, I was reluctant to throw it away. I've found a place for it now.

349 Ruby-Jude Hall
This is Ruby's doggy. She's had it since she was teeny weeny, haven't you Ruby?

350 Fynn Hall
This helped Fynn take his first steps, didn't it Fynn? He's had it for about six months. It's to wish you well on your maiden voyage.

351 Kate Watts
This is a wonderful 1970s wooden salad bowl! It was my mum's, so she's probably had it since before I was born. So many dinner party's salads have stained this bowl, now it's time to set it free. Given that it's 2011 and it's time for wooden salad bowls to die. This bowl has moved from Berkshire, down to the south coast, and it's been with me for a very long time. I inherited it from her – you want a Ming vase but you get a wooden salad bowl.

'A plunger goes down through the top here, and then there are holes around here, and the juice comes out.'

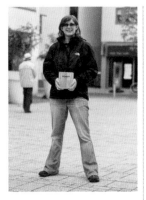

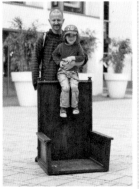

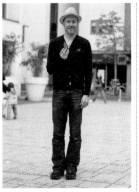

352 Kathryn Ripley
It is a Crabbies wooden chopping board, but it has memories. I've only had this since Christmas but it reminds me of lots of house parties since then, lots of happy times with friends. It was a present from my best friend, because they know how much I like the drink. I'm a fan of ginger beer anyway, so with the alcohol in as well – it's lovely! So there isn't much of a story, but it's got a lot of fond memories.

353 Neil and Hal Manuell
It's a judge's throne from a street theatre act. We did the Brighton Festival about seven years ago, which was before he was born. So it did the rounds for about a year or two. It's actually been in the garden for the last five years, storing stuff. It's gone all over the UK – Manchester, all over the place.

354 Steven Brett
I've brought you a small chipping from one of the trees that was outside the Pavilion gardens, trees they've just recently chopped down. Completely. The trees that I've loved for a long time, trees that have a history of their own beyond anything I've ever known about. So it's a donation from me and from Brighton. I found this last week – they'd chopped them down the week before.

355 Maia Sassatelli Chalcraft
Maia's had it since she was born, which was about two years and four months ago. And it was a kaleidoscope. But it's not any more – it's been disassembled! You've still got the kaleidoscope bit of it, haven't you, Maia?

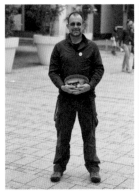

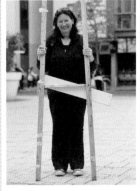

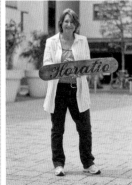

356 John Pohorely
My father never went to sea and never had a passport, but he knew every canal in the country. For about 20 years, he had a narrowboat at the bottom of the garden and some of the bits I've brought along are from that boat. This is a shaker box, an example of his appreciation of craft and design; this is a boxwood handle; this is a piece of an old folding ruler. He donated his tools to an open-air museum where they're on show as an example of an old workshop. I like the idea of something of him going out into the salt water.

357 Christine Clark
Last week on the royal wedding day my daughter and husband made a photobooth to go in my front garden. We had a street party and they wanted to make souvenirs for everyone on the street. I've brought a small part along today. This piece of wood at the back came out of my bathroom 11 years ago, a piece of tongue and groove panelling. The people on the street have got the photos as souvenirs. It's amazing how they start acting when they get in the photobooth! And amazing to see all the photos together on my daughter's laptop.

358 John Pohorely
This is another example of the craftsmanship my father appreciated. When he died not so long ago, I took everything out of his shed, but I've kept this for some years now. He probably picked it up at a car boot sale, he certainly never went to China or whatever it is. He just liked the carving. He must have had these for a good 25 years, in his dusty shed. God knows where he got it, but probably a jumble sale.

359 Christine and Alan Turnbull
It's the original nameplate from a 1970 motorboat, *Horatio*. My husband had a bit of a midlife crisis and decided he wanted a boat for us to live on. We found this boat in Shoreham, it was a bit unloved. It's not dreadfully big, 36 feet, but it's OK for two of us. He said it would take six months to do it up; it's taken five years – so far! And it's not finished. Another year to go, but after that we can start having some adventures on it. We haven't changed her name, that's tempting fate I think.

'He said it would take six months to do it up; it's taken five years – so far.'

360 Paul Vedamuttu
I scored a lot of runs with this bat, near Newport. About 15 years ago it was a style to try heavier bats, and I bought the same bat as Alec Stewart, the test player. I thought maybe I'd do well with it. And indeed I succeeded in hitting the biggest six of my life with it. We lost the ball! I had this bat for about eight years, then it was sanded down and had some weight taken off it; I wanted a lighter bat for playing in Sussex. Then it broke in the nets! Just cracked straight through.

361 Christine Gent, David Hadrill, Mike Wheeler and Teresa Heady
Christine: We've had this fine thing in our house for about ten years. I found it and knew I was going to find some really good use for it. Unfortunately in our house we've got hundreds of fine things that I'm going to find a use for one day. We never let any of them go, they just pile up. So we thought that this fine thing could go into a beautiful boat. I thought it would be quite nice as a shelf, or a display thing, or something for putting plants on. But it never found its home.

362 James Alias
It's well whittled, but not actually by me. I found it last summer when I was camping out by Berwick, and I made friends with it. It was in a bit of good old natural woodlands, lots of wildflowers around, and pre-existing fire pits and that sort of thing. So someone had spent a lot of time on this.

363 Ian Thornton
I've brought a little box. About two years ago I gave it to my sister Laura, but a year and a half ago she died. I thought it would be a really nice way of remembering her, this box that she had and that I gave to her. She went to Africa on holiday and took part in a tribal ceremony, eating some wood bark called iboga. Unfortunately it didn't agree with her and she died. We were thinking of ways of remembering her, like planting a tree – but this seems even more spectacular than planting a tree.

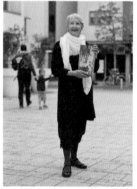

364 Dagmar Eberts
I live on the coast in Rottingdean, that's where I found this. It's quite a worn piece of wood that was washed up on the beach when the Brighton West Pier was collapsing, three or four years ago. Lots of wood came down our way, I've got several pieces. This one's got lots of layers, which I like, and the stone in the hole. Apparently the fact that it smells of petrol is good because it's preserved; that must have been something to do with the fire. I fill my house with stuff that washes up.

365 Beilah Chady
This is from Beilah's old wardrobe – she had it for one year.

366 Judith Scott
I don't actually know what this is. We spent the morning trying to think up a story, and came up with some fabulous ones, but actually we've no idea. I've just had new windows and this could be part of a window. But we couldn't see where it had been used around the house. Apparently it's a nice little piece of sapele, and my windows were made of sapele – although I'm only supposed to put soft wood in the house! Funnily enough, my friend thought she'd seen tiger paw prints on the carpet this morning, so there's definitely a connection.

367 Peter and Hilary Niblett
I found it in my next-door neighbour's front garden. We live quite close together. I think it might have come from his old bench, I'm not sure. He's on holiday at the moment.

'I thought it would be a really nice way of remembering her, this box that she had and that I gave to her.'

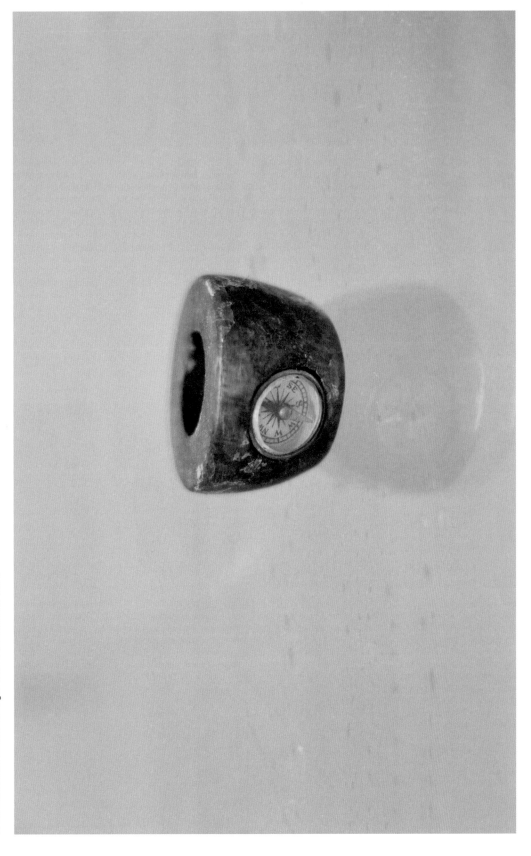

323 Eric Hinkley, see page 103

We had to sit on the grass verge at the trackside and wait until the Olympic flag had been hoisted, then we released homing pigeons. I was mortified when one of my pigeons refused to come out and stayed in the back of the basket! The next day I went to scout camp for a fortnight so I never saw any of the Games. But it was amazing to have a frontline seat there.

'The next day I went to scout camp for a fortnight so I never saw any of the Games.'

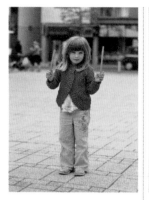

368 Abigail Westcott
Tweezers. I played with them and then they broke. I was getting toast out of the toaster. I didn't want to give them to the boat.

369 Janet Westcott
This is a picture frame that my husband made, but we've never found a picture to go in it. Before we donate it we're going to take a picture of us in the frame, so we've got a record of it. It was one of the first he made when he started making picture frames.

370 Rob Westcott
I've got a spirit level. It's a bit worse for wear and not very straight. I work for a charity called Tools for Self Reliance – we send hand tools to people in Africa to help them earn a living. This is one of the tools that was donated, but it's not in good enough a condition to send. Normally it would be refurbished, smartened up, and then it would be packed off in a toolkit.

371 Graham Johnston
This is a portion of the fourth plank of a Viking ship being built in Norway, and it's hoped that it will arrive at the opening of the London Olympics. It's an exact replica of a very famous Viking ship called the Oseberg ship and it's being built on the waterfront at Tonsberg. It's open to visits by schools; children get dressed in Viking garb and learn how to use Viking tools. The original Oseberg ship was found in 1904.

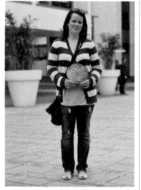

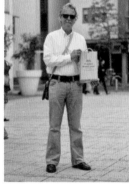

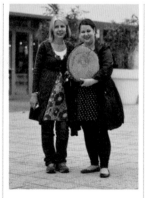

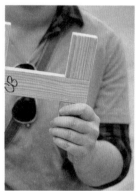

372 Jenni Minns
I found this a couple of months ago in Hempsted Forest. 'Denver Boy' – that's my dog. We took him on the walk that day, and he was put down the other week. So that's why we dried it out and engraved it, because we knew we were coming here. He was a little terrier, old and not very well.

373 Philip Minns
This is a bottle case for emergency supplies of wine. It was my dad's. He was a keen wine drinker. To be honest with you, I don't know how long he had it, but it was amongst his things.

374 Susie Minns
This is a memory. We took our dogs for a walk in the Hempsted Forest not long ago, and we stole a piece of wood from a tree. It's part of the memory.

375 Christine Bashford
I'm in my first year as a cabinetmaker and this is my first joint. So it's the start of my career. They're mortise and tenon joints – bridle joints. I'll probably train for three years, then go out on my own and do my own thing. I love wood, it's lovely to work with.

'We took our dogs for a walk in the Hempsted Forest and we stole a piece of wood from a tree. It's part of the memory.'

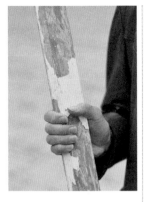

376 Tim Squire
This was part of my house, the first ever property that I bought. I decided to do some alterations on the space that was a sort of cupboard under the stairs, and this is one of the pieces that I pulled out.

377 Chris Kennish
It was my first ever guitar. My grandfather passed away and left me a couple of hundred pounds, not enough to spend on anything amazing, but enough to buy a guitar. I used to play in a folk band called The Golden Apple. We used to play up and down the country, at festivals, around campfires, that sort of thing. So this was my jobbing guitar for a long time. As you can see, the bridge has lifted up off the body, the whole thing's dried out; it's no longer really playable. Now I've moved on to six-string nylon-strung guitars.

378 Fiona, Charley, James and Richard Ayres
We've brought a plank of wood and we've all signed it. We had it because Charley's doing his GCSEs and he's working with wood.

379 Prem Krishna (Roy Dean)
This came from a 100-acre wood just outside Battle. We were staying at a friend's place there when my wife was very pregnant with our daughter. So it was a special place for us. A couple of years later, when I started a clinic called the Brighton Massage and Bodywork Clinic, I got timber from the man who owned the wood. I needed it to build a desk and put up shelving; it was very basic. When that eventually folded, I took the wood out and used it around the house, including in the room we call the healing room.

380 Lucia Elliston
A curvey thing, I don't know what it would be called. I salvaged it off my friend here and I haven't found a use for it.

381 Vicky and Richard Hougham
This looks like it's just a piece of log, which it is, but it has some candle wax on it. Because on 31st October 2009 Rich placed a little candle on it and a ring in front and proposed to me. So it's a marriage log! We are now married, and this has been sitting on a shelf for all that time, because neither of us have really felt that we can throw it away.

382 Ben, Leo, Jack and Taylor Hougham
I used to play with this in the old house where I used to live. And this one is new – Ben plays with it quite often, he likes to bite it. He chews everything.

383 Tina Eglinton
I've brought you an elephant from Zimbabwe. I did Operation Raleigh there in 1993 and brought back several elephants. I've decided I have far too many elephants now. I've been collecting them since I was about eight, but I've just moved to a small flat and I've run out of space for elephants.

'On 31st October 2009, Rich placed a little candle on it and a ring in front and proposed to me.'

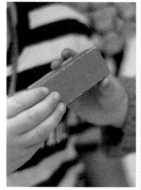

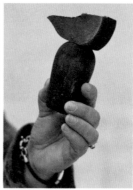

384 Johnny Johnson, Maeve, Finlay and Paul Hogan
I became separated from my mother when I was 12 and never saw her again. When I had children of my own she found out, and sent a set of bricks in a walker from Australia. Also we used the bricks to make scale models of Stonehenge, when the children were about two. When I was a child we lived near Stonehenge; we'd go there for walks with dogs. My father was also a tremendous sailor and he died some years ago. So this little blue brick brings everything together: my mother, father, and children.

385 Peter Wilkinson
It's a little piece of what's left of a cello. I had the cello for ages. I'm not a very good player, but I write lots of music, and did lots of recordings using it. One day I wanted to get rid of it, and sold it to this guy who was going to give it to his girlfriend for Valentine's Day. Unfortunately the courier destroyed it, it came back in shreds. I don't know what they did to it. The whole front was shattered into a million pieces. All I had left was this little bit of wood.

386 Jackie Blackwell
I've got the top of a cat, but it's missing the tail and the legs. It was a kind of table, I think. I bought it in Brighton for about a pound, years ago when I was a student. It was always a bit wobbly, and things like the tail kept falling off. It's tiny, but perfect when you're a student. Now I don't live in one room any more, thank goodness! I live in a house. Over the years it's just come with me. I was going to burn it, but it seemed a bit of a shame.

387 Sue Popper
It's the foot of my grandma's rocking chair. My mum had it, but years ago I took it when she was going to get rid of it. It's been to every place I've lived, falling to pieces more and more as time's gone on. But I couldn't bear to part with it. There's no space where I live now, so it's been in the garden where it's really started rotting. Finally I decided to get rid of it; and as it was being lifted up, the foot fell off. Now it feels like it's going somewhere it will always be.

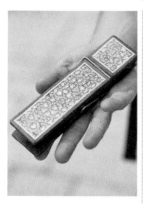

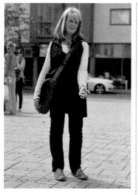

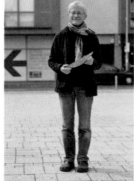

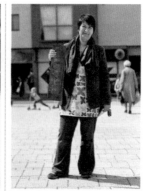

388 Mel Sheppard
It's a mother of pearl laminated peg. It was posted to me about six years ago, by a friend who is now training to build boats. And I've lived on boats for years, so I wanted our peg to be put on a boat.

389 Clare Nias
I've brought a maquette of a hand. It's supposed to be for artists to draw. It has articulated fingers, and is probably just about the right scale. I'm an artist and I like to work quite hands-on, so it's literally about what I can do with my hands and what I've always done with my hands, creatively.

390 Philippa Smith
I've brought part of the base of an oak-carved barrel. My father gave it to me as a house-warming present, half an oak barrel to put plants in. I used it for red geraniums, but it's finally fallen to pieces. I'm very attached to it, because my dad was going to come and see my house when I moved in and he never made it before he died. I kept just a few little bits of it. He loved sailing, and I love sailing, so it would be great to think of it becoming part of a boat.

391 Gill Hilton
I've brought the offcut from a piece of decking, which my husband Adrian made for us outside our new kitchen. He did it with our friend John, who came from Cheshire and spent a weekend with us. The deck has become a really special place in our house. We open our back doors and the whole back of our house opens up and leads out onto the deck, which is semi-circular in shape and has a white brick wall around it, and a bed with lavender and sweet peas.

'It's been to every place I've lived, falling to pieces more and more as time's gone on.'

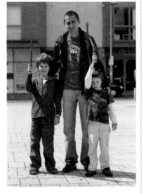

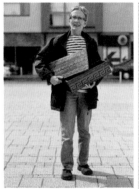

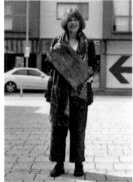

392 Joseph, Doro and Amos Marshall
Two sticks, from the beach.

393 Shelagh Doonan
This is a box my parents had. They've decorated it with some wrapping paper, it looks rather beautiful. Until today I thought they'd made it. But on the bottom there's a crown, King George, and it says, 'Diem 1918'. Which triggers a faint memory of my mum saying that there was some army box. One of her father's brothers died in the Somme; the other brothers survived the war. So I've a feeling this box is something to do with that. If it hadn't been for this project I wouldn't have looked on the bottom of the box and realised.

394 Lizo French and Polly Smith
I've brought a little hand that I carved. Seven months ago I started on a project of puppetry, and this is a puppet's hand. I'm trying to learn the skill of carving. It's cherry wood, a marionette hand. The puppetry was to help me through some mental problems, and it's helped.

395 Anna Fairtlough
It's a chopping board that I've used for many years. I once shared a flat with somebody who became very ill. One night she wrote me what I now realise was a goodbye poem. The next day she took herself to hospital with serious depression. I visited her a couple of times but she never contacted me again. She owed me money and said, 'You can have all my things'. This is one of those things. If she hears this she'll know: I'm sending my love to you, I hope you're well and you've had a good life since then.

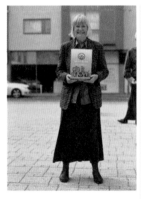

396 Libby Coleman and Nick Ainley
It's a paper holder, with a metal piece that says, 'Do it now'. This was always on my desk as a head teacher of comprehensive schools, and finally in Brighton on Whitehawk estate. It's where I put my most important paperwork that really had to be done. Since retirement my husband and I have produced a book called *Yes We Can Read*, it's for anyone who can read to pick up and teach someone else to read. That's our mission. I kept the book inside my 'Do it now' paper holder, but I don't need it there to remind me.

397 Phil James
These two pieces were part of a bundle of wood that was very kindly given to me when I was setting out on a new course in life. I didn't end up where I thought I would go, but it's an adventure nonetheless, and I've learnt a lot about myself. They look ordinary but they're quite significant.

398 Shaun O'Toole
This is a chopping board that broke this morning, just an Ikea wooden chopping board. It's not survived the dishwasher. Lots of Thai food has been made and chopped on it. And this I bought in Bangkok, in a market stall nine years ago.

399 Kate Langley, Matt and Owen Goulson
We've brought one of Owen's first building blocks, from his first birthday present. It came in the walker that he learnt to walk with. So now it can go and sail!

'She owed me money and said, "You can have all my things". This is one of those things.'

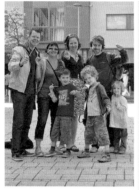

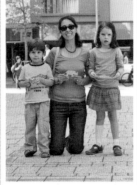

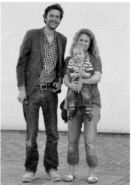

400 Alison, Sian and Daniel Porges, and Al, Theo, Nicola and Nell Hepworth
We've brought some chopsticks from our favourite restaurant in Brighton, Moshi Moshi. This is my cousin and they've come down to Brighton for the weekend and we thought we'd take them to our favourite restaurant. We had lots of sushi and the prawn tempura kept coming and coming and coming, even though we hadn't ordered it. Cousins getting together...

401 Kilian, Leyla and Maryam Tesche-panah
We're donating three animals from our Noah's Ark, because they're the three without any pairs! And they all need to be two-by-two. This was Leyla's idea, she said, 'We can give the animals that don't have a partner'. Now they won't be so miserable!

402 Gerda Sharma
I've brought a lolly stick, because that's all I could find in my bag. It's been there for probably about a week. When it's a really nice day I go to the shop in Falmer village, not too far from where I live, and they've got these really delicious organic lollies. I like going there because I can sit by the pond and chill out. This one was tropical fruit flavour.

403 Andrew Willis
I'm donating a pair of drumsticks, from several years ago. They're all chipped and broken. I used to have a drum kit in my flat, but with the birth of our daughter and that being more important, I had to get rid of the drum kit. So I have no use for the sticks any more. I only played once in a blue moon. I'm a guitarist really, and as a little vanity thing I had a drum kit in the house. But my daughter, Nancy, hits things – so it's obviously in the blood!

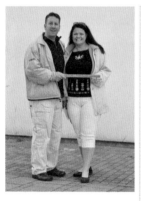

404 Paula and Sean Wright
We're bringing a piece of wood from our bathroom remodelling. We moved here a year ago from America and we live on Palmeira Avenue. We just thought it would be neat to have part of the home that we live in now being part of the boat. We love Brighton, we're never leaving – if they'll let us stay!

405 Sam Buchanan
A lolly stick. I've had it about ten minutes. It was kind of tropical.

406-407 Sue Craig
This is a drawer from the very first piece of furniture I bought after I left Newcastle in 1968. I got it for 30-bob in Kentish Town. It had pride of place below my Jimi Hendrix poster. When I let it go, I kept a drawer. I went to a wood yard, because I was making a recycled kitchen, and this came in while I was there. It's from the old chemistry laboratory at Roedean School. Some of it even has some bits of graffiti, but I don't think I've brought you any of that. This has still got the hole in it, the finger hole in the cover for the sink.

408-409 Sue Craig
This is what used to be the hall floor of Whitehawk School. The school was demolished four years ago, and we lifted the floor so as not to waste it. I've laid it across the whole of the ground floor of my house, and this is some of what's left. And this is from an ash tree that we cut down in Stanmer woods last October, for the first ever communally created yurt. It's going to be everything – an art gallery, a story-telling space, a felt-making space. We're going to cover it in felt from local sheep's fleece.

'We're donating three animals from our Noah's Ark, because they're the three without any pairs.'

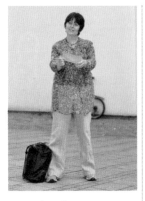

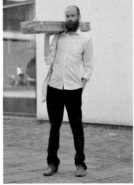

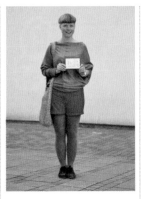

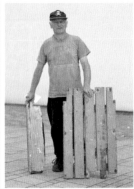

410 Sarah Earl
When my daughter came out of her cot we bought her a sleigh bed to fit in her room which was just short of standard bed length. After two or three years she started to yearn for a cabin bed. We found one in the local free ads, but it was a little on the long side, so we had to cut this bit off. That was alright for a few years, but then she didn't like being a metre-and-a-half above the ground because it made story time very difficult. Finally we found something suitable in Ikea – a three-sided day bed – but we've never been able to close the bedroom door!

411 Peter Knight
It's not as interesting as some of the other things you have, but it's the slats from the bed that I've had ever since I ran away from home and moved out, about 13 years ago. I've slept on it, met people on it, and talked with people on it. I don't need it anymore, and what better way of using that wood than as something that other people can share a journey on as well.

412 Beth Gardner
It's a picture frame from Berlin with a Zille cartoon. I bought this from a Berlin flea market in April after attending an event based on Zille the cartoonist.

413 Fred Cole
This is a part of my old Motor Torpedo Boat. It was the first boat over on D-Day, and it was also the first boat back. It led the flotilla on D-Day, apparently. I lived on it for several years. I bought it in 1980, and it sunk on us about eight years ago. And this is part of my replacement boat, which was a German Minesweeper. This one's called *Fish*. We named the MTB *Lunacy* – complete madness!

414 Polly Fridman
I'm donating my key ring, which is made by the Arran woodcarver. My parents live on the island of Arran, and when they moved there from the home I grew up in, just outside Glasgow, they gave this to me.

415 Nick Gardner
This is the last piece from a house renovation – a balustrade made of mahogany.

416 Ray White and Julia Gallagher
This is part of a boat that we've just converted, after four years' work – a houseboat. It was part of the original boarding in the cargo hold down below, which we've cut out. Our houseboat's called *Curlew*. When we were designing it we just marked out the walls, so these are the actual divisions of some of the walls inside.

417 Sofia and Ossia Dimoglou
Ossia: This used to be the doorstop when I was a baby, so my mum could hear me.
Sofia: And this is a packing case, for fruit. The grandfather of my friend in America built a log cabin, and inside it he put all the insides of crates; it was really pretty. So I decided that I was going to do the same one day, and make a lovely ceiling. And when me and Ossia went camping round France, I brought this back. I've had it for years. But I've realised I'm never going to do it!

'We named the Motor Torpedo Boat *Lunacy* – complete madness!'

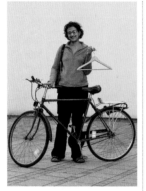

418 Fatema Rajabali
I've brought you my only wooden hanger. It's travelled around with me for a while, to different parts of the UK, and Budapest. And I'm pretty sure it's been to Marseilles as well.

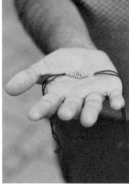

419 Patrik Patel
I've brought some sandalwood for you. This is Indian. There's a day in the year called Raksha Bandhan, and it's a day for your sibling. So my sister would tie this round my wrist, and then she gets money from me – it's not a good deal! There's gold and silver there. It's fairly tacky but you can try to find a place for something tacky.

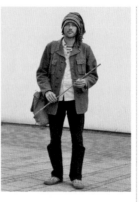

420 Richard Willis
It's a short piece of bamboo. This has been in Patrick Patel's kitchen, where it was part of a large, right-angled bamboo construction, like a private piece of sculpture. His kitchen's about 20% off due south-north, but all the bamboo was mapped on lines of latitude and longitude, so it was at a slightly strange angle. It was there for about a year and a half. It made the kitchen about half as usable as it was beforehand, but it was just a lovely thing to have there.

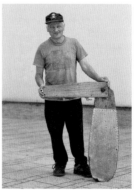

421 Fred Cole
It blew up in a hurricane in 1986, and I rescued it from the River Adur up in Shoreham and put it on the jetty. It's been on the jetty ever since. I've got a few dinghies out and I thought I'd use it somewhere along the line, do a bit of sailing with it, or do something with it. I've moved it around God knows how many times.

422 Patrik Patel
These are wooden templates from a violin I started making about six years ago. It takes quite a while to make one. My violin teacher said it's an 'organised sculpture', so it takes quite a long time. I'm probably going to finish it in the fall. My friend Richard has been making a shed for about the same time – so he's got a gross, sort of banged-together wood job, and this job is really fine and intricate.

423 Wynne Taffinder
A couple of years ago we moved out of our house and we rented it out. When we moved back, this was in my cupboard. I've no idea where it came from at all. I said I'd fix it up and stuff, but I never did.

424 Sasha Gabbé and Maria Marzaioli
We're here donating wood on behalf of Harry, because he's far too busy at the moment building his own boat down at the marina. We've just been to see him. This is eco teak. It's a teak deck and he's a very environmentally minded chap, so he wanted to source eco teak. I think it's from Brazil. His boat is going to the Med, but this wood can go up the Thames instead.

425 Bettina Linstrum
This has got the owner's name scratched into it: Victoria Darwell. She was my mother, and she died suddenly two years ago. Her own mother's still alive, in her 96th year. When my grandmother moved into a nursing home, we found a trunk from my mum's school, Cheltenham Ladies College. This was her tennis racket. The boat seems a fitting place for it to go. She was a sailor herself. Her ashes are yet to be thrown into the sea because they're waiting for our dad, who's also said that he wants to be thrown into the sea.

'It blew up in a hurricane in 1986, and I rescued it from the River Adur.'

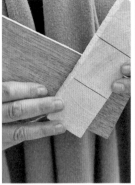

426 Erik Wohlfarth
I'm the father of Betina. This is a piece of the rudder of our very first boat, *Columbine*, which my wife Vicky and I bought and rather damaged when we first reversed with an outboard engine - every sailor knows what happens! Anyway, this is a piece of that rudder. I think it's a lovely coincidence that I can give it to you on Victoria's day; my wife's name was Victoria.

427 Alison Goosey
I'm donating this log. It's a piece of wood from the tree in my garden. When I moved into the flat that I live in now, it was blocking the side access to my garden, so my brother cut it up into logs for me. I was going to burn it on the fire next week, but I've got plenty of others. [Alison Goosey died in November 2011]

428 Ghita Thomas
I've built my own boat, a thirty foot catamaran that is currently in Brighton marina. It's called *Midnight Rambler*. Actually I'm just finishing off the inside now. This is a bit that I cut off just a couple of days ago, and the balsa is what I'm using for insulation. It's taken ten years to build, although I did take a couple of years off in between – you get fed up with building. Don't ever do one on your own, it's hard work!

429 Fiona Beldon
These are two pieces of wood that were salvaged from the wreck of the *Ice Prince*. It shed its load about four years ago, off the coast here. All the wood got washed up, and a lot of it we weren't allowed to take. But they couldn't get the bulldozers on to the beach along the undercliff path, and so that was just left. We've built a garden shed with it, and a fence, and a compost bin – and these are the bits left over. I hope your boat has more joy than the *Ice Prince*!

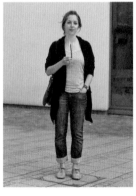

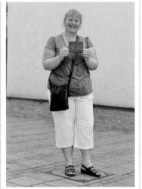

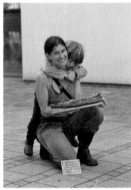

430 Phil Beldon
It is a memento of 20 years of the South Downs organisation. It's been laser-printed on to a piece of oak, and out of the little acorns of these organisations the great big oak tree of the National Park has been formed. Around 20% of the Downs is wooded, and this is one of the trees we took down when we were coppicing.

431 Eirini Kartsaki
I've brought a pencil. This represents a rite of passage for me, because I've just finished my studies and have got a full-time job, which I start very soon. And I'm 30 on Wednesday, so it's a very transitional stage. I will not be able to control what happens afterwards, I might feel imprisoned somehow, and I want to mark this moment in time with this pencil.

432 Carol and David Hancock
It says, 'Why be awkward? With a little more effort you could be ruddy intolerable'. It was my dad's motto. When he died I inherited a lot of these sorts of things, and I kept them all thinking that we'd have a little corner somewhere. But they were so awful we didn't really want to put them up!

433 Louis and Julia McKay
We think it's a piece of green oak. It's just lovely, with that bark on the edge. It's come from a skip in Brighton, along with lots of other pieces. It will be recycled – this one into a boat, and the rest of it probably into a new kitchen, or some shelves.

'I might feel imprisoned somehow, and I want to mark this moment with this pencil.'

434 David Hancock
I'm donating a pencil from Arthur Collar Ltd, a builder's merchants. My dad was a self-employed plumber and he was a regular customer. When I was growing up, all pencils looked like that. My dad died in 1976. When I read about the project I went down to mum's, she had a dig around, and she still had a pencil. I knew there'd be one somewhere. Arthur Collar are long gone, it's Boots the Chemist now. It used to be a proper place, with guys wearing brown overall coats, and everything in drawers. I loved going there with my dad.

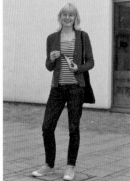

435 Annie Smedley
I have a bed that was made out of recycled pine about 20 years ago. Yesterday I was pulling the bed into a new position in the room, and this piece of wood just sort of fell out of it. It's an old knot that must have been part of one of the horizontal pieces. It just fell out, it was almost like laying a little egg! It has such a lovely smooth edge to it. So that's my little story, nothing more.

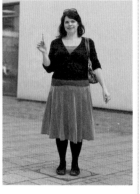

436 Jenny Martin
I've brought a wooden bobbin that I make lace with. The top of the bobbin has an area where you wind thread, then at the bottom there are some holes and inside you'd have a piece of wire with beads on, which would give weight and tension when you're actually making the lace. I've been making lace since I was quite young. My dad makes glass things and I used to go to the lace fairs where he would sell his beads and glass bobbins. This has been used since that time, when I was a young girl.

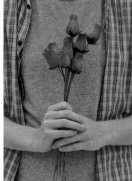

437 Richard Podmore
I'm donating ten wooden red roses. Very romantic. I've just bought them from down the road, but I thought you would need something beautiful to look at on the boat.

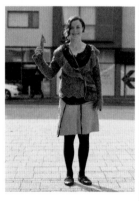

438 Isabel Woods
It's a parrot, a wooden tent peg parrot from Glastonbury festival. I was camping up in the green field. Now I use it to keep the mirror out from my dressing table, so it's at the right angle.

439 Sam McGregor
I salvaged this from a shop in Brighton about five years ago and used it to make some shelves. It's special to me because I made all the grooving myself. It was a very lovely set of shelves that was in our living room for about three years. They were quite unusual, stacked inside a corner and with no metal brackets or anything – all wood. Then when we moved house they were broken by the removal guys! My wife was very sad about it. They've just been sitting in our house for about a year.

440 Frankie McGregor
This is our next-door neighbour's. It holds open their door. So they're all closed in now!

441 Alex Fox
I'm giving this piece of wood that my nan found on the beach in West Worthing. We made it into a sword.

'This is our next-door neighbour's. It holds open their door. So they're all closed in now!'

442 Paul Sanderson
This is a log from the children's favourite tree at Littlehampton Academy, which had to be cut down for the new school building.

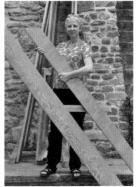

443 Peter Boyd-Smith
It's a plank from a Victorian tender to a sailing ship that traded into Southampton in the 1890s. I bought the tender in the 1960s and kept it until 1976, when it broke loose on the River Itchen, went ashore, and dried out in that very hot summer. The ribs came off, it totally disintegrated. This is all that's left. I've had it all these years not knowing what to do with it. She was a beautiful sea boat, it just literally skitted along the top of the water.

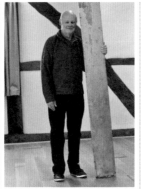

444 Christine Rawnsley
I'm the learning and interpretation manager at Southampton City Art Gallery and Museums. This staircase was in the Tudor Merchants' Hall, the room we're using for today's donation day. The staircase came out because the building was renovated as part of a lottery project. The hall's now our education space and also a public room, for marriages or parties. During the renovation everything inside had to come out. These banisters were the only bit of wood we were allowed to keep.

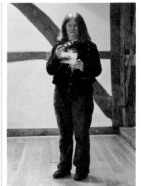

445 Nikki Goff
It's a piece of satinwood panelling from the SS *Olympic*, the *Titanic*'s sister ship; 2012 is the Olympics and also the anniversary of the loss of the *Titanic*. The *Olympic* traded until 1935 before being scrapped. I bought a number of lots of wood at an auction in Southampton in 2004. People were bidding like crazy. I bought it virtually by accident.

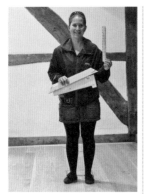

446-447 Sam Young
Up until yesterday, this was Rogers Yacht Design's doorframe. The previous door got a bit warped and the frame was starting to die, so we needed an update. It's been part of the company for at least a decade. Now we have an ugly fire door. I've also brought my first ever school ruler from my childhood in Zambia. I've had it since I was six. It was very popular with the teachers because it has a good flick. Us students used to keep ours hidden, because the teachers punished us by smacking us with our own rulers.

448 Marian Hubble
I've brought a piece of log, I think it's silver birch. It was picked up yesterday in the New Forest. I was out for a fantastic walk with some wonderful friends, and whenever we go out together we have an absolutely super time. It's one of the highlights of my life to go out with them. We walk about 12 miles – a comfortable distance.

449 Shirley Kane
It's my old boot box from childhood. It had Cherry Blossom polish in that side and the brushes and dusters in that side. On a Sunday night we'd get the boot box out in the kitchen and polish the shoes for school. It says, 'Guaranteed 1lb pats pure butter'. My father, who died last year, was a carpenter all his life. But when he was very young he worked at a grocers called Loves, in Addlestone, Surrey. It might have come from there.

450 Alex Leonard
The rest of this track is going to go to our baby cousin. It's been sitting in grandma's garage waiting for the next cousin who's old enough to have it. We've just brought a couple of bits, and a little engine – for a child's area on the boat!

'It broke loose on the River Itchen, went ashore, and dried out in that very hot summer.'

451 Jessica Leonard
It's a bench hook and it was a Christmas present for grandma from her friend Anthea, who moved to Cornwall. We think it would be nice to go on a boat because she's keen on boats.

452 Jenny Leonard
This represents unfulfilled promise, because it's a shelf from Ikea that's about 20 years old. I've moved house twice and it's never been used. Of all the projects that one plans and that don't come off, this represents somebody actually doing something with it for a change.

453 Ben Farnell
It's just a couple of offcuts of floorboard. I converted my attic into a studio for my artwork. It's a couple of years' hard work, every spare weekend. Did my back in, and it's still not right!

454 Hannah Farnell
Apparently it's from my dad's toy box. I didn't want to give any of the other ones away!

455 Maeve Farnell
This used to be my daughter's but she's too old for it now. I always liked it, so we've never given it away to anybody else. The footballer's missing, he must be at home somewhere but we've never found him.

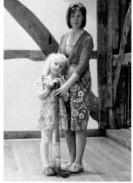

456 Rosie and Tina Dyer-Slade
It's a hockey stick that belonged to my dad – Rosie's granddad – and he's not with us any more. He was in the RAF, and he played hockey in the 1950s and 60s. And Rosie and her brother Jack both play hockey too, so we had granddad's old hockey stick to practice with. When dad died we set up a scholarship in his name, to give grants to young people to help with their sport, where there was financial need.

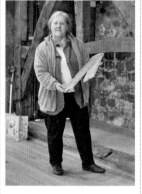

457 Angie Turley
This is a CD case that was very badly put together with weak glue, and I decided it was interesting. My dear daughter tripped over it and it came apart. I photographed it in different lights, in bad light really, so you get an interesting effect.

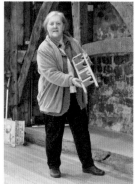

458 Angie Turley
This I found washed up on a beach on the Isle of Wight about 19 years ago. It's had new screws put in, because they were rusted through. I think it would have been used to put yacht ropes on, because if you imagine a coat going on there it's going to put a lot of pressure on the coat. It's natty – fascinating. I beach comb all the time. I go over to the Isle of Wight to see friends. We went on holiday there for 38 years. There's not much my husband doesn't know about it.

'The footballer's missing, he must be at home somewhere but we've never found him.'

459 Antonella Ianni
I've brought you a little Pinocchio from Italy that has been with us for quite a few years. It's been travelling a lot since then and now he's ready to leave.

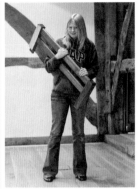

460 Marida Ianni
This is a bit of my bunk bed that we bought in Italy. We designed it and had it made. This piece recently fell off.

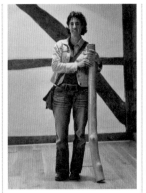

461 Beatriz Villaro
This is a didgeridoo that my partner and I made in Australia when we were travelling. We were staying at a campsite and we attended a workshop to make didgeridoos. There's a bit of a confusion – he thinks he made it, I think I made it. There were two made but I couldn't find the other one, so we're both claiming it. I just remember endless sanding until our hands were raw. We spent weeks trying to learn it but I couldn't get the circular breathing.

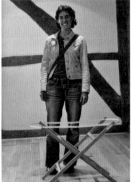

462 Beatriz Villaro
It's the stand that I used for my boys' crib when they were each born. It's quite sentimental. It was probably given to us - either that or Mothercare!

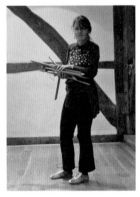

463 Cara Sandys
This is a pile of broken picture frame wood. My father died in 1984 and for the last couple of years he gave up work and did oil painting. He'd gone to art school, done fashion design and furniture making, but never oil painting. So he spent the last few months of his life churning out these paintings in fine detail, an unusual technique, quite photographic. He did landscapes, anything with trees and water. His pictures were his legacy. He didn't live to see me become a professional artist. I think I inherited his attention to detail.

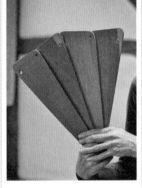

464 Cara Sandys
We still have quite a lot of 1950s furniture that is the same colour as this, so we're wondering if it was something to do with that. But we don't know what it is, I don't ever remember seeing them before. Actually, I think they're the end parts of a needlework bag.

465 Daniel Comben
I've got some lead. It's about 30 kilos of ballast lead, out of my own classic boat. Now it's surplus to requirements. My boat's 40 years old and me and my partner are hoping to get it back on the water by the end of the summer. We're hoping to potter around the Solent initially, and find out if we like sailing or not!

466 Michelle Hale
This is a teak cleat that's just come off our boat, *Vivienne S*. We've been working on it for about a year and a half and have stripped the hull back, done a lot of painting, and we're currently fixing the engine. It's been a bit of a labour of love. It's a Nantucket clipper, so it's quite a handsome looking boat. It had a sad life before we got it; it was in the marina at Gosport for about ten years and had been severely neglected. We bought her on eBay and have been working on her since.

'I just remember endless sanding until our hands were raw. We spent weeks trying to learn it.'

467 Keith Goddard
I've brought a wooden spoon that we've used for dozens of years. It's the only one we have! There'll probably be vestiges of tomato and pepper on there.

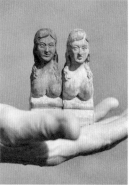

468 Roy Smith
They're two carved wooden busts – a good pair! And we bought them in 1979, somewhere around that time. There were originally 12 of them, and they came from a junk shop in Worthing. Over the years we've given them away, and these are the last two we have. They're very nicely carved, and they were all exactly the same. Monica, my late wife, gilded a couple of them. So these are the last two.

469 Ann Sutton
I've been a weaver for 50 years. Now I've given it up, I'm free. I've brought you two wooden weaving shuttles as a symbol of me stopping work. I've sold my looms but these little ones are quite precious. I went to art school to do pottery, but when I first put my hands in the clay with joy, I withdrew them with utter horror; I'd never thought to feel the stuff. I wanted something dry and comfortable, so I turned to thread. Now I'm working with paint: not paint on canvas, nothing conventional like that, but paint in space.

470 Rachel and Gavin Gardiner
It's a potting bench from my garden, which I felt was appropriate, because I love gardening, I spend a lot of time in the garden. And it's my new surname as well – Gardiner. We've just moved house so we've got a lot of work to do on our garden, but it's getting there. I've probably used the potting bench for about ten years. I quite like to be organised and it's nice that I can put everything on it, potting my seeds and so on; it's all tidy and neat. But it's started to look a bit sorry for itself.

471 Jonathan Brantigan and Mark Robinson
This is an old wine case from a château called Chasse-Spleen, in the Medoc. It's from the 2000 vintage. I visited the château some time ago and purchased this particular wine. And as you can see it's all been drunk now! We've got a shop in Arundel. And this is from some of our own boxes that we have in the shop, for putting wines in. We've been in Arundel for four years, but the shop's been there selling wines since about 1900. It's quite a well-established business, we're just custodians in a way, aren't we!

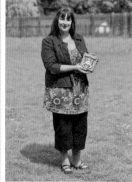

472 Rosie Parfitt
It's a shield of Littlehampton's crest that's been liberated from the mayor's parlour at the town council. That's the town's motto, 'Progress', and it's obviously linked with the water, and the river Arun. This bird here is the reference to Sussex, so it's all about the river really. I work at the council, and we knew you were coming, so on Friday I tried to get the gavel out of the council chambers! That was mugged off me quite quickly. But the mayor and I went shuffling round her parlour and found this, it's been there for some years.

473 Prue Furby and Mishka
My dad used to work with timber. He found this and he thought it looked like a swallow. He died in 1984 and I've just had it in my loft. It went to my granddad's pub for a while, and when my granddad died it came back to me again. I thought – boats, swallows, *Swallows and Amazons*, you know. I thought this boat would make a good home for it.

474 Diana Lyon
This cat came to me via my eldest son Daniel. Years ago his girlfriend at the time gave it to him. When they parted company, it came to me! I'm Catholic but I'm still very interested in the ancient Celtic ways. And the cat's been a guardian of my home, this house and my previous house in Arundel. I was reading out loud about *The Boat Project*, and the cat almost seemed to glow. I thought, the cat wants to go on this journey. It's done its time with me. It needs to guard the boat, and bring good fortune.

'I was reading out loud about *The Boat Project*, and the cat almost seemed to glow.'

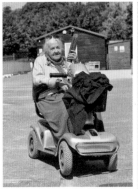

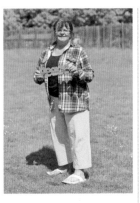

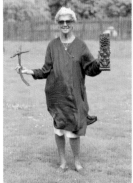

475 Nick, Sarah, Leon and Lily Myerscough
It's a test piece, part of the dashboard area for the Rolls Royce Phantom, pre-production, at the new Goodwood site, given to me on the day I left in 2003. It's bookmatched burr elm. I was there when my firstborn, Leon, came into the world. Left all that behind a long time ago, because it was probably the worst job I'd ever had! I went there thinking there'd be old boys with beards, aprons, hand tools, and I spent six months of my life literally pushing a button, counting to 30 and pushing another button.

476 Mollie Reb
A spliff box! It doesn't look like one, you see, so you can get away with having it around. There's nothing in it now, obviously – it's a long time since I've had one, I must admit. I'm 80, but not inside I'm not.

477 Ruth McCorquodale
My 'Peace' sign. I can't remember how long I've had it, it must have come from the days of 'Ban the Bomb' and all that, the beginning of the hippy days. I wasn't on marches or anything, it's just something that was relevant at the time. It did have a white dove connected to it, but I couldn't part with the white dove.

478-479 Mavis Gillies
This was given to me by a neighbour when I lived opposite Madame Tussaud's in London, years ago. Apparently some relative of his made this for an old sailing ship, and he had furniture in his apartment that was just incredible. It's a hand-carved panel. And this is a cross. I was just walking about, found it, kept it, sat it against a wall, and it's been there for years. It's moved around, London, here in Arundel, where I've lived for 12 years. When I go someone will just chuck them away so you might as well take them.

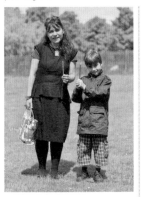

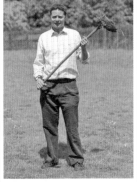

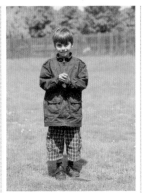

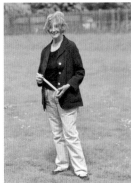

480 Bérengère and Leon Bonner-le-Fur
We have two pencils. One comes from St Nicholas Church choir. It's a pencil that the choir members would use when there is a piece of music that is particularly tricky, that we need to write additional annotations above or under so that we get it right. It has a long history of being used there – in fact, that's the one I've been using since I joined the choir in October two years ago. And this second pencil is Leon's donation, which also comes from St Nicholas Church, from the Sunday School.

481 Jason Eades
I've brought a witch's broom, which has been with me and my family for 25 years. It's been on its tour; it started off in Braintree in Essex, then moved to Denham in Suffolk, and it's finished its life down here in Arundel. It's been tidying up gardens, patios, my grand-mother's house, my parents' house. And it's been terrifying – lots of godchildren, thinking it is actually a witch's broom!

482 Leon Bonner-le-Fur
I found a little piece of wood on the floor and I thought it might be good for a boat. I was swinging around that blue pole and I saw it on the floor.

483 Margaret Nullens
It's the first kitchen roll holder I ever owned. We didn't have kitchen rolls when I got married, then suddenly I went modern and got a sort of up-to-date kitchen, and it's been going round the house and I've not known what to do with it. It was bought in Italy, where we lived for 32 years, on Lake Maggiore. We've been married 50 years; kitchen rolls came out about 30 years ago.

'A spliff box! It doesn't look like one, you see, so you can get away with having it around.'

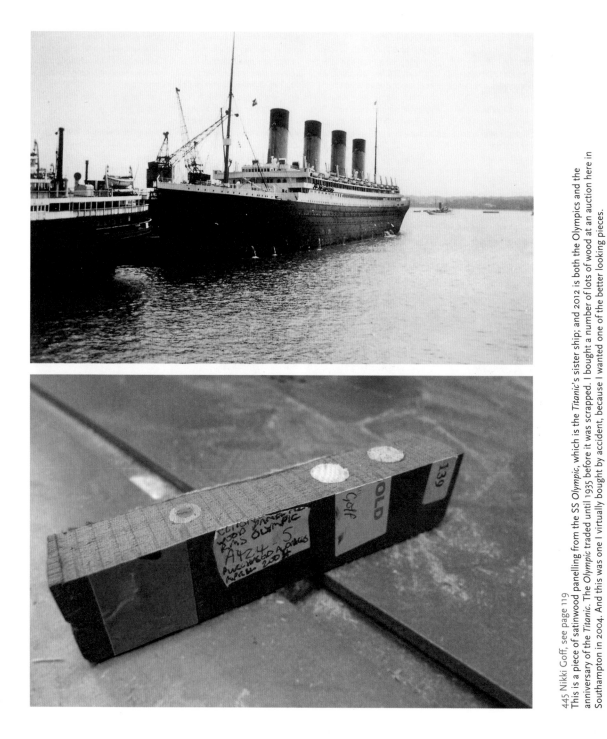

445 Nikki Goff, see page 119

This is a piece of satinwood panelling from the *SS Olympic*, which is the *Titanic*'s sister ship; and 2012 is both the Olympics and the anniversary of the *Titanic*. The *Olympic* traded until 1935 before it was scrapped. I bought a number of lots of wood at an auction here in Southampton in 2004. And this was one I virtually bought by accident, because I wanted one of the better looking pieces.

THE LONE TWIN BOAT PROJECT 124

'People were bidding like crazy, and I was just throwing my hand up at everything.'

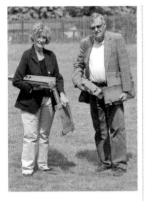

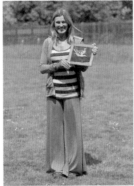

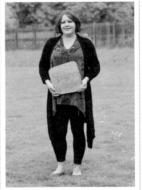

484 Margaret and Gilles Nullens
Margaret: It comes from the cupboard under the bathroom sink. We had no storage, and the carpenter made that out of solid pine. Now we've re-done the bathroom and I had a walk-in shower put in. I couldn't get out of the bath any more because of wonky knees. He refuses to use it. He goes to the one downstairs, he says mine's too posh.
Gilles: I didn't want to say anything because I would have said, 'Your old one was perfectly alright, so why change!' We don't have the same world thinking.

485 Pauline Swain
My first and only attempt at marquetry, when I was in plaster with a broken leg for six weeks, sitting around my mum's house. My uncle George was amazing at marquetry, and he suggested that I have a go. So I bought one of those kiddy sets and started carving it all up. And it was so hard. Blood, sweat and tears went into this. Frustration! Most of the woods splinter and break when you cut them. I had to redo everything so many times. It's not beautiful, but it's hung in my mum's shed for over 20 years.

486 Jenni Dixon
My donation is the top of a seat, from my classroom. It's my first ever year teaching, and this is a memory of my change of careers. I was a manufacturing engineer before. It's been a challenging year, to say the least. But enjoyable, extremely rewarding.

487 Stanley Dixon
Stanley's three and a half years old, and about a year or so ago we took apart his cot to make it into a bed. This is one of the bars from his cot, his very first cot.

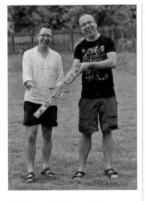

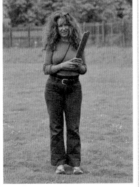

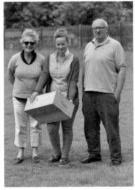

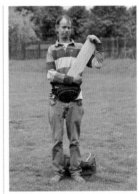

488 Darrell Gale and Simon Rose
Darrell: It's a piece of moulding from the bottom of my back door. It fell off about four years ago when the door stuck, and we had to kick it open. And as I always finish jobs on the house, it's stayed there for four years! The house is Victorian, but I think the door is 1960s.
Simon: It hasn't lasted as well, obviously!
Darrell: The last four years we've hardly been able to open the back door at all, because it just wedges. So getting rid of this helped it for a while.

489 Kay Wagland
I've brought some pieces of my mother's old clothes horse. It's at least 50 years old, but it's probably considerably older than that, because – being poor – she got it second-hand. For me it's a memory of all her washing and her ironing, hanging out in our sitting room when I was a child. That smell of ironing. And all the completely unreasonable things she ironed! That was in North London, Tufnell Park. I cut up the rest of it to make a gate. But it's had children and cats and God knows what, bashing it around.

490 Eugenie, Muriel and Dominique Chabernaud
Muriel: We had this in our cellar in France for years, and we just decided this morning to go to the warehouse and pull something out.
Dominique: As it says, it was a claret, it was the second one of the Montagne Saint Emilion and we thought it would be very useful to the boat.
Muriel: It's been moving with us from house to house. It started in the Loire Valley.
Dominique: No, the vintage is 2002. I nicked it from the place I was working!

491 Duncan Gillies
This is a piece of wood from my house in Arundel.

'That smell of ironing. And all the completely unreasonable things she ironed!'

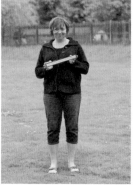

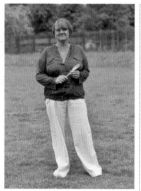

492 Debbie Kennedy
This is a slide rule from our ruler collection. My partner is a digital cartographer and he collects rulers, but this one's slightly damaged so he's agreed to donate it. We have had this for years; we've been together nearly 20 years and it's been kicking around the whole time. I work with computers also, and it's like a wooden computer. It's also very beautiful, very functional. You can do the times tables on it. But look, it's got symbols, it's got delta symbols and pi symbols. It would have been the iPad 2 of its time.

493 Bruce Henderson
It's a wood biro, which has written on it NZ Kauri. It comes from the kauri tree, which is specific to New Zealand, and is very old, 2,000 years old or something. I bought the pen while I was doing a round-the-world trip in 2006 after I'd retired. I met about 60 or 70 members of my extended family in Australia and New Zealand, ones I'd only been in touch with by email before that. I've got about 5,000 names on my family tree. As Celia says, I can bore for England on the subject of family trees!

494 Celia Henderson
This is my mother's wooden spoon. My mother Jean died 20 ago. We used this spoon when I was a child, to stir Christmas cakes; and I carried on with the same tradition. I just loved the idea of her being a part of this project, sailing off around the world. There was always a family tradition for Christmas cakes, and I've also got a knitting needle that we used to stick into the Christmas cake. I'm from Arundel and the spoon's been in a kitchen in Arundel ever since. So it's not a very well travelled spoon – yet!

495 Jake Woolcott and Josh Ogden
These are two hotel room doors, approximately 20 years old, from the recently renovated Swan Hotel in Arundel. The hotel is a Grade II Listed Victorian building, originally dating from 1759. It was completely refurbished in 2004.

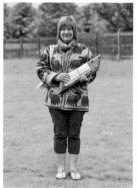

496 Annie Carder
I've brought in a piece off *Boomke*, a boat which was being built by my father, Dick Carder, before he died. He found it on Newport Quay on the Isle of Wight 20 years ago, looking in a very sad state, so he brought it home and started doing it up. These are two bits that he couldn't use in the restoration. He farmed most of his life but first he was a boat builder; he built MTBs in the war. He'd done the hull, and started the inside, but hadn't completed the engine, the trials and stuff.

497 Polly Atkinson
I've brought a pencil box, with various types of wood in it. It came with an explanation about all the different woods, but I'm afraid I've lost that. I found this about 30 years ago, in a store in the suburbs of Chicago; I used to trawl round the junk shops there. And I loved it, but I'm afraid I can't cope with the smell of it! I didn't want to just get rid of it, or inflict that particular smell on anybody. So I decided it would be best used on the boat. Where it might get weathered.

498 Margaret Birkinshaw
These ten oak drawers were handmade by a friend of mine, Tim Mugford. He had them in his garage, to store his bits and pieces in. But then he moved to Estonia, and didn't have any use for them, so he asked me to do something with them. I've had them about four or five years, waiting for something to happen. I've taken them to car boot sales, and everyone says, 'Oh where's the rest of it?' – thinking it's a chest of drawers. Tim used to sail as well. He married an Estonian girl and moved to Finland.

499 Vicky Rhodes
I've brought my old garden bench. I got it about six years ago, and had it in a nice sunny spot in the garden. It was on the lawn and when I went to move it, back in March when I was first going to cut the grass, I went to drag it across and one of the legs just sort of fell off.

'It comes from the kauri tree, which is specific to New Zealand, and is very old – 2,000 years old or something.'

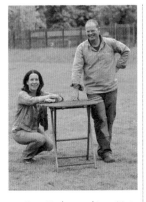 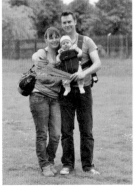 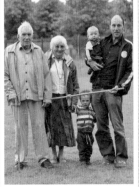

500 Jerry Lindsey and Jane Mote
Jane: It's the first dining room table we bought together 15 years ago, for our first house in Lllandaff, Cardiff. We bought it in Habitat for £25. Then we loaned it to my sister in Cornwall. Then it came back to us in Sussex, and we've shared many a meal and good wine with it, looking over the River Arun from our balcony.
Jerry: It was bought in a port, it lived in Penzance for several years, then spent the last few years overlooking the river. So it's not a bad destiny for it to end up as a boat.

501 Antony, Bianca and Noah Gascoyne
We have three bits of wood, one for each of us. We live in a very old house in Pulborough that we've renovated, and these are three bits that were left over from the renovation. They were actually for wattle and daub, so they're not really original. No one really knows how old the house is, but someone did a survey on it and they reckoned it was probably about 1400, maybe even earlier. And a lot of the beams are actually old ship beams. Whatever part we fix there's always something else that needs to be finished!

502 Martin, Julie, Dennis, Constance and Arun Webb
You are holding one of the struts from a baby's crib, the top bar – it was bought new for dad. Then his younger brother slept in it, and then it was used for seven grandchildren. And number six bust it up! So now obviously we need to replace it, and get it fixed... But we can't use this part any more, so here it is. For three generations it's stuck with our bit of the family.

503 Oly Curties
I've brought a sword that my grandfather made. I've had it for at least 28 years. My grandfather made it in the New Forest, in his little workshop. He was very good at carpentry and he'd make all sorts of things – forts, and bits and bobs for us to play with. He even made the stairs to his house. But this is a pacifist's sword – it's made with a pheasant's tail feather so it can't cause any damage, but it's still just as much fun.

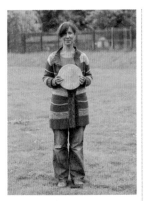

504 Fiona Andrews
I have brought a small breadboard, or it could have been used as a cheese board. I fished it out from the cupboard in our awful, ghastly kitchen. It is ghastly at the moment because we've got a flood; we'll never ignore a leaking pipe again. I tried to clear out the debris and came across this, which was very kindly given to me by my mum – because she's like that; she looks after us. I'll tell her that I've sent it overseas on an adventure. She'd say, 'That's typical of you Fiona, just like your dad!'.

505 Caterina, Solene and Mattis Declas
This is the headboard of the cot bed that all my four children have slept in, from about three months old to one and a half. It's been going for 11 years and I think that's enough now!

506 David May
I'm the chairman of the charitable trust formed after the council decided to shut Arundel Lido. We took it over. These steps were in the deep end, next to the diving board. The pool is now much shallower – we had it refurbished and it's now mostly a leisure pool, really. I kept these steps when I took over, thinking that they may go back somewhere in the pool, but they were far too long. They were in the pool from 1964 onwards, until the district council shut the pool in 1998.

507 Dominique and Jeffrey Booth
It was a nice Médoc. 2001 vintage, not bad. 2005 is better. They said 2009 was going to be fantastic. So you should invest in that.

'I'll tell her that I've sent it overseas on an adventure.'

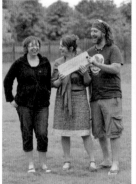

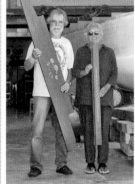

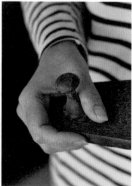

508 Debbie Kennedy, Felicity Jones and Nick Jenkins
It's an antipasti board! It's been purloined from the Osteria in Arundel, where we all play Scrabble on a Saturday and Sunday morning. We are the Osteria Scrabble Club. We didn't think the owners would donate anything so it has been stolen! He's our next-door neighbour. He won't miss a little bit of wood. It's beautifully made by Clive himself, who, with his brother and his father, did all the renovation on the Osteria. Clive made all his own antipasti boards.

509 Gerd and June Hassbach
I met June in 1965, in swinging London. We got married in 1970, and we lived in Germany and then in London. And this is part of an old bed from my grandmother. She was born in 1899, and when we got married we didn't have much money so she gave us this bed. June stripped it all off and then we painted it, and we had it for many, many years.

510 Sarah Riddell
This is my dad's mask. It's been part of our family's life for decades. It was put on to the wall outside in the garden, and dad decided to have a play around with it, paint colours on it. Dad died last year. In the last few years of his life he got really into sailing; he found what he really should have been doing with his life. My brother and I both really wanted the mask. This avoids arguments – giving it back to dad, like setting him off to sea again. That's where he would love to be.

511 Janette Scott
It's a last – a shape to mould a piece of leather around so it could become a shoe. I bought it in Jodhpur, India in 1994. It was the first time I'd ever been away on my own. That same day I went to a hotel in Jodhpur, one of the old Maharaja's palaces, and had a drink on the terrace, and George Harrison turned up! A helicopter landed on the lawn, and it was him and a whole entourage of people, and they got all the tablas and sitars out and started playing.

512 Ellen Norris, Jake Hickman and Mr Newman
Ellen: These used to be an oak tree. It was cut down for safety reasons but it means a lot to Petersfield School. The oak tree's been there longer than the school; it's at least 150 years old.
Jake: I was walking to Tesco and then I looked through the field and I saw it being cut down.
Mr Newman: We had to cut it down because one of the branches fell during the half-term holidays. Children used to sit underneath it, so there was a bit of a safety issue.

513 David and Pat Williams
Our son Matthew, who used to work as an oak carpenter, emigrated to Australia five years ago. Before he went he made us a lovely coffee table to remember him by – he even carved the date and everything underneath it. This is a spare piece. We've got a little grandson out there now. We use the coffee table all the time.

514 David and Pat Williams
These are ornaments that my mum Vera had in her flat. She died about five weeks ago, and she used to look at these every day. They're part of her collection – picked up on holidays. My mum always liked boats, and my father did as well, He was a fisherman back in Lowestoft in Suffolk.

515 David and Pat Williams
This is a part of an oar at least 30 years old, which I used to row out to our boat in its various moorings. It snapped, while I was using it! Like an idiot, I brought it home. I've sawn off a couple of bits, and this is the bit that's left.

'This avoids arguments – giving it back to dad, like setting him off to sea again.'

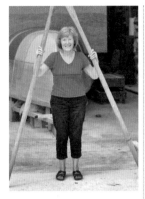

516 Margaret Wozniak
These are two oars that have come from a traditional 18-foot clinker-built motor launch called *Margaret*, after my mother. It was bought by my dad in 1934 from a boatyard in Bosham. After the war it was put in our garden, but unfortunately the children got in and did a lot of damage. My dad tried to restore it but didn't have the inclination as he got older. He would never let anyone buy it though. On his death we were asked if we'd like to get rid of it, so we let it go. Hopefully it's been restored now.

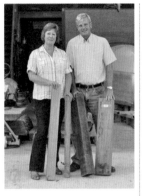

517 Michael and Angela Hodan
We've brought some oak. It's the result of a lifetime ambition; we wanted to build our own house, and we actually achieved this and finished it about two years ago. We used traditional materials, and we wanted a cottagey feel to the front of the house, so we sourced the oak in northern France. These are the offcuts. It's about 150 years old and when it was actually being prepared, shrapnel and bullets from the First World War were found inside – the tree had continued growing around them.

518 James, Luisa, Alex and Logan Hillard
It's the teak frame of a 1965 Guy Rogers sofa bed! It was James's parents and they bought it when they were first married. It came to us and we used it as a sofa briefly, until it broke. It had rubber supports, and every day another rubber support broke and we were getting closer and closer to the floor until there was none left! And then the new sofa arrived.

519 Peter Stern
These are all from *Barbary*. She was just a year old when we picked her up in 1966. We went all over the place, I've lost count of the number of times we crossed the channel. This was a little locker to keep bits and pieces and this was part of a rangefinder, in the days when you could locate your position by putting on headphones. You listened to the whistling, and when the whistle dropped you're pointing in the direction of an identifiable beacon on the chart. So you had a bearing. Much more hazardous than it is today.

520 Peggy Thomas
The cigarette box was made by my father Cecil Miller. I remember it filled with Craven A in the sitting room. He was in the Royal Marines, but between the wars he trained as a cabinet maker and would walk home from the yard with wood balanced on his bike. I can remember the smell of wood in his shed. He had an allotment and used to take baskets of veg to our neighbours to go with their meat ration on a Sunday. He put it on the doorstep and tiptoed away. A most generous man.

521 Caitlin and Cameron Nightingale
Some wood from a table from our daddy. He lived in France and the table's from France. The rest of the table was burned.

522 Ernest W Monnery
A scale rule. I started my life as an apprentice cabinetmaker, then I did my National Service, and when I came out I went into shop fitting. I ended up in the drawing office, when a set of these was given to me. It was used continuously until we progressed to computers. When computers came in, well, I was the wrong end of the scale as far as age was concerned, but I was always interested in that type of thing. I took to computers and I thoroughly enjoyed them. I still occasionally work on them now.

523 Valerie Catchpole
It's an unfinished, half model of a cadet. I started it as a project about 30 years ago for my eldest son and it never got finished, as you can see. Both my sons were enthusiastic sailors and cadets at Hayling Island Sailing Club.

'... shrapnel and bullets were found inside – the tree had continued growing around them.'

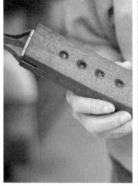

524 Valerie Catchpole
I don't know its official name, but it's a portable stand for a cello. You hook the two ends round a chair, put this on the ground, sit up on your chair, and put the spike onto that. I was a cello player but I haven't played for some time. I played it for about 12 years, as a very shaky amateur.

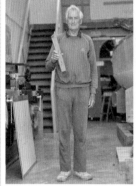

525 Tony Catchpole
Not much is known about it, I just found it on the beach at the bottom of our garden in Langstone Harbour. It looks as though it's come off a boat, because it has been quite well varnished at some point, but how it broke off I don't know. I've had it for about three or four years. Flotsam or jetsam, I'm not quite sure which.

526 Don Manson
I've brought some clothes pegs. My mother died 18 months ago and when we cleared her house, anything that was important – any documents – had a peg on them. Any cuttings she was saving for somebody to see, there was a peg on them. But it got to the point where there was a peg on hundreds of things! So you couldn't actually see what was really important. These are some of those pegs.

527 Carl Westby and Judy Allen
That's a brand new piece of timber from Wickes, but ... we had to buy it because Judy's dad, Fred, who's elderly now, has lived in his cottage for many years and the side gate blew off this winter. Last week, we went over to his house in Solihull, cut the timber to size, and we put the post up. Then we left him to put the old gate back together and hang it on there. For us it's just a bit of a memory. He's a hard man to please, but he was happy with the new post – remarkably!

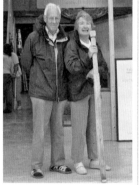

528 Liz and Robin Rolfe
It's off one of my grandfather's boats. His name was Charles Paxton, and he had the first mooring down at Cobnor. We don't know which boat this came off, he had lots of boats. He owned *Wild Swan*, which was here not long ago in Birdham Pool. When he died in 1969, aged 90, I inherited it. But why it came off the boat we don't know.

529 Becky Hurd
It's a wooden elephant bought from a Godiva Festival in Coventry. The elephant is the symbol of Coventry. The Coventry coat of arms includes an elephant and castle. Earlier versions included a tree. The Godiva Festival is the biggest Midlands three-day festival attracting thousands of people. I'm from Coventry, but I sail from Chichester Harbour.

530 Alice Kettle
A fellow artist made this. It's the head of a newel post, made into a sort of peg doll that we decorated for weaving. I'm a textile artist. The textile's gone, because you don't want any of that in your boat – except for the sails!

531 and 532 Joe Low
I'm afraid there's nothing sentimental about them at all. They're bits from the bike shed. One of Alice's daughters slept on this bed, and now it's a piece of wood that doesn't really have any purpose any more. And we're not sure where this second piece has come from, it's been down by the allotments for some time. It looks like it's part of a fence. But it has a point at one end, so it has purpose in life! It's pointing in a direction.

'I've had it for about three or four years. Flotsam or jetsam, I'm not quite sure which.'

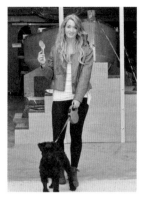

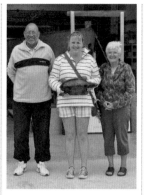

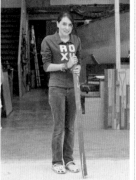

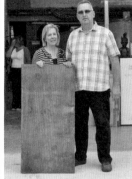

533 Maia Koumis
Two wooden spoons. They're from our kitchen; we use them for tzatziki and stuff. My grandpa is Greek and was a merchant seaman. He was in the Greek resistance and was in a firing squad. But he was saved with half an hour to go because his mother had given him a British passport as a child. And that saved his life. He was saved from the firing squad, put on a ship, and sent to England. He spent the rest of his life as a seafarer, a ship's engineer. He used to cook with us all the time.

534 Carol Masson
It's a turtle from Fiji, which I got when I was on Operation Raleigh, sailing on a square rigger from Hawaii to Australia. Then Mark Covell took over on the square rigger from me – we did the leg before him. We had to go into dry dock because the boat was sinking! We were there for a week unexpectedly. This was a present for my parents, because they were very supportive, with all the fundraising and everything. The grandchildren play with it, and the puppies have chewed it.

535 Rebecca Meades
A piece of wood from my birth tree. It blew down a year ago. I'm 12, so this is 12 years old.

536 Richard and Janet Brown
I think it's mahogany. It's part of the original science lab benches in Bournemouth Secondary School. It was taken out as part of a refurbishment, and this was left over. Janet's uncle, Charles Alan, was a local builder and party to the refurbishment work. And when they were moving out of their bungalow, and with me being an ex-carpenter-joiner as well, they passed on lots of timber and bits of these things to me. This is the last remaining piece that I have.

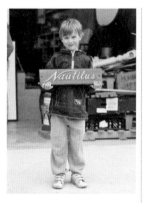

537 Oliver Gray-Rollings
It's the old name plaque from our boat. The name was *Nautilus*. We've changed it back to *Nimrod*.

538 Sam, Ben, Caroline and Andrew Thomson
This is the kitchen table that I ate my meals on for the whole of my childhood. I think it probably originates from 1965. It's been kicking around in my shed. It's a piece of solid elm, I think. My mum was a very good cook so we ate extremely well.

539 Helen and Lucy Dear
I've brought you the top section of a lovely bench that was made in memory of a very dear friend of mine, who died in 2009. One of her final requests was to have this bench made in memory of her at the Emsworth Sailing Club. But I very stupidly got the date wrong, and although she would have found it very amusing, it was a bit frustrating at the time. Consequently, there's a piece of oak up for grabs. The bench is on the decking at the sailing club, it looks out where she always sat – sunbathing!

540 Oliver Gray-Rollings
When I went off with my friend Kate we walked together and we found this piece of wood. It was much too big and we dropped it. Half of it broke off and fell down into the sea. We picked the other bit up together and we went all the way up on the bridge where there were all these stinging nettles. I also found lots of stones and shells, and some ancient wheat from an old Saxon field.

'He was saved from the firing squad, put on a ship, and sent to England.'

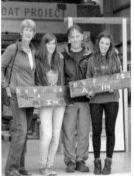

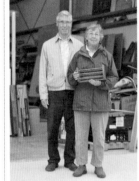

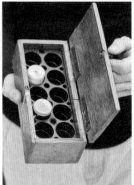

541 Diana Beale, Philip Taylor, Kate and Rosa Taylor-Beale
We live at Cobnor, and three years ago our very wonderful friends, and the two youth activity centres there, put together a fundraising music festival called Cobstock. These are two signs from last year's Cobstock. The girls came with a lot of their friends, and they had their special field called the backpacker's field. It was a bit anarchic. Masses of 15-year-olds! We've come straight from Cobstock 2011 today. We've just had the most amazing, happy community music festival.

542 Allan and Brenda Payne
This is a fruit basket, an old design, from my father. He was a London schoolmaster, and these were probably made in their hundreds, because it was the first school project that he got each of his classes to do. So generations of small boys would have made these baskets.

543 John Pile
This was in my garage for quite a long time, and it was cluttering the place up, so I thought I'd like to get rid of it. It's just an offcut.

544 Alison Stewart
I've brought a box that my grandpa made for me in 1981, out of a wardrobe door. He made it to put pots of paint in when I was at college in Glasgow. That's why there's paint on it. The hinges are from the wardrobe door as well. Now I'm a textile artist so I don't need a paint box any more!

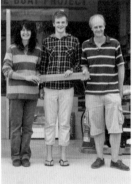

545 James, Becky and Thom Dunn
This is piece of floorboard from an inflatable boat, which we used back in the 1980s when the children were small. This is about the last remaining piece of that boat; the rest of it has fallen to bits. It was bought by my stepfather, and he used to take the children and their cousins on jaunts around the coast in Pembrokeshire. He's now long gone, so that's the end of an era. Happy memories of happy holidays.

546 Emma Macey, Harry Glover, Lily Gray, Henry Langford, Lara Mogridge, Katrina Dare, Leah Rees, Katherine Shepherd, Samuel Horsman, Fredrik Loh, Charlie Silver, Esther Tuttle, Edward Glastonbury, Sebastian Martin
Mrs White's husband Les made this mahogany cross. Mrs White is a dinner supervisor at St Alban's School and she's worked there for 25 years. It went in our Easter garden, on the school field.

547 Sebastian Martin
A cutlery drawer from my den. My granddad built the den with my dad. They got loads of pieces of wood, and they got the roof bit off my next-door neighbour, and they built the rest. There are rules in my den: no talking during meetings unless you're asked a question, no vegetables, no fruit, and as much chocolate as you can lay your hands on. I made those rules.

548 Lara Mogridge
It's from my boat, *Drifter*. It cost only £50. My dad's getting it ready, so I haven't been out on it yet. It's my birthday today and I'm six – it feels great.

'There are rules in my den ... no vegetables, no fruit, and as much chocolate as you can lay your hands on.'

549 Ernest Yelf
This T-square is nearly 50 years old and it was the one I used in my very first job when I was in architecture. I also tried to find a nautical connection, and the only one I could think of is that I did some design work on a pub called The Victory. I also worked on a pub called The Old Yachtsman.

550 Esther Tuttle
It's from St Mary's Church on Hayling Island. They're taking the pews away and my dad's taking the wood. He's going to make me a table for my house, but this is a bit he doesn't need. We've got an extension at the back of the house, that's where the table will go.

551 Ann Tucker and Oliver Fowler
This is the toolbox that belonged to my husband, Keith Edward Tucker, who was a shipwright in Portsmouth dockyard. He was a shipwright apprentice, then he became a design draftsman until he retired. He died of mesothelioma, a cancer he got from exposure to asbestos when he was a shipwright. It was just in the air.

552 Joyce Silman
A piece of oak carved into the shape of an oak tree. I gave this to my parents in the mid-1980s because their sideboard table and chairs – made by dad in the 1950s and 60s at evening class – were also in oak. The sideboard took a long time to make. This piece sat in front of the French windows for many years. I kept it when the time came to clear their home. This project would have fascinated my dad; had he been alive he would have been rummaging around to see what he could donate.

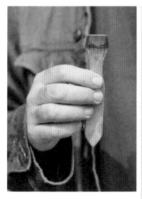

553 Jon Adams
This is a handle from a paintbrush that I used to make flags for the first time about two years ago. Now I've probably made about 15,000 flags. I did the flags project last year for Open Weekend: people around the country made flags from old books and kebab sticks, then planted them, drew them, or sang about them, all at the same time over that weekend. It's happening around the world now, and will carry on until 2012.

554 Jon Adams
I'm dyslexic and have Asperger's. At school I wasn't much good at lessons; drawing was the only thing I could do. The Head came round and saw the picture I was drawing and asked me to write my name on it. I had to ask for help or just guess. So I just guessed and he tore it up – said I'd spoilt it, because I'd spelt my name wrong. My mum worked at the school and dad grabbed a bit of the furniture they were throwing out. This is a piece from one of the bookshelves in that classroom.

555 Arthur Mack
These are from HMS *Invincible* – a pulley-block spindle, a fid for the riggers and part of a gunpowder barrel. In 1979 I was trawling and got my nets caught on the seabed. It took two months to find the spot again. I had that gut feeling there was something there. We had to get an archae-ologist and a conservation officer, we funded everything ourselves. She was a big ship, even though she only had two decks. We captured her from the French off Finisterre, on 3rd May 1747. Then she was commissioned into the Royal Navy as a flagship.

556 Tina Shervell and Tariq Al-Maskriy
It's a table and it was my grandfather's. He was in the Royal Navy, because when he was a very young boy his father fell from the rigging in the dockyard and died. So he and his older brother were sent to the naval school in Greenwich, as their mother couldn't support them. He was nine and his brother was 11. Then when he was 13 and was in the navy he purchased this, in somewhere like Singapore or Hong Kong, and it's been in the family ever since.

'I had that gut feeling there was something there ... She was a big ship, even though she only had two decks.'

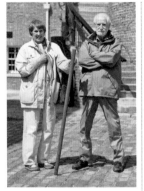

557 Ray and Kate O'Beirne
It's from a boat called *Tudor Miss*, which Ray used to sail and race. It was part of the restoration project on the cockpit in 1965. This wood has been propping up vintage motor cars as well, because Ray re-builds and races them. Last time I saw *Tudor Miss* she was in Shoreham harbour, but that was quite a few years ago. I don't know where she is now.

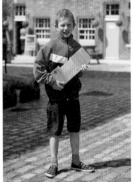

558 Samuel Taylor
This was a bed. It came from a tree, and then someone built it for my dad and my dad gave it to me. I kept some of it to keep me warm in the fire, and then I got a new one and now it's here.

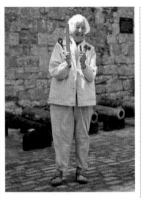

559 Jean Theobald
This is my husband Henry's school ruler. He later became a clergyman and worked in various places in London, and hospitals down here. This was a gavel that he used at various church meetings. And this was given to him by a Jewish friend; it's called a *mezuzah*, a little prayer which they have in Jewish houses. And the last thing – we were in Russia on our Ruby wedding anniversary in 1996 and we brought this wooden spoon back.

560 Keith Cornish
This is from the Bonham-Carter estate. Mum and dad were working there, picking hops. I was there from 1943, when I was born, to 1958. In the hop gardens you had a camp, in the camp you had four cookhouses, and in the cookhouses you had four coal-fire ranges. This was out of our cookhouse and – boys being boys – we got the poker and burnt holes in it. It was the Queen's Coronation, so we carved 'ER' on it. They disbanded the estate, pulled down the cookhouses. I've had this old bit of wood ever since.

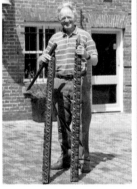

561 Chris Waters
These three pieces come from East Africa. In Zanzibar and along the coast of Tanzania there are many houses made with carved wooden doors, and these are from the frames of those doors. I acquired them in the 1970s when I was working in Dar es Salaam and travelled around Tanzania. The house had in fact collapsed and was just a ruin, and we were allowed to take these pieces of wood. I've had them all these years and haven't really done anything with them.

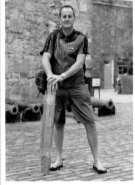

562 John Bagnall
This came from the garden of our house in Southsea. It was part of an old garden frame that had been built to grow plants in, or to shelter them. I dismantled it because it was falling to pieces; but some of the wood inside was very sound, and I'm always loath to throw away wood. I've been keeping it until a good purpose came along.

563 Heather Todd
It's a very small but perfectly formed wooden spoon. I was down at the Witterings camping a couple of weeks ago, walking through the sand dunes, and I saw this sticking out of the sand. So here it is! I almost didn't part with it this morning because it's just too lovely; it's all misshapen and the bottom's missing and it's covered in dried sand.

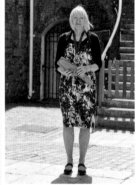

564 Cheryl Buggy, Lord Mayor of Portsmouth
I like the concept of beachcombing – maybe it's stuff for free that I like. But you do find lovely things on beaches. This first piece I collected here in Portsmouth a few years ago. And the second bit I collected in Maui in Hawaii. Every time I come back from travels I bring stuff I probably shouldn't bring! I have a room downstairs in my house that is full of baskets of driftwood. I'm not sure what I'm going to do with it all. But I just think memories are good, aren't they?

'In Zanzibar there are many houses made with carved wooden doors, and these are from the frames.'

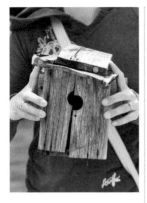

565 Helen Swatton
I've brought you a bird box that was on my parents' shed when I was growing up, and it had various blue tits and great tits in it. It's always been there and it's always been part of the garden. I remember it was the only thing that stayed on the shed in the 1987 hurricane – we lost apple trees and things like that, but the bird box still stood!

566 Helen Swatton
This is a shovel that for years and years has been outside my granddad's house, which my uncle now lives in. They're not quite sure of the story behind it, but apparently my granddad went out one day and came back with this shovel. Now my uncle's been using it as a snow shovel for the last 30-odd years, so it's got a bit of a family history to it. I'm not sure how my uncle's going to move his snow now!

567 June Sparrow, Lucy Tompkins, Russell Tompkins, Eleanor Tompkins, Harry Tompkins
Lucy: This is an oar of my dad's, and one of the tools that he made, a set square. He was a traditional boat-builder, for a small yard in Christchurch. The oar is from a dinghy that we had. We always used to have a sailing boat, but not any more.

568 Joyce and Joe Barber
This was washed up at Hayling Island. At the time Joe was collecting driftwood and making wonderful things, and my husband said, 'Shall we take it back for Joe?' But because it was heavy we thought we'd let Joe come down and decide. When Joe saw it he thought it was a lump of mahogany, and his dad said, 'Ah, that's mahogany Joe!' His dad died seven years ago and he just hasn't got the heart to part with it. We've had it for 12 years and it came from the sea, so this is just the perfect end.

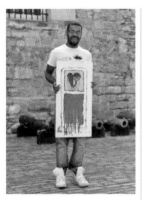

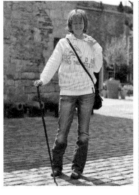

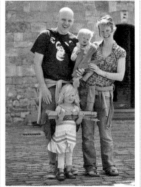

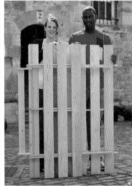

569 Nicholas Forbes
I've brought an old bit of artwork. I've moved on from this type of work now. I got it from the workshop at the University of Portsmouth, when I was a student, and liked the size and shape of it.

570 Anne Exton
I've brought my dad's walking stick. He died on May 23rd last year. He was a sailor, and we scattered his ashes at sea with the Inshore Rescue. We also had a bench erected in memory of him, at Lee-on-Solent in Gosport, looking out to sea, with 'John Herron always at sea' written on it. He was in the navy for 40 years or more, and was Chief Petty Officer when he retired. He loved it – that was his life. He's from Scotland but moved down to Gosport where he met my mum, who's a Pompey girl!

571 Del, Mia, Meg and Luca Thomas
We've brought four banisters and three bits of wood from our old kitchen in our first family home. We had to rip out a handmade kitchen that had about 2,000 nails – it took forever, and in the end we just attacked it with a hammer and saw. And the banisters were broken and we've replaced them. We bought the house off someone whose dad was a carpenter – the kitchen wasn't particularly child-friendly and it was slightly infested, so it had to come out. Thousands of nails. And lots of wood.

572 Laura and Shelton Chikomwe
It's part of a sofa bed that we don't need any more. It was given to us by friends who brought it back from Australia. They came over here and went back again and they didn't need it, so we took it off them. They had three dogs and a cat, so it's got some dog and cat damage, and is a bit bashed from transit.

'They had three dogs and a cat, so it's got some dog and cat damage.'

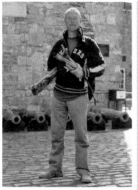

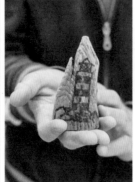

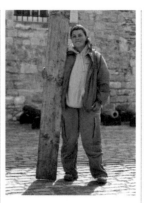

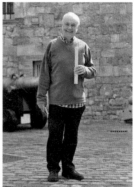

573 Martin Chalk
Since childhood I've gone along the seashore here and picked up interesting things. Among the selection here I've got a piece of wood that's particularly old looking, part of a boat I expect. It reminded me of my aunt, who would go down to the seashore every day, collect driftwood and burn it in her open fire. She never bought coal or wood, she just got it for free from the sea. It would kind of jump, presumably because of the salt in the wood. It's the thrill of the find – I call it fossicking, to keep that word alive.

574 Martin Chalk
On this piece someone's drawn a little picture of a lighthouse. It's almost like a piece of scrimshaw, the old whale's teeth. It's a piece of folk art. This was from along the seashore in front of the castle, down towards the pier. I just found it today, it was there waiting. When I turned it over, it revealed that – beautiful.

575 Michelle Heard
I like to beachcomb with my boyfriend. It's quite rough weather out there today so it was quite hard to get the sea to chuck this scaffolding board back out and then for us to grab it. I suppose, because we live by the sea, we're always down there picking up stones, or when we go crabbing with the kids we see if we can get stones with holes in them. It's just nice to walk along down there.

576 Stephen Kerr
It's a piece of pine from our first piece of DIY – we made a window seat. We made it about 15 years ago now but I just happened to find this.

577 Brenda Lock
My husband Ted made this when he was a little boy. He'd always wanted to be a carpenter, but it was a big family and they didn't have much money so he never became a carpenter. But his mother kept this box and kept her bits and pieces in it until she died, six months before her 100th birthday. Then it was handed over to Ted. He died suddenly four years ago and this is a little memory, because I've got nobody to pass it on to. He didn't become a carpenter; he became a stonemason.

578 Chris Collier
I'm a bit of a beachcomber and in particular I like sea glass and sea wood, and this is a piece of sea wood. I remember collecting it under South Parade Pier about 15 years ago. I beachcomb whenever I get the chance. Out of some of the suitably sized pieces of sea wood I've made instruments originally called diddley bows – an old basic blues instrument made with a single string and usually a screw. They need one bit of wood about two feet long, then some of the smaller bits to make up the bridge and nuts.

579 Jayne Dalley
It's a handmade wooden box, it's got a plaque with the name of HP Casey, my grandfather. He was born in the late 1890s. He was a big motorcyclist, we inherited some cups he won for doing the Lands End to John O'Groats run in 1925. He lived on a Thames houseboat called the *Count Dracula*. Granddad died, but grandma came here and was the publican at The Old House at Home. When she died this was left to my aunt. Then when my aunt died this was left in a box of stuff that my sister inherited.

580 Maxwell Hyde
It's a three-part hinged table to read your charts on. I no longer need it on my boat, *Hesperus*, which I bought just over a year ago and am currently restoring in Emsworth. I was desperate to donate something so I unscrewed it this morning! Originally *Hesperus* was a 1955 lifeboat, and at some point he was converted into a motor launch. I've had him for roughly a year and he's yet to move anywhere! I rarely get time to work on it. But it's the love of my life, a beautiful little boat.

'It's quite rough weather out there today so it was quite hard to get the sea to chuck this scaffolding board back out.'

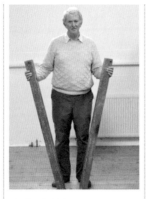

581 Julie Bright
I've brought some pieces of wood that have made a significant difference to my life. I went on a self-development weekend, and we had to walk over hot coals and break pieces of wood in half with our hands. So I've brought the wood that I have physically broken in half with my hands.

582 Sandy Dale
The only surviving pieces of a Victorian bedstead. It came through my father-in-law's family, who lived near Manchester. These two pieces have been transported around the country in various shapes and forms, and were something that my father-in-law always intended to use but never got round to using. I've had them for several years, never found a use for them. Then I suddenly thought, this is the best place for them.

583 David Merry
This is a boatswain's chair, used for getting to the top of masts. I made it about 40 years ago. It used to have a block and tackle, so I was completely independent of help and I could climb up about 40 feet. I worked between Brighton and Poole. In 25 years I only had one major accident, a customer let go of the wrong piece of rope. I went sailing down in space, and was off work for six months. I caught hold of the wires and eventually came to a halt; it put my shoulders out, and my hands.

584 Lt Cmdr D J 'Oscar' Whild
This is a large piece of teak, about seven or eight feet long and a foot wide. It was taken from the port forward section of the HMS *Victory*, during one of the many refits that she's had since coming to dry dock in 1922. I've been the commanding officer of HMS *Victory* for nearly three years now – it's the best job in the navy for a lieutenant commander.

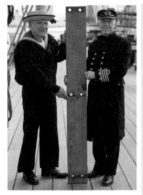

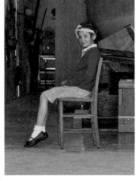

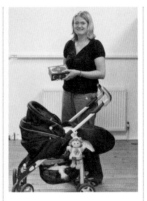

585 Cmdr Ken Jones
This comes from HMS *Warrior*, 1860, and I'm the captain. This is a piece of opepe from our bulwarks, which we're restoring. The ship is made of iron – it's the first of its type, the fastest and the biggest. Actually, it's the ship that changed the face of naval warfare. The ship was built on the banks of the River Lee, at the Thames Ironworks and Shipbuilding Company, under what is now Canning Town railway station in the London Borough of Newham. Which is where the Olympics are being held. So this bit of wood is going home.

586 Kieren Bateman, Robbie Bessey, Kirtis Bateman, Kayleigh Dyer, Keeleigh Higgins, Tommy Orsmond, Shay Heeley, Chrystal Brown, Chrystal Ponsford, Amy Smith, Matthew Garty, Rebecca Wolley, Shelby Edwards, Shania Hancock
Matthew: This is a wooden chair. It is one of the original chairs used at Riders School 56 years ago, when it was first built. These chairs are used on special occasions or for special things. We had five, so now we have four.

587 Fiona Willmot
This is a container that I've been using as a tea caddy, although it's not very airtight so it's not really very good! I've had it for 16 years, it's a traditional Romanian design – this sort of paintwork is very traditional in Romania. Not long after the fall of the Berlin Wall and the revolutions in Eastern Europe, I went to work for a charity that was helping people out there, and taught in a kindergarten in Romania. I loved all the traditional craft there and brought home lots of jugs and pots and plates, and this wooden container.

588 Nicki Conyard
I've brought you a bowl that my son's godfather made. He did a lot of woodturning, but he's now in his late eighties and I'm not sure he continues to do that work. It's just beautiful, and I thought it would look really lovely as part of the boat.

'Actually, it's the ship that changed the face of naval warfare.'

589 Sue Tate
I've brought for you a toast rack. It was given to me as a gift by my son, for Christmas one year. It must have been about 1982 because it was the first piece of woodwork he'd ever done at school, and he'd inscribed his name and his form on the bottom. We used it a lot of the time, especially when he was at home, but I'm afraid it's been stuck at the back of the cupboard for many years.

590 Elizabeth Bowles
It's part of my much-loved kitchen. I had an old fashioned larder, but that's come down now I'm having a new kitchen fitted. I've loved the old kitchen, so I thought I'd bring a drawer front – this was the cutlery drawer.

591 Valerie Bird and Lily Gray
I've brought you a piece of a crab-apple tree. It was originally planted for Andrew Bird – Andy – my son. It was about 17 years ago that he died. We buried his ashes in Warblington cemetery and then planted the crab-apple tree on top. It was lovely; it flowered and we took the fruit. Then somebody vandalised it, just chopped it off from the trunk. It was quite big by then. When this came up it seemed ideal, because he loved sailing. To be part of a boat would be absolutely brilliant for him.

592 Amanda O'Reilly
I've brought you the David Spackman sign that used to be above the theatre. All the signs have been updated and replaced but I've been keeping hold of this one. David Spackman was the founder member of Bench Theatre Company who were instrumental in having this building changed from the old town hall into a venue. He was also instrumental in it then becoming the Havant Arts Centre. David died of a heart attack a few years ago, but his wife still attends as a member.

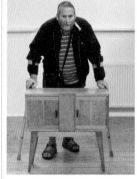

593 David 'Spike' Spears
This is a name plaque from the charter fishing boat *Bessie Vee*. There's two of them, *Bessie Vee* 1 and 2. I started helping somebody out, then I bought the boat because he gave it up. The *Bessie Vee*'s been in Langstone for almost 30 years. I've had to give it up for medical reasons. But the second one is now working down in Mevagissey, so her life is continuing. I owned the two boats for 19 years, I was a charter angler. I'm an ex-navy diver – so I've gone from working underneath it to working on top of it!

594 David 'Spike' Spears
It's a sewing cabinet. I made it back in 1969, at school – it was a project I had to do before getting thrown out! But we won't go into that. Wood wasn't my favourite subject, but it's stayed in the family ever since. This went from my parents on to us, then my daughter, and now it's being donated to a good cause. These days I build birdhouses and bird tables for anyone who wants them. If it wasn't coming here it would be turned into a bird box or something similar! Wood just doesn't get scrapped, you know.

595 Deborah Stallard
I took a few months off work in February. It was cold and I was worried about a high fuel bill. Where I worked there was a huge pyramid of wood used to fuel the boilers. I put the back seat of my car down and filled the boot! My husband discovered what I was doing and said, 'You can't burn it, I could tan it and make knobs with it'. I said, 'Knobs?' Now six years on are there any knobs? Of course not. I had to steal this wood back today. So here it is, twice filched.

596 Rupert Rowbotham
This is a light fitting, an original feature from our house in Oxford, when we lived there. I thought it a beautiful object. It's a symbol of the time I don't have. Because you can see it's beautifully curved wood and lovely wooden fixtures and I thought, that needs to be restored. But sadly I don't have the time. I've looked at it many times, and I've left it in my garage and I've gone, you know, I want that up in my room. And it's just not happened, in about ten years – so, a decade of looking!

'I thought it a beautiful object. It's a symbol of the time I don't have.'

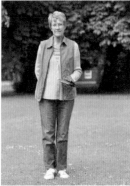

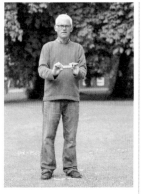

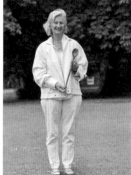

597 Nick Fox
I've brought an oak joist from our 17th-century house in the centre of Chichester, taken out recently when the death watch beetle got the better of it. We've lived in the house about 20 years. The joist is original, probably about 400 years old now. Death-watch beetles are fundamentally lazy beasts, and the centre of it – which is the old core of the oak – is unaffected, it's just the outside part. The death-watch beetle had given up holding hands in the middle! The repair job went alright, a bit tricky, but alright.

598 Ann Kent
These are two pieces of old roofing timber from our local 12th-century church, St Peter's at Westhampnett. And the other is a piece of flooring. We had a small fire last year, and it took a pew out. This is part of the platform that the pew was on – floor joists that would have been installed way back in 1862. The fire was a silly accident. We'd had our May fair and because it was Easter we'd left the Paschal candle burning, and some of the hot wax dropped down and set fire to the old floorboards.

599 Andy Jones
This is from a stunning, isolated place called Hilton, in the north east of Scotland – beyond the Black Isle. I was sitting on a beach, virtually for three years, because my cottage was on the beach, and this bit of wood drifted towards me. So I picked it out of the water. I was in theatre and I was drained – exhausted – so I thought it would be nice to live in the wilderness. I just thought, I'll stay as long as I feel comfortable with it, and then I thought, I need to come back to civilisation!

600 Victoria Atkin
I've brought this pretty spoon. It was given to us by some Argentinians, because they donate things like that; they give it to family and friends to promote good cooking and good hospitality in a house, and it's sort of like a memento, for good luck. Obviously I couldn't use it as a cooking spoon because it's too pretty. It's painted, and I don't like to hang things on a wall, so I decided to use it to threaten the children with! But I never actually used it, it was only as a threat. It's now 26 years old.

601 Michael Atkin
I've brought you my secret money box. Having been born just after the war, instilled into us as children was the whole principle of thrift. So given to me by my great aunt, I think, when I was very young, was this secret money box which still has a 1955 two-shilling piece in it. And it says on it: 'Thrift – Not for to hide it in a hedge, nor for a train attendant, but for the glorious privilege of being independent'. And I've lived by that all my life. So for me it's quite a symbolic thing.

602 Hilary Caffyn
This is a donation on behalf of my sister, Valerie Skues. It comes from St Peter's Church, East Blatchington, Seaford, in East Sussex, and it's part of an organ that was built in memory of the men who lost their lives in the First World War in the parish. It was replaced by a digital organ, so of course they didn't need the wooden pipes any more.

603 Jill Strudwick
This belonged to my grandfather. During the war it was given to my aunt to look after because we lived in London. And then I did music O-level, so I became the owner. I got married, had my children and eventually it ended up in my loft. When I retired a couple of years ago I thought: right, I'm going to try and play it again. But damp had got into the loft and the whole thing had disintegrated. It must be about 100 years old. I've cleaned up that inscription – 1721 – a hundred years of dirt.

604 Tim Gillin
My father was in the RAF during the war. He sent this to my mother and me from Singapore. She received a letter from the postal authority saying it was too big to send on. Singapore fell, then six weeks later we got a telegram saying 'Safe. Java'. Unfortunately by then Java had also fallen. My mother wrote a sob story saying it may be the last thing I ever get from my husband. He was one of the lucky ones. This spent the last 14 years in the nursing home with mother, until she died this year aged 101.

'I decided to use it to threaten the children with. But I never actually used it.'

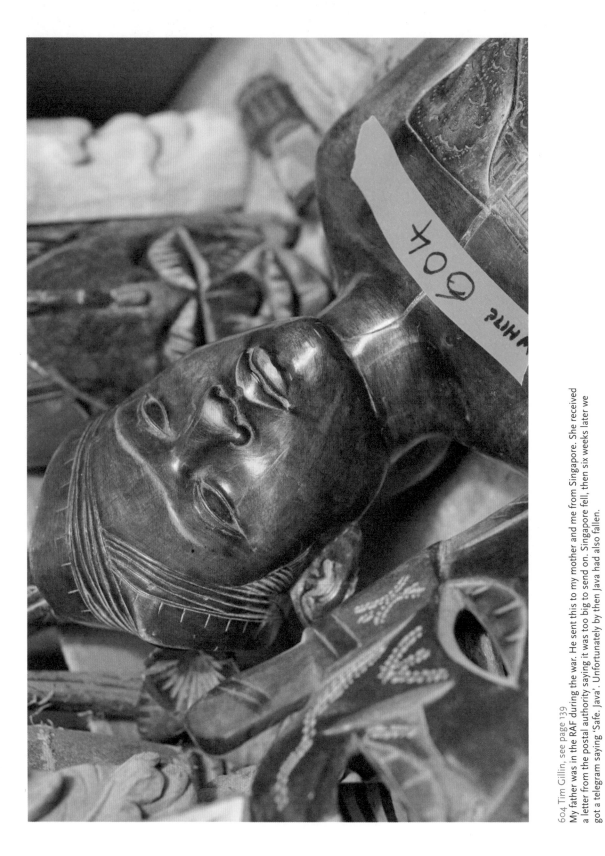

604 Tim Gillin, see page 139

My father was in the RAF during the war. He sent this to my mother and me from Singapore. She received a letter from the postal authority saying it was too big to send on. Singapore fell, then six weeks later we got a telegram saying 'Safe. Java'. Unfortunately by then Java had also fallen.

THE LONE TWIN BOAT PROJECT 140

'And this spent the last 14 years on the dressing table in the nursing home where my mother was... '

605 Shirley Craig and Bunty Clatworthy
These boxes contained thousands of pounds worth of securities that went to Canada for safekeeping when Churchill reckoned that Britain was going to be invaded, after France fell. Our father, Alexander Craig, was in charge of the operation, he was Chief Auditor and head of securities at the Bank of England. The value of securities was said to be £1,250m, and £637m in gold. We were in Montreal all through the war. Then a destroyer took everything back.

606 Lucy Burt
This is a piece of wood that I found at the bottom of my garden in a pile of sticks. It's probably been used for a barbecue!

607 Lara Robertson
I've brought you a plank of wood, from my garage. I think it was going to be used for some construction in the garden, a new patio, but we never used it.

608 Angus Peel
I've brought part of a tree from our back garden in Chichester, down by Chichester Gate – it was cut down because it was rotting away. It was just getting old and a bit of a hazard, so we cut it down. The tree was a screen in the back garden – from the ghastly other neighbours!

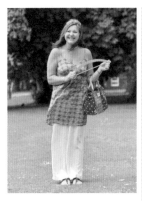
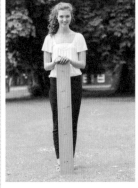

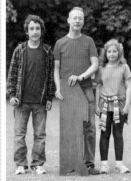

609 Sue Howell
It's an old wooden coat hanger. My grandparents lived in Germany for several years and when they came back about five years ago they brought it back with them. It had a garment on it that my granny gave me, and I kept the hanger – it reminds me of when they were there. They were just south of Berlin. I think they'd had relatives there before, and decided that's where they wanted to live, so they were there for about ten years, then decided that they wanted to be back in the UK.

610 Molly Peel
I've brought a plank from my old house's loft, in Westbourne. The loft had a collection of all the stuff that we kept over the years, and so I thought it would be cool to take a plank of wood, to remind me of that house. We left there about four years ago, so I've just kept it in my room – because I know that if I put it outside it will probably get used for something else, and I don't want that to happen!

611 Charlotte Howell
I found this in my loft, in Singleton. I was going to make it into a bird table but then I didn't have time – I just haven't got round to it!

612 Bill Johnson, and Jack and Sally Piper
I've brought a side of a bureau, which I had when I was a kid studying for O- and A-levels. I spent many hours studying at it. It became very dated so I ended up smashing it up and putting it in my loft. I felt a bit ashamed of myself breaking it up, but it's very much a dated thing and a dated thing you don't necessarily want to keep in these days of Ikea! I think my mum and dad got into going round salerooms; they liked buying old furniture and repairing it.

'These boxes contained thousands of pounds worth of securities that went to Canada for safekeeping.'

613 Naomi Weight, Liz Parkes, Sarah Stoddard, Charley Fox, Danielle Plowman, Reah Butterley, Alicia De Lacey, Natasha Hancock and Emily Jordan
This is a coat hanger. We are the Chichester Festival Theatre Wardrobe Team. Most recently, this had Tim Curry's costume hanging off it – he can't be with us because he's not very well. It would have been used for the heavier garments, and the ones that needed some padding in the shoulder. But it could have been anyone's: Diana Rigg's, Felicity Kendall's, Patrick Stewart's, any number of people.

614 Rupert Rowbotham
Paul Brown designed the set for Chichester Festival Theatre's *A Month in the Country*, the final production of 2010. *A Month in the Country* was a beautiful set, a gorgeous Russian villa and beautiful grass everywhere, and the set came right out over to the audience. This is a plank from the veranda, I think. And it was really very well received, a wonderful production, directed by Jonathan Kent, and it had Joanna McCallum, Janie Dee, Kenneth Cranham ... you know, all pretty well established and classy actors.

615 Greg Slay
What we have here are six pieces of wood. In fact they're actually originally two pieces of wood, they were two scaffolding planks, and we acquired them when we moved to our current house in 2006. They were left behind by the builders of the house in the early 1970s. Quite why the builders didn't take the scaffolding planks away with them is a bit of a mystery. We think they are contemporary with the age of the house, and they've lived in Fishbourne all that length of time.

616 Adrienne Pye
A 'Hog the Limelight' pencil from the rural touring unit that Hampshire run, so it's getting a little bit of theatre onto the boat! The Hampshire County Council arts service pay part of the cost of having an event in a village hall, at a village fete, or a festival, until the promoter feels they can go it alone – to get the local community more involved in the arts. We ran a marrow project last year – growing marrows, singing about marrows, dressing up as marrows. I dreamt about marrows for rather too long!

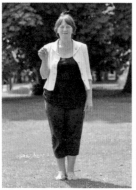

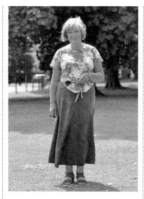

617 Jane Kilford
I've brought a wooden cotton reel, with a bit of yellow thread on it. It's quite an old cotton reel, from grandmother's button drawer. I used to sit and go through the drawer, with the bobbins and things. It's attached to the times I used to spend there in Otterbourne. She used to sew, and my mum sewed and I've inherited that ability to make. As an artist I use things with memories attached to make things. This represents me being able to let go of things. It's quite a big step, it means I've got to de-clutter my house!

618 Kim Hope
This is part of a table, and I don't know how it can possibly have worked – it had three legs. Apart from being a well-known children's book illustrator and Punch and Judy man, my grandfather was a conjuror, and this was part of his conjuring table. I knew you'd never guess it! He used to make furniture and he will have turned this himself. His name was Charles Folkard. But he also made his money doing children's conjuring shows. He was tall and had curly grey hair – he was an absolute magic man.

619 Lynne Jeffrey
A wooden spoon. Yes, it's much used, much loved – it was given to me when I got married in 1979, with bits and pieces dangling off it. It's been my spoon of preference for many years, but now it's split. So that's it. My favourite spoon.

620 Laura Doye
I've brought some bits of wood that have been used as drumsticks – they're not actually drumsticks, they're just bits of wood that I found. We've been rehearsing here at Chichester for a piece called *She Loved to Dance in the Rain*, with the Youth Dance Company, and now we have real drumsticks, so I can donate the ones that we've used for rehearsal. We've been in rehearsal for, well, about a month now, dancing our hearts out.

'My grandfather was a conjuror, and this was part of his conjuring table. I knew you'd never guess it!'

621 Diana Brown
It's our name pad from our boat, a Lymington One design, which we bought in Mallorca. We sailed out of Port Andratx. I wasn't very experienced but my husband was a bit. We had a lovely time, sailing and swimming off the boat. We came back 12 years ago. My husband wrote an article in one of the magazines in England, telling the story of what we'd been doing with this old boat. He died when we got back – just passed away in the middle of the night, a lovely way to go.

622 Richard Minton
This is from an oak tree that was felled in a skate park in the Westgate Centre here in Chichester, to make way for a new skate park. The reason I thought it would be appropriate is that a lot of the youngsters in Chichester would have grown up around the tree, skating, sitting around it and what have you. And they would appreciate it being remembered and being put to good use.

623 Lesley Mann
I've brought you my grandmother's walking stick that she used up until she was in her early nineties. And when my brother and I were clearing my mother's house, after she'd died, my brother thrust this into my hands and said, 'You have this, because you're going to need it before I will!' Yes, dear little brother! Anyway, I don't want it, I'm very happy to be passing it on. My cousins live near Milton Keynes, and the boat's going there, so I thought it will be an opportunity for them to see their grand-mother's walking stick.

624 Maureen Barrett
These are planks of teak. They've come from Earl's Court exhibition centre, from the old escalators they pulled out, I think it must have been in the early 1980s when they were renewed, and this teak was just thrown on the scrap. It's probably as old as the building. People who worked there got passes if they wanted it. My husband was a joiner there for years. We were living in Essex then, so it came with us. And we've used other bits to make things – a little corner shelf, a set of tables, and another set in the loft.

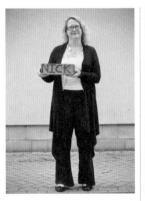

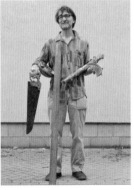

625 Wendy Atkins
This is ten years old, and it was carved by my nephews for their uncle Nick when he died. This was at the funeral and in pride of place. The project is something Nick would have loved and his nephews think it's fabulous that it might be part of the boat. Nick's ashes are actually scattered over the sea off the coast of Cornwall, where he used to go surfing as a boy.

626-629 Ian Bride
Before I moved into my house there was a 40-foot boat in the garden, and the guy left loads of bits of wood behind when he left. I think this piece might have been from that boat. This is a piece of burr oak that I found in Blean Woods, with the intention of turning it into a bowl. But in my haste I went through the bottom of it. That's just a pretty thing; if I see a nice bit of timber in a skip I'm right in behind it. And this is a piece of holly. I took a tree down from outside my house because it was undermining the foundations.

630 Ian Bride
This is one of my granddad's old saws. I didn't have the heart to chuck it away because it's got such a lovely oak handle. He was a very skilled craftsman in his day, and an accomplished photographer as well.

631 Miles Berkley
It's a cigarette box made out of wood from the first Bank of England. It belonged to my grandfather; he was a cashier there during the 1920s. He went through all the same economic turbulence then that we have now. He died quite early in his life, in 1931; the family story was that it was due to the pressures of dealing with the economic situation. When I was a boy the box was kept on the dining room table with cigarettes in, back when cigarettes were kept all over the place.

'They've come from Earl's Court exhibition centre, from the old escalators they pulled out.'

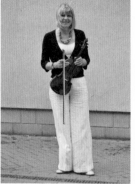

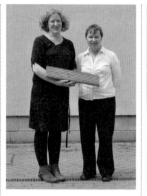

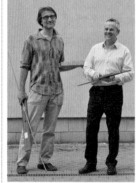

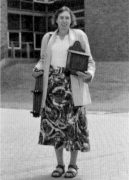

632 Louise Naylor
I'm donating my granddad's violin and bow. He was born in 1894 and lived until 1970. He took it with him in the First World War, when it was very badly damaged, and on my eighth birthday he presented it to me From the age of eight to 48 this was my violin, so it's been played for over 40 years. Granddad saw me playing it for two years before he died. He was always very encouraging; he'd say, 'That's wonderful!'. Of course, looking back, I know it probably wasn't wonderful!

633 Ian Bride and Miles Berkley
We've just been over to the university estates department and scavenged a bit of wood from their store. It represents all the stuff that's been taken out of the university for one reason or another, from the days when universities were made out of hardwoods and things like that. They do keep the pieces and they do eventually re-use them, but we thought it was good to liberate a bit from their store!

634 Sarah Fox and Francis Moran
This is a piece of decking from a beach hut in Herne Bay, – number 136. We're from a small arts charity in Canterbury called People United. We promote kindness and altruism. We did a project called *We all do good things*, which celebrated good news stories. One of the legacies of that project was this beach hut. We want to use it for people who need a space to think and reflect about how they can make social change in the world – especially those who don't have that opportunity in daily life.

635 Fran Beaton
When my mother was heading for university in the early 1930s, her mother had a very clear idea that it was all about books and nothing practical at all and so she gave her this hat rack and said, 'All the chaps won't have thought of one of these, you'd better have it with you'. She used it as an ornament – she hung her hats on it and never wore them. She's a devotee of fashion, so it would have been berets, trilbies and hats that were completely impossible to wear but she'd taken a fancy to them!

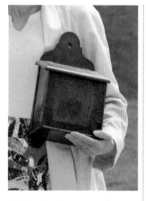

636 Fran Beaton
It is alleged to be a tea box. My great-uncle was a merchant seaman and was given this as he set sail from Liverpool to Canada by his father, who said it had hung on the wall of the family home and had loose tea stored in it. So he solemnly took it and fixed it next to his bunk as he went to and from Canada. Then it wound up back in the family farmhouse in Wales. By the time I found out what it was all about, my dad was using it to keep small umbrellas in!

637 Melinda Barry
I've brought you a boat. It's a bit cobwebby. It was made by my father-in-law for my kids to play with, and I don't think it ever floated! There are a few little gun turrets there and a helicopter pad – it's a bit of a rough and ready boat. He made it at least 15 years ago. He also made a huge and beautiful dolls house for my daughter, which was much more successful.

638-643 Phil Lennard
This one here's a tambourine, and it's symbolic of the fact that as a family we just love music. Here's a pair of size ten clogs; when I was a young lad, about six to eight years old, I lived in Holland. This is three quarters of a child's game that belongs to my two dearest possessions in the world – Isabelle, my granddaughter, and Oscar, my grandson. And this is a piece of decking from the back garden because we love to garden and love to be out in the garden.

644-650 Phil Lennard
Here's a piece of worktop from a kitchen I built for my daughter, also a mahogany box from a Beaujolais Nouveau trip in 1985, when we raised £3,000 for charity; a wine temperature testing kit, and a cooler box for picnics; two bits of strip material from model making. The handle of a screwdriver that belonged to my father-in-law. An owl - my wife used to collect owls and the like; now she's sick to death of them. Finally, a giraffe and a baby giraffe from the Masai Mara in Kenya a few years ago.

'My wife used to collect owls and the like; now she's sick to death of them.'

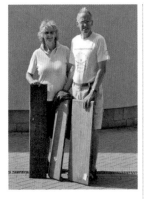

651-652 Noel and Margy Perkins
I look after some artists' studios between Brixton and Camberwell and this has no story that I know of. I'm hoping that the story is about to happen to it. It was left in one of the studios. And this was from St James, Balham, the hospital. I'd been a student nurse there and then it closed. My husband Noel was always a scavenger of things; he brought a lot of stuff back, and it was particularly evocative seeing as I'd been living there not very much earlier.

653 Chris Burke
This is a picture frame I made when I was in Spain in about 1975. I went to do some drawing and painting, and I framed one of my landscapes and brought it back. It went first to Hampshire, to my parents' place, then we moved to Birmingham and it hung on the wall there, and then I went to London and it was hanging there for quite a while. Then it was moved to Shepherdswell near Dover, where it came apart. I didn't put it together again, and I gave the landscape to a Spanish friend.

654 Jacqueline Edwards
It's a knob, presumably off a chest of drawers. It was found inside an old chest of drawers and I think it may be the one remaining original one. The chest of drawers has been in my family since time immemorial, and it's in my bedroom now. It's travelled from Pembrokeshire, via Newbridge where my father lived, and then when he died I brought it to where I live now, in Shepherdswell near Dover.

655 Rosa-Mae and Roderick Peter Botha
It's a tree house. In our old house in Cambridge we used to have a tree house den and we brought it with us, in pieces. But we don't have a tree big enough for a tree house in our new house.

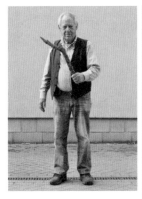

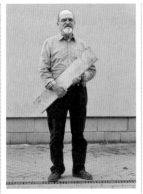

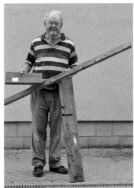

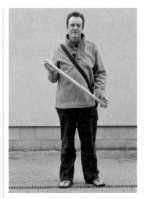

656 Richard Schechner
I've got a rough stick; it has no finish on it. At Kent University I'm staging a piece called *Imagining O*. I did some filming and one of the films I made was of a man being chased by a woman who was wielding this stick. I told the actress playing the woman, 'If you catch him, beat the fucker to death!' He runs into another and they start to dance, all holding on to the stick. I was going to use it in my play. So this is a true sacrifice, because it's a prop – it's irreplaceable.

657 Danny Rikh
John Makepeace runs a furniture college in Dorset in an old Tudor mansion. I was in one of the creaky old wings, wanted a pee, went across the passage and the door of my room shut behind me. I was nude. All there was to cover me was the bathmat. The only place I could think of sheltering was my car. I went down through the house, out through the car park in the pouring rain. I stubbed my toe on this piece of wood. That was 1982. I put it in my workshop and I got it out today.

658 Mike Godfrey
My son and I have for many years been restoring *Stardrift*, a 30-foot teak cutter – too many years to think about really. New and recycled teak is being used. In 2008 on eBay we found teak from HMS *Ganges* for sale, which had been used in the 1920s to extend the Drift Bridge Hotel in Epsom. HMS *Ganges* was an 84-gun ship of the line, built in Bombay in 1820. In 1899 it became a training ship, and she was broken up in 1920 at Plymouth. I've been using lots of it and there are a few offcuts here.

659 Mike Vallance
It's a splitting axe handle that comes from Victoria, British Columbia. My father came to visit me from Spain. He wanted to take a splitting axe back with him but there was no way my mother would let him. To get round the issue of him transporting one back, I cut the head off and buried it in their luggage. So I got to keep the handle. It was from a store in Victoria called 'Capital Iron' – they have an upstairs where they sell hardware, and downstairs they sell lots of antiques and bric-a-brac, quite a funky store really.

'One of the films I made was of a man being chased by a woman who was wielding this stick.'

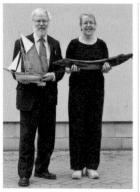

660 Manda Gifford and Peter Banbury
I've brought a piece of wood from the original oyster yawl *Favourite*, which has been restored and lives on the beach front at Whitstable. This is a piece of wood from the first *Favourite*. It's oak frame from the counter, hence the curvy shape, and it has one of the original copper boat nails in the end. It has been carefully treated, so all the woodworm is now dead. The boat was built in 1890. The wood was bent in place when it was green.

661 Peter Banbury
We've brought along a collection of offcuts from the reconstruction of the oyster yawl *Favourite* five years ago. She's now on the seafront, so that people can look at her and get some idea of Whitstable's ancient history. They're called yawls even though there's only one mast. They were designed so that men could work over the side and haul up the oysters. It was a remarkably hard life. At some point Whitstable delivered about half the oysters consumed by all of London.

662 Ailsa Naylor
A hockey stick, which I trained with for the under-10 Regionals. I play for Canterbury and we won the Regionals. I'm a defender.

663 Sara Tilley
I've brought a very recycled door. It was originally cladding from the old squash courts in Whitstable. When they sold the courts to build houses on, I had free rein with whatever I wanted. We took lots of planks. In our next house I built a playhouse in the garden, and these became the main doors. After my daughter grew out of the playhouse, it was recycled indoors as a cupboard in the bathroom. Then we moved again so it came with us to the new house, it's been waiting to find a home.

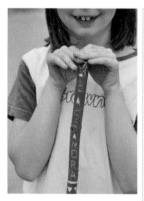

664 Cassandra Parry
It's a walking stick. There was a big bush and I found this stick in it. So I went home in the holidays and my Uppa – that's grandpa in American, because I'm American – carved it with my name and a little bunny rabbit at the top.

665 Katie Eastland
This piece of wood is from the London Pride tree that had to be cut down opposite the church hall. I thought the tree was very beautiful, bright and colourful and that it was a shame it had to be cut down. It was becoming dangerous and my dad was able to collect some. We thought this tree was part of local history as it must have been standing for hundreds of years.

666 Scarlet Buck
A rocking horse. It's my little brother's but he broke it. Me and Sam sat on the back and then it collapsed. I fell this way, and Sam my brother fell that way.

667 Jasmine Warner
It's my sister's trailer. My dad and me made it and we borrowed some wood from the Early Learning Centre and then we gave it to my little sister. Then some of the stuff fell off.

'Me and Sam sat on the back and then it collapsed. I fell this way, and Sam fell that way.'

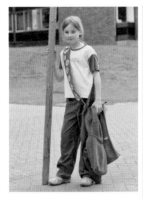

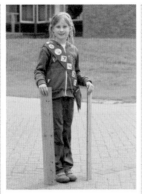

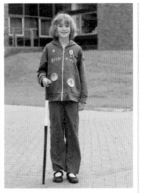

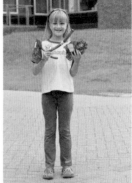

668 Alice Mount
This is something that you hold a tree up with and it came from my street and it's been there for about ten and a half years. I think it was a really thin pine tree. It was knocked down by a car crashing into it.

669 Isabel Mount
Two planks of wood. They're from our garage. They were used to make our shed.

670 Louise Flynn
This is not my walking stick but my dad's walking stick – and he used to use it for safari in Africa, to fight away the lions, a long time ago.

671 Megan Igglesden
This is from my tree, and I found those two. One was on the other side of the road at St Stephen's Green, and one was in a field.

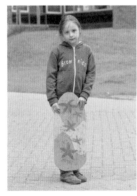

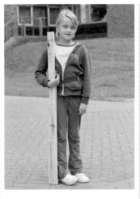

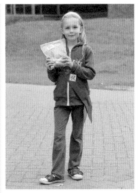

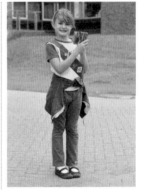

672 Mia Thomson
It's a wooden surfboard that I made with my dad. I used it for a school play. I decorated it myself.

673 Lilly Burlinson
Some wood from my dad's work. He does painting – he paints rooms and doors and walls.

674 Katie Elford
Some building blocks that you can make a bridge with. When I was a baby I used to build them and we used to push a train under it and I taught my brother when he was born.

675 Annabel Murphy
This is my hamster's tunnel, but my hamster's died. Her name was Jessica.

'He used to use it for safari in Africa, to fight away the lions, a long time ago.'

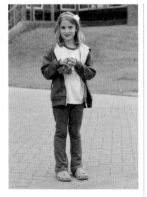

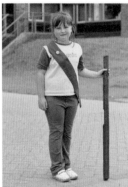

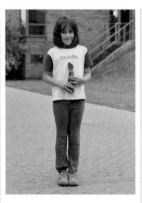

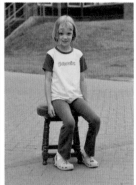

676 Holly Whitlock
My first puzzle. It made a rabbit.

677 Millie Hughes
Every Friday my dad takes me to the beach because my brother goes to Sea Scouts. Last week we went looking for pieces of wood and my dad found it, and he said that it had been in a fire and that it's a part of a boat.

678 Sara Razanadimby
I found this is in my garden and my dad was using it for the barbecue. He's got a block of them so I just took one.

679 Francesca Butler
It's a stool. It came from my daddy's pub, The White Hart in Canterbury, and he hasn't been there for very long so he gave it to me because he wanted to get rid of it.

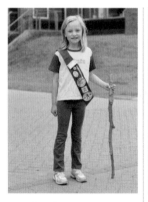

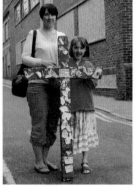

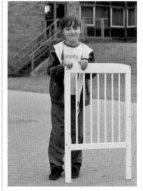

680 Ella Cole
It's a piece of wood from my tree that my daddy chopped down, because there were some low branches and he kept hitting them when he was cutting the grass.

681 Mr and Mrs Newby
This is a letter opener, which belonged to Mrs Newby's great grandfather. It was made from wood brought in the *Sophie Wilhelmina* – the first timber ship to enter the port of Manchester – with compliments of the owners of the cargo, Messrs Southern and Wheeldon. It is a memory of the opening of the Manchester Ship Canal in 1894.

682 Stephanie and Clary Reid
This is from St Saviour's Church of England Junior School in Westgate. It's a wooden cross and as part of the Easter journey we were asked to put four crosses together all showing different people. The four crosses were exhibited in the crypt of Canterbury Cathedral. They just came back about two weeks ago. Children would have taken it in turns to do little bits, sticking the papers on, then they would have all written something and the best one would have been chosen.

683 Emily Barten
It's a piece of my cot.

'There were some low branches and he kept hitting them when he was cutting the grass.'

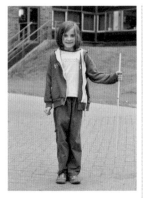

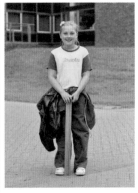

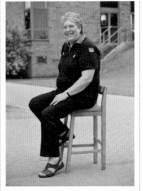

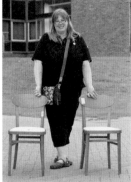

684 Rose Edgeworth
This comes from my dad's workshop. He makes loads of stuff and I help him. I've made little doll-sized beds and chairs and stuff.

685 Millie Floyd
A piece of my market stall. When I was three my dad got it for me and I used to play market stalls. I sold bread and groceries.

686 Chris Martin
It's a stool that my husband might have used at his school when he studied science. We bought it at a boot fair for a pound, to use as a high chair for my grandson. Now he's outgrown it.

687 Alexa Laurence
I've brought two chairs – they used to belong to our brownie guider and they were her grandmother's. She sat on them when she was a child, then they moved to her when she finished university and got her first flat. And then she passed them on to me when I got my first house. So they're quite old!

688 Rosemary Barford
A broom that's been used for about 20 or 30 years to clean St Stephen's Church down the road. We parted with it from our cleaning cupboard, and it's swept back 300-year-old tombstones many times.

689 Alexa Laurence and Girlguiding Kent East
These are tent poles from our county campsite. They're the type we would have used a few years ago for camping but we've moved on now, we use tents with fibre poles.

690-691 Louise Naylor
This is what's called a Cardinal Mashie Niblick. It belonged to my husband's grandmother and it's cut down from her own golf club set, so that the grandchildren could learn how to play. All the children have had fun playing with it over the years. I got this tennis racket when I was aged 12 and down in London staying with a cousin. I remember it was a brilliant summer, very very hot, and we played tennis every day... So I've never forgotten that.

692 Ella Mitchell, Millie Clifford, Nicholas Thoresen, Chenille Mummery and Jacob Page. Sally Adams, Jake Bennett, Callum Conlan, Linnie Slaughter, Joseph Odutayo from Milestone School
This is the egg from the Naga Princess story. We're making a sensory wall, with all the elements of it – the Princess, and the tiger, and the crocodile. The egg opens up, and there are rubies inside. We've all made it together.

'This is what's called a Cardinal Mashie Niblick'

693 Mark and Liz Rushall
Part of *Skunk Alpha*'s engine cover. *Skunk Alpha* is a 12-foot clinker launch with attitude and a highly temperamental Stuart Turner engine based at Emsworth Sailing Club. It was rescued by Cmdr Lawson RN before it was used for target practice by the navy. It's now owned by the Rushall family.

694 Corey De'ath
This piece of wood is from Meopham School. It's part of an old lectern. People have made important speeches in front of it, such as Jacques Arnold, the ex-MP of Gravesham; John Moules, Chairman of Ebbsfleet; and Casey Stoney, ex-captain of Charlton Ladies' team.

695 Cllr Tanmanjeet Singh Dhesi, Mayor of Gravesham
This is a childhood toy that's been in the family for several years. We don't know whether it was made by an artisan we knew or whether it was purchased. But it is very old. In essence it's a baby walker, but now it's kind of falling apart. Most of the toys in our family end up going on from one child to another.

696 John Stapley and Cllr Tanmanjeet Singh Dhesi
I'm the Mayor's chauffeur, and this comes from the Mayor's parlour that was. The building was refurbished in 1997. It had all these shelves – beautiful – and they all disappeared, apart from three, which myself and the other driver thought shouldn't go to waste. The parlour is officially the office for the Mayor. However school children come along whenever we have any twinning association events, and we use it for official engagements.

697 Charlie Smith
This came from the arm of a chair that was left in our house when my mum and dad moved in. We still live in the house today.

698 Harry Smith
This piece of wood comes from my nan's garden. It's part of their decking. Their garden is my favourite place to play.

699 Olivia Rayfield
It is a piece of a pirate ship floor from the school nursery garden.

700 Kesley Mustafallari
I have a piece of wood from my old tree house. My granddad and uncle built it. It was one of my shelves. We don't have our tree house any more because we took it apart, and I think we burned the rest of the wood.

'In essence it's a baby walker, but now it's kind of falling apart.'

701 Niel Ballingal
I've brought a bit of my old desk. I was away at a boarding school for five years and my desk was really my only belonging there, and my sanctuary. So it meant a lot during that time. I carved a bit of the drawer out to bring some along!

702 Nicholas and Jennifer Johnson
Nicholas: This is a length of teak bought in Priddy's Hard in Gosport. It was a slide that my dad made us when my brother and I were small; it was on the climbing frame. Probably wouldn't manage to go down it now!
Jennifer: And this is the top of a table that belonged to my mother. The legs have been taken off and they're used to poke the bonfire.

703 Mary Milton
David and Elaine Wells are in Farnborough. They say, 'Our donation is the wheel of our first boat, named Wren – a 13-foot day boat used on the Basingstoke canal and river way between 1989 and 1991'.
They've got a larger motorboat now, which they use on the Thames.

704 Mary Milton
This ruler has come from Kees and Vivien De Jager in New Zealand. Kees says: 'This old ruler came into my possession when I worked for the NZPO, the New Zealand Post Office, now Telecom. The date was 1975. I worked in the telephone exchange in Auckland and it was used in the pricing of manual calls department. Please accept this ruler as our contribution to The Boat Project'.

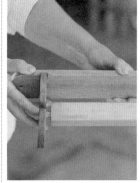

705 Jackie Hierons
These are from my mother, Nora Hierons. She died two and a half years ago. These tables were the first thing that she ever bought herself, after my father died. Up until then they'd always bought things together. So for her, this was something that she really, really wanted, and she thought a lot of them. That's why I didn't want to just give them away, and all the family thought this would be a lovely thing to do. She's been to see the tall ships several times, and loved that.

706 Jackie Hierons
This is on behalf of my brother, Ian Hierons. It's the only thing that he ever made at school and he made this especially for my mother. She was so proud of it that she had it in every kitchen in every house that she ever had. Wherever she went she took this. But the silly thing is that this bit is square, so you can't get a kitchen roll on it – you've got to fight with the kitchen roll to get it on! But she insisted that because he'd made it, she'd use it.

707 Sam, Pete and Mandy Jones
My dad made this wheel. It was for a gypsy caravan, a little one he was making. We wanted to donate this to show his skill at joining and carpentry. We've had it for a long time and it never got finished. Unfortunately, my dad has got Alzheimer's so he couldn't talk for himself, which is why we wanted to donate some of his work for him and to show what he's done, and appreciate it.

708 Michael Young
It says 'Rikki Tikki' and it's the name plate off the back of my grandfather's Sharpie. He went to sea when he was 14 years old and he ended his career during the Second World War as a pilot taking ships through the straits of Dover. After the war Dover was still a very major naval port, and I can remember him meeting me from primary school and taking me on all these royal naval ships, because all he had to say was, 'I'm a captain of Trinity House and I've guided all these ships up the English Channel'.

'But the silly thing is that this bit is square, so you can't get a kitchen roll on it.'

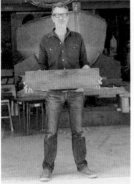

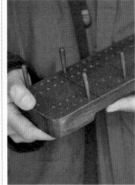

709 Neil Williams
I'm donating a bit of pitch pine from my boat. It's a French fishing vessel, built in 1954. It would once have gone off fishing for months on end, so there are four berths to the rear, which have been changed into a sort of workshop. The boat's called *Cap Horn*, which I only recently found out. It was called *Viking Star* for many years, and we scraped the transom back to wood and there it was – someone had filled it in, but it had been an original carving and had really quite unusual typography, very hand-done.

710 Geoffrey Boys
On the back it says, 'Made out of the Old Black Mill by J. Butcher in 1880 for Charles Hodson'. Charles Hodson was my great-great-uncle and the Hodsons owned Hodson's Mill, a smock mill on top of the hill in Brighton. But when they built the rail station the mill stopped working as there was no more wind to drive the sails. It's 131 years old as a cribbage board, but the mill was built in 1810, so the wood was already part of the mill for 70 years.

711 Clem Cobden
I've brought a wooden spoon. It belonged to my daughter Jenny's grandma, who was a farmer's wife for 50-odd years. Jenny's granddad came home for lunch every day and he had to have a pudding, even if he'd had a dinner. And that pudding had to come with custard. The spoon is all worn down on one side where she obviously stirred and stirred pints and pints of custard. She died about 11 years ago of cancer, and about two weeks ago Jenny's granddad passed away as well, so this is extra special.

712 Ken Cobden
This is just an oar, which was lying in the garden for many years as you can see. I think it's from when we were children, and it's probably all that remains of our first boat. We used to go down to Chichester harbour fishing. My uncle used to have a wooden boat from a big boat, so it was a lifeboat off a big boat, and this was a tender to it. There used to be many flounders in the harbour all those years ago. Not so many now, I hear.

713 Roger Shawyey
This is a pair of tools from my father's toolbox. He was an air engine fitter for 25 years in the RAF, and these would have been used on just about every aircraft from biplanes to Meteor fighters. He served in North Africa, through the Middle East and into the Far East, and I believe he actually made this himself when he was an apprentice. One's a wooden-handled screwdriver used for some of the more delicate parts of the aircraft engine, and the second is a valve grinder. The notches on them are probably to identify them as his!

714 Beatrice Lander
This was a price tag from one of my earliest art exhibitions for the Selsey Festival. We're always successful at the festival and we're pleased the public enjoy our work. I found this piece of wood in one of the woods where we went for a walk on the Downs, and I used a number of slices as price tags. This is just how I found it – it's a cross-section.

715 Bob Duvall
It's a solid oak bed bought by my mother in 1937 for 37 and sixpence, and it's one of a pair. It was in pretty much constant use throughout her life, and I think I was born on it, as well as my sister. It was used as a hotel bed for a while in Bewdley near Kidderminster. Eventually it wound up as my mother's bed in her old age; she died in 1998. I've been looking for a use for it since then, but I hadn't found anything worthy of it.

716 Bobbie Percival
I worked at a secondary school for 27 years, during much of which I ran the library. When the library was modernised these desks were thrown out, and the caretaker gave us one because otherwise they were going on the scrapheap. So we've had it at home – as a desk to start – and then it got broken up and put in our garage. The library ran lots of book events for the children, to try to encourage them to read – with varying degrees of success!

'The spoon is all worn down on one side where she obviously stirred and stirred pints and pints of custard.'

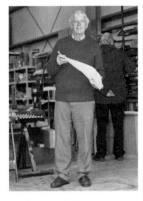

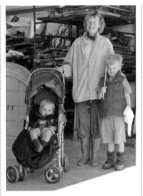

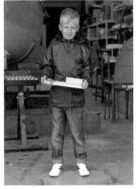

717 Tony Percival
The oak came from the stand for our television. Recently we tried to minimalise things, so I cut it down and these are the scraps. Also some pine from a corner kitchen unit, jelutong from a rocking horse kit which I bought off a retired Methodist minister, and more oak for some other projects found at an antiques fair. I started to make trugs and this is an old template. This came from a dismantled shed. I've got four sheds of my own, plus a garage and a workshop and a loft, all full of bits and pieces.

718 Patricia, Oliver and Leo Claxton
I've brought a long wooden spoon, which was made by my mum who we called Mutti. She was a sculptor, among other things, and when she went to her first lesson they were asked to make wooden spoons. They discovered that the tall people made long, thin wooden spoons and the shorter people made short, fat ones. She used the spoon a lot, she was always cooking, and she was also a potter. As children we never knew whether we were going to get apple tart with pastry or clay on the top!

719 Oscar Thomas Mason
I sailed it on the canoe lake. I made it in the garden, from a bag of wood. My dad told me that it looked like a dredger.

720 Elizabeth Comish, Geoff Paxton and Poppy
This is a box that my dad made. He made several of them, for slides. He was a carpenter in the Royal Air Force during the war, working on Mosquitoes. He did everything, he was also a chief cashier in the City of London; woodwork was his hobby.

721 Elizabeth Comish, Geoff Paxton and Poppy
This is a *rola-rola* board, and it was used by Maurice French and Joy in their variety act. Maurice was Australian and he started on the stage in the 1940s in Bombay. Then he came to England with his amazing *rola-rola* act and travelled all over. He appeared at the London Palladium, and in Rochdale at the Grand Variety performing for the King and Queen. Maurice recently died and we were charged with looking after the contents of his house. We needed it to live on really.

722 Heather Bowring
I've brought the paintbrushes I used for the commission that was given to me by the Mary Rose Trust. They asked me to make a tactile copy of a 16th century painting of the *Mary Rose*, and this is now in the museum in Portsmouth. I've also been asked if I would give permission for the same image to be used on a £5 commemorative coin, from the Jersey government. 500 years of the *Mary Rose*.

723 Janna Cundall
I've brought the name board from an old beach hut on Hayling Island, which my parents and their friends bought before the war. The friends' name was Men... something, and my family name being *Cundall*, they amalgamated the two and it was painted on a board. When the war started they were given 48 hours to clear everything out, but there wasn't time to take the hut away so my parents rescued what was in there and took the name board off. Then the huts were just bulldozed.

724 Barry Laing
One is Australian ironbark from the decking of the Albany whaling station in the south west of Western Australia, and as far as I know it was the last operating whaling station in the country. As a kid in 1976 I walked along that decking. The second piece is a very small slither with yellow paint on it. It's from the front steps of my grandparents' house, which was made of two railway cold-storage carriages that my grandfather positioned about equal width apart lengthways and put a roof between.

'This is a *rola-rola* board, and it was used by Maurice French and Joy in their variety act.'

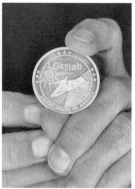

725 Monica Lesniak and Alison Lesniak Tengler
This Wood'n Nickel is from a store that no longer exists in Orleans, but is a keepsake of happy times spent on Cape Cod. Since the late 1970s, various members of the Lesniak family have vacationed in Eastham and Orleans – Leo and Irene Lesniak owned a summer cottage in the area for a number of years. Alison honeymooned there with her husband Joe, and Monica went to college on mid-Cape. We're planning a vacation there in September and are looking forward to spectacular sunsets and lobster dinners.

726 Geoff Lewis
I've brought a slice of my walnut tree. It's a very old tree in our back garden, and it was there when we moved in. A couple of years ago it just died – we were told it died of old age. So we're using it, sparingly, cutting slices off for chopping boards and all sorts. I'd like to get the big trunk milled and turned into a table or something. We had a great crop of walnuts the year before it died – its final fling.

727 Chris, Finn and Freja Vose
This is from a summer cottage we're building in Sweden in the Stockholm archipelago on an island called Ekholmen. We have a piece of the decking, a piece of the roofing timber and a piece of the outside wall, which is blue. It's the colour of all the houses, blue and white. We're 95% through the build, just some small bits and pieces to finish. Ready to holiday there now.

728 Professor Mike Whittle
In the 1970s I was a research medical officer in the RAF, and they loaned me to NASA to work on the medical experiments on the Skylab space station – which used some of the hardware left over from the moon programme. I was over there for three years, for the set up of the experiments and to analyse the results afterwards. There's a medal here that was given to all the people working on the project, and which contains metal from Skylab.

729 Wendy Whittle
My mother was born and brought up on the island of Dominica in the Caribbean. Her name was Rosalind Smith (née Shand). She always boasted how she was the best top spinner – and this is her top and it came with her from Dominica. She could still do it to a ripe old age; she taught me but I was never as good! She left Dominica at the age of 27 and never went back to live, although she did visit. She had a sign in her kitchen that said, 'I would rather be in the Caribbean'.

730 Joy Barham
My husband David was a decorator and a much-loved husband, dad, granddad, brother, brother-in-law and uncle. He died in April 2010 shortly after being diagnosed with pancreatic cancer. His family wanted to donate this piece of his work in his memory. It's the family name but it's not the family crest – it's from HMS *Barham*, the battleship that went down in the Second World War. He did three of these, one for each of our children and this one for us.

731 Chris Hedger
It's a lintel out of my Victorian cottage. We knocked a couple of doors down and this was there. It's oak and I thought, oak's OK for boats! We did the work about three or four months ago. The house is from about 1870, I believe. Presumably the wood was from even earlier.

732 Jane Young
I've brought a wooden van and it's got 'Dorado Boats, Emsworth' on it. It was made by a great friend of ours, Richard, who actually ran Dorado Boats in the late 1970s. He was a boat builder and a model maker and he made this for my second child, Sarah, who is now 30 with two children of her own. Dorado Boats don't exist any more – they kept going for a while but then they packed it in. Richard had a life-size blue van, just like this.

'There's a medal here that was given to all the people working on the project, and contains metal from Skylab'.

729 Wendy Whittle, see facing page 154

My mother was born and brought up on the island of Dominica in the Caribbean. She always boasted how she was the best top spinner – and this is her top and it came with her from Dominica. She could still do it to a ripe old age; she taught me but I was never as good!

'She had a sign in her kitchen that said, "I would rather be in the Caribbean"'.

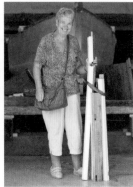

733 Tony Young
A kindly aunt gave it to me when I left the Royal Navy to become an architecture student. She thought, what you'll need is this T-square, because that's how you draw. For quite a long time I did actually use it, but then it was overtaken by drawing machines, parallel motions and, ultimately, the computer. It's slightly wobbly as well, which means the first lines I drew did have a little chink in them! It's fairly useless as a T-square, but it means something.

734 Caroline Manners
They're the paddles to our tender, our boat called *Seascape*, which was a Seadog we had for about 25 years. We did a lot of mileage — I remember it coming up to something rather extraordinary! She was a family friend. My son-in-law and daughter have got a boat and they had these oars for the tender, but her younger brother sat on them last week I think and finally broke them!

735 Dee Warner
My grandfather was a doctor in the Royal Army Medical Corps during the First World War and he went all over. This box has been to Albania, then he was in Germany as a prisoner of war. Then he went to Malta, India, Aldershot, then Egypt, Khartoum, Cairo, then back to the UK. So this is the box that went with him. I just found it in my attic. It had loads of stuff in it and I liked it because it had his name on it. It's obviously been in a lot of ships, it's been knocked about.

736 Mary Milton
I've brought some bits of a window frame from my bungalow. The house was built in 1981 and this is the original one. I had it replaced a couple of days ago. This is from the back bedroom window and it's the last one to be replaced. It had a view of my back garden — where I can watch the birds on the plum tree.

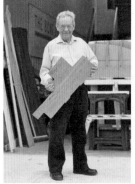

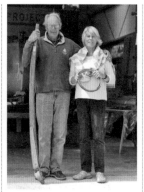

737 Barbara Dunbar
My husband had these on the Norfolk Broads and he used them a lot, rowing about. He used to have a yacht and a rowing boat as well. This was years and years ago, and I think they were old when he got them because they were handmade.

738 Mark Everson
I've been the organist at Southbourne Church for many years — church warden and general historian, as you might say. This is a part of the furnishing in the Lady Chapel, which was removed during the reordering of the church. I think that was in the early 1980s; since then it's been stored in Bill Knight's shed.

739-740 Sheila and Anthony Penfold
The mast hoop and tiller are from *Mavis*, a Dublin Bay gaffcutter my parents owned from the late 1940s to the 1960s. During the Suez crisis they sold her because she had three and a quarter tons of lead on her keel. Someone took her out to New Zealand. We went there for the millennium and found records of her winning races. We wrote to the owner, and mother sent an envelope of photos and bits and bobs. He never replied, but we heard that she was wrecked on a reef off Fiji. So a fitting end actually.

741 Tony Wilkinson
This is from a tree in an avenue reported to have been planted in 1166 to celebrate the 100th anniversary of the Norman Conquest. I was given a piece 23 years ago and I intended to use it to make a chessboard, for the white squares. But I'm afraid I've not yet got round to it. I think the trees there are about 30-feet high. But they're all under conservation order and you can only collect the wood from branches that have fallen off, you can't cut them down. So it's quite a valuable bit of wood to have.

'I was given a piece 23 years ago and I intended to use it to make a chessboard, for the white squares.'

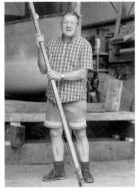

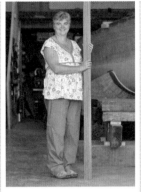

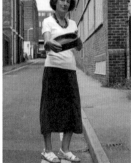

742 Jonet Bown
This spoon belonged to my husband's grandmother, Margaret, who was well known for her culinary skills, particularly cakes and roast potatoes. I think she had it from the time she was married, around 1911. There's something wonderful about wooden spoons. This one's been rubbed at the sides where it's been scraped on the edge of a saucepan. It's almost a half-moon. I can imagine her making cakes. I've used it mainly for making jam, that's my forte. So this beautiful spoon remembers nearly 100 years of cooking.

743 Michael Earley
It's the boom off an 18-foot marine ply boat which was the original boat of South Downs College. It was a part of their curriculum to sail it. I bought it off them in 1998, and I had it for about five years. We took it all the way across the French canals, from Brittany down through to La Roche-Bernard, through the Canal du Rance to Rennes on the River Vilaine. It was a lot of fun. Unfortunately the boat rotted away and it was irreparable, and this is what remains of it.

744 Jane Inglis
This came from a building site 20 years ago. It was double-ordered by two different site managers so it was surplus to requirements. It was special order because of the chamfer on it, so the supplier wouldn't take it back. We had about 1,000 metres too much so everybody on site had about 30 or 40 pieces to 'lose'. Lots of it has been used for other things, like thresholds and fireplace surrounds, and I've still got some left.

745 Annie Fullbrook
This is very special to me as it was a wedding gift from my brother in 1964; shortly afterwards he was killed in a road accident. I have always treasured it and know that on my demise it will just be dumped when the house is cleared, and not recognised for its sentimental value – but now a small part of it can live on in memory of Graham.

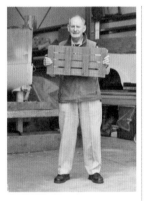

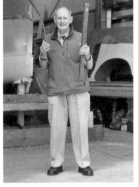

746 Roger Silver
This little grille was put in the bottom of a boat used to lift logs from the mud here in Emsworth. This one would have been in the bow, it was where a chap stood – there were normally three of us in each boat. The logs were seasoned in the mud and they'd been there many years, sunk right down to the bottom – solid, black, horrible smelly wood. They rowed them back in and would cut what wood they required, it was all used for boat building.

747 Roger Silver
This piece of oak came off the fire engine that was driven by my aunt Isobella, the only fire lady in England at the time. Her picture is in the Emsworth Museum, and she was one of the first people to go to Lumley Mill when it was burning down. People wouldn't help her with her hoses because she was a woman. In those days a man's job was working the fire engine but a woman's job was in the home cooking the dinner. My dad rescued this piece when the old fire engine came to a close.

748 Roger Silver
I was at Itchenor boat yard in the 1960s as part of the rigging team and this is called a fid. Now this one is a very hardened instrument; it's very solid, and you use it for pushing the tacks through. It could only be used for splicing ropes, not wires. It's quite ancient. If you ever go down to the dockyard at Portsmouth and go through the sailmaker's loft, you'll see all these instruments. You'll see marlin spikes, all different sizes, thimbles, and different strands of rope. All sorts of things.

749 Liz Casson
My father, George Frederick Upfold, was a cabinetmaker, a boat builder and a wheelwright, and he just loved wood. He had a workshop at our family home in Selsey and that's what he did – more of an artist than a businessman, that's for sure! He built things because he liked them and he would have fads. For a while it was clocks, and we ended up with about 20 grandfather clocks! This is a veneer hammer and he would have made this too. And these are marquetry pieces that would have all been made by hand.

'This piece of oak came off the fire engine that was driven by my aunt Isobella.'

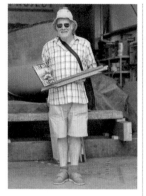

750 Tony G Spencer
I cut this when I learned to do picture framing, and it's just one I liked and kept. After a stroke I learned to paint, with my left hand, and realised it was much cheaper to make my own frames than to go out buying them. So I did. And this is one of the first ones I made, probably in 1987. I paint boats, sea scenes, landscapes and wildlife, all of which I'm still painting, although I'm going blind.

751 Elle Howell on behalf of Holy Trinity School
My granddad made a giraffe and it's one of those ones that pops ups and down. He gave it to my auntie, who gave it to my mum, who gave it to my sister, who gave it to me! He makes a lot of wooden furniture too.

752 Jake Kampta
It's my daddy's stick. I painted a bit of it, and the other bit needs to be painted but we ran out of time to do it.

753 George Boyd
Alan West's a member of the Chantry Model Club, and this piece of wood came from his father's boat. Originally it was a shelf from the skipper's cabin on a Thames tug called *Contest*. She would have been built in the 1930s and, like all the boats then, would have been beautifully fitted out with wood panelling. Alan's father removed the wood while she was still on the Thames before she went to be scrapped in Antwerp in 1965. He then put the shelf into his own boat, which he used on the Thames.

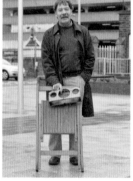

754 Sue Munday on behalf of Northfleet School
I'm a teacher at Northfleet Nursery School. This is a leftover offcut from our new garden. It's only just been finished, and the Mayor opened it for us on the 27th May this year. It's a fabulous garden and we'd like everyone to know about it, because we're really really enjoying playing in it.

755-756 Michael Wenban
It's one of the folding deck chairs from the steamers that used to take passengers to the coast at Calais. This particular one came from *Royal Daffodil*, it ran from Gravesend until the late 1960s. I used to be a captain on the tugs. On the older tugs they used to have fitments, and this particular object is a carafe and tumbler holder from the chief engineer's berth of a very old Watkins tug called the *Hibernia III*. When she was scrapped in 1961 she was the oldest working steam tug on the Thames.

757 Jamie Clifford on behalf of Kent County Cricket Club
This is a piece of the original lime tree that stood inside the boundary at the Canterbury cricket ground. We were the only cricket ground of international standard in the world with a tree inside the boundary. It blew down in a storm about eight years ago, it was at least 100 years old. The rules were adjusted specifically for the tree; if the ball touched it, it was automatically a four. Only one player ever cleared the tree: Carl Hooper, a West Indian who played for us in the 1990s.

758 John Higgins
It's a part of the play equipment from Woodlands Park, the local parkland. It's Douglas Fir – a softwood.

'The rules were adjusted specifically for the tree; if the ball touched it, it was automatically a four.'

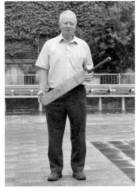

759 Jonathan Pike
It's a piece of church pew, made of yew wood, over 100 years old, from the Gravesend Methodist church. It's been stored in the church cellar for a number of years since the choir stalls were taken out of the church. It's surplus to requirements.

760 David Turner
This bat has a great deal of sentimental value to me. I've been looking for a home for it for many years. It was given to me by my father in 1960, when I was at school, and the first three times I used it I scored a century! I would have been 18 when he gave it to me – don't ask me how old I am now! I would have used it last in about 1962, because when I thought I was a great cricketer I bought a much more expensive bat, as one does!

761 Mark Cordingley and John Higgins
This is a part of a bench that was down the prom in Gravesend. It had been damaged over time so we just replaced it. The guys think it's been there for about 25 years.

762 Carl Webster-Dowsing
This belonged to my great-uncle, Carl Wragg, who I was named after. He was an artist and he had some work exhibited in the Tate Gallery years back. This is part of the belongings that were found in among his art equipment. He had his brushes, pens, pencils and stuff, and this was in there with them. I don't know for what purpose he had it, whether he planned to paint something on it. I've been carting it around for years and have never been sure what to do with it.

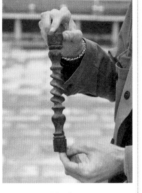

763 Anita Tyso and Denise Gould on behalf of Woodville Halls
We're donating Cinderella's carriage that was used in our pantomime in 2003. Laura Hamilton, who was in *Dancing on Ice*, was starring in the pantomime that year. And last year Kim Woodburn from television's *How Clean is Your House?* also used it as a prop for a bit of marketing we did last year. So it's got a celebrity background.

764 James Elford
It's Victorian. I discovered it in an area of the Thames marsh where they dumped debris from the Blitz. The rubble and the contents from a lot of houses that were destroyed were put on to barges and sailed down the Thames estuary. Now because of the erosion that's happening you find debris across the beach and it's very evocative. It's peoples' lives – crockery and household belongings are still to be found. They've been dumping there since probably the mid-19th century.

765 Brian Goodhew
I worked on the paddle steamer *Medway Queen* in the 1950s, and these are two pieces of decking and wood from the guard rail. She went to Dunkirk – seven times in nine days – so some of the survivors from Dunkirk might actually have stood on this decking, or a couple of them might even have died on it. After many years of preservation and Lottery grants, she is being restored at Bristol exactly to the 1924 plans, which has caused a problem because everything in feet and inches has had to be converted into metres and centimetres.

766 John Kaller and Melanie Norris
It's screening from our civic centre, which was built in 1974 by the architect Cadbury-Brown, who also did the Barbican in London. The civic centre's Barbican-esque. It's quite ugly, but inside the architecture and build are fantastic. We did some renovations to make it open plan, and the architect who worked on the renovations was impressed by the panelling and the intricacies. But we couldn't accommodate this in the renovation. It's actually wood that was used for decking on boats and ships.

'Because of the erosion, you find debris across the beach and it's very evocative. It's peoples' lives.'

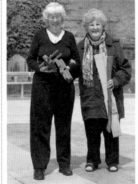

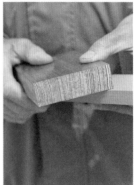

767 Melanie Norris
I've brought a chopping board and an ornament with an inscription, 'Sit long, talk much, laugh often'. I thought that all good boats have got to have some sort of kitchen area to feed the crew, and there's going to be a lot of sitting around at times, reflecting on the day and sharing stories. So hopefully it can be part of that.

768 Mary Cox (right)
We lived in our old house for 46 years, and until we had central heating this is the axe that my husband used to chop all the wood for our fire. I had seven children in there and it used to get freezing cold! The axe was probably made by my brother-in-law, I don't know what's happened to the axe head. This other piece hasn't got a long memory with it, it's just the first bit of wood that we bought for the new house, to make a trellis. The new place is brilliant, I love it – because it's warmer.

769 Alan Austen
Until 2010 this piece of Douglas Fir was part of the original pews from the Emmanuel Baptist church, Gravesend, which was built in 1843. Apart from a small selection of historical events, imagine what else has transpired, from the germination of the seed to this wood's felling. If you look closely at the annual rings, you can see how the climate has varied during the period from the earliest to the latest. It's the history behind this that makes it very special to me. It's got a story to tell all of its own.

770 Alan Austen
In 1998 I went to Romania, because I wanted to help people who were going through an awful traumatic experience after the death of Ceausescu. I went for a couple of weeks and made some furniture for a children's AIDS clinic that had absolutely nothing. I made a dozen child-sized chairs and two tables from beech wood like this, and then some blocks and bricks for the children to play with. It was an absolutely wonderful experience. People there had so very little but they shared everything they had with you.

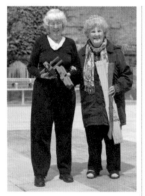

771 Mary Cook (left)
My granddad, Harold George Vickers, was a carpenter, and this is from when he was an apprentice. He was also an artist and photographer, and he entered lots of competitions. Everything's marked with his name. All of this has lived in my garage for 37 years, until I moved last week. He made furniture and he used to work at Shorts.

772 Jackie Denton
This belonged to my dad. He was disabled and he couldn't use his legs – he was in a wheelchair. His shed was kitted out with all sorts of stuff, and he made bowls, musical things, jewellery boxes. Then he got cancer and he lost the use of his arms as well. This was the last piece of wood he was going to make something out of. He died two and a half years ago. I've got things he's made all round the house.

773 Nigel and Sophie Allen
This tennis racket was my mother's. She originally came from the Bexleyheath area; she met my dad on a holiday on the Isle of Wight and eventually stayed down there. I was born on the island and spent all my childhood there. Then I went to university at Greenwich and settled there. When my mother died we were going through her things and I found the tennis racket with the Bexleyheath address on it – which is how we realised she came from there. So without knowing it the family's come back.

774 Jesse Loynes
It's a sign from the front of the Southsea Rowing Club. There's always work to update the building and keep it looking smart, so there's now a new sign. Founded in 1860, I think Southsea's is the oldest rowing club on the south coast. I've been a member for about a year. I've just started with a new crew and we've got our first race coming up. So having done lots of practice we now get to find out how quick we are. Saturday will either be good or depressing, we'll see!

'I went for a couple of weeks and made some furniture for a children's AIDS clinic that had absolutely nothing.'

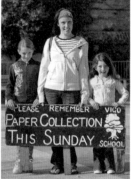

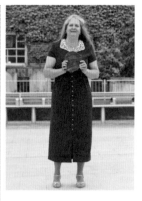

775 Stanley Brotherton
This is a cross that has been made by someone in my church here in Gravesend, the Emmanuel Baptist church. It was made from old pew wood. The pews were taken out just under two years ago when the sanctuary was refurbished and replaced with chairs. Many crosses were made and other items as well.

776-777 Ian Brown
This is left over from when I put new flooring in my house a year or two ago. I believe it's Russian oak – that's what it was sold to me as. It was too nice to throw away, so I kept it for a special day. And this is from Christ Church, Milton-next-Gravesend. In its original position, it was next to the barracks where General Gordon preached to his troops. Also 48 Royal Marine Commando came to Christ Church for their last service before D-Day in 1944.

778 Rebecca Knight, Carla Perry-Knight and Sophie Perry-Knight
We've brought the paper skip sign from Vigo Village School. I put it out at the end of the village each first Sunday, because I'm the closest one to the end of the village. There's a big skip and we all put our paper and our cardboard in there, and then it gets collected and we get money from that. Loads of people use it. It's been in the school for years and years and years.

779 Senja Compton
This is a piece of art given to me 30 years ago by my brother, Bernie Saari. I'm from Wisconsin, so this has followed me around, moving from job to job and place to place. My brother was a really hands-on person; he liked guitar, woodworking and the outdoors. Unfortunately he committed suicide, so this is all I have left of him, apart from a tape recording of his music. I call it Herman – it's a strange looking creature shape – and I donate it in memory of my brother and of my late sister Tina Kadunc.

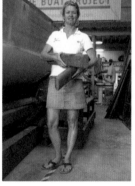

780 Gemma Wade and Grace Barton
We've brought a log from the nature garden at Riverview Infant. We're an Eco School and we replace the wood every now and again to help the many beasts grow and to give them somewhere to live. The nature garden's been there as long as the school has. It's a little quadrangle, with a nice pond, named two years ago after our caretaker. It's now called the Lowe garden.

781 Chris Hague-Smith
This is from the original cabin side of *Josh*, my Finesse 21 Cruiser. She was built in the mid 1970s. I got her on St George's day in 1991 after the previous owner died. She has given me many happy hours of sailing and maintaining her – lots of memorable experiences. But I've used her very little over the last ten years, and inactivity takes its toll on a traditional clinker-built boat. I've always been threatening to sell her, but it's very hard to part with such a faithful companion. However, I think that time has now come.

782 Sue Crafer
This formed part of a reversible thwart on an American racing schooner called *Gypsy*. She was a 101-foot timber boat built in 1857 for a member of the New York Yacht Club. She sailed from New York to Cowes in 1863 in 20 days, making her the fourth yacht to cross the Atlantic. She later became the club headquarters for the Essex Yacht Club. When *Gypsy* was broken up in 1930, my aunt Betty, who was the first lady Commodore to my uncle Stuart Readman, salvaged this wood and it was stored in his shed awaiting a purpose.

783 Jill Daugulis
This is a piece of redwood that was used for weir building on the Thames in the 1960s. My husband was doing the work, and he was with Thames Conservancy for about 40 years. So he knows the river very well.

'I call it Herman – it's a strange looking creature shape.'

784 Jane Bowden
I've brought some wooden clogs that I've used for gardening for years. I was just about to put them on the log pile! I've re-soled them lots of times, but eventually they got to the point where they're not much use. I must have had them for about 25 years, in two different gardens. I grow fruit and vegetables and these have walked miles around my garden. I think they're Danish, because as you can see they're leather on top, unlike the Dutch clogs.

785 Nick White
I have brought the back from one of the seats at the Yvonne Arnaud Theatre in Guildford. It was on seat P18 between 1985 and 2011. We estimate that roughly 10,000 people have sat on it, so this is our way of bringing all the enjoyment those people have had to your project. We're a pre- and post-West End touring venue and a producing house as well. The last show that this seat served would have been *The Lady in the Van*, which was showing last week.

786 Tom Smith
The level is from my first tool kit, given to me by my grandfather, and the offcut is from fridge magnets that I've made. I keep all my offcuts because I'm a bit of a hoarder! I made the fridge magnets five years ago, and I laid my first bricks with this level. My grandfather will have used it a lot before then. He's my favourite man but sadly he's gone. It was actually granny who inspired me to be creative, as she was a potter. So I did pottery with her and mending bits around the house with granddad.

787 Chris and Sheila Wright
Hazel is quite significant for us because last year I tracked down a cousin I'd lost touch with for 20 years, and he works in wood, as I do. He showed me how to make wands and staffs and walking canes, and he encrusted them with copper and things. He invited us to a craft camp called Superspirit which was very inspiring. This hazel was just cut today. You have to use hazel when it's new if you're going to bend it because if it becomes old it will snap. It becomes less flexible, just like human beings!

788 Sue and John Darbey
It's a piece from our old mantelshelf from when we replaced the fireplace. It's a nice piece of mahogany, but it's seen better days. It would have been a mantelpiece for probably about 40 years, I don't know really. It was a very 60s, brick-built, low-level fireplace, with a gas fire in it. We had to get rid of it all when we got a new posh gas fire. Some of it has been used already, to make little stands for bits of sculpture that I make. I work with wire, so it's ideal to support little wire sculptures.

789 Andy, Angus and Niall Gibbs
It came out of a props room in Debenhams in Guildford. My wife Angie used to work there and they were throwing these in the bin. But it never turned out to be useful; it's too big and too heavy. They don't make them like this anymore. It's quite an old reel, I'm not sure how old, and it would once have had handles jutting out and there would have been a big old wooden rod. I do fly fishing for trout, this is for sea fishing. I've been fishing forever, since I was a boy. I taught myself.

790 Susie Campbell
This desk has got a broken leg. I've been trying to use it propped up on books, but it's just not possible to keep on using it. Not that long ago I went through a bit of a crisis, but the one thing that as a writer always keeps you going is the ability to sit down and write. I write poetry, mostly. I thought I needed to set up a writing corner for myself, so I sat down to write, and in that first attempt the leg just broke! At that moment my sense of humour came back.

791 Jenny and Alan Taylor
These bits came from an old timber rowing boat that was parked on the river Thames, where we used to have a bungalow, at Bourne End. I have a feeling it might have been what they call a Hampshire Punt, but I'm not sure. The boat was known as *Moldy Warp*, and we believe it was built in the 1940s. We also had a sailing boat for about 30 years, but we've sold her. Now we sail on other people's boats!

'He showed me how to make wands and staffs and walking canes, and he encrusted them with copper.'

792 Alice Empringham
This is part of what was called a darning mushroom. The men in the country wore thick socks, which were usually hand-knitted. They were pulled over this darning mushroom and then the socks could be darned. I haven't darned all that many; it was my grandmother who used to do it. She lived in Sussex. She looked after a lady who had been injured in a carriage accident, and so my granny had to push her around in a wheelchair. This must be well over 100 years old.

793 John and Jean Empringham
This comes from a narrowboat that was constructed in the 1970s by Hancock and Lane. It was built as a hire boat originally, but then we took it over. We refitted the kitchen and this is a piece that came out. It's got happy memories for us because it used to be around one of the shelves we kept all the drinks glasses on! Don't ask me why I've still got it, but things collect in my garage.

794 Jean Empringham
This paper knife is supposedly made from a piece of the bowsprit of the HMS *Victory*. It was given to Geraldine Gould in the 1950s by a neighbour who was downsizing. Now she's downsizing her house, and when I told her I was going to bring a piece of my narrowboat, she suggested that I might like to bring this, because that would be boat-to-boat as well.

795 Wally and Lesley Wassell
This is a teak plank. I used to be a boat builder, and I was given the teak plank by our old neighbour who was a window fitter and who didn't need it any more. I was going to make a table with it but never got around to doing it.

796 Robert and Valerie Godwin
It belonged to my father, George Roland Godwin, and I believe it was in his possession from about 1949 until his death in 1992. He was apprentice to building contractors Healy and Evans at Fareham, and worked for them for 50 years as a wood machinist carpenter. He used to make the wooden windows, doors, winding staircases – all the complicated jobs. I remember him bringing home paper and dimensions and working on the dining room table making up stair drawings.

797 Norman Thompson
These oars were with the dinghy on my boat when I was captured by striking French fishermen in the early 1990s. We had gone into Le Havre with no knowledge of any strike. Once we were there we were prisoners. We thought we'd make a run for it, and chose the time when the French are at their most vulnerable – lunch! We got about five miles out when they surrounded us in big steel fishing boats and towed me back. The French strikers gave us a present of a few mackerel!

798 Colin Derrick
This timber was taken from the most famous of barges the *Cambria*, and was given to me as a memento by the owner/skipper from the 1960s, the late Bob Roberts. It was a privilege to have spent time with him on the *Cambria*. He was a great character – equally at home in a force 9 gale or at the Cambridge Folk Festival with his 'squeeze box' and songs of the sea. *Cambria* subsequently sank, was moved to a yard, damaged by fire and is now in Faversham where a group of volunteers are attempting a complete rebuild.

799 Joanne Blandford
I wanted to donate a piece of wood with a grain in it, so you can see the grain of the tree. I was thinking about the beautiful park near where I live with all the beautiful trees, and there was a tree in a pond near there. It had become so badly deteriorated that it had to be chopped down, so I asked if I could have a piece of it. It's an alder tree. It's beautiful, isn't it.

'These oars were with the dinghy on my boat when I was captured by striking French fishermen.'

800 Rupert Baskcomb
This is a piece of a bed that about 50 years ago my mother saw lying in a garden shed at an auction. She bought the entire contents of the shed, and in it was this. It's part of a Hepplewhite four-poster bed, and I was conceived in it! The rest of it is in France with my brother. A Hepplewhite is probably now worth about £30,000. It's oak, and it must be at least 200 years old. This was from Northamptonshire, where my mother bought it and where we lived.

801 Maisie and Sally Riddle
There's two pig pots and a peg. This peg used to be part of a little game; you'd put it on a ladder and it would fall down. Maisie's sister, Holly Riddle, died in the 2004 tsunami. We'd like to put something of hers in the boat. She used to like pigs, so she collected pig pots.

802 Susy Davidson and Beth McNaught-Davis
Susy: I learned to play stoolball at Prep School. We were even filmed for television once as it's a traditional Sussex game and used to be played by milkmaids who used their milking stools as a wicket! It's a cross between rounders and cricket.
Beth: I played it too at Junior School. There are 11 players on each team, you run between two wickets and score 4s and 6s for a boundary. The ball is small and hard.
Susy: Now we both play in the Red Triangle Stoolball League.

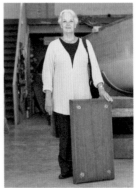

803 Felicity Newton
My father used to work for *Encyclopaedia Brittanica* and when they were building Portland House in Stag Place – where *Encyclopaedia Brittanica* moved to – he provided the beer for the topping out ceremony. The chippies made him this table as a thank you out of one of the doors. It's absolutely solid; the doors must have been phenomenal in that building. But *Encyclopaedia Brittanica* was American-owned and dad didn't like the way they treated people, so he decided to call it a day and bought the post office in Northiam instead!

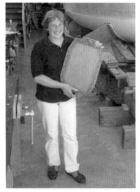

804 Diana Wallace
Two pieces for you: first a TV cabinet which was changed into a sideboard by my father who restored lots of things, and a wooden tray which my mother brought home as a memento from Kashmir in India. She lived in Indonesia as well as India. Sadly she has recently passed on.

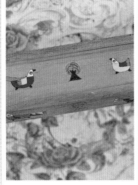

805 Julie Fair
This pencil case was bought by my mum, Helen Speakman, for her granddaughter Zoe – my daughter – in 1993 when she was about five. My mum might have got it from abroad somewhere – she travelled all over the world. It meant a lot to Zoe and helped her develop a lifelong passion for art. She loved it because of the inlaid pictures of brightly coloured birds, which inspired her to do lots of drawing. We donate this in loving memory of Helen Speakman who died on 1st of June at the age of 78.

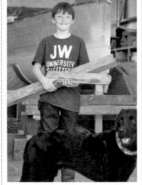

806 Huxley Alman and Alfie
I've got two pieces of wood from a play boat that's in my garden. The boat was lost at sea, and some people got it out and pulled it along with their boat and brought it over and put it in the garden. Then we bought the house and the boat along with it. This was used in part of the zip wire that came down from the boat, and it fell off again. So now I've got it to give to you.

807 Robin Wilson
I won this Sussex County Cricket Club 'Year Zero' cricket bat at a fundraising event in 2000. It's signed by the Sussex squad, including England members Chris Adams, Mike Yardy and Matt Prior. We were raising funds for the new Sussex CCC Youth Cricket Ground at Blackstone, Henfield. The campaign was very successful and two new cricket grounds and a new pavilion were set up. I come from a strong cricketing family. My son Alasdair has been playing for the Nomads First XI this summer.

'It's part of a Hepplewhite four-poster bed, and I was conceived in it!'

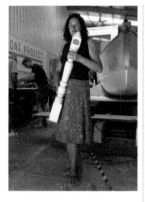

808 Julia Clark
This is from our Edwardian house in Balham. The previous occupants Connie and Arthur, a brother and sister, had been bombed out of their house in Pimlico. Their milkman found them in the rubble and told them that they could live with him. They put their possessions on to his horse-drawn cart and rode down to Balham where they lived until they died. Arthur became a submarine electrician, which could account for the awful surface mounted electrics everywhere when we bought the house.

809 Margaret Charles
I'm pleased to give this, because my late son, Glyn, was crew with Mark Covell and this is my son's plaque from his old school, Pangbourne College in Berkshire, which is where he really learnt to sail. It was given to me by a couple of the masters at the college, after the memorial service I had in memory of my son, who was lost in the Sydney-Hobart race in the 1990s. From a little boy he used to say that he wanted to be in the Olympics when he grew up, for sailing – that was his life.

810 Bobby Clayton
After my parents died, and in the sorting out of all their belongings I found this very small piece of wood that says it's from HMS *Victory*. I really don't know if it is! But I don't know what to do with it, I don't know if it's worth anything. My parents didn't sail, but my brother did, although unfortunately he's not with us any more either, so there's no other information to it. In the envelope with it were two photos my parents have obviously taken of the *Victory* and a postcard of the ship.

811 Nicole George
I'm a carpenter from a family of boat builders in Bosham. I was asked to turn four acorns as bedposts for a bed. The oak was too knotty to use so I had to give up. I've kept the unused wooden pieces in my workshop for the last 15 years.

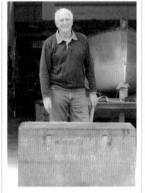

812 Colin Matthews
These two pieces of sapele were bought for furniture making many years ago – probably 40 years! However, they were never used and I've now forgotten what they were bought for but I kept them anyway.

813 Tony Poulet
This mahogany mantelpiece came from my house during restoration work. My wife was looking forward to seeing a new mantel above the fireplace.

814 Brian Sendall
This was my father-in-law's when he was a Crown Agents health inspector in Aden in the 1960s, and we think it was procured from army/navy surplus in Portsmouth. He used it to carry his possessions when he was recruited, in the days when Aden was a British Protectorate. He was forced to leave due to the Yemeni uprising. The chest came back through Rotterdam but we don't know the name of the vessel. His name was Harry Potter and he died some years ago. He was the first Harry Potter!

815 Matthew Townsend
I was responsible for refitting a 1934 Alfred Mylne design, a boat called *Alinda V*. The interior was, as the owner put it, like a well-used boys boarding school! So we dismantled the whole of the interior and rebuilt a new layout in exactly the same style. But we ended up with all this 1932 oak timber, which I didn't quite have the heart to throw away. The boat looks exactly the same on the outside, the hull's still the original, it's still 80% the original deck, it's just 90% of the interior that is new, with all mod cons.

'Their milkman found them in the rubble and told them that they could live with him.'

816-818 Sue Foster
The fabric has rotted on this garden umbrella, but we've had many times underneath it. This little bit I'm particularly fond of, because it came from my mother's sewing machine. She used to make all my clothes, and I remember as a little girl it used to make people laugh when they'd say, 'What a pretty dress! Did your Mummy make it?', and I'd say, 'Yes, and it has matching knickers!' This chair is an old Habitat one that I had in my first shop, a fabric shop, in Portsmouth.

819 Julia Oakley, Susan Fitzroy, Pauline Duncan and Sandra Badcock
We found this while we were sailing around Emsworth, about ten years ago. We've been using it a bit. I'm sure it's had a history but we don't know how it arrived in Emsworth really. We scavenge and hoard things, we're war babies you know! We don't let things stay in the water, we pick up the rubbish.

820 Julia Oakley
During the war my aunt and uncle were tea exporters in Ceylon. We lived in Wales and they'd send us tea. The part that says 'Tea' has gone, but it does say 'Ceylon'. I was only a little girl at the time. It would come to us by ship, full of loose tea because, as you know, everything was rationed. Recently this has been used in the workshop for keeping nails. I've just tipped them all out!

821 Jane Watt-Smith
It's a tiny piece of wood that has served its purpose for the last four months stopping my lounge getting damp by diverting a downpipe and holding up a diverted bit. At last it's all been mended.

822 Nicola Walpole, Laurie Walpole and Catherine Baxendale
It's been used as a chopping board for about 50 years, mainly for onions and strong-tasting herbs. It used to be part of a slide in the school gardens that Vera's daughter attended and has travelled a lot, as they moved house many times. Other members of the family thought it should be destroyed, but she kept it. Vera says 'I shall have to purchase an up-to-date board made of plastic, which I'm told is much more hygienic. I'm 90 and I haven't yet been poisoned by using it'.

823 Keith Balding
This was actually owned by my grandmother, Eva Balding. The head was the thing that wore out, every single time, but the handle always survived. She must have replaced the head about six or seven times. I can remember it from when I was very young, because whenever we visited one of the things we always had to do was sweep up. Eventually, when she died, I inherited the broom. It was always a memory of her, and it's probably been without a head now for three years, but I haven't ever had the heart to throw it away.

824 Keith Balding
This chunk here caused me massive heartache. It was put in by some jobbing builder to hold up the water tanks in the roof of our house. It wasn't put in very well and recently it gave way, which had a sort of crescendo domino effect – all of the other beams gave way and the tanks fell down, ripping out the pipework. I wasn't in at the time, so it resulted in the entire house being destroyed by water. So seeing as this has an affinity with water, we thought we'd bring it!

825 Tessa Vallings
My husband was involved in sailing boats and sailed many races. When he retired from the navy he held the chairmanship of the Cutty Sark Tall Ships Race for ten years. That's when he was presented with this by a Danish ship, the *Jens Krogh*, which was always on the races with us. A belaying pin is what you have in a square rigger. My husband had it on his study wall, but I had to move house after he died – so it's been in a packing case and that's not a very sensible place to keep it.

'I wasn't in at the time, so it resulted in the entire house being destroyed by water.'

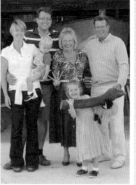

826 Heather Way
It's a piece of maple from the floor of my house, number 35 Maisemore Gardens in Emsworth. In 1962, when the houses at Maisemore Gardens were built, maple was used for floors in all houses and it's still seen today. Rumour has it that the maple came from a liner that was to be dismantled. Apparently at some stage somebody had a really bad flood in one of the houses, and the insurance company didn't want to replace the floor with maple because of the expense, but the owners insisted.

827 Sienna Springett
These are four lollypop sticks. We use them to plant with.

828 Simone, Richard, Sienna, Sandy, Theo and Clive Springett
This is part of a tree we cut down in our garden a year ago. It's the last little bit of it.

829 Simone Springett
It's a lollypop stick with the inscription – 'In loving memory of my daddy who died on Monday. His name was Stephen Leslie Riches. We love and miss you'.

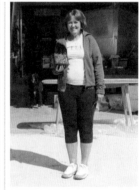

830 Joel McDonald
I've brought a salad wrench. One of my little sisters was working in Boston and she sent them over as a birthday present a couple of years ago. So we used them, but they're absolutely hopeless! They're just a novelty item but actually you can't get any salad with them. I was loath to throw it away, but it's also not really any use. I'm sure she'd prefer it to be used.

831 Gillian and Adrian Bouch
These cricket bails were on the stumps during the cricket matches we used to play down at Easthead when we took our boat down. The first boat was called *Emma B*, the second boat was called *Pebble*, and more recently *Blue Moon*. The family would come down, our son and daughter Emma and Will, and then a lot of other family. We had a lot of fun down at Easthead beach playing cricket. Wonderful memories.

832 Antony New
I joined the navy as a boy and served for 14 years, then I went on to work in shipyards and retired about 15 years ago. About ten years ago I went to Southampton to see the STS *Tenacious* a ship run by the Jubilee Sailing Trust, which gives disabled people a chance to sail the world. She was the largest wooden ship to be built in England in the last century. They were taking donations for pieces from various projects and this is a curved, laminated offcut from a rib where they had to fit the keelson.

833 Hilary Temple
It's a little chest that my mother Margaret used to keep her special things in. It was kept in her bureau and it's been around for as long as I can remember, 55 years at least.

'This is a curved, laminated offcut from a rib where they had to fit the keelson.'

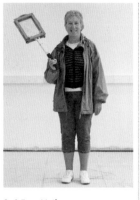

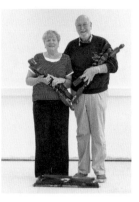

834 Sarah Treseder
When I was a little girl I was obsessed with the *Swallows and Amazons* books. I wanted to be Nancy Blackett, the cool one. I grew up sailing, I started at one. At the weekends we'd sail the real boat, then this would be in London during the week when I couldn't sail. It came with me everywhere. It wasn't a bath toy, it was a kind of dream machine. I'd load up the bow area with hazelnuts and food they'd be carrying. Sometimes they'd go through bad weather and the whole thing would have to be lashed up together.

835 Frank Illston
About two years ago some extensive repairs were done to the roof of St John the Baptist Church in Kirdford, West Sussex. During the repairs a lot of new timber was added to the roof and some very old and ancient timbers were taken out. These old timbers have been kept and preserved, looking for a suitable place to use them. There's more provenance on it – it's probably four or five hundred years old.

836 Fran Hailstone
I had this tennis racket when I started secondary school. It was second-hand then, in 1960, so it has been used a huge amount over the years. It's approximately 55 years old.

837 June and Patrick Perks
These are legs from a barley sugar oval oak table from the 1920s, we think, given to us second-hand by elderly friends in 1964. The table holds memories of our babies and our early family life when we had a small dining room necessitating a folding table. It was used for many milestones and family occasions – christenings, 21st birthdays, silver weddings, etc. We lost one leg when we moved 17 years ago, and therefore the table has now been made into a modern coffee table. These are the pieces that were left over.

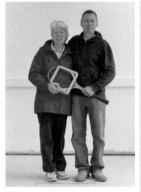

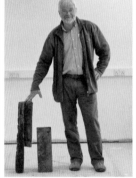

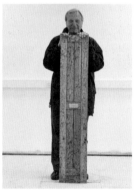

838 Patricia and John Bonella
It was my late husband's tennis racket from when he joined the tennis club in Billingshurst. It's possibly 42 years old.

839 John Griffin
I bought an old Elizabethan farmhouse and with it came half a 17th century barn; the previous owners had taken away the part of the barn that was falling down. Because it had lost its partner, it was leaning about nine inches off perpendicular. An architect friend said I had three options: prop it up, take it down, or do something with it. I chose the third option, to completely restore the missing end. This first piece is from the original barn. Also I've got an offcut from the French green oak used to make the replacement end.

840 Pamela, Richard, Anita and John Spencer
This piece of wood was the sign used by the builder's business started by my father Jack Ralph Conisbee and his brother Frank. Jack served with Royal Sussex Regiment in the 8th Army under General Montgomery as a desert rat, and Frank was involved in Italy at the relief of Monte Cassino. They started their business with the gratuity money they were given when they were discharged from the army in 1945, and we would like to donate this to *The Boat Project* in their memory.

841 Richard Spencer
This is the remains of a locker that once was at Christ's Hospital, Horsham. Because of renovations lots of things were being replaced and these lockers – lots of them, not just this bit – were taken away and scrapped. We got this off the man who did the clearance. It was used by my grandchildren for the storage of their wellies and their outdoor clothes when they came in from the garden and school.

'It came with me everywhere. It wasn't a bath toy, it was a kind of dream machine.'

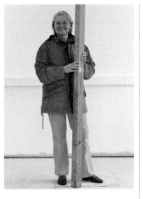

842 Tony Priestley
These come from an old desk that was built by a local craftsman called Jimmy Seed for my great-grandfather on my mother's side, Robert Greenep. It's made of rosewood from Bentham in the Yorkshire Dales, and I think it dates from about 1900. These were part of the desk and they'd sit at the back. I still have the desk, but I don't need these. My great-grandfather had a study; he had a big house and he had this desk built locally.

843 Amanda Jupp
I'm the chairman of the management committee at Andrew Hall. Next year it's the 25th anniversary of our art show, which we started in order to raise money to maintain the Hall. We're going to have a big celebration. This was one of the original posts that held the screens for displaying the paintings. It was quite a marathon to set it all up. We wanted it to be a Sussex art show, and it's continued over the years and we have artists from near and wide. It's become a great village occasion.

844 Helen Abbott
This was bought by my late husband's family when they were in Kenya in 1951 and 1952. They were there at the time the Queen succeeded to the throne, and it's been in the family since then. He died in January 2004. There's also a tom-tom, and a little stool with beads hammered into it, and some more carvings. He wouldn't go back, though; he said too much blood-letting still had to go on there. He felt that it was not the place he knew.

845 Carol Terry
It's an oak plant stand made by my father, Graham Terry. He's 93 now, and he and my mother are still living in their own home in Canterbury. He used to repair our shoes, mend our electrical items. He used to say he could mend anything except a broken heart. He was working at the fire station in 1950; the firemen were clearing out some broken furniture and threw an old snooker table into the cellar. He realised it was oak and reclaimed the wood. He made some furniture out of it, including this plant stand for my mother.

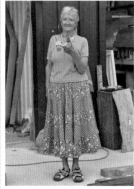

846 Squid
This small cylindrical red box was given to me by my son Sam years ago. I kept three shells in it for over a decade. A safe place to be, if you read Sam's story! Sam's story: 'On the top of the lid in a circle around the centre, I used to be able to make out some grooves or indentations. I believed that they might well be some kind of small runes. Runes are good. So whatever went in there would be quite safe. And I never lost anything that went in there. So I was most definitely correct'.

847 Tessa Gleeson
I travelled to Newfoundland to see whales and kayak with them. I played a toy accordion and sang shanties to coax them into coming near. I licked an iceberg and kayaked with seals; saw a mother moose guide her child across a stunning lake; saw seagulls picking off puffins; flocks of my favourite birds, Canada geese; even saw, at a distance, the curved back of a 'common' whale. One night, camping alone, I made up songs to soothe and amuse myself. I found this driftwood whale there, and brought him home.

848 John Sadden
This nameplate, taken from the door of the headmaster's study in 2000, represents the 18 'captains' of the Portsmouth Grammar School ship since its foundation in 1732. Former pupils, or Old Portmuthians, have included many shipwrights, as well as high-ranking naval men, marines and war heroes. How many boys had memories of sitting in fear outside the headmaster's study, waiting to be punished? This particular sign dates from more recent times when corporal punishment was replaced by nurturing and encouragement.

849 Judy Covell
It's a little toy dog on wheels, with a wagging tail, called Snoopy. We bought it for my daughter Julia's first birthday. She used to drag it along with her into all the shops, and it wagged its tail and ears and all the shopkeepers knew her. She loved it. It's been in the family since 1965, with Julia, then Mark in 1967, and then four grandchildren – they've all played with it. Now it's on its last wobbly legs. It's always meant a lot to us, because the children always enjoyed pulling it along when they went on little walks.

'He used to say he could mend anything except a broken heart.'

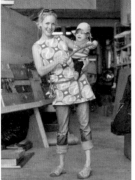

850 Sadie and Clementine Griffith
This is a wooden hanger. It's got a cover on it, knitted by my granny. Which means that the last person to see the wood inside was my dear granny, who's no longer with us. I think she knitted it in the 1970s. It's been used by her, by my mum, and by me, and it's now being bitten by Clementine. She was quite into knitting hanger covers to protect clothes and make them last as long as possible.

851 Bex, Ian and Rosie Thurston
We've brought a very light wood heart-shape with the writing 'Baby Girl' inside. Rosie was born on the 15th January this year, so it's something personal to us and we thought it would tell a good story. We've written her name on the back as well, just in case. We got loads and loads of things when she was born, so we thought we could spare this one.

852 Jerry and Gwen Thurston
This originates from Wisborough Green. My father-in-law, a farmer, took the tree down some time in the 1970s. It was taken to the local sawmills, made into planks, I took some probably about ten years ago, made various things around the house – television stands etc. – and these are just the remnants of what's left.

853 Mel Walker
These are earrings that I used to wear when I went out in the 1990s. I think they were bought in one of the coastal shops around Norwich. They've seen a few parties and nights out.

854 Mel Walker
Bill is 11 and Jim is four, and this was a present from their aunt from New Zealand. She did a month out there exploring the islands.

855 Felicity Smith
This is a stand for a Chinese bowl, I think. I used to work in an antiques shop and that's where I got it. I haven't ever used it.

856 Christine and Dennis Whelan
It's part of our children's cot, which we bought almost 44 years ago from the Co-operative store in Leicester. Our children Gregg, Carole and Sue all slept in there while they were babies. And then also Scarlett and Dexter, our grandchildren. Dexter's now ten, so it's many years since he last used it; it came back to us about a year ago.

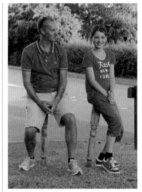

857 Virgil Tracy and Scarlett Tracy-Whelan
Two legs from our old garden table. It's also been used as a cat-scratcher. I still love it, but I was overruled by my wife Sue; she said the top had become unhygienic. Which it had, a plate and cup would no longer balance safely on it. Fine for our family to eat off but not good for guests. We had it for five years. An auction find, £8. It's sat in the garden through all weathers. We used it for Sue's 40th birthday party, and the two or three times a year it's warm enough to eat in the garden!

'They were bought in one of the coastal shops around Norwich. They've seen a few parties and nights out.'

THE LONE TWIN BOAT PROJECT 171

834 Sarah Treseder, see page 168

This scratch here is me with a pencil or something, trying to make a centreboard casing. I was disappointed that the design wasn't properly integrated, so I started making some modifications. This little boat would come with me everywhere. It wasn't a bath toy, it was a kind of dream machine.

'I wanted to be Nancy Blackett, who was the cool one. I kind of grew up sailing.'

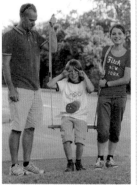

858 Virgil Tracy and Scarlett and Dexter Tracy-Whelan
The swing's from our climbing frame in our garden. Our cat Felix used to hang off it, and he'd sometimes fall off and land on his back. The climbing frame broke – it was rickety and it split.

859 Viv Williams
Mike Harting was one of our friends who got involved with the Solent Sunbeam fleet. They were a classic boat, designed in 1923 by Alfred Westmacott. This is one of the original sweeps from the Sunbeam that Mike acquired a share of. I went to Cowes and raced with him there 25 years ago. I thought, these boats are amazing! We have multi-millionaires in the fleet who could sail any boat they want, but they choose the Sunbeam because it's just beautiful. It all stemmed from Mike getting involved, and we've all had our lives changed.

860 Viv Williams
This is cut out of the wooden pontoons, the staging that goes outside and over the water from Itchenor Sailing Club. The club was one of the old traditional sailing clubs, founded in 1927, and some of the best early dinghy racing took place from Itchenor. There was always rivalry between Itchenor and Hayling Island. It goes on very well, and it's recently been renovated and changed round. It's a very active sailing centre.

Boats and yachts whose timbers are shivered in this boat include the following 76:

The African Queen, Alinda V, Arrow, Aryba, Athene, Barbary, Bessie Vee, Blackbird, Boomke, Camp de Mar, Cap Horn, Cambria, Caprice, Calypso, Carmania, Columbine, Conqueror, Contessa 32, Contest, Curlew, Drifter, Echo I, Echo II, Ella Jane, Favourite, Fish, Golden Wings, Gypsy, Hesperus, Hibernia III, Horatio, Hunter's Moon, Ice Prince, Iona, Jens Krogh, Josh, Kerrara, Laura, Lively Lady, Lunacy, Marelle, Margaret, Mavis, Meg, Melissa Jane, Midnight Rambler, Moldy Warp, Morning Cloud III, Nautilus, Ocean Lord, Old Florence, Rikki Tikki, Robin, Royal Daffodil, Samantha Small, Seascape, Shy, Skunk Alpha, Sophie Wilhelmina, Stardrift, Suhaili, Symphony, Team Philips, Terror, Tigger, Touchstone, Tudor Miss, Ugly Duckling, Valerie, The Valiant, Victoria and Albert, Viking, Vivienne S, Why, Wild Swan, Wren

Remnants of these naval vessels, grand yachts and liners keep them company:

The Prince of Wales, HMS Ark Royal, HMY Britannia, Cutty Sark, HMS Ganges, SS Great Britain, HMS Invincible, HMS Iron Duke, the Mary Rose, RMS Mauretania, The Medway Queen, HMS Nelson, SS Olympic, the new Oseberg ship (Norway), STS Tenacious, HMS Victory, HMS Warrior, HMS Wolf

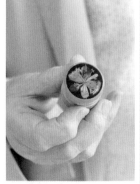

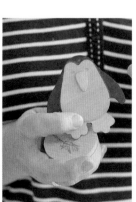

861 Felicity Smith
This is just a little wooden pot with a flower on the top. I think I probably got it at a jumble sale.

862 Lucy Cooper
This is a bobbin of some sort that's been made into an egg timer. My sister gave it to me as a present. I used to collect wooden boxes. And this is a penguin – I also collect penguins! It was in a children's shop in Greenwich, but I bought it for myself! I can't remember who gave this to me, but I'm a teacher and it might well have been a present from a child.

863-864 Lucy Cooper
Friends used to be delighted because they would always give me penguins for presents. But I'm just remembering now that we actually got this one on a day trip to Greenwich with the children. I bought it for myself! So my house is full of penguins. And this is just a small, round box with a little wren carved into it. I looked on the bottom and it was bought or made in Chichester.

'Our cat Felix used to hang off it, and he'd sometimes fall off.'

865 Sadie Sillett
I've had this for nearly seven years – it's a baby-changing unit. I bought it at a sale somewhere for my little baby boy, and I've had it through three consecutive babies. It's going to be very sad to see it go because I'm a bit attached to it, but all my brood are growing up now. Lots of happy memories, day and night!

866 Mandy Burton
Two rigging blocks. I love boats and sailing so I was delighted to discover your project online. I really wanted to come to Milton Keynes with a piece of interesting wood for you but couldn't find a suitable piece. I live in a huge mansion, which is a housing co-op in Winslow. One of my community jobs is beekeeper. Recently I was tidying the junk in what we call 'bee cottage' and I found these and thought 'Aha!' I very much look forward to seeing your boat next year.

867 Jane and Naomi Everard, Erin Percy and Megan the dog
Last April we went to Uganda to see some projects for a charity we worked with called 'Send a Cow'. We went on a safari at the very end and bought this for Naomi. But then we got stuck because of the volcanic ash cloud, and ended up in Uganda for another 11 days. We stayed with some friends on a Christian base, and went to see some orphanages. It was quite a turning point. My husband's now looking at going into the ministry. It was a huge, wonderful experience, and we want to go back some day.

868 Jane and Naomi Everard, Erin Percy and Megan the dog
Martin Stiles is my brother-in-law. He made this cross out of wooden pallets used for delivering bricks. In 2004 he was having treatment in a London hospital for mantle cell lymphoma. He had to have a blood transfusion and he found that holding a cross was a great comfort at that time because he had to be in isolation. Whittling wood gave him great joy. Since then he's made 74 crosses for friends and family; this is number 74. It's saying thank you that he's alive and well and enjoying his family life.

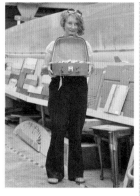

869 Teresa Grimaldi
I've brought part of my collection of lolly sticks with jokes on them. I've done performances with them, telling the jokes; the audience join in, embellishing the jokes, working out how to make them better, or just shouting out the punch-lines. Granddad was supposedly the first to sell ice cream in Brighton, and his grandparents were ice cream vendors when they came to the country. So I've always had a strong relationship with ice cream and lollies. A lot of the sticks in my collection were left over from when my sister and I had an ice cream kiosk.

870 Angela Smith
I am most interested in your intended voyage of adventure and in a very small way I would like to be part of it! I am enclosing a sample of turned laburnum on which I have been learning the use of the lathe. I am a potter and have been taking part in open studios this last June. I also play the accordion and am in the process of making a hurdy-gurdy; the laburnum strut is part of its ornamentation. I do hope your project will be well supported and you will sail with the goodwill of all your subscribers.

871 Sarah, Tara and Freddie Nuttall
This is from Kenya, it's called a 'rungu'. They're used by the Masai for killing lions. They're held like a catapult, and the idea is that if it's thrown in the right way it either gets the lion under the jaw or on the head. We were on safari and the Masai who act as guides show you how to use these. They're often decorated in beads. They're rather heavy and very beautiful. We bought so many of these, we just love them.

872 Sarah, Tara and Freddie Nuttall
This is a totem of some description. I got it in a market in Nairobi, and I have tried to find out online where it might be from. It doesn't look Kenyan to me but it looks possibly Namibian. We have quite a lot of artefacts at home from Africa – our house is pretty much full.

'The idea is that if it's thrown in the right way it either gets the lion under the jaw or on the head.'

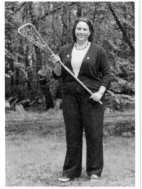

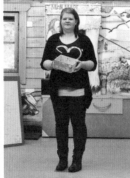

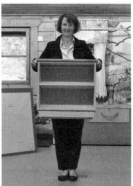

873 Sarah Groom
I'm donating my old wooden lacrosse stick from school. I played lacrosse from the age of about nine to 12. Then I changed schools, where they played hockey instead. So that was my short-lived lacrosse career, although I very much enjoy it. It's quite a wild game, there's a lot of clashing of sticks and bashing of each other! I actually hold this stick responsible for a slight break in my nose! I've got a photograph of my school lacrosse team, and I'm still in contact with more than half of those girls and see them regularly 30 years later.

874 Louise Isaacs
My donation is a drawer from a chest of drawers which I've had since I was born. It's part of a very large chest of drawers, and some drawers are now missing. When I got older it changed into a stationery drawer, and it's now living in the garage and was home to a mouse until last year. It's covered in pen and it's got stencils painted on – shells – which is what my bedroom was decorated with when I was younger. I've moved house since, so I've got all new furniture.

875 Louise Isaacs
This is the foot of my cot from when I was younger. It was also my brother's and he's eight years older than me. So it's fairly old. It's one of eight feet and when the cot was no longer being used it was put in the garden and made into a plant container, and has since started to rot. So I've taken this foot off. It's still standing, it just has one foot missing!

876 Liane Gibson
In 2000 I was living in Sydney and the Trade and Further Education college were offering older people an opportunity to do an intense cabinet-making apprenticeship. I'd had twins in 1997, and was thinking of getting into another career. Our first project was to design a piece that could be made on a production line, and then we had to make it up. I got 92%! It came over when we moved to the UK in 2004 and my daughter's been using it for books. She never wanted it finished or decorated. It's pine and pine-veneered chipboard.

877 Eleanor Henderson
It's a clock without a battery. I made it four years ago when I was in Year 5, because it was the first year we were allowed to do woodwork. I got to draw on it and stuff – it was very exciting at the time. It has worked, but it's always moved too fast. Then I got into making axes and swords. I don't really like making clocks, but they were the easiest things to make.

878 Alan Meeks
I've brought two specimens of wood that have been taken from the world-famous Elmhurst Ballet School, which was in Camberley from the 1920s until 2004 when it was demolished and moved to Birmingham. During the demolition I spent about a month as a photographer there and I took such things as these wooden artefacts, which are pieces of the flooring from the dance school and the barre. I worked at the school as a part-time photographer and videographer for about ten years.

879-880 Megan and Daniel Banks, with their father Roger
Megan: A spoon. It comes from the kitchen. I like making biscuits.
Roger: Daniel likes picking sticks so he wanted to give you a stick. It's his favourite.

881 Tim Dodds, Mayor of Surrey Heath
Nearly all the council members have signed this piece of wood. We're really happy to have done it. The wood is something we'd had made as an example of how we could emboss the council's logo on a piece of wood for our playgrounds and outdoor areas. It's really just a sample.

'It's quite a wild game, there's a lot of clashing of sticks and bashing of each other!'

882 Ian and Salma Sams
It's from our children's rabbit hutch. The rabbits were called Sophie and Matilda. When my daughters went to university I was left to look after the rabbits. Eventually, the hutch fell to pieces and Sophie and Matilda legged it. They were never seen again. I preserved the hutch for some time hoping they'd come back. Hopefully they made it to the allotments, where perhaps they're breeding to this day. We were very fond of them.

883 Nick Mowat
It's a centre strut from a double bed, which I've owned for about 15 years, although I don't sleep on it any more. I slept on it for about nine years, so in terms of something that's been pertinent to my life for the longest time I've probably spent about three years actually resting on this piece of wood! I'm not a big hoarder of things, so I thought this was probably something that carried the most memories.

884 Suzie Parr, with Kerry Hobbs and Pippa Hopkins
I moved to Slough about five years ago, and this belonged to one of my housemates in my first house. He didn't really like it and I said, 'Oh it's really nice, you've got to keep it!' But I never really liked it either! When I moved out a year later he gave it to me as a present. And it's just in my drawer, I don't think I'd ever get it out. He was working with British Airways, so maybe it was a souvenir from his travels. I think it's from somewhere in Africa.

885 Wendy Alves
When my dad retired he took up woodturning and made all sorts of things, and this was just one piece. He started off making bells using the wood from the village church where they were re-hanging the bells; it was the church we were married in. This is just to put grasses in the top, like a little vase. My dad is 100 next month. He's got too much arthritis in his hands to do woodturning now, but up until about five years ago he was still doing it. His father was a carpenter, so he grew up doing woodwork.

886 Wendy Alves
This belonged to my mother's eldest sister, Kathleen Underwood, who died about ten years ago. She'd now be 105, and it was just on her dressing table when we went to visit. I think it's probably ebony. When my aunt died I collected them, they were in amongst all her bits and pieces. There was a hairbrush as well but that had actually fallen in half! It went in the bin.

887 Tim Dodds, Mayor of Surrey Heath
I'm donating three pencils. The first is Lifeboats. We have a friend who runs the RNLI locally, and we went to the base in Poole and had a special guided tour. The second is from Vinopolis in London. We took some friends there who'd been very kind to us. The last one is from the Royal Military Academy at Sandhurst. I brought a handful of pencils as a memento. I carry these things around in my pocket and take them out and tell a little story. It's a little icebreaker.

888 Francine Renton
This has come from Cornwall. It was part of a shipwreck back in the middle of the 1990s – lots of the wood was washed up and made into sheds and garages all along the coast. I can't remember what the ship was called, but some time later these bits washed up around Tintagel. I've had them ever since and carried them with me. I beachcomb everywhere, even since we've moved up to this area I've been combing beaches.

889 Francine Renton
This piece was a bit of beachcombing wood, washed up in the little cove below Tintagel Castle. I found all sorts of things there – including a beautiful piece of amethyst and this piece of wood. It probably came across the Atlantic, as much of the wood did. Lots of the finds would come from Newfoundland or somewhere like that. But it's an old bit of wood off something, I don't know what. I'm an artist and maker, and this sort of wood we used to make into sculptures and candlesticks and things to sell.

'Eventually, the hutch fell to pieces and Sophie and Matilda legged it. They were never seen again.'

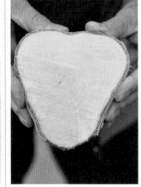

890 Liz Seward
This belonged to my late husband and this is its third transformation. At one stage it was an old antique desk, which was then made into a coffee table that matched his dining room table. He would be very pleased if it was made into a boat, because he was a sailor in his youth and he used to paint boats. He used to crew on huge sailing ships in his youth.

891 Robin and Diana Clout
It's a 40-year-old birch tree that we got when it was a sapling. There was a nursery being dismantled, so we got the little birch tree into our car, brought it home, and it's now 40 years old, and it's also the 50th year of our marriage. But it has to be cut down, unfortunately. We had two birch trees, and the other one will sadly have to be cut next year. This one died in the drought – that's the end of it.

892 Rory Kitney
It's a piece of train track. I have a big train set with lots of trains. This bit's broken.

893 Andy Clout
This is a cricket bat that I bought in 1981, inspired by Botham's Ashes. I started playing cricket and became captain of the school cricket team, and this is the bat that I used to open the innings for the three years between 1981 and 1984. I used to play for a works team too, but obviously I outgrew the bat. After that, it was used by the nieces and nephews in the garden. At the time it was quite an important part of my maturing – it was treasured.

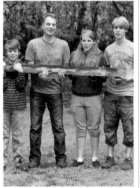

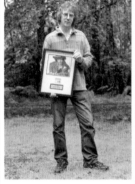

894 Leigh, Holly, Finn and Jago Thornton
It's from an oak tree on the Basingstoke canal, the local waterway running through Surrey Heath Borough. I used to be in charge of Basingstoke canal, and we had two key problems: no money, and too many trees. So we invested in a new saw bench, to turn the felled wood into something useful. This was one of the first experimental pieces, trying to turn trees into posts, planks and things. The canal's got all sorts of problems, but it's there, it's useable and millions of people enjoy it locally.

895 Keith Smart
I'm a musician and collect guitars, and I run the Zemaitis Guitar Owners Club. Tony used to make six guitars a year and one of them was played by Jimi Hendrix in 1967 – it's actually featured in the film *Jimi*. A friend of mine repaired and restored the guitar a couple of years ago, and he sent me a load of shavings. So this is one shaving! The other half I gave to a museum in Japan, dedicated to Tony Zemaitis. Tony died in 2002. He started making guitars around about 1960. All rock's royalty play them.

896 Levi Bullard, Nagahama Shoninsan, and Sister Marutha Yoshie
This is from one of the cherry trees planted in 1980 for the inauguration of the Milton Keynes Peace Pagoda. Altogether 1,000 cherry trees and cedars, donated by the ancient Japanese town of Yoshino, were planted on the hill around the pagoda. People come daily to pray. It is a visible statement – that civilisation does not need to have electric lights or aeroplanes or nuclear bombs; to be civilised means not to kill people and not to destroy things, it requires mutual affection and respect.

897 Anita Dunn
I've brought a sweep oar to mark our tenth anniversary this year. It was one of our original pieces of equipment. We started out very small, with boats stored on milk crates by the edge of the river. We've come a long way since then.

'This one died in the drought – that's the end of it.'

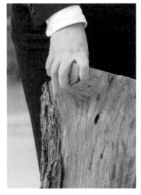

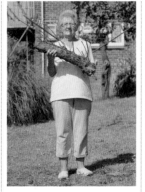

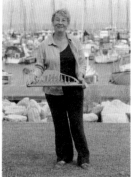

898 Fiona McKerlie
This is a piece of a cedar tree that had to be chopped down. It originally stood outside Walton Hall, at the headquarters of the Open University in Milton Keynes. It was attacked by aphids, and this is one of the pieces of the trunk that came down. It's about 200 years old. The remaining stump has been carved into a statue, so there is a piece of the original tree still there.

899 Dylan Crabbe and John McLinton
This is a pergola from Oldbrook Green. It's a piece of wood from the gateway across the park. It was put in in the 1980s and over the years the ground round about has risen, so they had to adjust the pergola because people were banging their heads on it. We've actually taken this off, so it's a lot easier now. This is part of Milton Keynes, really.

900 Yvonne Hall
This is a bit of my apple tree. To be honest, the tree's never been looked after, so all you get are little tiny apples. I pick out one or two, just to say I've tried the fruits for the year, but there's nothing really that's harvestable from it. A lot of the tree was growing out over my clothes line so the volunteer service cut it back for a donation, which is good – I could never saw through it myself. I've been here 23 years, and the tree was already quite big when we came in, so it's quite old.

901 Susan Pester
It's a model of my husband's boat, *Marelle*. It was made by my father, Tom Morris, in 1991, but he died before he finished it. My husband and my father worked on the actual boat, and did a lot of restoring. Then my father, who was a carpenter, thought he'd make a model. My husband Ben also died, last year, and I've had to sell the boat. I didn't know what to do with this model, but then I felt sure that they would both be delighted to know that it would be part of another boat.

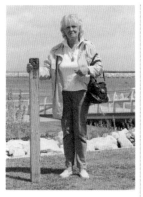

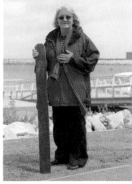

902 Sara Weber
It's a piece of driftwood found on the beach at Castle Cove where I live, and I've always thought it was a bit of a boat but I'm not at all sure. I found it about three years ago and it's been in the sea a long time, I think. I always thought it would be useful. I love it.

903 Dorothy Scutt
I've brought a piece of fence from our garden that blew down about two years ago in a storm. Now the light gets to the flowers a lot more and they flourish. There was a plan to repair it, but I've stolen this bit so now it never will be.

904-906 Mike Venning
This is ancient oak from Cerne Abbas church in Dorset. It was part of the support that held the flagpole on the tower. About 40 years ago my son removed it and fitted a new one. I used another piece of this to help support the roof in an extension I've built on my bungalow. And this was part of the battery room door on a tug I was engineer on when I was a working at the naval base. This was given to me by my friend Doug Watson, five or six years ago. I don't know where he got it – or what it is

907 Mark Jackson
I'm restoring a shop in Fortuneswell that was built in 1897. I've brought one floor joist and three of the original floor planks. Since most of them were covered in bitumen, lino and all that stuff, they've had to come out; it's a fire risk now. Lots of people will remember the old shop as being Lipton's, back in the 1940s. We bought the shop about five years ago. The original shop was Scores, and they were 'Purveyors to Her Majesty's Navy'.

'This is part of Milton Keynes, really.'

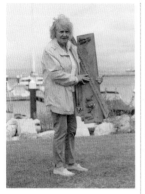

908 Sara Weber
This was taken from a skip in the 1980s in London, outside St Clement Danes. They were refurbishing the church and chucking this out – there was so much good left on it, they should have restored it. The peas in the pod were a Grinling Gibbons' trademark, so it could be his carving, we're not sure. It must be old, perhaps from the 18th century. We kept one good piece for ourselves, which we cleaned up and it's really beautiful.

909 Mary Civil
My husband Graham was a boat builder, but of model boats. He was always interested in making things in wood, including these. He died about ten years ago now. He never used kits, it was always from scratch. The actual pieces themselves were all handmade. The rope there came from my brother, who's a dentist; they used to use that stuff in the surgery. I didn't use the bobbins for lace making, they were ornamental. But the idea was they would go in as railings on a transom or things like that.

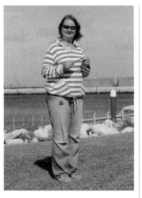

910 Kate Cope
I'm donating this pencil, which I used for my RYA Yachtmaster exam. It helped me pass, I think! The exam itself was really tough, and 43 hours long. We had John Goode, one of these sailing legends who writes for the magazines. He showed us some really cool techniques with the boat. Sometimes I think he was actually teaching us more than examining. The RYA has different levels of yachting qualification. I've done Day Skipper, Coastal Skipper, then this Yachtmaster. Now I could nag at a job in the industry, which is quite cool.

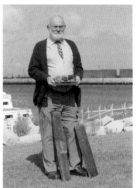

911 Tony and Susan Wells
These are part of the pews from Holy Trinity Church in Weymouth. We cleared the organ and broke the pews up. We found out afterwards that some churches were flogging them for about 50 quid a time! But they are good solid wood, they're Douglas pine. The church itself is now 160 years old, so I've no idea how old the timber is. I got several things made out of it, and I've still got a pew left behind in the shed.

912 Tony and Susan Wells
It's a set of dice I made for my mother 15 or 20 years ago. Because everything for mum had to be bigger and better, hence the six dice. I can't remember what all the pegs were, but the main dice were labelled. The bog oak came from John Makepeace, who had a woodwork school in Dorset and I used to go and do their kitchen refrigerators. It's a good pastime. I made several of these for a shop but they said, 'Oh we can buy them cheaper than that'. But what they're buying is rough-cut, basically, with painted dots.

913 Tony and Susan Wells
They're antique Bruges lace bobbins. One's the first one I bought in Weymouth, and the other I had given to me. Any more than that I can't tell you. I've had them for 20 odd years. I've used them up to now, and at the moment I'm making a lace angel for a Christmas tree. It's nearly finished.

914 Michelle West and John Kennedy
We're midway through a seven-mile run, and we've been carrying this with us. It's part of the new rafters in our loft extension that we've just had built. It's the first project we've done together, apart from running! We have a luxury master suite in the loft now – we've just moved in. It's lovely, apart from the seagulls, and the rain. It's nice when you're up there and you're not trying to sleep, but in the middle of the night, it's not so good!

915 Sally Watkins
Rowan's nearly six and he's in a transition stage between wooden trains and the new Tomica Hypercity, which he calls his Japanese bullet train. That's why he's okay about donating this, six months ago there was no chance! It was a prized possession, he had it in his first set when he was two. He loves any train, freight or passenger. In our house the train tracks pretty much go from room to room, under the furniture and everywhere. He's very into boats as well; boats and trains are his two favoured means of transport.

'The peas in the pod were a Grinling Gibbons' trademark, so it could be his carving, we're not sure.'

916 Jean Brock
I bought this little treasure chest in Kingcombe in Dorset, for a treasure hunt for a school residential there. It was full of chocolate coins. That was about ten years ago. Since then I've been using it to keep hair bands and hairgrips in.

917 Sonia and Andrew Weston
We made this from our rabbit hutch. The rabbit died last year, so we sold the hutch but kept his run and the walkway we'd made for him. This is a love heart with an anchor inside. It's our fifth wedding anniversary today, and the fifth is for wood, so this is our wedding anniversary present. We're down here on holiday and we thought we'd make something especially for *The Boat Project*. The love heart's for our anniversary, and the anchor's for the boat. Andrew cut it out and I sanded it down.

918 John and Jean Mills
I'm donating a rather heavy piece of timber that was used to support a vine room at our house. We grow vines and they produce nice grapes that we make into preserves. When we bought the house we decided that the room was probably better as a studio, and that's where Jean has her art work. So the vine room has now gone, and the vines have been transferred to various parts of the garden – they're thriving.

919 Kevin Podger
I've brought two pieces of hardwood, which my father Kenneth built into a piece of furniture at home about 50 years ago. He encouraged sailing greatly, although he never actually sailed himself; he loved the sport. He built my first Mirror. Those were the days when you could buy a Mirror kit for £67 and off you went! This piece of furniture was a drinks-cabinet-cum-bookshelf-cum-display-cabinet in our lounge. Father liked a drink, so it was kept busy.

920-921 Dennie Farmer
This is left over from when my husband was working on our yacht, *Carmania*. It was sold shortly after his death, so I'm boatless now. It's the last little piece. And this is associated with my husband's family. He came from a long line of sailors. His great-grandfather and grandfather were both masters under sail, and his own father was a master under sail and a chief engineer. My husband was a chief engineer also; he worked on the *Queen Elizabeth* and the *QEII*. This is from the cockpit of his grandfather's boat.

922 Sally Wood
I used to be a hockey player – I really enjoyed it. I played with this stick since I was nine. We always switch positions but mainly I think I was in a position out on the side.

923 Milly Boyle
A bow I made last year some time. I got it from Woodside Park and then I made it at home. It worked really well, and we made the arrows too.

924 Hattie Rogers
This is some eco wood. *Calypso* was built out of it and she's the first eco boat, built by my uncle Kit and my grandpa Jeremy Rogers. Eco wood is good for the environment. My grandpa gave this to me to donate and it's been living at the yard for quite a long time.

'The love heart's for our anniversary, and the anchor's for the boat. Andrew cut it out and I sanded it down.'

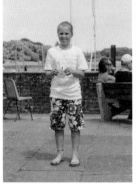

925 Charlotte Boyle
It's a badge from Minstead Study Centre. You pick it out of a bag and it says an animal in Latin on it.

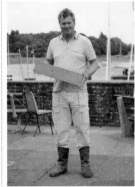

926 Simon Rogers
It's a piece of cherry from a tree that was outside my bedroom window when I was five. The tree fell down and my father planked it up into one inch boards and laid it down for about 20 years. Then when each of my brothers and I got married, my father handcrafted something for us. Kit and I both have corner drinks cabinets. My parents still live in that house; they've replaced the cherry tree with a slightly smaller one. It had wonderful blossom, and if you didn't shut the window in the morning the blossom blew right through.

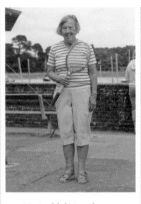

927 Marigold de Jongh
I've brought an old tennis racket that I used in the 1970s and 1980s before I had one of these modern ones. It's been sitting in my attic ever since. You can see the dark mark in the middle where I hit the ball every time. I played mainly doubles, in Suffolk where I used to live. It's a Grays racket, made in Cambridge, and it's got a Union Jack on the end, which shows it's British made.

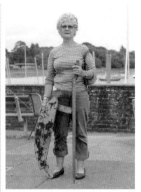

928-929 Sue Grimwood
This I found in Norley Wood. It was planted, stuck there, obviously lost. So I took it home and hoped that somebody would claim it, but nobody has. It's a nice piece of wood and it says the maker's name on it. And this was found on the beach about three years ago. I haven't a clue what it is. It's got a funny angle there, it's not symmetrical, but it's obviously a bit off a boat. I find loads of stuff on the beach. I thought I'd write something on it but I never got round to it.

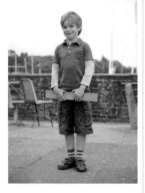

930 Tom Rogers
I sanded it down at my grandpa's yard – it's a piece of teak. I cut it on my own. I like working with wood.

931 Paul Driscoll
This is a boom from a boat I owned for about eight years. Originally the X One Designs were gaff-rigged and the boom was much longer. Then they got Bermuda rigged but the boom stayed the same length. Then in 1951 apparently they got Bermuda rigged with a shorter boom. So this could be the original boom shortened, but it's more likely to be a new boom. Eventually, in the 1990s, you were allowed to have a rectangular boom, which was stiffer and lighter, so people started to change them.

932 Jo, Mark, Jack, Will, Meg and Molly Broadway, and Jasper
Our house is quite well known locally. The previous mayor raised her family there. It was a nursing home for a while. We've been living there for the last ten years. This part was built in the 1700s, and then a well-known local architect built the tower in the 1930s. Five years ago we did some renovations on the tower, we took all the floor out and found this. It's from the carpenter who laid the floor back in 1934. He left a reminder of when it was done and who by.

933 Nancy and Angus Urry with Marika Bjerstrom
My grandfather, known as Captain Bill Urry, had a tendency to collect any wood he could get hold of to build a boat. So when the bathing station in Bournemouth was demolished in the 1960s, he collected up the teak. He was building a boat at the time, and these are the leftovers. They are two of the doors of the bathing cubicles. My parents have sloped off to France and left me with strict instructions to donate them!

'It's got a funny angle there, it's not symmetrical, but it's obviously a bit off a boat.'

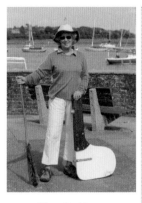

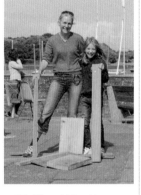

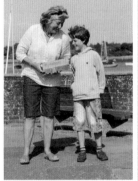

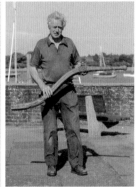

934-935 Zissa Davidson
I've brought my old lacrosse stick. You can see my initials on it there. I didn't do any work at school; I just liked playing lacrosse and tennis. I played for about seven years at Queen Anne's School in Reading, ending up in the first team. Lacrosse sticks needed a lot of attention; you have to oil and clean them – now it's rather dirty. And this is from the family scow that was built in 1969 at Palace Yard on the Beaulieu River. It was changed to a lifting rudder in about 1997. It's been in the garage for a long time.

936 Emilia and Mary Montagu-Scott
I built my own house 20 years ago, and it's on the coast overlooking the Solent. It's got a big wooden deck, it's timber-framed and timber-clad – entirely timber. So this is the flooring that runs through the house, some decking, and some Beaulieu oak, which forms the steps.

937 Jane Wilford and Oscar Cain
I think it's a bit of green oak and it came from a summerhouse I built in my garden. It's really peaceful up there. It's from the middle section, and we've put a hook into it that we hang a lantern on in the evenings. I didn't want the summerhouse too twee, so I thought, green oak, I'll try that!

938 Jeremy Rogers
This dates back to 1978. I was experimenting with different styles of tiller. It has split a little bit, but it's still structurally okay. One of my guys did the carvings. It was used on *Contessa 32*.

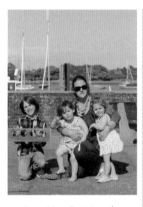

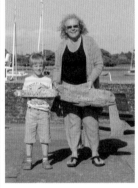

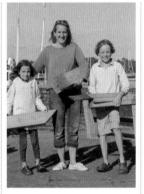

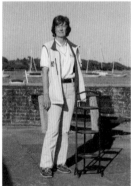

939 Lucy, Max, Beatrix and Poppy Markby Brans
It's a drinks holder. It came from a boat called *Kerrara*, which was moored up here for a while and housed my sister when she lived in London opposite Hampton Court at Surbiton. She lived on it while she was at University. We used to keep it here in the summer holidays and then take it up the Thames and moor up there. We don't know where the boat is now.

940 Arthur Mann and Marilyn Freedman
We're donating two pieces of driftwood that we found on the beach at Inchmerry near Lee where we used to live. My grandchildren made this one for me, and it was on my door. This second piece we used to keep outside the house on the step. Nobody heeded the warning though! We thought we should give up something that we like. We've got lots of different shapes and patterns of driftwood, and the grandchildren did all sorts of drawings and paintings on them – they did it all.

941 Charles, Charlotte and Alicia Pearson-Chisman
These are roof rafters. The roof is keeping us safe and warm and dry so we thought we'd give them to the boat so it stays safe and warm and dry! We had an extension done last year and we've kept bits of wood from it for tree houses and den-building. We brought six pieces, because we've got two doggies and there are four of us. So that's one for each.

942 Ann Brunskill
This was my mother's, and possibly her mother's beforehand. But I remember it from my childhood. When she had somebody to tea, the cake stand came out with the cakes and the scones and sandwiches that she had made – and there it was. It's been in our loft for at least 30 years. Her name was Margery and she died in 1962. I used it for a while, in fact we used it for plants, which is why it's a bit watermarked.

'I didn't want the summerhouse too twee, so I thought, green oak, I'll try that!'

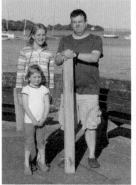

943 Alexandra, Charlotte and Fred Bassett
It's a post from our house. We had a gate but we decided to take it out because we needed to put a bigger gate in. So we kept this behind our bike shed for quite a while. The new gate's rubbish; it's falling down and it bangs in the night. We wish we had the old one.

944 Charles and Leopold Fox
We're donating the skateboard that my brother got for his sixth birthday. We've had it for three years. We go skating near the DVD shop. We've got new boards now. Our favourite moves are a front wheelie and a flicking move, where you flick it and it twizzles round.

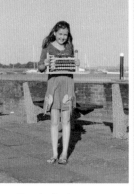

945 Natasha Fowle
It's an abacus, with my name on it. I've had it for about nine years, and I got it from my godmother when I was three. It was used quite a lot but now it's not really much use because I've learned how to count.

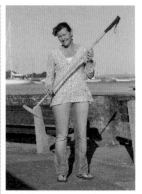

946 Jo Fowle
I'm bringing a polo stick. About 19 years ago in Singapore I bid on an auction for polo lessons, and it included a polo stick. I had the lessons and I loved it, it was fantastic. But I'm not a brilliant polo player, although I'd love to say I was.

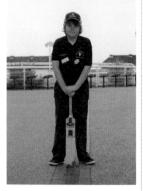

947 Ryan Bailey
I'm donating my first cricket bat. I've had it for seven years, since I was three. My nan and granddad gave it to me. I play for two teams, my school team and St Andrew's Cricket Club. I don't bowl so much but I enjoy fielding and catching the ball a lot. I've hit a couple of fours, but only one six so far.

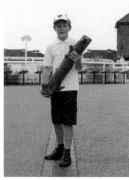

948 Tom Wright
I am donating a part of a tree that has been in our school for a very long time. It was very big. Last year it was cut down because it was leaning over too much. Now the logs are on our school field for the children to sit and play on.

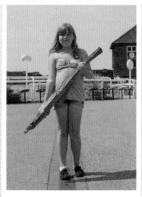

949 Kayleigh Ford
A piece of driftwood from my school, and it's been there for four years. It's from our outside area by our library. It was found on our local beach down the seafront.

950 Jesse Loynes
A bit of mahogany veneer with a little bit of woodworm on the back of it. It's from a tallboy that's been in my wife's family; we're the fifth generation to have it. It was bought by her great-great-grandfather when he was fitting out Matfield House in Kent, which was the family home. It's still going strong, although it needs some repairs. Like a lot of furniture, the front was made of nice timber and the back was made of cheap timber with veneer on it. It's in our dining room; it's used for the cutlery and that stuff.

'The new gate's rubbish; it's falling down and it bangs in the night. We wish we had the old one.'

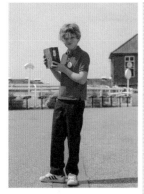

951 Billy Beard
It's from the old bell tower on our school. The bell tower was originally built in 1890, but then after about 100 years it had to be removed. But the public wanted a landmark, so a new one was built. Then in 2010 that collapsed, and this is some of the wood from the bell tower that collapsed in 2010 – so it's about 21 years old.

952 Ewan Clinch
I don't know nothing about it. The caretaker of the school just found it on the school field. It could have been a direction pole or a fence. He just found it on the field; it wasn't nothing to do with the school.

953 Stani Miles
I'm donating this boat because my grandfather built a boat in Argentina, and then when I was born he wanted to restore it so I could play with it in a pond. He died, so he never got to finish it. It's in memory of him. I really like it; I think it would be able to float probably. Now, by being part of a bigger boat, it can sail.

954 Santiasgo Yanez
It was a piece of wood that my dad made a shelf out of. On that shelf was a book that my auntie gave me, who's now dead. The book was about stuff you can do and build.

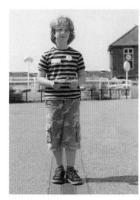

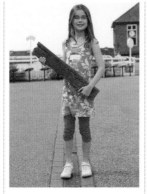

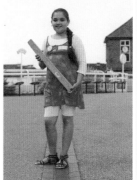

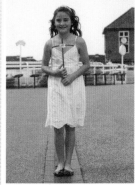

955 Jed Smith
This is a piece of elm wood, and it's from one of the only elm trees in England. It was in our wildlife garden at school. We've got three in there, which is good – it helps preserve the natural growth of plants and trees. Our wildlife garden is maintained by children. Birds and creatures of many descriptions use the trees as their natural habitat. It's a little haven based right in the city centre of Brighton, and provides opportunities for educating children about nature and ecosystems.

956 Maia Walker
We have a living classroom at school, which is basically like a garden where we grow things. We used to have a bench in it but the bench broke so I brought this in. I've been at the school since nursery, and I probably sat on this bench.

957 Shammah Joseph
This piece of wood was from our school garden. It was part of a fence but it got knocked down when we got a new garden. We grew a cherry tree because the mums of the school wanted one, but it died three times because it kept drooping. So we put this next to it and the cherry tree grew, and now we have cherries most of the time.

958 Lauren Snow
Because we're a Christian school we put up this cross and it's been hanging in our reception area for a lot of years. Everyone goes up to pray at it on church days. We all recycled it ages and ages ago when we came, in Year 3.

'I don't know nothing about it. The caretaker of the school just found it on the school field.'

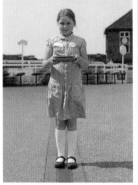

959 Rebecca Holmes
It's a music block that loads of children from our school have hit.

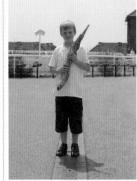

960 Lewis Terry
This piece of wood fell from a tree that blew down in the school field. It's been used in Year 5 for observational drawing for more than nine years.

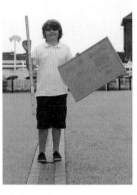

961 Sam Miles
We've got this ruler and we use it in school to measure stuff and to count up in times tables. And we use this notice board to pin things up in the school halls, like the sports equipment and kind of things you need to take. The ruler could be used for holding the sail in place. The notice board could be for things to remember or rules.

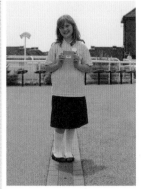

962 Abigail Hubbert
This piece of wood comes from our new chicken run at school. Year 1 have incubated eggs and watched chicks hatch. Now we have seven chickens that lay lots of lovely eggs. Year 3 look after the chickens, and they collect the eggs to sell them at the school gate. The eggs remind us of God's daily provision and the need to care for the earth and all living things. One chicken died, it was called Eggloo. Year 5 called one Ginger, there's another one called Crumble, one's called Chicken Licken!

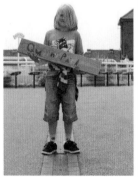

963 Angus Simpson
This is a big piece of timber. We're having a building extension to the school and this is part of the building work. It's really huge; there's no playground to play in now! There'll be three new classrooms, a new ICT suite, loads of other stuff – it's massive. But I feel really sorry for the people on the other side of the street, because they've got this huge building. They'll just wake up and see this massive building. They're putting it up really fast, it's nearly finished already.

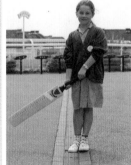

964 Eve Badger
This is the cricket bat that we got as a reward for winning the tournament in 2008. It's signed by the Sussex County Cricket Club. I don't play cricket. My favourite thing at school is Art.

965 Tommy Head
This trophy is special because it was awarded to Carden School for their fair play and attitude towards getting along as a team. Carden has a fantastic sporting achievement record and specialist PE teachers who motivate and inspire the children to achieve in all areas of sport and fitness. They underpin the ethos of fair play, teamwork and enjoyment of all areas of sporting curriculum. My favourite sport's rugby.

966 Winifred Grenier
This was from the Year 3 cloakroom about 20 years ago, they used to put their coats and bags and stuff on it when they came in. We've got new ones now.

'The eggs remind us of God's daily provision and the need to care for the earth and all living things.'

967 Megan Hall
About ten years ago Father Roger from Lancing College travelled to Africa, and while he was there the people hand-carved an ark with all these animals and gave it to him as a gift. When he returned to England he gave it to our school because our symbol is the ark. The ark, complete with all its animals, has been at the school since that time; these two wooden animals are part of the collection. We're not actually sure what they are – the first time we looked at them we thought they were bunnies.

968 Emily Vause
It's the handle off an old school bell. It was quite old and it had been used a lot in the school. It would have been rung in the morning before school and at break time and at the end of lunchtime. There's a new bell now.

969 Analise Evanson
This is from a blown down tree and we keep it to attract insects and butterflies, because they can live in here. It was kept at school in one of those places where you just throw things in, you don't actually go in because you can disturb things.

970 Megan Maker
At school people have been using our dewpond to put their rubbish in and the pond began to leak. So the pond area's been cleared. We're trying our best to make this place eco-friendly for wildlife and beasts and birds, where children can discover more about the animals around them. We've made space around the pond, creating attractions for animals: log piles, birdhouses, feeders, flowers. This piece of wood is from a tree that was cut back. It's a symbol of our school's continuing effort to improve our environment.

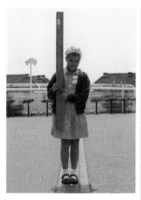

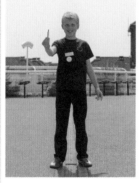

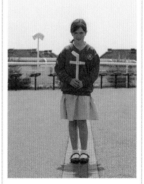

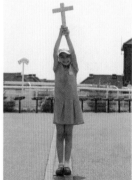

971 Casey Randall
This was from the original St Joseph's Playgroup, which was constructed in the 1970s, but it was knocked down in 2009 and a new one was built in 2010. Dave, our caretaker, found this piece for me to bring, it was with a pile of others underneath the new playgroup building.

972 Harry Garnham
It's a pencil made out of elm tree and charcoal. I made it on a school trip to the Stanmer Park Earthship. There was a guy called Matt and he built yurts out of all different elm tree wood and we got to make our own pencil. First it was cut off without charcoal in, then I pushed a thick pin through the soft bit in the middle to make a 1 inch hole, and then I put the charcoal in and scraped the wood off and it was just like that.

973 Jenna Grant
Our school chose this because we believe in Jesus and because we're Catholic, and we believe that choosing a cross is letting Jesus keep the boat safe in the Olympics.

974 Talia Maysey
Our school is Catholic, and this cross symbolises how Jesus helped us on the cross – and it's very special because I made it with my dad. I took the wood home from school and did it one night. Dad cut it in half and then made it all special. I love my dad, he does so much for me. He's a builder as well, so he makes lots of things. It's also about all the trees we have in our school. We even have gardening clubs, and we grow trees and plant them.

'While he was there, the people hand-carved an ark with all these animals and gave it to him as a gift.'

975 Jamie Wilson
This spoon is special to me because my nanny made special fairy cakes with it. It's my favourite spoon and it's always with me. It's been in another adventure called an egg and spoon race, which my dad won when I was three.

976 Jack Thornton
These are my first drumsticks that I used to learn my grades on. I passed my Grade 2 with these drumsticks. I've been playing for about two years now. I like Arctic Monkeys and stuff like that.

977 Bobbak Rabiei
I've got this wooden doll that my grandmother had, but she passed it on to my mother and before my mother left to live in Sweden with my step-dad she gave it to me. So it's quite special. I've kept it on the mantelpiece.

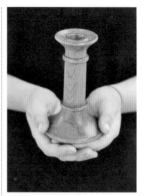

978 Dana Theodosiou
It's a candlestick that my grandpa made. Me and my grandpa were quite close but a couple of years ago he passed away. I think he would want me to give it to you for the boat because he loves wood. It's got his signature on it. He also made me a dolls house and it comes up to my neck!

979 Marc Paul
It's the clock I made on the taster day when I came to Peacehaven Community School. It's the first wooden thing and pretty much the only thing I made that day. The other option at the taster day was drawing up plans, but I do enough drawing at home. The clock's been around quite a bit, but because we've got so many clocks at our house, it's getting a bit hard to keep all the batteries energised. At one time I had two clocks in my room. Eventually I disabled one of them because I was bored of hearing tick-tick-tick-tick-tick!

980 Catherine Verrall
I'm the business manager here at Peacehaven Community School and I've got my hockey stick, which was bought for me by my father when I passed the 11-plus to go to the high school in Eastbourne. I played for the house team at school, although I was never particularly good. I've had it since then but I haven't used it very much. It has my name on it.

981 Rodney Browne
Wooden it be good if the world was a boat that floated in one direction lit by hope? Wooden I be free if my sails could catch the southerlies of truth? Wooden the disconnected fragments make a great raft to carry us through stormy seas? Wood you be part of something that saved your life, that saved your heart, that saved your soul? Wooden it be good?

982 Sam Harris
This is my wooden boat. I made it in Design Technology. I want to donate it because it was the first thing I made in Year 7 Peacehaven Community School. It symbolises my journey.

'Wooden I be free if my sails could catch the southerlies of truth?'

1000 John Kempton and Brian Burton, see page 190

They're a sandwich that's going into the rebuild of the *Medway Queen*. The paddle minesweeper *Medway Queen* was in the Royal Navy from 1939, and she did seven trips across to Dunkirk, rescuing 7,000 men from the beaches. She has the title of 'The Heroine of Dunkirk' for her exploits there. She actually downed three enemy aircraft, one of which was a Spitfire that had been captured by the Germans and was attacking the vessel.

'She did seven trips across to Dunkirk, rescuing 7,000 men from the beaches.'

983 Callum Kirton
It's a board game I made in Design Technology and it's the first thing I've made since I've been at this school. I made it a couple of weeks ago. The game is a basic board game where you roll a dice and you go a certain amount of spaces, and if you land on a certain space this lights up. It's called 'Tour of Duty'. I got the name from 'Call of Duty'.

984 Skye Saggers
I've got my board game that I made in Design Technology. It's a game called 'Celebrity Smasher'. There were cards and dice to it, but basically when you land on a celebrity you take a card and when you've got all the cards you've won. I never made a dice so I haven't actually played it.

985 Dylan Briddick
This is my great-grandma's spaghetti curler from the 1900s. She made the most delicious spaghetti and her spoon is very special to my family. She's given the spaghetti recipe to my mum.

986 Billie-Blue Christer
This is a Harry Potter based wand that I whittled myself, and then stained with coffee. I originally did it for a costume party but then over the last few years I've found myself being quite obsessed with Harry Potter, so I've got lots of them at home. This is my most recent one. I thought there could probably be a better use for it than me running around shouting things like 'Incendio' at people. If this was an actual real wand, someone would catch fire. Obviously, being the nerd that I am, I know all of the spells.

987 Helen Cryer
This is from one of the first things built in Peacehaven Community School, ten years ago – it's our tenth anniversary this year. Some students and staff have signed it too. It's a memory of how the school began. It was shelving that some students made, the first students to ever make anything here.

988 Helen Cryer
This is a coaster with a koru inlay, which is a Maori design. These are from a set of placemats that I brought back from New Zealand after living there for a number of years. So it's a good memory of a lovely time. But it was also the present I brought back for a very dear friend, Mike Dell, who was a sailor. Mike died before I got home, so this is going to go sailing instead of him.

989 Lawrie Richards
Me and my family were walking along the beach between Newhaven and Peacehaven and we found a piece of wood that we think is from that boat that crashed, *Team Philips*. I took it home. I just like picking up pieces of wood.

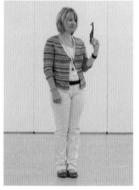

990 Jenny Alborough
I've got a giraffe that was carved by Zulus in South Africa, and it was given to me by my father who lives there. It's had its little place on the mantelpiece where it was sitting with an elephant. I've seen them in the flesh only once, and that was at the zoo!

'I thought there could be a better use for it than me running around shouting things like *Incendio!* at people.'

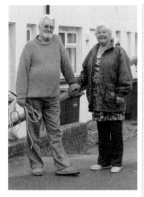

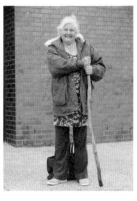

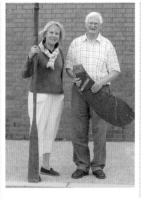

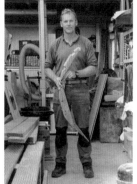

991 Rosie and David Lee-Boutcher
There was a boat parked just across the way and the children were jumping in it and it wasn't very sound. They made holes in it. Then one day my late husband and I looked out to see some children holding this and running towards a car headlight. So I roared, they ran and we put it in the garden, safe. That was about 14 or 15 years ago.

992 Rosie Lee-Boutcher
This was the first thing I used in the New Forest after coming off crutches. That was about 14 years ago. I've had three operations on my spine. I use walking sticks now and a wheelchair, but this was the first time I walked upright. My husband's arm's a good support! It was on Long Beech campsite. There was lots of rain, we grew webbed feet, read lots of books, and then had a week of glorious weather after that.

993-994 Brian and Jane Goudge
The oar was the only remaining piece of the first dinghy I ever owned. A local design called a Slipper, a double-ended, clinker-built boat called *Meg*. I had hours and hours of fun on it. We had it for ten years. I believe the other oar got broken. And this belonged to a National 12 that my brother owned in the early 1960s and raced locally and around the country. The boat's name was *Tigger*, because he and his wife were keen on those characters and they lived in a house called *Kanga*. This was the original rudder.

995 Keith Rathbone
I work for Chichester Harbour Conservancy; I'm one of the rangers. I get out and about in the harbour quite a lot, and just tidying the foreshore I picked up this piece of wood and I thought I'd dry it out in my barn first and then bring it in. It's from another boat and I think it's a stringer, which supports the hull. I've been a ranger here for three and a half years. The harbour is my office, so every day's a lovely day to come to work.

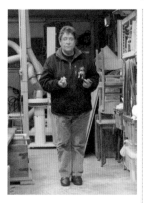

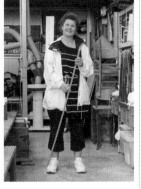

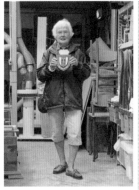

996 Anji Clarke
We've had him quite a while now, for three house moves, and he's been with us for 21 years. As you can see, he's a doorstop, but the house we've got now has no doors! When we bought the house we never even realised that downstairs had no doors, but now we have thick curtains, which we like better anyway. So he might as well go to sea and enjoy himself. Maybe a second figurehead in the bilges?

997 Peta Taylor
It's a piece of skirting beading that was left in my house along with about five or six others. I had a wood floor put in and I was supposed to finish the job off. That was ten years ago, and it still needs doing. But I find my time is perhaps more interestingly spent doing painting and writing! The guilt does go with this, although I've left a little bit of guilt behind.

998 Jill Wynne-Potts
My husband was in 42 Commando Royal Marines and he died two years ago. It was a great part of his life. He was in the marines for 37 years and he loved it. That's the Royal Marines battle honour, 'Gibraltar', because their slogan is *Per Mare, Per Terram*, which means 'By Sea and by Land'. He was with them in Burma, where he was wounded, and I met him in Gibraltar, when I was a secretary and he was MA to the Governor. This has been in my garage, I should think we picked it up somewhere.

999 Anji Clarke
This is olive wood – it's a Celtic cross and it's used for protection. We used to go abroad quite a bit, though not too far. But we don't now because I've had too many operations. I thought people on this boat might like a little extra protection.

'The guilt does go with this, although I've left a little bit of guilt behind.'

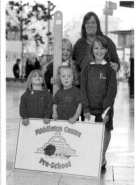

1000 John Kempton and Brian Burton
These are four planks; they're a sandwich that's going into the rebuild of the *Medway Queen*. the *Medway Queen* was in the Royal Navy from 1939 and did seven trips across to Dunkirk, rescuing 7,000 from the beaches. She has the title of 'The Heroine of Dunkirk' for her exploits there. She actually downed three enemy aircraft, one of which was a Spitfire that had been captured by the Germans. The top part of the sandwich is the original deck plank. They've been cut down and cleaned up and then laminated onto a new piece.

1001 Pat Hurst, with Lucy, Alice, Olivia and Grace
We've brought the plaque from Middleton Centre Pre-School. We were at Middleton Centre for 20 years in a community hall, and then we moved to Tickford Park Primary School, and we are now River Meadow Pre-School at Tickford Park School. So we've brought some of the children who were with the Meadow and some who were at Middleton Centre. This is the sign that we had in the window, and this piece of wood is from a balancing board. We thought it could be the bridge between the two settings.

1002 Mike Townesend
Here's a coffee table and a stool, both made by me at school; a paper rack made by my grandfather; a tray that fits in the stool made by my father – and part of my grandfather's conjuring table. So there's work here from three generations of the same family. I shared the conjuring table with my sister Kim Hope. She already gave her bit to *The Boat Project*, so I thought I should give the remainder here. My grandfather Charles Folkard became a well-known book illustrator. I inherited his genes, and now I'm a painter.

1003 Ciaran Hammond and Rhiannon Hankins
I've brought a piece of monkey puzzle tree. When my mum was born in 1944, on Christmas day, her dad planted a monkey puzzle tree, and when he died 50 years later, we cut the tree down and planked it up. We're furniture makers by trade and we made a lovely dressing table for my mum out of it, and this is one of the last boards left. My mum's got bad arthritis in her hands so the design is made specifically for her, she just has to push the insides of the drawers and they swivel out.

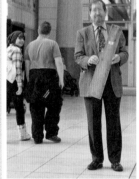

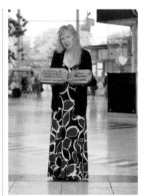

1004 Sylvia Bebb
It's part of a portable barre used by some of the ex-pupils of the Sylvia Bebb School of Ballet. They've gone on to be principals of the Royal Ballet Company and played leads in *Fame* in the West End. That's just a few of them. There are hundreds of them, all over the world. I was in the English National Ballet Company myself. All of these ex-pupils have used this barre.

1005 Phil Gallagher and Morris Rickson
We represent Woodchuck Recycling, a community company from Milton Keynes. We've brought a few examples of what we've got in our unit – a piece of oak from America, an oak post, hardwood board from Uruguay, scaffold board and pallet wood. Rather than it going into landfill, we recycle and reuse it in the community. People can buy it to build their own things. We also support volunteers to learn skills – making shelves, chairs, seats and so on.

1006 Simon Greenish
This is a piece of floorboard from Cottage 3. Cottage 3 was a key building in World War Two. It was where the first Enigma break was made in 1940, and where Alan Turing and the famous code breaker Dilly Knox worked. So they both walked on this piece of wood. There was a drain problem, and this was a bit that came out as a result.

1007 Maggie Travis
I've brought two memorial plaques. When my father died I had a plaque made in memory of him and my mother, who'd died when I was quite young. I was going to plant a tree where his ashes are buried, but my husband died before we could do it; so I had another plaque to make for him. Now my brother's died in Canada. I brought back some of his ashes and wanted to remake my parent's plaque with his name added to it. As you can see, they've weathered, so I've decided to remake my husband's plaque as well.

'Cottage 3 was a key building in World War Two. It was where the first Enigma break was made in 1940.'

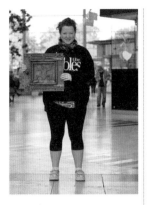

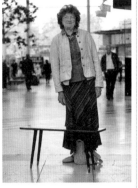
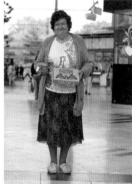

1008 Julie Higgins
When me and my boyfriend got together we started salvaging out of skips and thrift shops to decorate the house we'd moved into. This is one of the first pieces we found in a skip in St Albans. It was a bedside cabinet. We were able to restore the rest of it apart from this piece, it had a crack down the front. You can see where we've tried and failed! It's in our bedroom now; it's like an open unit, a bookshelf. We've got a shed full of weird stuff we've found – lots of 'to-do' projects!

1009 Amanda Buckland
My father was one for do-it-yourself. He was always fixing, making, creating things. He taught us about wood and things you could do with it, how to machine it, how to put it together. He'd sit in his garage and use this little piece of wood as a straight edge, and he used it to hold bits of his creations together when he was gluing them. It just always hung around, it was really useful. So this is in memory of my dad, so that something of him is in the boat.

1010 Margaret Ellins
The wood originally came from a Victorian chiffonier, which was my grandmother's on my father's side. It lived in Bethnal Green during the First World War, and in Walthamstow during the Blitz. When my grandmother died in 1958, my auntie had it converted into a drinks cabinet. The left over pieces were made into various objects, this being one of them. My father made one of the shelves into this table to fit in an inglenook fireplace. I used to keep things the children made at school on it. Because I'm a sentimentalist.

1011 Moyra Archibald
I've brought a smoked salmon box. It was given to me by a Canadian lawyer friend who died of AIDS a few years ago, so it's a bit special to me. Inside is the handle of a wooden walking stick. My first walking stick wasn't very strong and the handle broke off the first time I used it. So now I have a metal one instead.

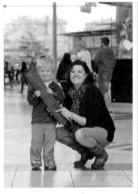

1012 Isabel Barnbrook
This started life as the end of my granddad's bed. He was a French polisher before the Second World War, so I reckon a lot of his furniture he acquired that way. When he died and my mum came to clear his house I said, 'Oh, I'd quite like to have a bit of granddad's bed'. Because I like wood and I like the shape of a scallop. I took the foot end and when I got married my husband put some uprights on it and we had it on our first bed.

1013 Diana, Jack and Jenny Towers
About 18 months ago my husband Nic decided that our Humphreys 36 offshore race yacht needed re-decking. He worked on her through all weathers at Hamble Point Marina until last April when he died. In this box is a section that showed how the old decking had been done originally and her are some trial pieces Nic made to work out how he was going to re-deck it. Jack and Jenny and my brother-in-law finished the work, and now we're refitting her.

1014 Louise and Alfie Bird
This is a piece of wood from our loft which we had converted about six weeks ago. Ours is a Victorian house built in 1901, so it's an old piece of wood. We cut the rest up for firewood.

1015 Nadir Farrell and Briony Seginson
This cricket bat started its life over 20 years ago as a willow tree grown in one of Milton Keynes's lovely parks. Each autumn the Parks Trust selects and fells the willows to produce some of world's highest quality willow for cricket bats. The wood is then shaped by craftsmen at Kippax Bats in Yorkshire. The bats are used by many international cricketers. We plant new willows in their place, so the whole cycle can begin again. And money from the sale of willows is ploughed back into caring for the parks around here.

'This is one of the first pieces we found in a skip in St Albans. It was a bedside cabinet.'

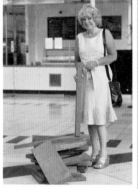

1016 Lesley Turner
This belonged to my late husband Keith Turner, who had a model shop in Durham in the late 1980s. Almost all his life he'd been into building model ships, model boats, and he was very into sailing. Wherever we've moved this wood's gone with us! I wanted to throw it away, but he wouldn't let me. Since he's died I still haven't been able to; I could still hear him saying how much it was worth! I'm delighted it's going to this project, I can't think of a better home for it, he was so much into ships and boats.

1017 Nina Newton
These pieces of oak came from the bell frame of our local church, St Martin's in Dunton, Buckinghamshire. We restored the bells in about 2005 and converted them from full-circle ringing to chiming, which meant there were some bits of old wood that were taken out, mostly rotten. The bits that weren't rotten I've salvaged, and made into lots of bits and pieces which we've sold to raise funds, such as corkscrews – very religious! These are the odd bits that haven't been used.

1018 Ellie Ellery
At any rock concert, you'll see a wall of Marshall Amps. Jimmy Marshall started out as a drummer giving drum lessons and he opened a drum store in West London. One day Keith Moon and Pete Townshend came in and they said, 'Why can't we have a British-made amp'? So Jim got a team together. We still manufacture in the UK and at the factory we produce our 1960 speaker 'cabs', and from these cabs we need to cut out four disks of wood to put the actual speakers in so that 'Marshall sound' can come through.

1019 Alan Richards, Mayor of Milton Keynes
It's the coat of arms shield, with an oak tree symbolising the steady growth of Milton Keynes. The tree is ringed by a walled crown, a symbol of local government. The white, blue and red bars of the ancient Keynes family symbolise the town's historic past. The crest is of a medieval helmet. The supporters are bucks. On the shoulder of each buck is a double-headed axe. The motto lists the qualities needed by a forward-looking local authority: 'By knowledge, design, and understanding'.

1020 Ann Limb
These teak lamps were found in the attic after my partner's father's death. He was George Cooke, born in Wolverton in 1909. He left school at 14 and served an apprenticeship in the railway works, becoming a railway coach finisher. He lived in Wolverton all his life in one of the Victorian terraces, which he completely refurbished. These are unfinished lamps. We were thinking that these humble remembrances of one man's life could be part of something bigger that's also going to be handcrafted. He would have loved that.

1021 Kirsti Roberts
This wooden foot was mine. I'm an amputee of 25 years. It's the old-school style, although it was quite technical at the time; it enabled me to adjust the angle of my ankle, and to go from flat to heeled shoes. I wore it for about five years. It's made specifically for me, to match my other foot as much as possible. I've been in a newer foot for about the last five years. The new one's very good – I've got a button now rather than an Allen key. That's progress!

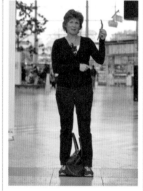

1022 Hazel Staten
It's driftwood from the shores of Lake Baikal in Siberia. Some years ago I was diagnosed with leukaemia. While going through the treatment I felt that if I ever got better I would give a message of hope to people going through the same thing. I did get better and I decided to follow in the footsteps of Gladys Aylwood, a missionary in the 1930s who travelled overland to China. She's best known for taking a hundred orphans across the mountains. I travelled overland all the way to China, and stopped off in Siberia on the way.

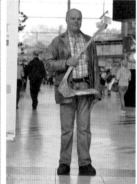

1023 Malcolm Skevington
In 1939 London Transport built 40 experimental buses code-lettered CR, with the engine in the back. When the war came along they all got parked up; afterwards they were used to ferry athletes to and from the Olympics. A lot were exported, and in time they fell apart. This pillar came out of one that went to Cyprus in the 1950s and was repatriated by an enthusiast. The restoration took me eight years, I did it evenings and weekends. I did a wedding with it earlier this year and it goes out to rallies. And sometimes we shove 20 people on it and go out for a picnic.

'One day Keith Moon and Pete Townshend came in and said, "Why can't we have a British-made amp"?'

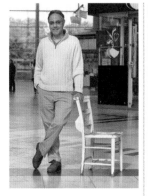

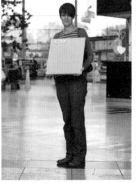

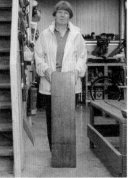

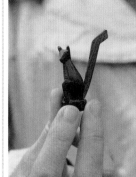

1024 Jonathan Silvertown
I bought this chair when I was a student in Brighton over 30 years ago. It was probably the first piece of furniture I ever bought. It cost me about two quid, and I found it outside a hairdressers in Kemp Town. It's a chapel chair that's made of solid beech. I think I bought about six of them at the time, and we've been using them in the family ever since. Somewhere along the line this one got used for decorating, so it's in a bit of a state. The others are going strong though.

1025 Julie Kemp
This is one of our cupboard doors. We're having an extension built in our school this summer. The extension's going to be in Foundation, and for Key Stage 2 – to cheer us up. They're putting all new cupboards in so we don't feel left out. It's actually out of our art area, where all our art materials were stored. It's spent 30 years looking after paintbrushes and pots. I'm the art co-ordinator, so I ripped that door off this morning ready to bring down!

1026 Jenny Lacey
I've known this wood most of my life. In 1948 my father Norman, a railway surveyor, found some men burning a heap of beautiful carved oak, plain oak, and books. They were supposed to be clearing a house. He stopped them, thinking it must be a mistake. In the end he volunteered to take all the oak and look after it. He was trained as a carpenter and joiner. During the war he joined the Royal Engineers Port Maintenance division, building boats, mending the dock gates at Dieppe, and working all up the coast.

1027 Janice Dykes
He's a lemur from Madagascar. I spent two weeks there doing some teacher training in March this year, and this is one of the little chaps I brought back with me. It was very interesting but really hard. They're not qualified teachers and they have a long way to go. The kids out there have to learn French or they can't get anywhere in life, but some of the teachers don't know French very well either. So it's a difficult situation for them. Fascinating country. And we also got a couple of days off to go and see lemurs.

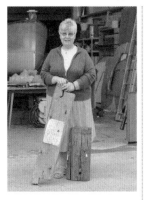

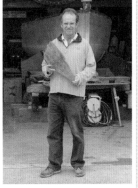

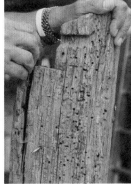

1028 Linda Newell
The upright piece is *Echo I*, the other is *Echo II*. *Echo I* was the queen of the Emsworth oyster fleet, launched about 1900 and the most technically advanced oyster smack sailing out of an English port. She had steam winches, and her dredges were operated by steam as well. When she came off the blocks they laid down the next one, which was ready for launching at the time of the typhoid scare in 1902. So she was launched but never named or rigged. She was put out in the harbour and left. The locals called her *Echo II*.

1029 Stephen Dykes
This is a Picasso Triggerfish from the Maldives, where I first learned to dive some 15 years ago. It was one of the first fish we saw, which was stunning – beautiful. I bought a model of it and have been diving ever since. We still see these fish from time to time, and they're still our favourites!

1030 Tim Goodhead
Emsworth Sailing Club was originally a bathing club formed in 1792. At the time it was almost a beach hut for the people of Stansted Park and some of the big country houses. They had a large wooden swimming pool structure around the front, and this is part of that original tide pool. Allegedly Princess Caroline swam there, so we like to think that Nelson may have visited as well. The club prospered in Victorian times, went into a slight decline in the First World War, then was reformed as a sailing club in 1919.

1031 Chris Clode
This is a roof timber from our house in Bath Road, Emsworth. It's a waterfront house, built around 1802. When we bought the house we did a big renovation on it. In the roof we found that all the timbers had death-watch beetle. While ripping them out we realised that lots of them were actually old ship's timbers. So they must have been old when they went in there in 1802. I've kept various pieces in my garage, and given them away to friends who use them as lintels above their fireplaces or Agas.

'Fascinating country. And we also got a couple of days off to go and see lemurs.'

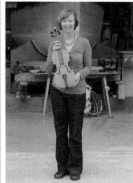

1032 David and Patricia Watts
This was a plaque from the old naval school for new recruits in Gosport. This was the name of the establishment and 'HMS St. Vincent. Thus' was its motto. I think it belonged to my father, Tom Watts; he was the headmaster of the school. It's been in the garden shed for about 20 years.

1033 Jacky de Laporte
This is a violin that was made by my father-in-law, Eric Rolfe, who lived and died in Southbourne. He taught science at a teacher training college. When he retired he went back to his first loves, art and music. He used to play the viola in an orchestra in Exmouth. One of his hobbies was to make violins. This is his last violin, which was never completed. His granddaughter, my daughter Gemma, is now a teacher and she loves sailing. She thought it would be a fitting tribute to him to have a piece of his violin in the boat.

1034 John and Angela Brown
I found this lead in the garage. I bought it to go round the big windows, thinking we had a leak, but in fact the leak was coming through a flat roof above the balcony.

1035 Beth and Jack Mackenzie
It's a French decoy duck. It was used out on water to attract other ducks so you could shoot them. But it's more of an artistic thing nowadays. We were given it by our grandfather who makes decoy ducks, and this is one of the ones he's collected.

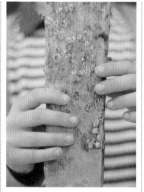

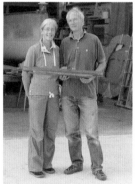

1036 Michael Cooper
These are some chair legs that were snapped off because a few months ago my sister was sat on Facebook on the computer, and she shuffled it and it snapped off and broke! So she fell on the floor and I was sat on the computer next to it and it was quite funny. She was alright, but it was quite funny. It randomly just went – *doosh*! We've had the chair for absolutely ages. I couldn't bring the rest of the chair along because I was cycling here. This is all I could fit in my bag.

1037 Branwen, Manon, Geraint and Dominique Melville
This is an old floorboard from our house, which is 100 years old. It's on the Billy Trail, which was the old steam train railway down from Havant to Hayling. Obviously the train's not there anymore – but the houses are an old terrace, presumably built around the rail track. Our house was a big wreck and we had to do lots of work, but we kept some of the things we took out. Our garden looked like a junkyard, and now it looks over 1,000% better!

1038 Manon Melville
I found this at the Witterings. We were looking for pieces of wood for the boat and I found lots of different types, but then I found this one. My mum thought it would be a really good idea because it has these little shells on it.

1039 Paul and Roz Walland
This is from the side cockpit of our first little boat, a Topaz. We sold it and bought a Crabber, which had been renovated by somebody who loved wood; this second piece is from that boat. We did more sailing with it, but Crabbers don't actually sail that well, so we bought a wooden Shrimper we found in Bosham and renovated it. That's what we're now sailing, and it's been a good friend. We've just done some renovation on the foredeck, this is some of the original wood. So these pieces are from the three boats, all sailing in Emsworth.

'It's a French decoy duck. It was used out on water to attract other ducks so you could shoot them.'

1040 Les Treagust
When I was eight, I was asked to climb through a neighbour's window because she was locked out. She was a Deaconess and she rewarded me with this small, carved wooden barrel made of wood from the RMS *Mauretania*, the famous trans-Atlantic Cunard liner. I was also given an ivory snuff spoon made by the Zulus. The barrel used to have a plaque on its side which said 'From the Decking of the *Mauretania* – The Old Lady of the Atlantic', but it's been removed. You can see the holes it left on its side.

1041 Harry Wilkinson
I've brought a shield from Havant Rugby Club, along with an oak profile of a rugby ball. I'm the president of the club and I've been associated with it for nearly 30 years. The club was formed in 1951 and this year we celebrate our 60th anniversary. I've played from the age of 11 and I finished playing about four years ago for the veterans, since then moving on to the management. It's semi-full-time now as president; it takes as much time as I want to give. I'm retired and I like to fill my time doing practical things.

1042 James Mant
It's a tea tray, and it was made during the Second World War by my grandfather, Fred Mant, who was a shipwright on HMS *Wolf*, but I'm not entirely sure of that. I suppose he made this tray for himself, but on board the ship. I've had it for about 20 years, and the handle got broken at some stage. I think it lived in the loft for quite a long time.

1043 Zak and Peter Hume
This is my first skateboard that I got when I was five. I've got a bigger one now, and I skate down at Hassocks Skate Park. But I'm more into BMX-ing.

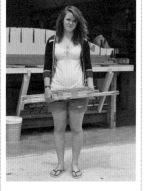

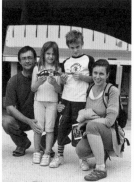

1044 Liz Heath
I've brought my daughter Abby's hockey stick. She left it behind when she set sail on the *Anna Christina*, a Norwegian square-rigger that went to Australia following the trade winds, a re-enactment of the First Fleet, the convict ships. She was 24 during the nine-month trip, and she's lived there ever since. She met a South Australian sheep farmer and now they have two children. He was on the South Australia ship on the fleet. He's a true Australian, a sheep farmer, a sailor and a keen hockey player!

1045 Poppy Reid
These are seven planks from the back of the canvas of the first painting I sold. It was a Jackson Pollock kind of splatters of green paint, because I'd watched a documentary on him when I was little and loved it. Then my mum bought it off me for her office. I was about 11 or 12 at the time, and I'm 18 now. The canvas is now folded up and in my room.

1046 Tadeus, Milena, Caroline and Ernesto Ruiz Harrison
It's the balsa wood helicopter my uncle Jose made. He doesn't work because he is ill with leukaemia, so all his time he's making beautiful paper flowers and wooden toys. He gave me and my sister a plane and a helicopter – this is it. We're going to give the helicopter, because he is not healthy enough to go travelling, so we think he might be happy if he hears that one of his toys is going travelling instead of him.

1047 Seamus Maddock
We went round to see Mark this morning and he said, 'I've got something for you here. This is a dowel that I picked up in the harbour from the *Echo* oyster catcher boat'. It was picked up after the day the boat was disassembled. We've known Mark for almost 50 years.

<div style="writing-mode: vertical">THE LONE TWIN BOAT PROJECT 195</div>

'I was also given an ivory snuff spoon made by the Zulus.'

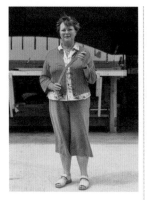

1048 Elizabeth Salmon
My grandmother had a son, Roland John Walker, who drowned at sea during the Second World War, aged 21. When we were clearing out my grandmother's house we came across this coat hanger with the initials R.W. Roland Walker's the only person in our family with those initials, so we hope it's his. It's so appropriate to go on a boat. I've been trying to find out the name of his boat, but it was never really talked about. We have a grave for him, but I'd like to know a bit more, I never knew him.

1049 David Beal
This is all that's left of my old toolbox. I had it from 1939 when I joined the navy. I was Ordnance Artificer and Apprentice Artificer on HMS *Fisgard* at Chatham – qualified right the way through. I served on four battleships: two 15-inch battleships, two 14-inch battleships. I came home on an eight-inch cruiser, then did time on a Corvette frigate. This toolbox went everywhere with me. When I left the Navy in Coronation year I stopped using it. I've still got the rest of the toolbox, the lid just came off! And I'm still using the tools.

1050 John and Sarah Simpson
It's a piece of wood that has been immersed in a bog at my cousin's farm in Ireland for between 3,000 and 4,000 years. The farm's 40 miles west of Dublin, in Ballyshannon. My cousin gave this to me when I told him about the project – he was keen to give it. We tend to go over every year and we're quite close to the family. It's a wonderful part of the world, with this great expanse of bog and flowers, and periodically they find these stumps.

1051 Alena Kotzmannová
I'm an artist living and working in Prague. I found this piece of wood three years ago on the seashore in Portugal. In 2009 I made a site-specific installation *193 m.a.s.l.*, a boat with a cottage on board and historical postcards of various seashores inside. It was for the finalists' exhibition of the Jindrich Chalupecky Award at the Dox Centre for Contemporary Art, Holeovice. I used this piece of wood as part of the cottage built in the boat hull, for 'good luck from the sea'. I can't bring you the wood myself because I'm pregnant.

1052 Kyrle Hobbs
It's a short wooden spirit level that I used when I started to build my own house, 30-odd years ago. That was in Newport in South Wales in 1978. I've used it to build extensions but not other houses. I think that's quite enough, don't you?

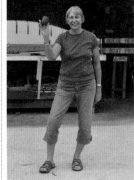

1053 Sue Slight
This little barrel was made by my grandfather, using teak from the deck of HMS *Iron Duke*, Admiral Jellicoe's flagship at the battle of Jutland in 1916. My grandfather, William John Lockyer, was a member of the crew on the *Iron Duke*, he was a chief PO sailmaker. My dad Sam used to keep his cufflinks in it. I've had it since I was about five, I'm 66 now. I was going to pass it to my son Oliver, who's a Lieutenant Commander in the navy, but he said, why don't you give it to the project.

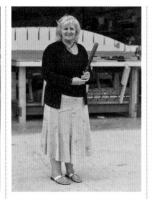

1054 Sue Moore
I have a truncheon. Its origin I don't know. I think it is probably quite old. My husband, who dies 32 years ago, was a policeman and he got it from somewhere. I found it upstairs in a box where it's been for the last umpteen years. I just thought it's silly leaving it there. There's a few notches on it, but it's probably been used for banging nails in or something! I'm sure it's not his – he did have a wooden truncheon, but his was in much better condition I think.

1055 Lucy and Ben Hodges
This is a wooden mast from an Enterprise dinghy. The boat was bought for £200 when the children were eight and five to teach them to sail. The boat went 'west' many years ago, but we kept the mast and have been storing it ever since.

'I'm sure it's not his – he did have a wooden truncheon, but his was in much better condition.'

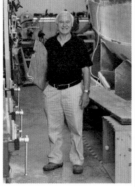
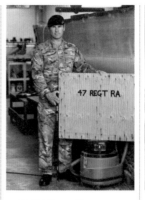
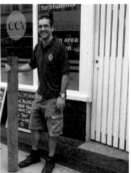

1056 Anya Loynes with Jasmin Gunnell, Samuel May, Tay Campbell, Tyler Beckles, Michika Burton, Sanchia Burton, Harriet Child, Eoin Collins, Thea Davies, Julia Deluchi, Bethan Foley-Bird, Charlize Martin, Jasmine Wagner
Here are nine wooden letters. I had a half-term tidy of the resources room at Morelands Primary School and found an old wooden jigsaw puzzle. It used to have all the letters of the alphabet. However nearly all of them were missing except the ones needed to spell the school name MORELANDS – so special.

1057 Bernard Clarke
This is the transom seat from *Ocean Lord*. This boat has been right around the world over two years in company with *Gypsy Moth IV*. The transom seat broke, so I am donating it to *The Boat Project*.

1058 RSM Simon Torr
We've brought the lid of an MFO container. It was in Herrick 12 with the guys from 25/170 Battery who deployed to Afghanistan. They were there for six months, but this freight stayed there for nine and brought back weapons and the webbing of the guys who deployed there.

1059 Deri O'Regan
I'm Assistant Head Teacher at Kidbrooke School. I've brought some wood from the school, which was built in 1954 as the first comprehensive school in England. Kidbrooke's closing down this summer and we're re-opening in September as Corelli College, London's first co-operative academy. The parents, local community and staff jointly own and govern the school for the interests of the children.

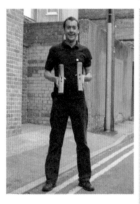
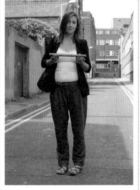
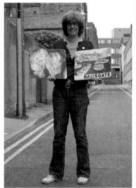
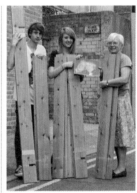

1060 Joseph Cornwell
I'm the production manager at the Theatre Royal, Margate. This is one of the wooden cleats from the 'fly rail', which is where we control all the ropes that hold everything up above our heads. Unfortunately we had to replace them with cast iron ones. The originals were installed by the two men who built the theatre. One was a local brewer, one was a sailor. So this may have come from one of their yards or their boats. The cleats would have seen a lot of action, a lot of rope and a lot of shows.

1061 Beth James
This was used in a production of *The Tempest*. I run a theatre company for young people with learning disabilities and the boy playing Ariel, Jack, used this in the production last year. Apparently it's from Peru, but I don't know very much about its history.

1062 Jenny Duff
They're two big tablemats with sea-related images on them. There's one of Whitstable oysters, which I took a couple of years ago, and one of Ramsgate Harbour, because I thought it might be useful to you, for when you get there, to see what Ramsgate looks like! I made the prints. I print on to paper, then my print's incorporated into the melamine mat. They have hardboard underneath and cork on the back. I sell them in Ramsgate and Whitstable and all over the country, I sell trays and coasters as well.

1063 Mary Sanderson, Lauren Austin and Richard King
My husband Jack built this bed in 1972. It's had various mattresses over the years; it's been a spare bed, my daughter's bed and, then our bed. This year we decided to splash out and have a Hypnos bed. The day before it arrived, Jack was taken ill with a stroke, and died. He never got to sleep in his bed. It's a fitting memorial for him. He was a pilot on the Thames and he'd been a deck officer from 1947. He was a tremendous man. Super husband, super father, super grandjack.

'The cleats would have seen a lot of action, a lot of rope and a lot of shows.'

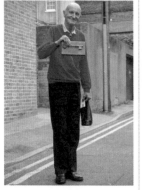

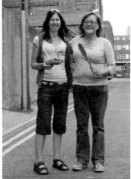

1064 Rodney Mander
It's a piece of wood with a key. Unfortunately the key's a bit tarnished. It was sent to me in 2001: 'To Rod, a key worker. From all at Invicta Storage. Finally the key to the back door you always wanted'. I never had possession of the key but now I've got one! I worked there for three years and resigned three times – they finally accepted! But one door closes, another one opens; one has to move on. It's been on my sideboard for the last ten years.

1065 Sara Mathews
This is a paddle for a wok that they use for making desserts, rather than savoury things. It's 23 years old now. I bought it when I visited the highland people of Thailand, this was made by a Hmong. I was in Thailand to celebrate my friend's wedding, and we actually went on a honeymoon too. It came back with me to London. My sister stole it and used it for many years. Then I stole it back, and I've been using it since that time to make curries. Because it's made out of hardwood it's lasted all these years.

1066 Heidi Village
This is driftwood from the sea, it's been in my garden. I don't throw anything away; if I see something I like, I keep it. I was a teacher but I got ill with viral encephalitis 11 years ago and lost my language. I've had to learn language slowly all over again, talking and under-standing. For three or four years I couldn't make a sentence, all I could do was walk, listen to music and make my sculptures. So my sculptures often show what I feel; and they have helped. I had no language, but I was the same person.

1067 Costas Pikatsa
I lived in Sea Bathing for three and a half years: hospital room 52, second floor. I worked at West Hanney. The nurses there were fed up with me, turning up for work living out of my car. I used to sleep in the car park, then go into work. So they got me a room in Sea Bathing, £40 a week, all in. It was already furnished, and I shared all the other facilities with the student nurses and locums. This is part of a chest of drawers that I used to keep cutlery and odds and ends in.

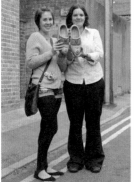

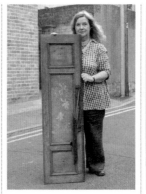

1068 Samantha Drew-Griffiths and Melissa Roberts
We've made up lots of stories, but the truth is we wanted to donate something so we went looking in a charity shop for something wooden! On our half-hour lunch break. We thought these were quite quirky. They cost £6 for the pair – not too bad. They were from Pilgrim's Hospice, the new vintage shop. So these are actually vintage clogs. And they've been worn, apparently.

1069 Stephanie Winters
It's a shelf from a unit purpose-built for a bay window. When we moved into our flat, the people who'd had the flat before gave this to us. My husband had always said that once we had a place of our own and it was fully furnished he'd propose, and he did. He put on stripy leg warmers, a pair of moccasins, a posing-pouch, a velour dressing gown, a ski cap and bow tie. He had a sparkler in either hand and set off the fire alarm! Very romantic. We've been married 20 years and together 33.

1070 Sue Blakesley
This is all that remains of a piano given to me by my now ex-husband, a Collard and Collard built in 1903. Above it hung a photographic portrait of my grandmother taken in the same year: a beautiful young actress holding a bunch of lilies like the ones inlaid in the piano. When we got married in 1972 our dream was to sail our own wooden boat where wind and work took us. Over time the piano and our relationship dried up. Six years ago he sailed away in a fibreglass boat. I followed my grandmother on her theatrical adventures.

1071 Jim and Anne Sharp
This tray was presented to my maternal grandfather, who was working as a bank cashier in Ellesmere at the time. The bank got taken over by Lloyds and they moved him to Rushden in Northampton. My mother met my father in Ellesmere. He went to India in 1925 as a tea planter and they kept in touch for the next six years. Then he came home and married her in Ellesmere. So this is really connected with them; it was my grandfather's. My brother obviously didn't much like the tray either, he left it to me. We've never used it.

'I bought it when I visited the highland people of Thailand; this was made by a Hmong.'

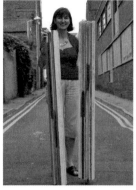

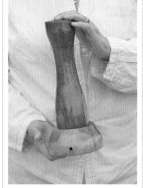

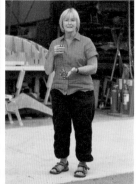

1072 Jim and Anne Sharp
Jim always wanted a walnut tree in the garden. He was working in Norway at the time so I thought I'd get a walnut tree and plant it for him. So I ordered one and it was planted, but of course it turned out not to be an English walnut but an American black walnut. We never got the walnuts to pickle! It's huge, it's a park tree really, and it was becoming too big, so we got a tree firm in to lop some of the boughs. This is one of them. The tree's still alive and well.

1073 Alison McLeod
My husband worked in Folkestone for the Institute of London Underwriters from 1986 to 1990. In about 1989 they replaced the windows for UPVC double glazing. One day he saw these bits of wood in the skip. They were in excellent condition and he thought they might be Japanese oak. It was a dreadful waste, so he took four long pieces out of the skip, as much as he could fit into his little Ford Fiesta. It's been in our garage since then, including a house move. He's used one small piece of it to repair an old oak chair.

1074 Jennifer Bond
I've brought a piece of yew that's been made into a lampshade by an elderly gentleman called Tom Davenport; I think he's now dead. He was a member of the congregation at Westbourne Church, and the yew's from one of the trees in the avenue there. It was made about 30 years ago but the timber's obviously three or four hundred years old. My late husband was curate there at the time, and we were given this by Tom. It was a working lampshade years ago, but it's a beautiful piece of wood. The grey in it is lovely.

1075 Elisabeth Bush and Diana Ponting
This olive wood pendant is donated in memory of our mother, Mildred Ponting, who died in 2000. It was a gift brought back from one of our holidays in the eastern Mediterranean. We are retired primary head teachers and have lived and worked in this area for many years. *The Boat Project* brings together Libbie's love of sailing and our interests in local history, geography and travel, all of which have enriched our work with children in Hampshire and West Sussex.

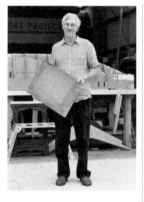

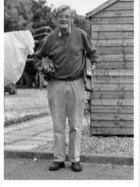

1076 Graham Taplin
My father, John Taplin, used this piece of wood as a drawing board. His job was to design microscopes, but he also built garage extensions and things for the garden and house. He used to pin pieces of paper to this for his designs. He started off as an apprentice in the 1930s, and died in 2006. He always aspired to have a boat and never could, and my mother wasn't that crazy about sailing. But when she died he came on holiday with us to Turkey and at 76 he got his RYA certificate for dinghy sailing.

1077 Chris Atrill
I've got two piles of assorted wood, both hardwood, and they have two different origins. The better condition pile has actually come from my garden shed, which I've recently been sorting out. The second one, in a rather worse condition, is actually part of my garden seat, which I've been replacing. I suppose, if there is a story here, it's that we have enjoyed many hours sitting on this old seat.

1078 Nick Ogle
This is part of a large boat that I helped to build many years ago, an RNLI lifeboat – the last wooden lifeboat to enter service with the RNLI. This was at William Osborne's at Littlehampton, back in the early 1980s. We had to cut out a section of the hull above the propeller shaft, because an inspection well had to be put in. There were about six of us working on it, it took about a year to build the hull. I worked on all the RNLI lifeboats and things, but I've worked on yachts and other craft too.

1079 Jeff Thatcher
I've brought you a length of afromosia. When my father retired he went to the Isle of Wight and built himself a house, and he used this wood to line one of the rooms. This was just one of the planks left over. My father has since died and I scattered his ashes on the ebb tide at The Needles. So this is a bit of an heirloom really.

'It turned out not to be an English walnut but an American black walnut. We never got the walnuts to pickle!'

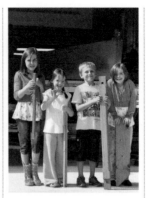

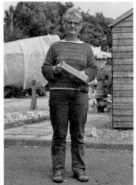

1080 Will Barker
A piece of greenheart that was previously used as a dry dock gate. The dry dock was originally a lock. This was taken off about a year ago and it's been in storage since then, but it was part of a dock gate for about 60 years. The two dry dock gates were taken off and fully renovated, and now all the wood's been completely replaced, but with similar timber.

1081 David Young
This is a Small Ships Registration plaque (No. 80489) in timber. I home-finished a Hunter Pilot 27 called *Why* in 1997. This was the original plaque I made, but it has since been replaced with a smarter version.

1082-1085 Caitlin Nightingale, with Emily, Amy and Cameron
This is from the roof of Nanny's barn that the builders have been mending. Nanny is a master doll maker. This is another piece; the barn is a hundred years old. This is from Nanny's dining room at their house in Hambrook where they are having an extension built. This is a table leg from a table which came from France when my family lived near Versailles. Nanny says it was lovely, but it hasn't lasted three children and five grandchildren!

1086 Sue Grimwood
It's a piece of oak, a banister rail, from the extension that my sister, Maddy Coates, has just had put on her house. She lives in Lymington. It's an old bungalow but she's had a lovely loft extension with a painting studio put in the top.

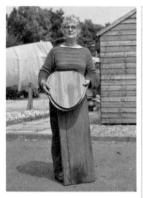

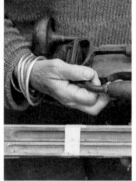

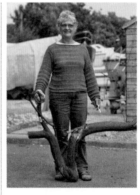

1087 Sue Grimwood
It's a piece of East African camphorwood from a packing case we had made in Tanga, Tanzania in 1981. My husband was born in Kenya and didn't like this climate. He was a master mariner out there, a harbour pilot and harbour master of Dar es Salaam. He knew the coast like the back of his hand. We were returning to the UK and wanted to have a case made with some decent wood. Most of it's stored in the loft waiting for some suitable project. I used to make wooden toys, mirrors; I even built my own Miracle dinghy.

1088 Sue Grimwood
These are some old tools that my late husband collected. He loved all these old wooden tools and gadgets. This is from an old camera projector, and he took it to pieces to re-do, but unfortunately he got cancer and so he didn't make it. It's sat there all bound up ever since.

1089 Sue Grimwood
This was a strawberry tree from my garden that unfortunately decided to fall over. I got emergency permission to have it cut down. It's been down about three years now, and it must have been pretty old.

1090 Peta Taylor and Stephen Loska
This is from what was Ceylon at the time, now Sri Lanka, where my uncle and aunt were tea planters. It's probably 50 years old at least. When I was little this was on my bedroom wall, it used to scare me quite a lot! But this is Stephen's donation. We used to be an item and he's had this hanging on his spare room wall for 15 years. It's also a little bit frightening for Stephen, he has obsessive-compulsive disorder and doesn't want to touch it. He brought it in a plastic bag and I'm handing it over.

'This is from the roof of Nanny's barn that the builders have been mending. Nanny is a master doll maker.'

1091 Tony Freeman
I've brought this chunk of wood from the West Pier in Brighton. When it collapsed into the sea I picked it up from the beach, along with hundreds of other people. So this is my donation to you today. It's been lying in my garage, redundant.

1092 Tony Freeman
This is a piece of mahogany coaming from *Morning Cloud*, when it foundered off Brighton. Two crew members were lost - one of them was Christopher Chad, the godson of the ex-prime minister Edward Heath, whose boat it was. They were bringing the boat round to the Hamble from Burnham-on-Crouch after a winter's racing. Ironically, Edward Heath's other boat had foundered too. The first *Morning Cloud* was wrecked off the coast of Jersey two days earlier. He had five and the current one was built by Lallows on the Isle of Wight; it's now called *Opposition*.

1093 Tony Freeman
These fine sheets of mahogany were worktops that otherwise would have been on the fire at Roedean School, because they didn't like people coming into the school to collect this so-called rubbish. They used to burn furniture down there as well, some of it superb. I rescued a few of these bits for my own home use. I was on the maintenance staff there, and in my lunch hour used to go up to the bonfire to see what had been thrown on. These have been in my garage since I worked there, which is a few years ago now.

1094 Marie-Dominique Bader
This is a wooden spoon that I brought back from Africa. I lived in Kenya for 20 years and that's where I met my friend Sue Grimwood. I sailed on board a cruising ship for five years, then decided I'd had enough, so I became a resident in tourism. I did West Africa, Morocco, and finally ended up in Kenya for a season. I stayed for 20 years. You can see the vinegar's eaten this a bit at the top!

1095 Patricia, Colin and Caroline Carman
I've brought three coat hangers. One's a trouser or skirt hanger. They've been in our family for generations and we've all used them. They belonged to my great-grandmother, Florence Hunt.

1096 David 'Spike' Spears
It's only a few bits of wood. One's a very heavy piece of timber. We've been landscaping the garden, and this is one of the big bits that's left from making up a bench. The other piece is a bit of mahogany boarding that was going to be used for something but wasn't; some of it's been made into swings for the grandchildren. And these are just some latch bar bits off a fence; couldn't see them going to waste. I thought I could use them to make bird nest boxes for people. I'm a bit of a wood collector.

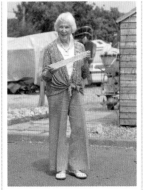

1097 Jaffrey Nias
A bit of an old picture frame, which went round a painting that my daughter Clare made. We all paint too much in our family! I paint landscapes, flowers, any old thing – I've got some yellow lilies hanging up at home. I've recently moved house so things have gone in all directions.

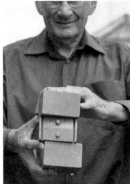

1098 Ken and Yvonne Healey
These are part of a bridge, which was part of a huge set of building blocks that my first son had in 1957. When my second son was born he played with it as well. It's probably been round the world. It's been to Sydney where we lived for two and a half years. From there it went to Scotland, to the Faslane submarine base. I was in the navy for about 30 years. Now our nine grandchildren play with these blocks too.

'This is a piece of mahogany coaming from *Morning Cloud*, when it foundered off Brighton.'.

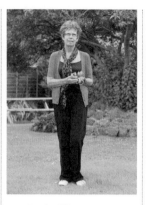

1099 Caroline Fisk
This is a soup kitchen display unit. I wanted to donate it because we like making and eating lots of soup in our house, and I thought that it would be quite fun and unusual for the boat. In each compartment was a soup bowl and then whenever we had soup we would take out a bowl and eat our soup from it. Our favourite is tomato soup. Now the bowls are sitting very forlorn on the top, so I'll have to put them away.

1100 Grace Fisk and Isabel Stratford-Burden
We're giving our favourite toys because we really like playing with these animals. I've got a giraffe, a cheetah, a rhino and a zebra. They came from grandma one Christmas, about eight years ago. We normally play animal rescue games with them – we're jungle vets!

1101 Carolyn Elliott
My dad was called up to join the army in 1939, a week after he married my mum Zetella. He joined the Royal Engineers, probably the East Lancashire Brigade, as he came from Accrington. He served in North Africa and the Middle East and didn't see his new wife again until the end of the war, which was five years after they were married. Inexpensive enough and small enough, I presume, to fit in his kit bag, these Jerusalem eggcups and napkin rings were a gift for his new wife on his return.

1102 Austin Lawler and Gwen Van Spijk
This is Bilbo, a border collie, and he's six. This is a piece of wood from the plum tree in our garden, which bears abundant fruit. Each year a branch breaks off. As you can see, Bilbo absolutely loves playing with sticks. This is one bit he hasn't managed to break or chew or snap, so he's decided he's going to give it to *The Boat Project*!

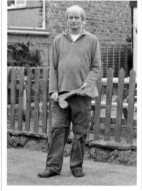

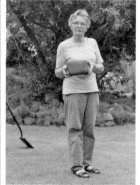

1103 Austin Lawler
This is off the back of my parents' garden chair. My parents were both Catholics and the church meant a lot to them. My father, who died when I was quite young, bought this pew that the church in Wootten Wawen, St Benedict's Church, was selling off. We know it's 1800s. Recently we were in Lymington looking out towards the Isle of Wight, a beautiful day. And it occurred to me that this was the last image he would have had of Britain before going on D-Day, which thankfully he survived. He spent many an hour sat on this.

1104 Gunilla Treen
The first item is my grandmother's jam spoon, from Sweden. My grandmother was a Lapp, from the upper part of the Arctic Circle. I watched her making jam when I was a child, and I've used this spoon to make jam too – it's a very good shape for it. The second item is one of my father's brushes – he was an artist. The third piece might look as though it's got woodworm but it hasn't. I used to be a jeweller, so I would drill through metal and use this as a blank. So, three lots of craft pieces.

1105 Steve Hill
It's a piece of elm shaped into a shelf bracket. The guys who opened Woodworm Recording Studio in Barford St Michael – Dave Pegg and friends at Fairport Convention – rescued a lot of Dutch elm that was condemned in the 1970s. And a lot of it found its way into the studio, including a rather wonderful staircase, and this shelf bracket. Fairport recorded every album they made from 1979 to 2009 in the studio. It's been an interesting elm-filled experience.

1106 Cathy Peacock
It is a cigarette box that my uncle brought back from India just after the Second World War, and I'm afraid that's all I know about it. He gave it to my mother and then it came to me. It's been with me for about 40 years, I suppose. I kept jewellery in it.

'My grandmother was a Lapp from the upper part of the Arctic Circle. I watched her making jam when I was a child.'

THE LONE TWIN BOAT PROJECT 203
1050 John and Sarah Simpson, see page 196

The farm's 40 miles west of Dublin in the Bog of Allen, in Ballyshannon. My cousin gave this to me when I told him about the project – he was keen to give it. We tend to go over every year and we're quite close to the family. It's a wonderful part of the world, with this great expanse of bog and flowers, and periodically they just find these stumps.

'It's been immersed in a bog in Ireland for between three and four thousand years.'

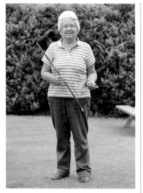

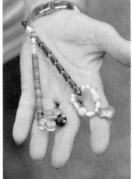

1107-1108 Mariann Young
The pipe belonged to my grandfather, William Gilroy Cook, born in 1867. He used to sit by the fire smoking it. I was born on his birthday, so we were great mates. I learned to fill a pipe with this and probably had a puff or two! It used to have an amber mouthpiece, but when I got it out yesterday it just crumbled. The swagger stick belonged to my uncle, John Davison Cook. He joined the 8th Hussars as an ordinary soldier, so I don't know how he got a swagger stick. He was 17, at the start of the 1914-18 war. He lost a leg in France in 1915.

1109 Mariann Young
These are from my mum. She was a great lace maker. The original beads could be early 1800s – they're quite old. She took up lace when she was in her mid-60s and it became an absolute passion. She'd get up at six-thirty in the morning, light a fag, and start doing this wonderful white pillow lace with the ash hanging off the end! Her name was Minnie Gilroy Young.

1110 Ann Beesley
A walking stick, which was given to my husband when we were both living in Ghana, and a couple of carved hardwood wall plaques. We lived in West Africa for 30 years. My husband Dennis managed a brewery in Ghana, Nigeria and Sierra Leone. He used to go to a particular festival every year in Cape Coast, and one year he was seized to be a chief of Number Seven Company there. He had to find finance, buy gunpowder for shooting muskets during the celebrations and provide beer. We wore matching lace robes.

1111 Alison, Ian and James Duffy and Jonathan Lewis
A little while ago we moved house and we've completely changed the look of it by having an enormous porch built on the front. It's become a bit of a talking point in the village – now everyone in Barford wants one! We've got some offcuts of the upright posts, some lovely solid oak. There are two of them and we've called them porch and starboard.

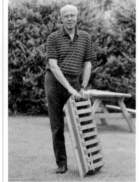

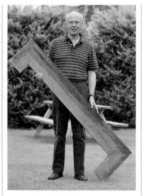

1112 Gwen Van Spijk
It's one of a set of four Dutch breakfast boards. We've only got three left, this is one of those three. In Holland everyone has these little boards to put their bread on. My father was Dutch, and we've had these in our family since I was tiny. I love using them. For breakfast, but also for tea and supper in Holland, there are spreads, cheese and stuff in the middle of the table. And you have your bread board, you put your slice of bread on it and you butter it. Instead of using a plate, basically.

1113 Rodney Hobbs
I met my late wife in 1986, and a couple of days later she came over here with her two girls, then aged 12 and ten. There was a lot of snow and we went sledging with cheap plastic sledges. We got married a few months later, and my dad very lovingly made some sledges for all of us. Here's one of them, he wasn't a woodworker but he put so much into it. He lived by the sea on the Isle of Wight, and he would love to know that some of his handiwork is now in the boat.

1114 Rodney Hobbs
It's the mantelpiece from a fireplace we had. When my wife and I moved in to Pear Tree Cottage, we redid the fireplace and this is the mantelpiece from it. It's since been superseded by a marble one. We replaced it two years ago, and it's been sat outside for a while. We had family photographs, and Christmas and birthday cards on it. And some ornaments.

1115 Rachael Winter
Dillon loves sticks and he's always collected them. This is one of the logs he gets out of the fireplace; he's had it for ages. He gets them out for people to throw for him. He's ten now. He'll steal stuff as well, he's a big thief – he likes stealing handbags. He's a true pub dog! He's even been in the paper, for stealing so many handbags and purses. He gets big wads of cash out of people's bags, he's stolen indigestion tablets. He takes everything – quite a clever dog.

'He gets big wads of cash out of people's bags; he's stolen indigestion tablets. He takes everything – '

1116 Tom Eden
It's a little model canal boat, because canal boating's the only boating I've ever really done. I painted it when I was seven after going on a canal boat holiday for eight days. It's been sitting in my room for about 13 years, gathering dust. I work in a car body shop, but I also do bits of artwork and lots of gaming.

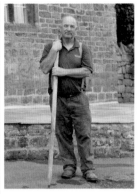

1117 Pete Eden
It's a fence post from a job we've just done. Mags was going to use it in the allotment; now her beans will be on the floor! I've been fencing for about 30 years – you don't get that for murder, do you? I was born a few miles from here, we've lived around here all our lives. With a wire fence for sheep, we'd do about 100 metres per man per day. But with post and rail we'd only do 50 metres a day. This is what you'd use for electric fencing, to keep horses in.

1118 Maggie Eden
I'm offering a little wooden hen, because I keep hens. Although at the moment I don't have any; a fox has had the last two. We've lived in Barford just over 21 years and had hens most of the time. I love gardening, my hens, and doing villagey things. So that represents my life. This was a present from my mum. I also collect hens – china hens, wooden hens. I just spotted him on the shelf. The last flesh and blood hens we had were Copper Black Marans before the fox had them.

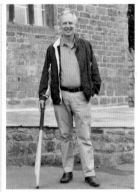

1119 Rick Allen
It's a cricket bat my father gave me as a reward for scoring 50 in a school match when I was young. Very poignant, because he died of lung cancer not long after, when I was 14. I was at Ealing Grammar School at the time. I carried on playing cricket, but when I came to Chipping Norton I'm afraid I decided that 33 was the age to retire. I wish I hadn't, I miss it now. My son Jamie is nine and he's just started playing cricket, and I'm really enjoying watching him and helping him with his skills.

1120 Glynnis and Jeremy Eastwood
They're two pencils from my father, Donald Eastwood, who used them as a navigator in a Lancaster Bomber. They are green at one end and red at the other – to mark the way out and the way back. We've got quite a few. We've given you two but we've kept the rest, because they are quite precious.

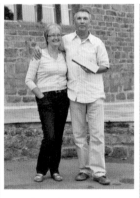

1121 John and Jane Hepburn
There was a Worcestershire hawthorn sapling growing in our garden, which was on the boundary with our neighbour, and it's probably been growing for about ten years. But it became too big and unfortunately we had to cut it down. It was destined for the incinerator. But we thought it would be nice to cut a section of it out and donate it, so at least a part of that tree will live on.

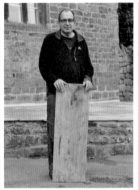

1122 Pete Leney
I live in an old cottage in Barford. The same family had lived in it for 60 years and nothing had been done to it, so we had to restore it completely. This is an old elm board from a shelf in a bedroom cupboard, and I've just kept it not really knowing what to do with it. But elm is quite scarce now. It's a piece of Barford. One of my builders or somebody years ago has made some calculations on it. The house was gutted from top to bottom, everything.

1123 David and Lavinia Crowther
We're not quite sure where it came from. When my uncle died five or six years ago we found this little piece of wood in his possessions. On it is written 'HMS *Victory*. Fred' – my uncle Fred. So we believe it's a small piece of HMS *Victory*. Which is a bit of a coincidence because of the relationship with Nelson, who my wife is actually related to – he's her great-great-great-great-something uncle!

'I've been fencing for about 30 years – you don't get that for murder, do you?'

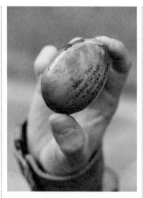

1124 Patsy Clarke
When the *Mary Rose* was raised from the bottom of the Solent, my late husband Peter sent off for this piece of the ship for me. Shortly afterwards I saw it when it was in situ. I remember thinking, 'Goodness, that's big'! It's always been hung on a wall, it means a lot to me. I used to work in Greenwich, and lots of our ancestors, the Thorntons, were fishermen out of Greenwich, also ferrymen and stevedores. So I'd like this to go on the boat as something to remember them by. Because they went fishing and gave their all.

1125-1126 Andy Speight
It's an Ashanti stool, bought on the 5th March 1957, the day before Ghanaian independence. My father was working there with the West African Rifles, and Nkrumah, the president, had previously worked for my father. My father always regarded it highly, but it's just been gathering dust. And I'm donating this lump of oak on behalf of Barbara Alt. It's from a 250 year old tree that fell down in a field near Hempton. So, a little bit of history from the local area. Old age and high winds.

1127 Elly, Isabel and Jamie Crowther
It's a wooden egg from when we lived in Trinidad. We've got a collection of about ten, two of which were painted on with my brother's and my name when we were there. We had a spare one for my sister; she wasn't born yet. This is one of the other ones. It's got a picture of a yellow flower on it and it's teak. It was decorated by a local artist. We kept them in the family and as kids we used to play with them. They've just stayed in the living room as ornaments ever since.

1128 Blonde Fever – Christine Adams, John Hepburn, Austin Lawler, Mark Stevens, Tyler McNulty and Steve Hill
This is a polo mallet head. We're a new band and our first performance was at a polo party at a polo farm. It has come from Argentina, and it's a 52, which is a standard length for a polo mallet. It's been used for playing polo in Argentina and in England.

1129 Janet Payne
I've brought a piece of narrowboat ware – a wooden spoon with a traditional narrowboat decoration. It's in memory of going through the Llangollen aqueduct. It was at seven o'clock one morning in August 1995. The sun was just coming up and the shadows stretched half a mile.

1130 Oliver Broughton
It's a tool, a mortice gauge – I found it in the garage. I've never used it, but my dad probably did. There's loads of stuff in our garage, loads of rubbish.

1131 Vicki Bowen
This is one of three wooden caskets I purchased many years ago when I began practicing as a green witch. I used it to store herbs and essential oils for spells and good luck charms. May it bring the boat good fortune and safe passage on her journey.

1132 Tony Bastable
In 1948 when I was ten I produced this piece of carved woodwork. All done by hand, we didn't have any mechanicals to use just after the war. I was excited about the Olympics being in England. It was the first time exciting things were happening that weren't associated with violence. I thought it was kind of a duck! It was hidden away at home, everybody thought it looked more like a club. It was in my mother's home until I got married in 1963, then for 40 years it was on the kitchen wall in our house in Hunstanton.

'So, a little bit of history from the local area. Old age and high winds.'

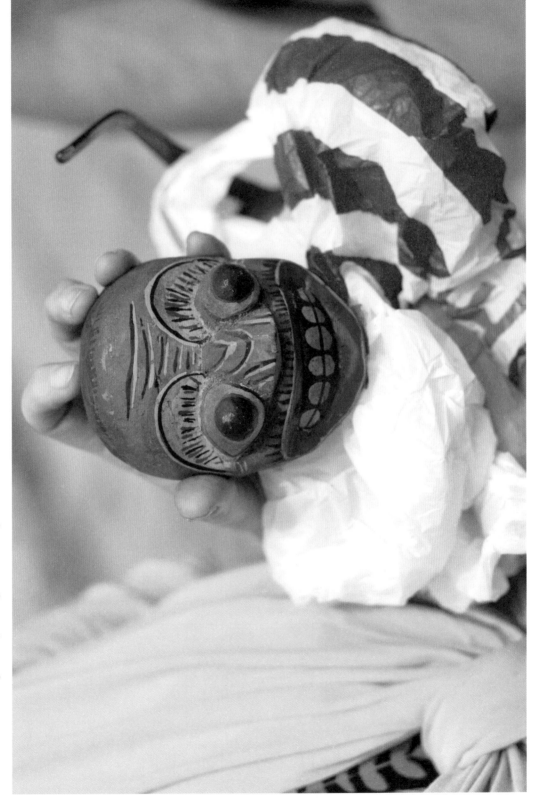

1090 Peta Taylor and Stephen Loska, see page 200
We used to be an item and he's had this hanging on the wall in the spare room for 15 years at least. It's quite scary looking, but it's also a little bit frightening for Stephen, because he has obsessive-compulsive disorder and doesn't want to touch it. So he brought it in a plastic bag and I'm handing it over.

'He brought it in a plastic bag – and I'm handing it over.'

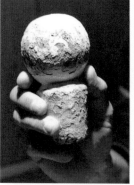

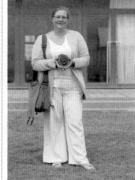

1133 Martin Winter
I'm the landlord of the George Inn at Barford St Michael. This is an Aunt Sally doll, something peculiar to north Oxfordshire. It's now a pub game, but it evolved from the time of the Civil War, soldiers throwing sticks at the hub of gun carriages between battles. To be honest, most of our players are lucky if they hit the doll very often, but that's probably to do with the strength of the beer. This Aunt Sally doll is old and battered as you can see. No doubt it will get battered by the waves in the future.

1134 Karina Sargent
I'm not sure really what it is. It's come down through the family. It came from my gran to my mum and then to me. I think it's from the Holy Land, the Knight's Templars, the lamb and flag – but I'm not exactly sure what it is. I just like the wood.

1135 Andy Bashford
I've brought a pencil from the De La Warr Pavilion. I'm the Front of House Manager there, and because it's an iconic Bexhill building we felt you needed something from the Pavilion. I've worked there for about six years, I joined when it re-opened. We're drawing a lot of people into the area, to see the building and the art as well – we're now a leading contemporary art venue. There's also a beach up on the roof, which is pretty unusual! That's here for the summer.

1136 Malcolm Head and Di Denman
I've brought a lolly stick. Last Tuesday we were at Belle Tout lighthouse in Eastbourne, where my father's ashes are. They've opened an ice cream place there, so we all had one. I'd been trying to decide what to bring to this project, I wasn't allowed to bring the dining room table! Then I suddenly had this piece of wood in my hand. The boys and my sister wrote their names on here. I put mum and dad, because dad's there and mum's recently passed away. It was her favourite spot.

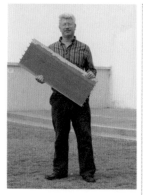

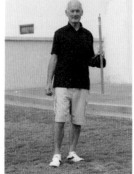

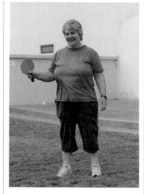

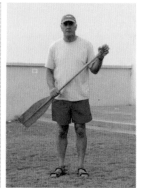

1137 Julian Porter
This bit of timber is actually one of the old showcases from the former Bexhill Costume Museum. In 2003 we amalgamated the town's two independent, volunteer-run museums to create a new medium-sized museum for the town. This is one of the casualties of moving out of the original site. We salvaged lots of bits of useable wood that we thought we could use for other projects, so it's been sitting in our basement.

1138 Michael Darran
I've brought a rod with a hook on it. It's a present to my wife. About ten years ago I found this bit of wood on a construction site near Ashford. My wife, being a bit on the small side, couldn't reach the washing line, so I invented this so she could reach up and pull it down. It was a bit longer at one point – I needed a stick to stir my paint with, so I cut a bit off. It also doubles as a toy for the grandchildren. Now it will be part of a boat.

1139 Sue Adamson
It's my table tennis blade. Top players change their rubbers every few months. I played for Surrey, and for Scotland in the 1989 Commonwealth Championships and I still play in the Veterans British League. I used this blade for years, but technology moves on. They use different types of wood now. They put carbon layers into it, they're lighter, and the rubbers are faster. The whole game's just faster. My spirit's got faster, but the knees are a bit dodgy!

1140 Michael Adams
This is a paddle that's been down at Bexhill Sailing Club for years. I don't know who it belonged to or where it came from, but it's been lying around and it's well-used. We don't carry paddles anymore, we have rescue boats instead.

'I think it's from the Holy Land, the Knight's Templars, the lamb and flag – but I'm not exactly sure what it is.'

1141 Felicity Harvest
It's a World War Two history ruler, showing key dates such as Dunkirk. I collect rulers. I've never counted them but it's a large collection. I also collect tape measures and other things that measure. I've been collecting rulers for about ten years. They're not all wood, but they have to be particularly interesting. They either have to be very naff if they're plastic, or have some peculiar quality, or come from a very memorable place. My favourite ones are the fold-up ones with the brass ends.

1142 Jan Cowlard
We've lived locally for almost 40 years and I've always wanted a beach hut. Of course I had tiny babies then so money wasn't available, and now the huts have become so expensive. Up the other end you actually own the hut but not the land – the council own the pebbles. We've now got a beach hut, and this is a piece of wood where we've re-roofed it. You have to have them painted white with green trim. A bit boring, it would be much prettier if they were all different colours.

1143 Jane and Jeni Price
We're donating a wooden kitchen utensil in memory of our parents, Grace and Cedric Price. Mum died nine years ago. Dad died more recently, at the grand age of 94. They spent the first years of their marriage in Ghana. He worked for Lever Bros as a pharmaceutical chemist; she was a nurse, but she gave that up. They ended up in Portsmouth. We have such vivid childhood memories of the sea, swimming every night. Mum expressed her love for her family through her cooking. And dad loved his food.

1144 Michelle Broomhead
It's something we've had in our family for ages. It's an old cutlery drawer and it eventually worked its way down to me. I used it for artists' materials when I was doing my GCSEs, but it's something we always had. I got it from my mum, and she probably got it from her dad who never threw anything away.

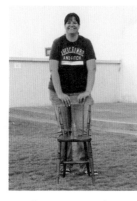

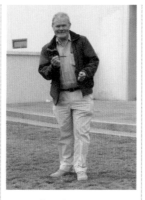

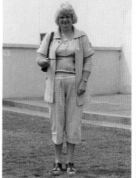

1145 Christine Townsend
It's a chair that was used for feeding lambs when I was very little. I was given it not long ago, and they said, 'Oh you can use it in the house'. I meant to get it fixed and I didn't. It's been in the family longer than I've been around. I didn't grow up on the farm but I spent quite a lot of time there with my family. I've never actually fed a lamb on this stool. I use it now to put my washing on.

1146 Paul Lendon
I love this project and my football team is Arsenal, so I thought it would be nice to have an Arsenal red pencil as part of it. Also, if you ran out of wind, their nickname's The Gunners, and you think of old ships with guns on – there's a little link there! My father took me along to watch Arsenal when I was a boy, I've supported them ever since. I've got memories from the old stadium. I took my son to the Junior Gunners when he was young. Now he's grown up and he has a season ticket.

1147 Libby Powell
I've brought a pencil. It's from the Bexhill Costume Museum, I'm a custodian there. It's been open a year or two now. This pencil is from the shop. It was in my bag, and it's been used – the rubber's gone! I'm a freelance hairdresser, so I've used it for writing my appointments in my diary.

1148 Melanie and Michael Sykes
We've brought a very old wooden spoon, which was my husband's when he was single and living in Birmingham. We've been married for 36 years, and as you can see the spoon has worn away quite a bit over the years. It's been used for cooking all this time.

'I've never actually fed a lamb on this stool. I use it now to put my washing on.'

1149 Lynne and Rod Bayes
We've brought a hand-carved oak drawer front, which used to be in our kitchen. We were very loath to get rid of a lovely hand-carved oak kitchen, but we had an extension to our house built and it had to go. It's been in the garage, because we didn't want to get rid of it. I think it's about 26 years old.

1150 Jean Wyatt
My dad grew up in Barry Island, Wales, and went to sea when he was 14. They thought he was 16 because he was tall. When he came back he joined the army, and met my mum. He died in 2005. In later life he started painting. I thought this was Barry Island, but in fact it's stormy Lands End, painted in 1991 by Clifford George William Wyatt. Every day he'd talk about the weather. In Barry he saw the sugar clippers coming in from Jamaica. It was in his blood, but he ended up in land-locked Coventry.

1151 Jean Wyatt
In the 1950s we used to play this board game called *Buccaneer*. You had a little galleon, the only thing made out of plastic – plastic had just come in in the 1950s. With my three brothers and twin sister we used to play. You had to go round the Caribbean islands and collect things: rum, pearls, rubies, diamonds. You could stop people on the way. There was mutiny and pirating, and you could take somebody else's stuff if you had enough points. This is one of the barrels, it was on my windowsill with all the other little bits.

1152 Ros Barker and Franny Swann
We have brought a hobbyhorse, which was created as part of the Farningham Hobby Horse Project for the Kent Cultural Baton. It's a blank child's hobby horse that the community was then invited to design, to represent who they were and what they did. We had 120 people join in, aged four to 90. This is the original blank horse that we kept to show everyone where the project started. The project was launched in 2011 and it runs until June 2012. We're travelling all round Kent.

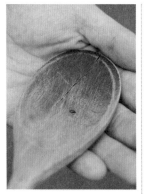

1153 John Mortlock
I've brought a wooden spoon, which until this morning was probably the most often used item of equipment in my kitchen. It's been with me for about the last five years, so it's played its part in feeding myself and a lot of other people. I think it's a savoury spoon, but who knows what's ingrained in the patina of various colours on it. An all-purpose spoon.

1154 Paul Wright
I was a member of the Hastings Runners from 1990 until 2002 and took part in many road and cross-country races. The club also organised its own races of varying distances. One annual race was from Eastbourne pier to Hastings pier, that's about 15 and a half miles. On the 8th Nov 1992 I did the race in two hours and six minutes, and finished in 80th place. For completing the race we all had this little commemorative wooden plaque. I'm afraid in 2002 my Achilles tendons said they'd had enough of running, and now we go walking instead.

1155 Tamsin Poole
These are bits of my cot that my dad made. He's good at making things. The cot's been under the house since then, in the basement.

1156 Megan Mitchell
This is a bit of the pole from the flag from Kate and William's wedding. It's been behind my chest of drawers. I was in London. We were there the next day of the wedding – it was very good. I liked the dress very much.

'He saw the sugar clippers coming in from Jamaica. It was in his blood, but he ended up in land-locked Coventry.'

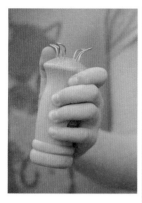

1157 Imogen Mitchell
It's a French knitting thing. When I was little I got some wool and I used to make French knitting. I made coasters with it. It would come out this end in a sort of tube and I tied it round and made coasters, for presents and things. It's only very rarely that I use it any more.

1158 Roger Comerford
It was the first piece of furniture I ever bought, in my early 1920s. I was reading Douglas Coupland's book *Generation X*, which I really enjoyed. I remember one of the characters says something about buying your first item of furniture being the mark of transition to adulthood. I was just moving into an unfurnished flat and it caused me a bit of angst. Perhaps I thought about it a lot more than I should have! It was a coffee table for a while, then a shelf. Now we've run out of space, especially with a little one.

1159 Kathlyn Pope, and Martin, Antonia and Nastassja Selow
My parents retired to Bexhill because they have family here. My husband and I live in Berlin. This piece says 'Tante Emma-Laden', which means 'Auntie Emma's Shop'; it's like a little corner shop. They don't exist any more in Berlin. The first time we came to Bexhill, about eight years ago, we found this in a charity shop. So the children were able to play with an original Tante Emma Laden when they came to stay with their grandparents.

1160 Jonathan and Mary Strong
It's a transom off our 14-foot clinker dinghy, which is a One Design. She's called *Athene* – goddess of war, daughter of Zeus, and said to be very chaste. She was built in 1946 at Dickies Boatyard in Bangor, North Wales. We've sailed her ever since, with varying degrees of success. She's at Anglesey now. We bought her in 1990. In 1994 she was on her mooring and somebody sailed into the back of her and split the transom. I've been intending to do something with this original wood, like stick a clock or barometer on it.

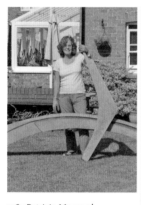

1161 Patricia Maynard
My father, Ivor Roberts, used to sail in Dover Harbour as a kid and built several sailing boats over the years. After the war he took on his big project, building a Water Witch. But his partners dropped out and the finance went. Ten years later, he asked to store the wood in our workshop, but he died in 2009, and never built his boat. When he was alive he always had this spark, that one day he was going to sail down to the Med with it. So it would be wonderful if this oak could take to sea.

1162 Patricia Maynard
My sister, Diane Copas, wants to donate this. It was a plant trough that my father made as a birthday present for her many, many years ago. He built pieces of furniture, tables, cabinets – all sorts of things. His passion was boats. She used this for years, until fairly recently.

1163 Richard Williams
It's part of a box my grandmother left me when she died. The box came from Persia, now Iran, where my grandfather worked in the oil wells and my father was born in the 1920s. So it's at least as old as that. The box was used for writing implements, jewellery, and other trinkets. It's inlaid with ivory and maybe ebony. I loved it as a child. My grandparents' names were Sidney James and Helen, but they were also known as Lord and Lady Mink. And that's Speedy the tortoise, he's now in his late seventies and still going strong!

1164 Ben Whaymand
This is a mask from the Maldives. It was a bit of a struggle getting it back, but I made it through Customs. I've not really been able to find a place at home for it. I got it three years ago when I went out there – I visited Sri Lanka first, then went to the Maldives. I stayed on an island called Fun Island, and it lived up to its name. They use these masks as various different gods, but I'm not sure what's behind this mask. The wife doesn't think its décor fits in the house!

'When he was alive he always had this spark, that one day he was going to sail down to the Med with it.'

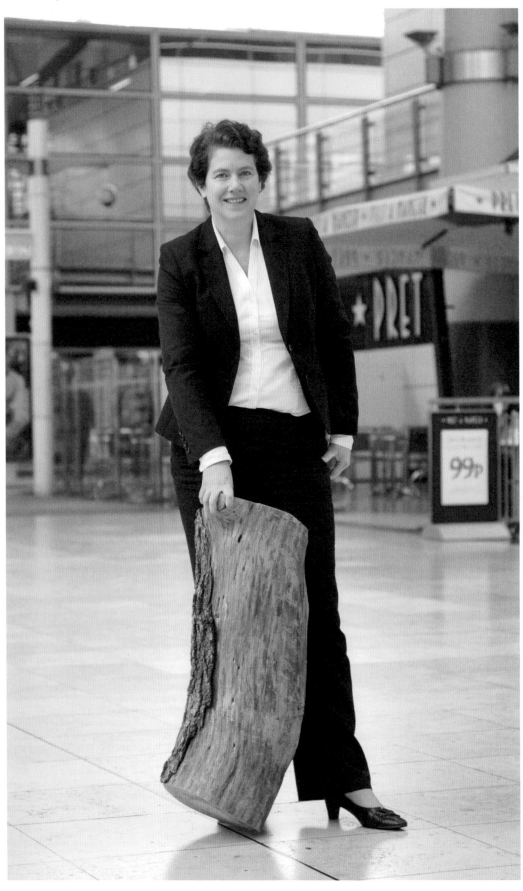

898 Fiona McKerlie, see page 177
This is a piece of a cedar tree that had to be chopped down. It originally stood outside Walton Hall, at the headquarters of the Open University in Milton Keynes. It was attacked by aphids, and this is one of the pieces of the trunk that came down. It's about 200 years old.

'The remaining stump has been carved into a statue.'

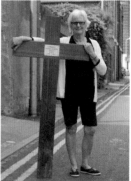

1165 Debi Daniels
I've brought a piece of the bench from home, which is over 30 years old. My parents got it in 1985. I can remember because it was Live Aid, it was in the garden and it was hot. Only the adults were allowed to sit on it; the children weren't in case they scratched the teak with their shoe buckles! Their house was in Cornwall, in a village called Tetcott. When my mum died 20 years ago, dad gave us the bench to look after. It's falling apart now. We'll probably make a compost bin with the other bits.

1166 Alistair Coleman
I've brought a family of five wooden elephants that I bought in the Cameroon in 1999. They are a souvenir of an unhappy time I had there, and I'm hoping that they'll bring more happiness to other people. They've been in my hall on the telephone table, but I've moved house and I thought it's time for them to move on.

1167 Oona Muirhead
It's one of the plaques that the South East England Development Agency gives to projects we've supported. We're all about the economy of the South East, from the marine sector to the offshore wind sector, and bringing regeneration and economic development to places like Hastings and Bexhill. We've created education for unmarried mothers, and given young local people a sense of being able to get out and do things. We're being closed down next year. So this will commemorate the life and times SEEDA.

1168 Patricia Carroll
This was on the grave of my husband, James Joseph Carroll, until we bought him a headstone. It's special to us also because he was a cabinetmaker. He and his brothers owned a furniture factory, and they made this for him. So when we got the headstone I just couldn't throw it away.

1169 Paul Fisk
It's a portable wooden noughts and crosses set, it's very special to our family. It came with us on a sailing cruise around the Mediterranean and provided 16 months of entertainment. I'm the noughts and crosses champion. We started in Scotland, went to Ireland, the Scilly Isles, France, then into the Mediterranean to Italy, as far south as Naples. We spent Christmas there before coming home in time for school. Now we're about to go on our summer holidays in the same boat. Noughts and crosses will be replaced by iPods and DSs!

1170 Jack Fisk
This is a wooden man on a flying bike. It went on my mobile when I was a baby. He kept falling off, and he's lost a leg!

1171 Tiffany Robinson
This is a piece of yew I found in the ancient yew grove at Kingley Vale. It's about 2,000 years old. The trees were planted by Chichester men who'd slain marauding Vikings. I find this piece interesting because of its form, and the place it was found – near where they carry out the ceremonies, like Samhain. I keep various pieces of wood around my house, I'm an artist and I use them to inspire what I do. I work with film and installation, but they're also great for sketching exercises. They twist and turn in very human-like shapes.

1172 Colin Ottewell and Sam Twigg
This commemorated the Second World War, because it's dated 1939-1945. It's a carved holder. It used to have a barometer in there but that came off and then it broke. It belonged to my uncle, who had a very interesting war. He was a Chindit in Burma and was also at Dunkirk. So I'd like to give this to you in memory of him. His name was Jeff Wonham. This was always in his room with the barometer on it, and when he died we inherited it.

'It's about 2,000 years old. The trees were planted by Chichester men who'd slain marauding Vikings.'

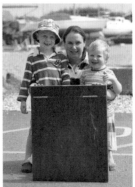

1173-1174 Kate Houlden
It's a piece from the bunk bed my two younger brothers and I all slept in at various points, it's donated by my brother Anthony. Once as kids we were playing blind man's buff, and Anthony climbed on top of the bunk, forgot and walked off, straight into the air. When I was four, my parents moved into a house which was the only one on the road that had two gates; this is a chunk from one of them. One morning one of the gates had vanished; someone had gone along the entire street, removed everyone's gates, and laid them in a neighbour's front lawn.

1175 Kate Houlden
Despite leaving my parents' house 11 years ago, moving to Australia, and living in eight different houses since, this bit of wood has travelled with me and been my bedroom doorstop since I was about six. It must have come from Mr Petri the dentist's house when my parents moved in. There were all sorts of strange things: a dentist's chair, a red wardrobe with fake chocolate biscuits inside. Mr Petri retired to Hampshire to pursue his love of sailing. So 27 years later this little doorstop has followed him to go sailing by itself.

1176 Jonquil, Chris, Verity and Dominic Tonge
I've brought a perch that has come off the chicken house that we built for our seven chickens. They're colourful ones. They don't lay very much but they're pretty. The chickens are white or brown with black spots, and silky ones and grey ones.

1177 Tina, Nick, Charlie, Sam and Freddy Irish
We have brought the original bar hatch from the White Swan at Bosham, which closed in February 2009. We hope to reopen it in September. We bought the property and we've been carrying out a substantial refurbishment.

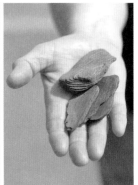

1178 Sam Darling
I've got a really small boat. It was my great-aunt's. Every summer I come down to Bosham and do some sailing, and it symbolises that really. I reckon this is very, very old. It used to be on my great-aunt's mantelpiece.

1179 Gregg Darling
I've got a piece of driftwood. I found it in the creek off Bosham last year. I kept it because it looks like a bird's beak. I've got lots of driftwood at home, and I pick up shells too.

1180 Sylvia Harrison
About ten years ago I had a cattery built in my back garden, to change my life and alter what I was doing. It's become a very big part of my life, and these pictures show them building the cattery. This is an offcut that came from it. I have a license for 22 cats, and as I speak today I have 15 in the cattery. I have three of my own cats – Mel, Tish and Delilah. I'm into cats.

1181 Sylvia Harrison
These are small pieces of wood that I picked up beside a lake up in the mountains of Corsica, in 1997. It was a very nice holiday. I've got a kind of memory bowl that I put bits and pieces into, and these happened to be in there. It was very special.

'Someone had gone along the street, removed everyone's gates, and laid them in a neighbour's front lawn.'

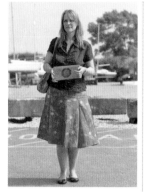

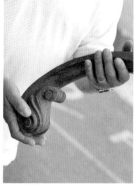

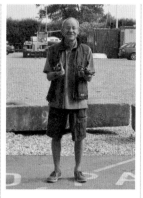

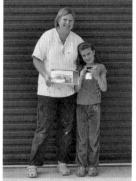

1182 Pearl John
I have a piece of wood that I broke on my first taekwondo belt in 2001 – I kicked this and broke it in two. As a gift for my taekwondo teacher I laser etched it. I was living in Columbia, Missouri, at the time, teaching laser technology to high school kids. Paul, my teacher, killed himself in 2005, so this is in honour of him. I've had this piece of wood ever since, not quite sure what to do with it. It felt precious, but giving it to *The Boat Project* feels like a nice thing to do.

1183 Roger Palmer
We know that this mystery piece of wood came from Bombay about 95 years ago. It came on a piece of furniture that was on the *Prince of Wales*, the first Royal yacht with a sail, before engine power. It came from my great-grandfather, who was Chief Stoker on the *Prince of Wales*. I think he just picked a piece of furniture up on a Royal tour of India. I assume the rest of it has rotted over the years. I've had it for about 67 years, which is my age, unfortunately – it's probably in better nick than I am!

1184 Mike Gilpin
I've got some wooden curtain rings and a finial from my parents' house on the Isle of Wight. I've no idea of their provenance; they're probably just pre-war, I would have thought. I lived in that house for about 30 years.

1185 Katie and Tilly Jarvis
This is a medal my grandfather, James Henry Jarvis won for the 400 yards relay in 1932. He was killed in 1940 aged 29. The photo is of my father, James, as a toddler with my great-grandmother saying goodbye to my grandfather, Corporal James Henry Jarvis, who was going to war with the Royal West Kents. It was the last time my father saw my grandfather. My grandfather's brother, my great uncle Henry, was in the Parachute Regiment, He died in 1944 blowing a bridge up in Tunisia. As a family we lost seven men in two world wars.

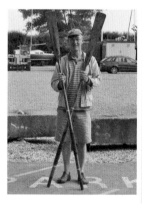

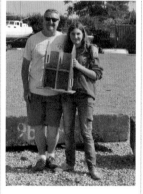

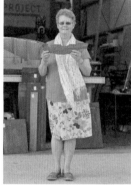

1186 Peter Bullen
Here are two oars for a dinghy. It was a carry craft, a sort of 14-foot rooftop thing that has long passed. It belonged to my uncle, Lionel Hutchings, and he kept it at Keyhaven. I inherited the boat, but the boat has passed on and the oars have been in the garage for 30 years. I stay on dry land now.

1187 Isabel and Neil Holly-Williams
We've brought Isabel's dolls house. It has been used by her since she was about five years old, and now she's 12. When I was unemployed for about three months we had no money coming into the house at all, and I bought this in a charity shop for £2.50.

1188 Hilary Langton
The cross is from my mother's grave in Warblington Cemetery. Her name was Shirley Wenman, née Baxter. She was a president of the Emsworth Horticultural Society. The cross was made by a family friend, Len Moss. It's in memory of both of them really; they shared the same birthday. Len also renovated this stool, which was in my mother's summerhouse in Wimbledon when she was a little girl. I remember sitting on this stool and playing houses in the shed. It's got some beautiful carvings on it, but I think it's been rather neglected recently.

1190 Tina Lamplough
I found this piece of driftwood on the beach at Hill Head round about 1980. I was a primary school teacher and I was always looking for interesting things. It was a starting point for many a story. We could never make up our mind whether somebody had made it and lost it, or whether it had just been beaten into those shapes by the waves.

'I kicked this and broke it in two. As a gift for my taekwondo teacher I laser etched it.'

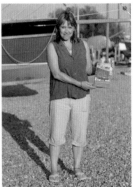

1191 Sarah Leppard
It's a piece of olive wood I picked up in Crete a few weeks ago, when we were walking down the side of a mountain to a beach. The roads were quite hairy, and every time we went round a corner we all got scared and wanted to touch something to make sure we were okay. So I just picked up a random piece of wood. Every time we set off on a journey, we touched it. It was a security object. Hopefully it'll bring luck to the boat, although we still got lost quite a lot in Crete.

1192 Sarah Bungay, Zac and Tallulah Partridge
This is a stick that my fiancé Jez picked up in Georgia, Tennessee, at the start to the Appalachian Trail in 1988. It supported him across 2,134 miles of the most challenging terrain the East Coast of America had to offer, helped him to climb 420 mountains and saved him from fast-flowing rivers, the advances of rattlesnakes, copperheads and wild dogs. The notches on the side of the stick denote the number of days he spent on the trail. He's on his stag do at the moment in France.

1193 Liddy Davidson
I've brought you a ruler, in memory of my late father Frank Wilson. He used to keep his pencils and rulers on his desk in lines. He was so organised he had seven toothbrushes, in different colours for each day of the week. I remember going with him to Hove and him buying seven new ones in one go. We had a family building company in Brighton founded by my great-great-grandfather in 1836. My father worked terribly hard when he should have been a professor of history – something completely different. He died aged 54 when I was 13.

1194 Liddy Davidson
When she was 85 my mother wrote her first book, *Home was a Grand Hotel: Tales of a Brighton Belle*. She was born in the Grand in Brighton in 1923. My grandpa was the manager there for nearly 40 years. Her book's an autobiography, a social history and a wonderful story. It's full of tales of celebrity guests who came to the hotel and lots of stories about the Second World War. The hotel provided a mountain of sandwiches for the guys who came back from Dunkirk on the little ships.

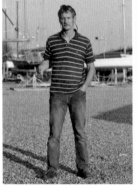

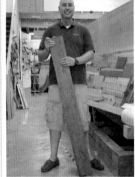

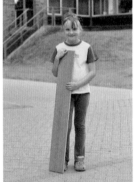

1195 Ian Davidson
It's a miniature figurine of a Malay woman carved in a local mahogany. It was bought by my parents when my father was serving in Malaysia, in Malacca district, during the Indonesian emergency, the Communist insurgency. I was born there. My parents had three of these. When my parents died I got this one, the smallest, being the junior member of the family. It's followed us around the world, it's been on funny mantelpieces in Australia, New Zealand, Panama, Fiji. It's been on my window sill for 15 years, going a lighter shade of pale.

1196 John Edwards
My father worked in the port of Southampton as a dock worker, and my childhood memories are of being close to the Solent and having a real passion for the sea. My father drowned in 2003. I'm donating this plank of cherry in his memory. It is a solid piece of timber that signifies our relationship, and it's a fitting way to re-connect us both back to the sea.

1197 Shannon Jones
I've got a toilet seat and a plank of wood from the air-raid shelters underneath our playground. We're not allowed in them because it's dangerous. Some of the wood turns to dust if you touch it. There were buckets used in case children needed to use the toilet, and there were these on top, so it was bit more comfortable. The caretaker went down there to get them.

1198 Rhianna Igglesden
This is a piece of wood from my kitchen, which I took from the builder who is building a new kitchen.

'He was so organised he had seven toothbrushes, in different colours for each day of the week.'

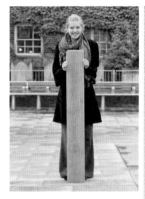

1199 Finola Muligan
It's a floorboard from my first ever flat which I got in February. It's in Greenwich. It's a spare piece of board we had after we renovated it.

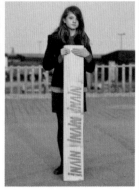

1200 Sharn Lewis
We've been involved with the Banksy that appeared on the beach in the other part of St Leonards. We look after it a little bit, and when it got vandalised pretty bad last year, it was me and Sharn that cleaned it off. Sharn wanted to have a go at doing some stencil, and this was her first piece. It says Invin, which was her pretend fairy name when she was younger.

1201 Gemma Norman
This is a plaque from the Gravesham Schools Sport Partnership. It is from our conference last year, which opened the whole Young Ambassadors programme. We had Paralympian gold medallist Danny Crates as our guest speaker and he signed it. Our 200 young ambassadors designed the logo.

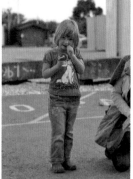

1202 Daisy Lane
This is a baby rattle. I used to bite it and scrape it when I was a baby. Now I'm four. Mummy gave the rattle to me. I was walking when I was one, even when I was still a baby. Now I like to play with my Barbies, and the favourite thing I love doing is making.

1203 Dan Lane
It's a Hunts County cricket bat from the bat manufacturers in Huntingdon, where I bought it in 1995. My father supported my love of cricket by buying my bats, and this is the best of the lot. I've scored the most runs with this bat: 149 in a league game, and 151 in a non-league game. I've taken it from Cambridgeshire to Devon, down in West Sussex and also in London. I've played with it all over the place. In 2004, at probably the most picturesque ground in Britain, the Valley of the Rocks down in Devon, I broke it.

1204 Robin Wilson and Liddy Davidson
This paperweight used to live on our late father's desk. The plaques relate to 'F T Wilson', our family's building company, which was established in 1836 when William Wilson came down from Derbyshire supposedly 'with a barrow and a couple of mates' just before the railways reached Brighton. Our father, Frank Wilson, was born 'over the shop' in Kemp Town in 1915. He was the fourth generation of the family to run the business. When he died in 1969, our mother Pamela became Chairman; then I was until it closed in 1991.

1205 James and Jemma Wilson
During a period of childhood illness, much of which was spent in hospital, my father took up building model aeroplanes. The 'Club Duration' model, from which this balsa wood piece is donated, was given to him for Christmas in 1941 by a close family friend. It was the largest and most complex model he'd received, so he decided to save it until he'd completed the others he had. But by March he'd recovered sufficiently to return home, and so the model was never assembled.

1206 Ken Lyon
It's from my grandson Jesse's first train set, which he's been playing with since the day he could put it together. Jesse's father, Daniel, nominated me to be crew on the boat. His grandma – my wife – has already donated a cat, so this donation binds us all together. Jesse says he's going to map where the boat goes, so that he can make his own little history of where his piece of train track's going. A good story for him to tell his kids in 30 years time!

'It says *Invin*, which was her pretend fairy name when she was younger.'

1207 Jerome Timmins
It represents me and an illness which resulted in me being here at *The Boat Project*. My mother got this wood to hide damage to our bath at home. I made the damage when I suffered from rage. My mental health co-ordinator, Lesley Robinson, monitored my recovery to full health and attitude, and she nominated me to be involved with *The Boat Project*. The wood is a bath accessory stand, and I've sawn a section and it's been signed. I and others have put our signatures on the wood. My cocker spaniel Lola used her teeth.

1208 Paul Shaw
I'm the High Performance Manager for women's and girls' cricket at the National Cricket Performance Centre, Loughborough, putting together programmes for the under 15s right through to the England squad. When I learned about *The Boat Project*, I went to the ECB and obtained this bat, signed by the England Women's First XI who won the Nat West Quadrangular series in 2011.

1209 Helen Ottaway
These three chairs are from the art installation *Still Ringing* at the Lead Works in Bristol in 1997, a work for voice, dance and handbells by the group '3 or 4 Composers'. The chairs are thought to be part of the free hanging, mobile scenery, designed by Deborah Thomas.

1210 Seve Ashmore
This is part of a 'tro', the wooden blocks which Hastings fishermen use to haul their fishing boats up the beach. It's just to illustrate how much I like living there. I met my wife there. I've settled there. I thought it was quite poetic – that it would have spent all its life being underneath boats as they were dragged up over it, and now it's going to live in pride of place on a boat like this.

1211 Gregg Whelan and Gary Winters
In 2001 we drove to Wales to see a coracle race. A few months earlier we'd thought about making a couple of coracles to carry across London on our backs. On reaching the Thames, we'd get in them and cross the river. But we didn't know anything about coracles. We thought we might meet somebody at the race who could help us, but we were late arriving and the race had finished. The winner was an old chap, and he gave us this paddle. He'd broken it in his efforts to come in first.

1212 David Easton
This is from the gates of Sir Christopher Wren's Marlborough House in London, now home to The Royal Collection restoration workshops as well as the Commonwealth Secretariat and the Commonwealth Foundation. It's a mahogany panel from one of the main gates. They were replaced about ten years ago because they were rotten. Marlborough House has been home to many members of the royal family including Edward VII, when he was Prince of Wales, and George V, when he was Duke of York.

1213 David Easton
The second item from the Royal Collection is a piece of flooring from Windsor Castle, one of the Queen's official residences. It was salvaged after the fire of 1992, which destroyed or damaged more than 100 rooms. This wood is from the border of the design that was in the Crimson Drawing Room, created by George IV. It's a dusty old length of mahogany with some of the original parquet detail still there – peeling a bit, but hopefully it can be saved. It would look beautiful cleaned up.

1214 Michele Di'ett
This paddle is from TS Hastings Sea Cadets. I've been a sea cadet since I was 13, so it means a lot to me to have something on the boat that's part of it. I probably do more hours there than I do at work. My first sailing experience was very entertaining. I went out with one of the girls, and the boom hit her on the head, and she went out of the boat, and left me all on my own. It was a Topper; I had no idea what I was doing. But get thrown in the deep end and you have to learn.

'I had no idea what I was doing. But get thrown in the deep end and you have to learn.'

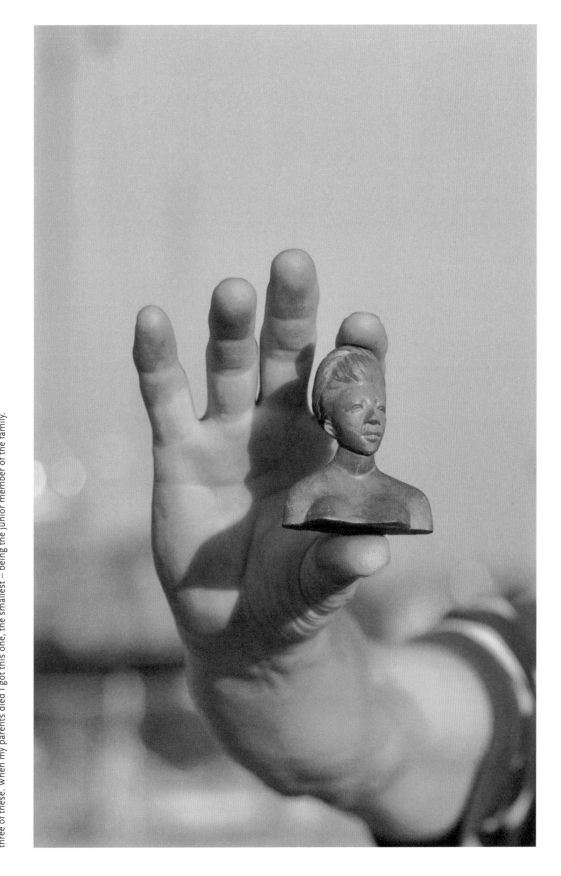

1195 Ian Davidson, see page 216

It's a miniature figurine of a Malay woman carved in a local mahogany. It was bought by my parents when my father was serving in Malaysia, in Malacca district, during the Indonesian emergency, the Communist insurgency. I was born there. My parents had three of these. When my parents died I got this one, the smallest – being the junior member of the family.

'It's followed us around the world; it's been on mantelpieces in Australia, Panama and Fiji.'

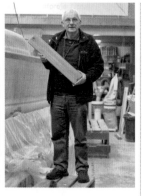

1215 Julie Wright
It's the handle of one of my father Ronald Wright's saws. He's a retired carpenter, and as a child he was constantly building stuff for me. My earliest memory is of him building a swing and slide which was the Porsche of swings and slides in the whole street, and when I was at art school he built me the most fantastic workshop. Even now, at 78, he's tirelessly helping me to renovate my house. I think it's appropriate to include a carpenter's saw, considering the craftsmanship that's gone in to building this wonderful boat.

1216 Tony Ford
I'm the Executive Officer of HMS *Warrior*. We were on a liaison visit with the *Cutty Sark* as part of the the current restoration programme after the fire in 2007. To keep the restoration complete, they were sandwiching old beams together. But there was some collateral damage. I picked up this piece from the deck, asked if I could keep it – and it's now yours! Before the fire, that part had not been disturbed, so it could have been one of the original timbers. They're hoping to complete the rebuild in time for the Olympics.

1217 Bob Daubeney
I'm the shipwright on HMS *Warrior*. In 1997 when the Royal Yacht *Britannia* decommissioned we were able to acquire from it some bits and pieces and in amongst them there was some teak decking. It's been marked in pencil 'refit 1987'. Unusually, that work was done in Devonport. *Britannia* used to refit in Portsmouth. It marks the moment when Devonport ceased to be a royal dockyard and was competing for business in the dwindling private sector.

1218 Bob Daubeney
This is a piece of Canadian rock elm that was a 'fellow's piece' in the wheel of a field gun. Our engineer on HMS *Warrior*, George Carr, is a member of the Portsmouth Action Field Gun Crew who re-enact the competition that was run at Earls Court for all those years as part of the Royal Tournament. It was a legacy of the Boer War and the relief of Ladysmith when they took cannons from several ships and had to adapt different carriages because the ones on board had different sorts of wheels.

1219 Tony Jones and Sue Farrow-Jones
It's the Dartington Hall coat-of-arms, the White Hart. It was given to me 20-odd years ago, when I started working at Dartington College of Arts. I was a student from 1987-91, and then I worked for the College for 19 years. It's been with us in the flat where we lived on the Estate. We just thought Lone Twin – all the Dartington connections – that it was an ideal thing. But it's heavy; watch it doesn't sink the boat!

1220 Simon Davies
It's a Gibson Epiphone copy, quite a cheap one, which I bought when I was a student at Bristol 25-odd years ago. It was the time of The Smiths and the end of new wave bands so it was quite difficult to get into any of them with the three chords that I'd learned, but since then I've managed to add a few more. I think this is a last 'hurrah' for it really because it's probably been abused beyond imagination. The hole in its side came about when we were camping in France and my other half ran over it in the camper van.

1221 Daniel Jehan
These decking boards are from the waterfront at Gunwharf Quays in Portsmouth Harbour. They've been there for ten years and have had the spectators and crews of three round the world races trample on them. They've also been part of a venue for spectacular fireworks displays, and had millions of people strolling up and down over them, admiring the view of the marina and the harbour entrance. So it's fitting that they should now have the chance to go to sea as part of this magnificent project.

'But it's heavy; watch it doesn't sink the boat!'

It was part of the bargain between the project team and all of the donors that once the boat was built they would be able to visit it and point to the spot where their donations had ended up. The next section will enable them to do that, as well as giving other readers a better sense of the fabric and complexion of the boat. It numbers and illustrates the main parts, and then indexes all 1,221 embedded objects alongside an identifying reference. In the case of the hull, where so many pieces intersect, the key is based on the compass, and the index serves as an atlas. So the remains of Simon Davies's *ersatz* Gibson Epiphone guitar, [1220] 'abused beyond imagination' before he donated it, are listed as being on the port side at 30°N 061°E, a position described and explained over the page. The handle of Julie Wright's father's saw [1215] should be easier to find at 'Cockpit S' – in the cockpit, to starboard.

Collating the index has been quite a complicated undertaking, as you might imagine, allowing for the intuitive assembly methods described earlier – those thicknessing and dry-stone walling techniques the build team developed. So there is an element of field archaeology about the final reckoning represented here. We believe that this is a largely reliable record of the 'congregation of wood' and the fastening of 1,221 stories. Please forgive any small mistakes you might uncover. Worse things happen at sea.

Index of parts

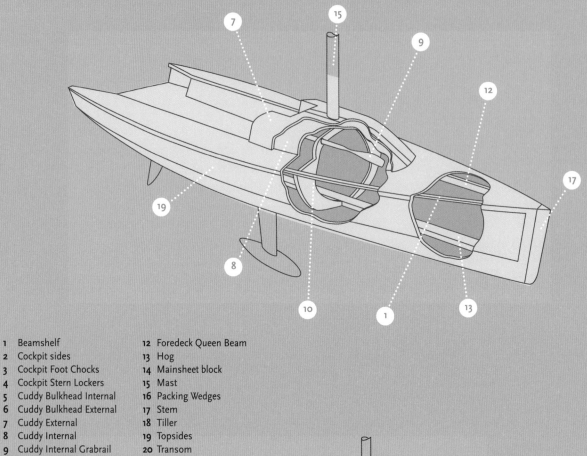

1 Beamshelf
2 Cockpit sides
3 Cockpit Foot Chocks
4 Cockpit Stern Lockers
5 Cuddy Bulkhead Internal
6 Cuddy Bulkhead External
7 Cuddy External
8 Cuddy Internal
9 Cuddy Internal Grabrail
10 Cuddy Ringframe
11 Cuddy Trim

12 Foredeck Queen Beam
13 Hog
14 Mainsheet block
15 Mast
16 Packing Wedges
17 Stem
18 Tiller
19 Topsides
20 Transom
21 Under-deck Bulkheads

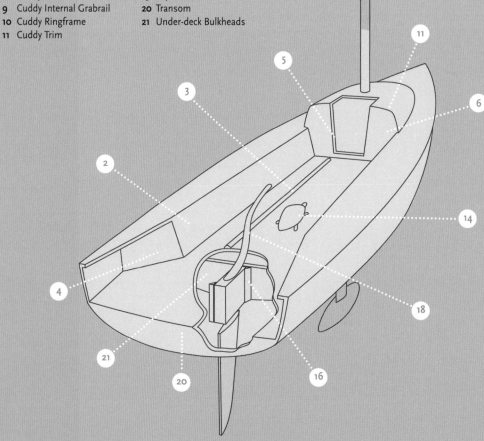

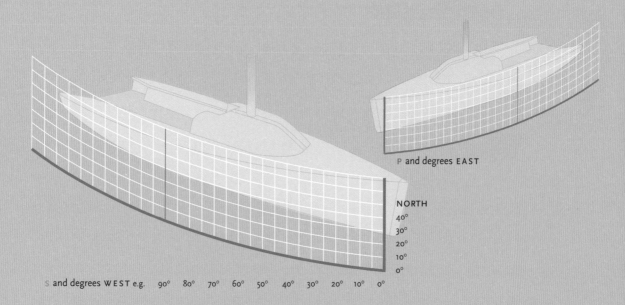

P and degrees EAST

NORTH
40°
30°
20°
10°
0°

S and degrees WEST e.g. 90° 80° 70° 60° 50° 40° 30° 20° 10° 0°

Donations have been used in almost every part of the boat, but the majority are on the 'topsides' – the port and starboard elevations of the hull visible above the water-line. The key to the topside position of individual pieces uses longitude and latitude coordinates, as the diagrams on this page show. Topside entries on the next pages are detailed as being either on the East (E, port) or West (W, starboard) side of the boat, and the two sides are sectioned by degrees. The North (N) value indicates where above the red line painted on the hull a donation is located. The degree values on the diagram are replicated more accurately on the boat itself. So, for example, an item located on the port topside is indexed as:

Top P 10° N 130°E

or on the starboard side as

Top S 15° N 085°W

P stands for port, and S for starboard throughout.

Other locations described on the facing page appear in the index, as follows:
Beamshelf = Beamshelf P or S
Cockpit sides = Cockpit P or S
Cockpit Foot Chocks = Cockpit FC
Cuddy Bulkhead Internal = Cuddy B'head Int
Cuddy Bulkhead External = Cuddy B'head Ext
Cuddy External = Cuddy External P or S *and a number to show the position in relation to the centre-plank*
Cuddy Internal = Cuddy Internal P or S *and a number to show the position in relation to the centre-plank*
Cuddy Internal Grabrail = Cuddy Int Grabrail
Cuddy Ringframe
Cuddy Trim
Hog
Mainsheet Block
Mast
Packing Wedges
Stem = Stem P or S *and by a number to show the position in relation to the centre*
Tiller
Transom = Transom *and by a number to show the position counting items from the port side*
Under-deck Bulkheads

Some more mobile locations given in the parts index are not shown in the diagrams. They include: Accessories (such as Bowls, Spoons and Fid); Anchor Holder; Boomcrutch; Bow Figurehead; Bow; Cuddy Hatch and Washboards (= Cuddy Hatch & W); Decoration (such as Bulkhead Decoration and Above Bunk); Flagstaff; various Furniture (such as Book Box, Loo Frame, Stove Support, Cuddy Shelf, Cup Holder, Tool Box Holder. Dock Box and Tray). Other essential components include: Brackets, Anchor Warp Holder, Teak Cleat Blocks in Cockpit, Cuddy Outboard Bracket, Mast Foot Bolt Washer, Rope Ends, Gangplank, Keel, Keel Block, Keel Pad, Signage, Step and Rudder.

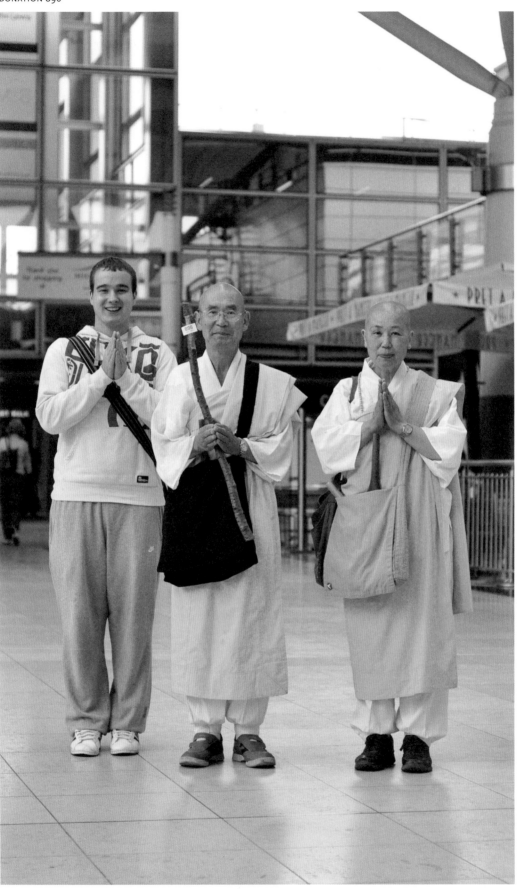

896 Levi Bullard, Nagahama Shoninsan, and Sister Marutha Yoshie, see page 176

Altogether 1,000 cherry trees and cedars, donated by the ancient Japanese town of Yoshino, were planted on the hill around the pagoda. People come daily to pray. It is a visible statement – that civilisation does not need to have electric lights or aeroplanes or nuclear bombs; to be civilised means not to destroy things.

THE LONE TWIN BOAT PROJECT 230

'This is from one of the cherry trees planted in 1980 for the inauguration of the Milton Keynes Peace Pagoda.'

Postscript

Interviewed by *The Guardian* newspaper when plans for the Cultural Olympiad festival were published in March 2012,[1] Gary Winters explained how Lone Twin's original bid for 'Artists Taking The Lead' funding had been boiled down to nine words and three acts: 'People contribute wood, a boat is made, boat sails'. This book confirms what has happened since: people *did* contribute wood, a boat *was* made, and, as I write, the final, open-ended act *boat sails* is about to begin. Very soon it will be put on the water for the first time to be made ready for its formal public launch at Thornham Marina in Emsworth on the public holiday in early May.

Between now and then, the boat is undergoing sea trials and fine tuning while a volunteer crew of six is in training. Of mixed experience and age and selected from hundreds of public nominations, the crew members will be serving with the boat's chosen captain, Mike Barham, an experienced sailor and yachtmaster instructor. Most recently they have been in action in The Solent aboard the Royal Electrical and Mechanical Engineers yacht club's craft *Seahorse* and *Craftsman*.

Towards the end of 2011 Lone Twin asked various people associated with the project to suggest possible names for the boat, and a shortlist of ten was opened to a public vote in January 2012. The name that attracts the most votes will be revealed and conferred as part of the launch event in May – a day of celebrations and performative transitions, marking endings and beginnings. The build team will formally hand over the boat to the captain and crew, before it is lifted by crane on to the water in a fleeting moment of flight. This book will also be launched and a copy placed in a container on board, before final preparations are made for the maiden voyage.

Winters describes Lone Twin's approach to the curation of events on this three-month summer journey towards the Olympics: 'On the face of it, and this would be one of the differences from earlier Lone Twin work, *The Boat Project* has no "show" or moment of congress in a usual sense. However the maiden voyage takes on something of this performance aspect, it's the moment when everyone can see and celebrate what's been going on over the last two years.

Julie Wright, 41,
from the Isle of
Wight, was
nominated by her
husband Seth.

Daniel Lane, 46,
a teacher and
photographer from
Emsworth, was
nominated by his
wife Philippa.

Michelle Die'tt, 25,
from St Leonards-
on-Sea, has been a
Sea Cadet since
she was 13, and is
a sailing instructor.

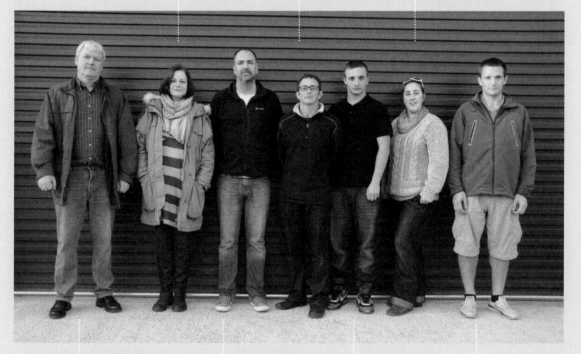

Kenneth Lyon, 50,
a plumber and tile
fitter from Arundel,
West Sussex, was
nominated by his
son Danny. (*Alas,
Kenneth has since
had to withdraw.*)

Steve Ashmore, 48,
from Hastings,
a scuba diving
instructor and
graphic designer,
was nominated by
his wife Amanda.

Harry Custance, 16,
from Guildford, has
been offered an
internship to assist
Boat Captain Mike
Barham on- and
off-shore.

Jerome Timmins, 27,
from Bexhill-on-Sea,
is studying at Sussex
Coast College,
Hastings.

We knew the boat would be arriving by water at most of the places it will visit, so we were keen to embrace some of the traditions that come with a docking – the sense of a welcome party or flotilla, the sharing of stories from the passage, the community hosting and taking in the crew, good luck charms and a blessing for the departure. Each of these practices, and others specific to the maritime or nautical connections of the stopping points, have been incorporated into the programme of events on this first journey, alongside moments that embrace the themes of the project as a whole: collections, journeys, stories, and so on'.

This programme has been developed in conjunction with partner organisations and festivals at ports of call en route, in Brighton, Portsmouth, Hastings and Margate. The itinerary also includes a trailered trip inland to Milton Keynes via the M25, and a final journey to Weymouth for the duration of the Olympic and Paralympic sailing competition. Events include specially commissioned work by artists and local communities, exhibitions, artist's talks, and performances on board or on the quaysides. Flotillas will accompany the boat on sea and land, with diverse musical and choral performances marking arrivals and departures – there's even a blessing from the Bishop of Horsham as the boat leaves Brighton Marina in late May. One will be able to see the boat docked at its moorings in port, on dry land, and in full sail off the coast.

One of Lone Twin's core contributions to the maiden voyage was to invite proposals for an artist's commission to create a 'ship's log' over the course of the journey. It was awarded to singer-songwriter Johny Lamb, who works under the sobriquet of Thirty Pounds of Bone. Based in West Cornwall, his alt-folk songwriting draws thematically on the sea, itinerant travel and wryly observed narratives of displacement and destitution. Lamb considers the ship's log an opportunity to create an episodic, cumulative song cycle registering some of the stories, sights and sounds experienced during the boat's journey; he will produce a song for each leg and give each new song its premiere in the five major ports of call in collaboration with local musicians. Whelan: 'Johny's recent work has a fascination with field recordings and ideas of "sited" sound, and it's perfect for the Ship's Log. He knows about folk song and its traditions, but that's married with a very contemporary sense of the here and now. As a mode of capturing something of the boat and crew's experience of the voyage it feels like a really exciting proposition. And each new part to the piece will be played at a gig, so it provides a social, lubricated element to the voyage'.

Finally, in autumn 2012, in the wake of the Olympics, the boat will begin an autonomous life, entering the legacy period considered an integral aspect of *The Boat Project* from the first. Managed and maintained by a charitable trust, the boat is being made available as a multi-functional civic resource: as a vessel

for sailing, teaching and trialling, an object for exhibition, and also as the focus and stimulus for an annual arts programme. As Whelan explains: 'Artists will be invited to sail it, and to make art from it or triggered by it. So it will be a sort of mobile residency space, as well as an archive and exhibit in its own right. All of Lone Twin's work has been about making mechanisms for opening up to the world, and that's always been our goal with this boat'. Perhaps above all, as the material product of countless gifts, collective dreamings and hard work, the boat will tell something of the story of the experiences, hopes and generosity of people who come together to make something remarkable – and then let it go.

NOTE

1 Gary Winters in Mark Brown, 'Cultural Olympiad 2012 reaches the critical masses', *The Guardian*, 13 March 2012, p. 14.

1192 Sarah Bungay, see page 216
It supported my partner, Jez Partridge, across 2,134 miles of the most challenging terrain the East Coat of America had to offer, passing through 14 states and helping him to climb 420 mountains en route. The notches on the side of the stick denote the number of days he spent on the trail, carved at the end of each day before turning in.

THE LONE TWIN BOAT PROJECT 236

'It saved him from the advances of diamondback rattlesnakes and copperheads, and a pack of wild dogs.'

Appendices

Chronologies and credits

JANUARY 2011 Boat shed is fitted out with tools, machine shop and work benches • the 'block' is laid from laser-cut MDF formers • cedar bead and cove are ordered from Bristol marine specialists Robbins Timber.

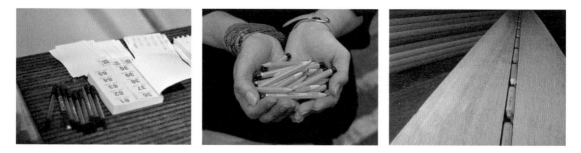

FEBRUARY 2011 Boat shed opens to public • donations start to arrive • building block is planked with cedar to create a thin shell – thin enough to put a fist through • Jan Wheatley's pencil stubs are laid into bow stem.

MARCH 2011 Epoxy holds the cedar together, plastic nails tack the planks to the formers • planking of hull is completed using West System • it looks like a finished hull but is very far from it.

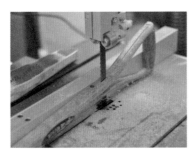

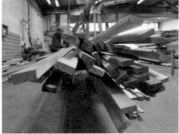

our cedar at Robbins Timber

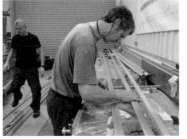

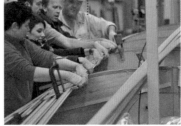

volunteers help with the strip planking

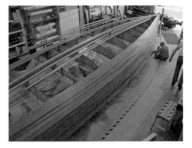

Jesse, Mike and Ian laying the last planks

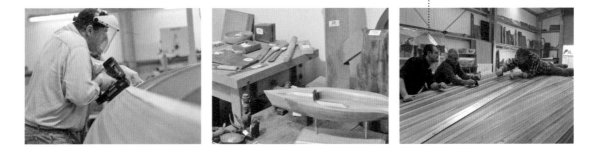

Donation days were the project equivalent of the BBC *Antiques Roadshow*. The team toured the region, met the public and gave a sympathetic verdict (generally, 'yes, please!') on the belongings they brought with them.

MARCH DONATION DAY
25 Community building in the RNLI boathouse, Stade, Hastings

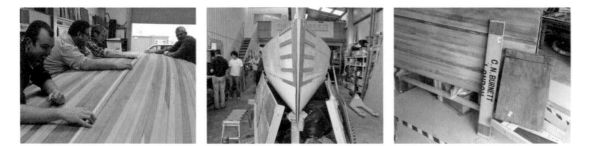

APRIL 2011 Long, dusty job of boarding and fairing hull • stem knuckle is made from C N Burnett teak plank and elm top from the bar of The Old House at Home, Chidham • hull is glassed and vacuumed down to remove all air • more filling and fairing • more fairing and filling.

MAY 2011 Scaffold cradle is built for turning the hull • a structural engineer assesses shed's roof strength• hull is turned using roof beams and very clever rope work – big day, many volunteers • MDF formers are removed.

JUNE 2011 First stocktaking of donations, 545 are counted and logged • begin to dismantle and cut donations • pieces are assigned to parts of the boat • hull interior is filled and faired and faired and filled, and, finally, glassed.

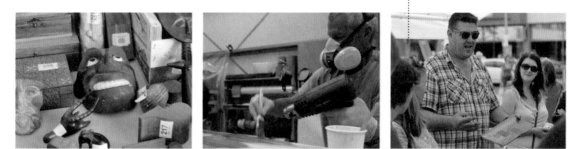

Mark briefs volunteers at a donation day

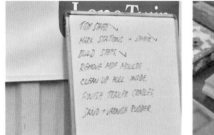

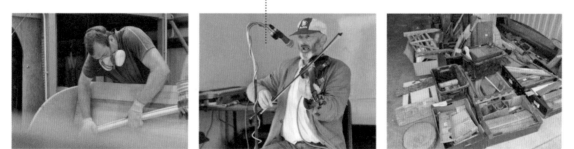

entertainment at Gravesend donation day

MAY DONATION DAYS

8 Jubilee Square, Brighton for The Brighton Festival
14 Westgate Hall, Southampton
15 Arundel Lido, Arundel
22 Southsea Castle, Clarence Esplanade, Portsmouth
28 The Spring Arts and Heritage Centre, Havant

JUNE DONATION DAYS

4 Oaklands Park at Chichester Festival Theatre, Chichester
15 University of Kent, The Gulbenkian Theatre Foyer, Canterbury
16 The Civic Square, Gravesend
26 Lockwood Day Centre, Slyfield Industrial Estate, Guildford

JULY 2011 Hog and beamshelf are built using donations from HMS *Victory* and *Warrior* • keel and rudder holes are cut into the hull • after six months of receiving donations we shut up shop (31st).

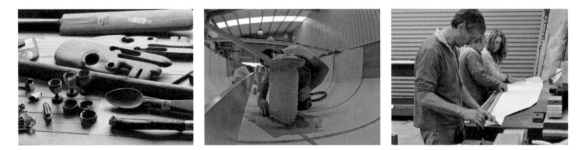

AUGUST 2011 Grand stocktaking of donations – the extent of them unnerves the team • cutting and assigning of donations continue • keel and rudder cases and internal bulkheads are fitted • cuddy roof is assembled over recycled formers.

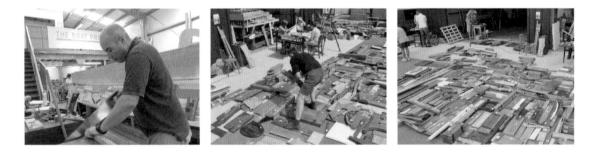

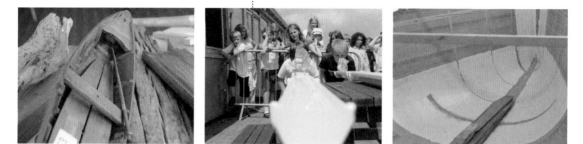

gutter racing with Brighton schoolchildren

hundreds visit the boat shed to check on progress

Gary and Gwen keeping count

JULY DONATION DAYS

8 Portland Marina, Osprey Quay, Weymouth and Portland Spirit of the Sea
10 Royal Lymington Yacht Club, Lymington
12 Peacehaven Community School, Peacehaven
16 Daux Road Industrial Estate, Billingshurst
17 Lightwater Country Park Visitors Centre, Surrey Heath
19 Midsummer Place, Milton Keynes
20 George Inn, Barford St Michael
23 Bexhill-on-Sea, the De La Warr Pavilion seafront
24 Rivermead Leisure Complex, Reading
29 Theatre Royal, Margate

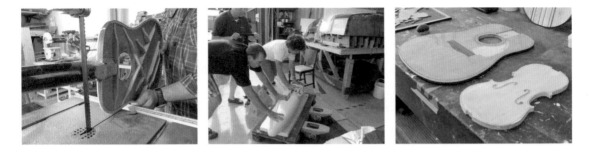

SEPTEMBER 2011 Donations are 'thinned' to 10mm for fitting and fixing • rudder, strut and lead keel are delivered (the keel weighs three quarters of a tonne) • hatches, lockers and reinforcements are constructed.

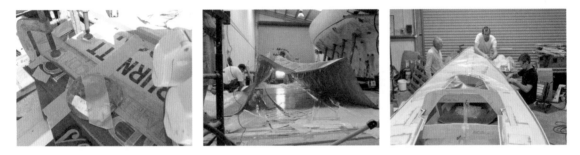

OCTOBER 2011 Sole and deck cut and fitted from foam – high density around the fittings, low density everywhere else • foam sections are glassed using a vacuum-bag • cuddy roof is fitted.

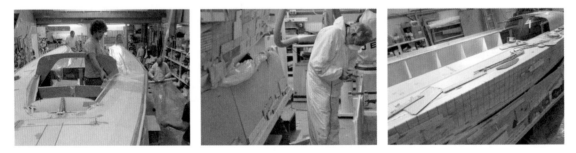

NOVEMBER 2011 Donations are dry fitted to hull topsides • team tries to follow dry-stone walling rule that, once picked up, a donation must be found a place • other building strategies are attempted • a wooden foot is placed inside a clog.

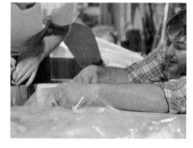

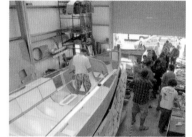

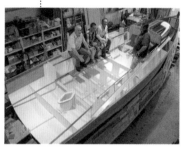

first time on the boat for crew members

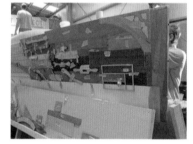

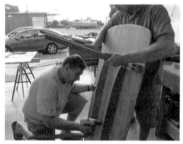

time for a tea break, everyone

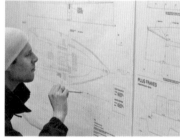

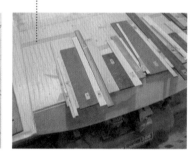

an idea for the transom design

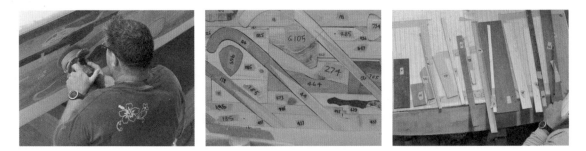

DECEMBER 2011 Donations are glued and fitted to topsides • all are vacuum-bagged in situ • topsides are faired and sealed • transom donations are fitted.

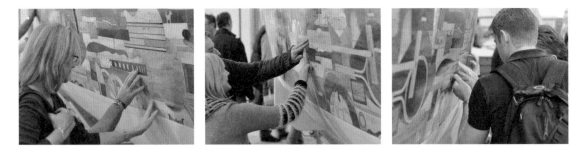

JANUARY 2012 Bespoke aluminium trailer is delivered • mast and boom arrive from Seldén • the boat is exhibited unfinished at the London Boat Show • last few topsides donations are added • cockpit side panels are made.

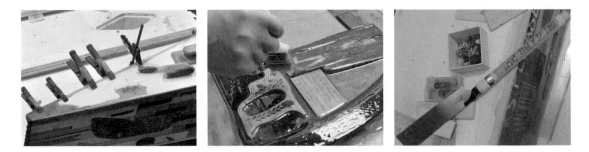

FEBRUARY 2012 Cockpit side panels fitted • deck and sole are faired • team give selection of donations to Rolls Royce to build the gangplank • positions and fastenings for deck gear are set out.

Gretta and Liddy cross reference the positions of donations

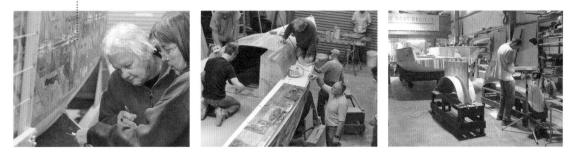

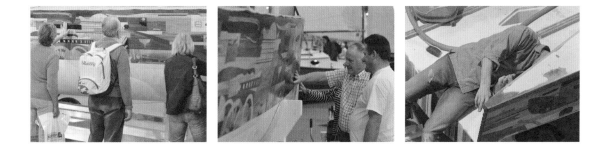

foot chocks being made from the Lower mast donated by Hastings Fishermen's Protection Society

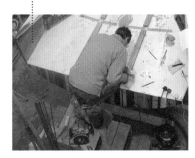

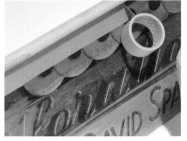

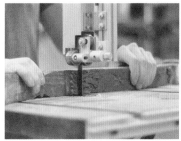

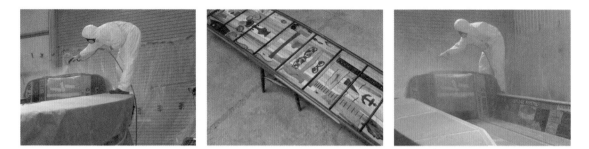

MARCH 2012 Boat is sprayed and sprayed • interior fixtures and fittings are installed • mast compression post is fitted • an onboard cabinet is made for this book • all deck gear and winches fitted • running rigging made • gangplank arrives from Rolls Royce.

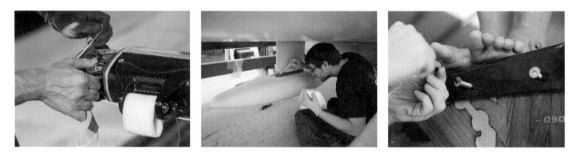

APRIL 2012 Tiller is made from final donations • hull is lifted for strut and keel fitting • mast step, standing rigging, bowsprit and outboard are fitted • sails are delivered and rigged • sea trials begin • fingers are crossed.

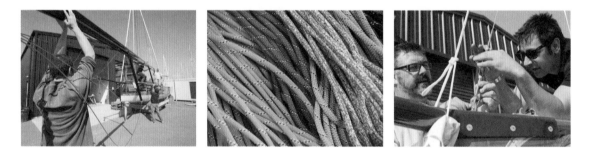

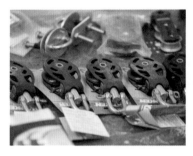

Keith and Roger get stuck in

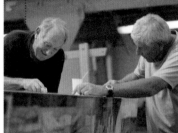

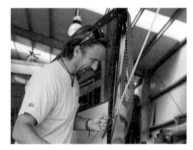

7th May 2012 – remember the date!

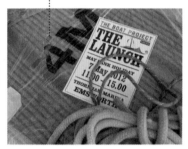

stepping the mast

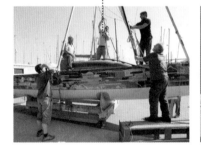

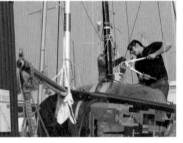

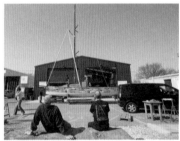

Maiden voyage 2012

MAY

7	The Launch, Thornham Marina, Emsworth
9	Emsworth Quay
18	Hayling Island to Shoreham – the inaugural journey
19-27	Brighton Marina (Pontoon 6), for Brighton Festival
27	The Solent, including Lymington and the Isle of Wight, until June 21

JUNE

2-5	passage to Portland with the Royal Yachting Association; in Weymouth for the Diamond Jubilee weekend
23	Portsmouth – Gunwharf Quays, for Portsmouth Festivities, until July 1

JULY

1-4	Littlehampton
5	Eastbourne
6	sighting from Bexhill-on-Sea
6-8	Hastings
9-10	Dover
10	Folkestone
10-12	Ramsgate
13-16	Margate
18	Gravesend
19-29	Milton Keynes for Milton Keynes International Festival
30-31	Barford St Michael, Oxfordshire

AUGUST

1-11	Weymouth for 2012 Olympic and Paralympic sailing events

Core team

Lone Twin
Gary Winters, Gregg Whelan (Artistic Directors)
Lone Twin production and management: Gwen Van Spijk (Executive Director),
Catherine Baxendale (Project Manager)

Designer: Simon Rogers
Technical Manager: Mark Covell
Build Team: Jesse Loynes, Ian Davidson, Sean Quail, Mike Braidley
Surveyor/RCD: Paul Handley
Boat Captain: Mike Barham
Boat Crew: Steve Ashmore, Michelle Die'tt, Daniel Lane, Kenneth Lyon,
Jerome Timmins, Julie Wright
Boat Captain's Assistant: Harry Custance
'The Ship's Log' artist's commission: Thirty Pounds of Bone – Johny Lamb

Project personnel

Liddy Davidson (Project Coordinator), Austin Lawler (Production Manager),
Ally Wade (Producing Assistant), Elly Crowther (Production Assistant, Summer 2011)
PR and Marketing: Tracy and Adam Jones of Brera, Julie Turner, Janette Scott
(until March 2011)
Launch Event Manager: Simon Davies
Launch Technician: Robin Yeld
Intern: Poppy Reid
Photographers: Toby Adamson, Mike Austen, Mark Covell, Lone Twin, Ian Roman,
Molly Haslund, Don Manson, Poppy Reid, Grace Surman
Line art for boat drawings: Nic Cowper

Build suppliers

With thanks for generously given materials and time: Philip Aikenhead (technical advice), Marlow Ropes Ltd (ropes), Nik Pearson (running rigging), Raymarine (compass), Rolls Royce Motor Cars (creating the gang plank from donations), Seldén Masts Ltd (bowsprit), Spinlock Ltd (deck gear), Steve Hill (scaffolding tower), Steve Hulme (general assistance), Structural Dynamics (standing rigging)

With thanks for discounted materials and time: AFC Aluminium Finishing (anodising and polish work), Ashdown Marine Ltd (spray paint and finishing), Axminster Tools (tools), Covercare Ltd (boatcover), C-Quip Ltd (deck gear), Deborah Services Ltd (scaffolding), Demon Yachts Ltd (appendages, keel, rudder and bowsprit), DTC/ Direct Tool Company (tools and consumables), Even Keel Sailing (gimbal chair), Fluid Fabrications Ltd (metal work), Grapefruit Graphics (graphics), Harken UK Ltd (winches and deck gear), Havant Glass and Glazing (glass plate), High Modulus Europe Ltd (structural engineering), JR Services (metal work), Marineware Ltd (paint and consumables), North Sails UK (sails), Peter Bird (electrician), PEP Pearson Ellis Portsmouth (structural engineering), Preston's Welding/Keels on Wheels (trailer), Richard Faulkner Composites Ltd (glass work), Robbins Timber (structural timber for hull), Sailboat Deliveries (logistics), Seldén Masts Ltd (mast and boom), Soluxion Ltd (IT web cam), Sparks Boatyard MDL (marina berth for sea trials), Speedy Hire (lifting gear), Stainless Steel Centre Ltd (fastenings), Thornham Marina (lifting and yard), Tim Gilmore (timber machining), Wessex Resins and Adhesives (West Epoxy)

Build and archiving volunteers

Boat building volunteers
Toby Adamson, Dave Bulger, Claire Dalgleish, Robert Duvall, David Easton, Carleton Edwards, John Edwards, Glenwood School, Damien Grounds, Gavin Huckvale, Maxwell Hyde, Austin Lawler, Sam McGregor, Ernest Monnery, Tikki O'Connell, Roger Palmer, Emma Purcell, Phil Reid, Keith Rodwell, Alyson Salkid, Ben Sanderson, Julian Saxty, Chaz Shaw, Jerome Timmins, Jonquil Tonge, Paul Underhill, Jar Vahey, Adam Weymouth, Harry Wilkinson, Bill Woods

Shed donation archiving volunteers
Clem Cobden, Brian Edward-Picknett, Anna Hennings, Julie Higgins, Gavin Huckvale, Maxwell Hyde, Alice Leppard, Sarah Leppard, Don Manson, Mary Milton, Pam Wilkinson, Jemma Wilson

The 'A' Team (archive)
Joanna Brown, Linda Casey, Clem Cobden, Dan Lane, Pippa Lane, Mary Milton, Ingrid Murnane, Flick Newton, Gretta Pescod, Jonquil Tonge, Ally Wade, Heather Way, Pam Wilkinson

Donation day archiving volunteers
Lorna Crabbe and Mark Prime (Hastings), Sarah Leppard and Chaz Shaw (Brighton), Sarah Leppard (Southampton), Roy Smith, Debbie Kennedy and Felicity Jones (Arundel), Sonia Rebecchi (Portsmouth), Ashley Fulham and Don Manson (Havant), Ashley Fulham and Andy Roberts (Chichester), Jaime Andres Cabrera and Victoria Tedder (University of Kent, Canterbury), Gemma Norman, Aaliyah Mathurin and Ashley Fulham (Gravesend), Sarah Leppard (Guildford), Sarah Groom, Louise Isaacs and Liane Gibson (Surrey Heath), Julie Higgins (Milton Keynes), Jessica Stiles (Bexhill-on-Sea), John Edwards (Margate)

Launch and maiden voyage partners

Launch partners: Havant County Council, Chichester District Council, West Sussex County Council, The Emsworth Arts Trail, Emsworth Business Association, Making Space, Southbourne Sea Scouts, The Boat House Café, Caroline's Diaries, Harrie's Food

Brighton partners: Brighton and Hove City Council, Brighton Festival, Brighton Fringe, The Nightingale Theatre, Brighton Marina, Premier Marinas, The Basement, The Lighthouse, Fabrica, St George's Church, The Diocese of Chichester

Portsmouth partners: Portsmouth Festivities, Gunwharf Quays, Portsmouth Historic Dockyard, Aspex Gallery, The New Theatre Royal, Explosions Museum, Portsmouth City Council

Hastings partners: Hastings Borough Council, Fishermen's Protection Society, Jerwood Gallery, Project Art Works, Steve Cooke

Margate partners: Thanet District Council, Kent County Council, The Dreamland Trust, Parrabbola, South East Dance, Turner Contemporary, The Theatre Royal Margate

Milton Keynes partners: MK IF – Milton Keynes International Festival 2012, The Stables

Other maiden voyage partners: RYA, Royal Lymington Yacht Club, Shoreham Port, Littlehampton Academy, Littlehampton Harbor Board, Littlehampton Town Council, Premier Sovereign Harbor, Rother District Council, The De La Warr Pavilion, Eastbourne Town Council, Folkestone Fringe, Folkestone Harbour Company, Shepway District Council, Gravesham Borough Council, the George Inn in Barford St Michael, Maritime Mix Festival, Atwork, Something Somewhere, Dragonfly Creative Solutions Ltd

Things outlast us, they know more about us than we know about them. They carry the experiences they have had with us inside them and are – in fact – the book of our history opened before us.

W G Sebald, in Sebald and Jan Peter Tripp, *Unrecounted*,
London: Hamish Hamilton, 2004, pp. 79-80.

Supported by
**ARTS COUNCIL
ENGLAND**

With thanks to Arts Council England 'Artists Taking The Lead', particularly the
team in the Arts Council England South East Office, Rebecca Ball and Chloe Barker
(until 2010), Jon Linstrum, Nicola Jeffs (2010 onwards) and Caterina Loriggio;
Forma, who were project producers in the early stages – David Metcalfe, Iain Pate,
Kamal Ackarie and Emily Cummings; Jeanette Critchall at Thornham Marina,
Slipper Sailing Club, Hayling Island Sailing Club and Sparkes Marina, Hayling
Island; British Marine Federation – Rob Stevens, Hayley James, Ed Mockridge and
Emma Jones; Royal Yachting Association – Sarah Treseder, John Derbyshire and
Celia Edgington; Luke McCarthy for assistance with the recruitment of the Boat
Captain; Crew Clothing; Viv and Anna Williams at Hollybank House, Emsworth,
a home from home. Our former company manager Kate Houlden and *Absolutt
Galskap* festival director Sverre Waage made invaluable contributions in the early
stages of the project. Sverre helped to shape our thinking in Kongsvinger in 2000
and again in Stavanger a few years later; Kate was instrumental in securing the
Artists Taking The Lead award.